The Reconfigured Eye

The Reconfigured Eye

VISUAL TRUTH IN THE POST-PHOTOGRAPHIC ERA

WILLIAM J. MITCHELL

The MIT Press
Cambridge, Massachusetts
London, England

Fourth printing, 2001

First MIT Press paperback edition, 1994

This book was set in Melior and Univers by DEKR
Corporation and was printed and bound in the
United States of America.

Library of Congress Cataloging-in-Publication Data

Mitchell, William J. (William John), 1944–
 The reconfigured eye : visual truth in the post-
photographic era / William J. Mitchell.
 p. cm.
 Includes bibliographical references and index.
 ISBN 0-262-13286-9 (HB), 0-262-63160-1 (PB)
 1. Image processing—Digital techniques.
2. Images, Photographic—Data processing.
I. Title.
TA1632.M55 1992
621.36′7—dc20 92-14462
 CIP

■ Combined with this was another perversity—an innate preference for the represented subject over the real one: the defect of the real one was so apt to be a lack of representation. I like things that appeared; then one was sure. Whether they *were* or not was a subordinate and almost always a profitless question.

Henry James, *The Real Thing*, 1892

CONTENTS

ACKNOWLEDGMENTS

■ **The Reconfigured Eye**
Visual Truth in the
Post-Photographic Era

This book developed from seminars and design
studios taught at the Harvard University Grad-
uate School of Design, and its content reflects
numerous discussions and collaborative inves-
tigations with students, technical staff, and fac-
ulty colleagues at the GSD. In addition, various
people made specific contributions for which I
am particularly grateful. Debra Edelstein was
crucially involved in this project from its in-
ception—in the discussions that led to its ini-
tial formulation, through her comments on
early drafts, and through her insightful editing.
She also tenaciously pursued photographs of
and reproduction rights to works in museum,
library, and corporate collections. Steve Oles
carefully read an early draft, raised questions,
and provided corrections. Wade Hokoda and
Angela Perkins produced many of the original
illustrations using the facilities of the GSD's
computer network. Mark Rosen resourcefully
solved technical problems. Malcolm McCul-
lough and Elaine Fisher provided illustrations.
Carla Hotvedt of the Silver Image Photo
Agency, Gainesville, Florida, efficiently located
numerous photographs and secured reproduc-
tion rights. Maja Keech of the Prints and Pho-
tographs Division, Library of Congress,
provided invaluable assistance in locating orig-
inals of some photographs. Steve Thibodeau of
Lintas: Worldwide Advertising, New York, en-
dured the difficulties of securing the multiple

permissions needed to reproduce stills from a Diet Coke commercial. Yasuyo Iguchi of the MIT Press responded superbly to the design and production challenges raised by a book that includes great diversity of graphic material and required use of some new and unfamiliar prepress technology.

The Reconfigured Eye

1.1 Tracing an image by hand: Karl Friedrich Schinkel,
The Invention of Drawing, **1830. Von-der-Heydt-**
Museum, Wuppertal.

BEGINNINGS

Three Snapshots

Pliny the Elder tells a mythic tale: a Corinthian maiden traces the shadow of her departing lover.[1] An image is captured by the work of her hand: painting is born (figure 1.1).[2]

William Henry Fox Talbot traces a scene at Lake Como with the help of a camera obscura. He begins to wonder "if it were possible to cause these natural images to imprint themselves durably." By 1839 he has perfected the art of chemically fixing a shadow. He announces to the Royal Society his invention of a way to record images permanently on specially treated paper "by the agency of light alone, without any aid whatever from the artist's pencil."[3] Simultaneously, Daguerreotypes make their public appearance in France. The history painter Paul Delaroche exclaims, "From this day on, painting is dead."[4]

Scientist Russell A. Kirsch and his colleagues, working at the National Bureau of Standards in the mid-1950s, construct a simple mechanical drum scanner and use it to trace variations in intensity over the surfaces of photographs (figure 1.2).[5] They convert the resulting photomultiplier signals into arrays of 176 by 176 binary digits, feed them to a SEAC 1500-word memory computer, and program the SEAC to extract line drawings, count objects, recognize characters, and produce oscilloscope displays (figure 1.3). Patterns of light and shade become electronically processable digital information; an early computer supplants the artist's recording hand.

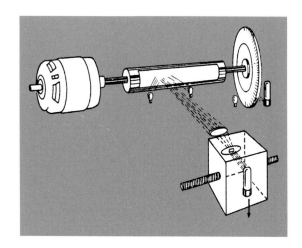

1.2 Tracing an image electronically: scanner constructed by Russell A. Kirsch and his colleagues at the National Bureau of Standards in the 1950s.

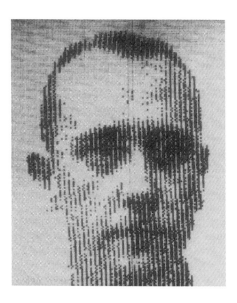

1.3 One of the first digital images: this picture was scanned from a photograph by the NBS mechanical drum scanner, processed by the SEAC computer, and displayed on an oscilloscope.

The Raster Grid

We might, of course, choose to regard the digitally encoded, computer-processable image as simply a new, nonchemical form of photograph or as single-frame video, just as the automobile was initially seen as a horseless carriage and radio as wireless telegraphy. Indeed the terms "electronic photography," "still video," and "digital camera" have rapidly gained currency. But such metaphors obscure the importance of this new information format and its far-reaching consequences for our visual culture. Although a digital image may look just like a photograph when it is published in a newspaper, it actually differs as profoundly from a traditional photograph as does a photograph from a painting. The difference is grounded in fundamental physical characteristics that have logical and cultural consequences.

The basic technical distinction between analog (continuous) and digital (discrete) representations is crucial here. Rolling down a ramp is continuous motion, but walking down stairs is a sequence of discrete steps—so you can count the number of steps, but not the number of levels on the ramp. A clock with a spring mechanism that smoothly rotates the hands provides an analog representation of the passage of time, but an electronic watch that displays a succession of numerals provides a digital representation. A mercury thermometer represents temperature variation in analog fashion, by the continuous rise and fall of the column of liquid, but a modern electronic thermometer replaces this with a digital readout.

A photograph is an analog representation of the differentiation of space in a scene: it varies continuously, both spatially and tonally. Edgar Allan Poe shrewdly observed this and noted its significance in his 1840 article "The Daguerreotype":

If we examine a work of ordinary art, by means of a powerful microscope, all traces of resemblance to nature will disappear—but the closest scrutiny of the photogenic drawing discloses only a more absolute truth, a more perfect identity of aspect with the thing represented. The variations of shade, and the gradations of both linear and aerial perspective, are those of truth itself in the supremeness of its perfection.[6]

A century later, in an essay concerned with identifying the qualities that characterize photography and distinguish it from other art forms, the modernist photographer Edward Weston echoed Poe precisely:

First there is the amazing precision of definition, especially in the recording of fine detail; and second, there is the unbroken sequence of infinitely subtle gradations from black to white. These two characteristics constitute the trademark of the photograph; they pertain to the mechanics of the process and cannot be duplicated by any work of the human hand.[7]

But images are encoded digitally by uniformly subdividing the picture plane into a finite Cartesian grid of cells (known as *pixels*) and specifying the intensity or color of each cell by means of an integer number drawn from some limited range.[8] The resulting two-dimensional array of integers (the *raster grid*) can be stored in computer memory, transmitted electronically, and interpreted by various devices to produce displays and printed images. In such images, unlike photographs, fine details and smooth curves are approximated to the grid, and continuous tonal gradients are broken up into discrete steps (figure 1.4).

1.4 Enlargement of a digital image: smooth curves and continuous gradients are approximated by discrete pixels.

There is an indefinite amount of information in a continuous-tone photograph, so enlargement usually reveals more detail but yields a fuzzier and grainier picture.[9] (The plot of Antonioni's *Blow-Up* pivots on the observation that a photographic negative may contain more information than immediately meets the eye. We see David Hemmings, the fashionable photographer, obsessively enlarging parts of his negatives to reveal previously unnoticed details—a face half-concealed in the foliage, a hand holding a gun, and a body on the ground.) A digital image, on the other hand, has precisely limited spatial and tonal resolution and contains a fixed amount of information. Once a digital image is enlarged to the point where its gridded microstructure becomes visible, further enlargement will reveal nothing new: the discrete pixels retain their crisp, square shapes and their original colors, and they simply become more prominent.

The continuous spatial and tonal variation of analog pictures is not exactly replicable, so such images cannot be transmitted or copied without degradation. Photographs of photographs, photocopies of photocopies, and copies of videotapes are always of lower quality than the originals, and copies that are several generations away from an original are typically very poor. But discrete states *can* be replicated precisely, so a digital image that is a thousand generations away from the original is indistinguishable in quality from any one of its progenitors.[10] A digital copy is not a debased descendent but is absolutely indistinguishable from the original.

Digital Image Creation

It follows from the fundamental constitution of the raster grid that, just as the elementary operation of painting a picture is the brush stroke and the elementary operation of typing a text is the keystroke, the elementary operation of digital imaging is assignment of an integer value to a pixel in order to specify (according to some coding scheme) its tone or color. Complete images are built up by assigning values to all the pixels in the gridded picture plane.

One way to assign pixel values is to employ some sort of sensor array or scanning device (like that constructed by Kirsch and his colleagues) to record intensities in a visual field—to make an exposure with a digital "camera": this appropriates digital imaging to the tradition of photography. A second way is to employ the cursor of an interactive computer-graphics system to select pixels and assign arbitrarily chosen values to them: this makes digital imaging seem like electronic painting, and indeed computer programs for this purpose are commonly known as "paint" systems. And a third way is to make use of three-dimensional computer-graphics techniques—to calculate values by application of projection and shading procedures to a digital geometric of an object or scene: this extends the tradition of mathematically constructed perspective that began with Brunelleschi and Alberti. The digital image continues but, as we shall see, also redefines these older traditions.

Mutability and Manipulation

Edward Weston also contrasted the workability of a painting with the closure of a photograph. He valued the fragile integrity of a photograph's surface and argued that it inherently resists reworking or manipulation:

The photographic image partakes more of the nature of a mosaic than of a drawing or painting. It contains no *lines* in the painter's sense, but is entirely

made up of tiny particles. The extreme fineness of these particles gives a special tension to the image, and when that tension is destroyed—by the intrusion of handwork, by too great enlargement, by printing on a rough surface, etc.—the integrity of the photograph is destroyed.[11]

Paul Strand extended this characteristically modernist argument about the inherent qualities of materials by suggesting that photo-manipulation of any sort was not only difficult, but also unphotographic and fundamentally undesirable:

Photography, which is the first and only important contribution, thus far, of science to the arts, finds its *raison d'être*, like all media, in a complete unique-ness of means. . . . The full potential power of every medium is dependent on the purity of its use, and all attempts at mixture end in such dead things as the color-etching, the photographic painting and in photography, the gum-print, oil-print, etc., in which the introduction of hand work and manipulation is merely the expression of an impotent desire to paint.[12]

There have always been photographers ready to take issue with this sort of formulation. A few of these mavericks have succeeded in producing convincing composite images: Henry Peach Robinson's and Oscar G. Reijlander's nineteenth-century "combination prints," John Heartfield's photomontages, and Jerry Uelsmann's haunting constructions of the surreal come immediately to mind. But there is no doubt that extensive reworking of photographic images to produce seamless transformations and combinations is technically difficult, time-consuming, and outside the mainstream of photographic practice. When we look at photographs we presume, unless we have some clear indications to the contrary, that they have *not* been reworked.

Here photography and digital imaging diverge strikingly, for the stored array of integers has none of the fragility and recalcitrance of the photograph's emulsion-coated surface. Indeed we can precisely invert Weston's principle: the essential characteristic of digital information is that it *can* be manipulated easily and very rapidly by computer. It is simply a matter of substituting new digits for old. Digital images are, in fact, much more susceptible to alteration than photographs, drawings, paintings, or *any* other kinds of images. So the art of the digital image cannot adequately be understood as primarily a matter of capture and printing, as Weston conceived photography: intermediate *processing* of images plays a central role. Computational tools for transforming, combining, altering, and analyzing images are as essential to the digital artist as brushes and pigments are to a painter, and an understanding of them is the foundation of the craft of digital imaging.

Furthermore, since captured, "painted," and synthesized pixel values can be combined seamlessly, the digital image blurs the customary distinctions between painting and photography and between mechanical and handmade pictures. A digital image may be part scanned photograph, part computer-synthesized shaded perspective, and part electronic "painting"—all smoothly melded into an apparently coherent whole. It may be fabricated from found files, disk litter, the detritus of cyberspace. Digital imagers give meaning and value to computational readymades by appropriation, transformation, reprocessing, and recombination; we have entered the age of electrobricollage.

**Digital Images and the
Postmodern Era**

The tools of traditional photography were well
suited to Strand's and Weston's high-modernist
intentions—their quest for a kind of objective
truth assured by a quasi-scientific procedure
and closed, finished perfection. But (as the cul-
turally attuned will be quick to recognize) we
can construe the tools of digital imaging as
more felicitously adapted to the diverse proj-
ects of our postmodern era.[13] The intellectual
residue of the poststructuralist wave arouses
queasiness with Weston's unabashedly totaliz-
ing formulations and foments skittishness
about hugging a logocentroid quite so closely;
a medium that privileges fragmentation, inde-
terminacy, and heterogeneity and that empha-
sizes process or performance rather than the
finished art object will be seen by many as no
bad thing. Protagonists of the institutions of
journalism, with their interest in being trusted,
of the legal system, with their need for prova-
bly reliable evidence, and of science, with
their foundational faith in the recording instru-
ment, may well fight hard to maintain the he-
gemony of the standard photographic image—
but others will see the emergence of digital im-
aging as a welcome opportunity to expose the
aporias in photography's construction of the
visual world, to deconstruct the very ideas of
photographic objectivity and closure, and to re-
sist what has become an increasingly sclerotic
pictorial tradition.

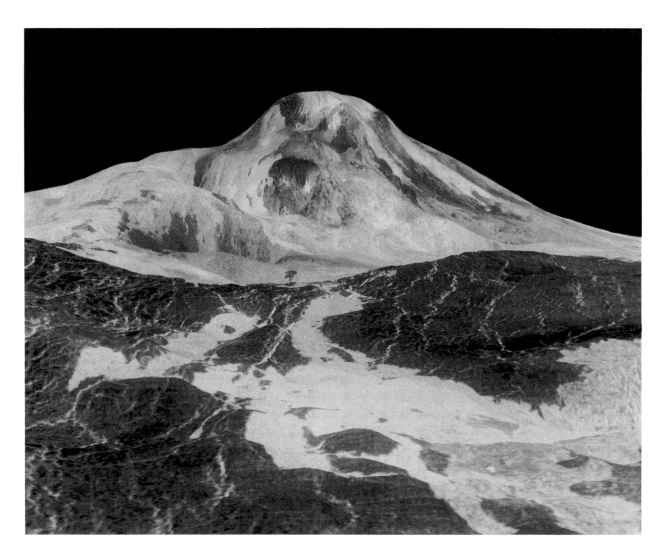

2.1 Spacecraft imaging: a perspective view, synthe-
sized from Magellan synthetic aperture radar data com-
bined with radar altimetry, of the five-mile-high volcano
Maat Mons on the surface of Venus. Courtesy NASA
and the Jet Propulsion Laboratory.

■ **Early Development**

In the decades following the first experiments with translation of pictures into arrays of integers, digital imaging evolved into a vigorous and increasingly important scientific field. A sophisticated mathematical theory of digital image transformation and combination was worked out and became the foundation for computer image-processing systems. New devices were invented for capturing, storing, transmitting, and displaying digital images. A laboratory curiosity matured into an applied technology; correlated social and cultural practices unfurled. The uses of images—and therefore their meanings and their value as tokens of factual discourse—began to change fundamentally.

The early development of the technology coincided with the era of space exploration, so digital imaging systems quickly began to play much the same role in twentieth-century voyages of discovery as topographic and botanical artists had played in eighteenth-century ones: they reported previously unseen marvels and inventoried potentially colonizable territory. First, the moon: by 1964 NASA scientists were able to use digital image-processing techniques to remove imperfections from images of the lunar surface sent back by the Ranger 7 spacecraft.[1] Digital enhancement also gave dramatic clarity to the famous closeup of Surveyor 7's footpad resting on the moon dust in 1968. Then the earth itself: since 1972 ERTS, Landsat, and Spot satellites have been transmitting

back an unceasing stream of multispectral digital images of our planet's changing surface.

Digital imaging systems were crucial to the great Voyager and Magellan missions. In 1979 the information sent back by Voyager 1 was processed to produce astonishingly beautiful, brilliantly colored images of Jupiter and its moons. In 1989 Voyager 2 transmitted digital images of Neptune from a distance of over 2.5 billion miles, and in 1991–92 nearly three trillion bits of data produced by radar scans from the Magellan spacecraft were processed to construct close-up panoramic views of mountainous landscapes on Venus (figure 2.1). As the digital images have streamed back from remote reaches of the solar system, we have gazed in wonder at incomprehensibly distant, unexplored worlds of fire and ice and emptiness.

Scientists soon realized that sensors of many different kinds could be combined with computer image-processing technology to yield specialized imaging systems with powers far beyond those of the unaided human eye. Infrared satellite scans could be processed to distinguish lost ruins from surrounding jungle, for example, and radar scans could penetrate desert sand. In the 1980s archaeologists searching the Arabian Peninsula for the lost city of Ubar—as, a century before, Heinrich Schliemann had sought the remains of Troy at the tell of Hisarlik—surveyed the terrain with an imaging radar system carried on the space shuttle, then computer processed the resulting digital images to reveal faint traces of ancient caravan routes.[2] These converged on the well of Ash Shisar near the Qara mountains and then disappeared beneath a sand dune. Ground reconnaissance in 1990 turned up artifacts suggesting that the tracks had been part of the frankincense trade route, and subsequent exca-

vations uncovered an octagonal eight-towered city—probably, indeed, that "imitation of Paradise" whose destruction had been chronicled in the *Arabian Nights*. A NASA geologist forgivably bragged, "Ubar could not have been found without radar and space imagery."[3]

To produce highly magnified images of Lilliputian landscapes that were invisible to the naked eye, both Louis Daguerre and Fox Talbot took photographs through solar microscopes. In the 1970s and 1980s scientists developed new devices for measuring the most minute surface variations and employed computer imaging systems to convert the resulting data into breathtaking perspective views. At IBM's Zurich Research Laboratory, Gerd Binnig and Heinrich Rohrer developed the scanning tunneling microscope and used it to produce the first pictures of atoms forming the surface of silicon.[4] Other scientists joined the hunt and soon captured atomic-resolution images of gallium arsenide, platinum, graphite, benzene, and DNA. And several more varieties of scanning probe microscopes—the atomic force microscope, the friction force microscope, the magnetic force microscope, to name only a few—have emerged in rapid succession.[5] Sharp, detailed pictures of atoms and molecules no longer seem surprising.

Leonardo da Vinci and his Enlightenment successors dissected cadavers to explore the organic complexities concealed within the human body (figure 2.2). Wilhelm Roentgen took the first step toward modern medical imaging when he found a way to photograph the living body as if it were partially transparent. With the development of sophisticated electronic imaging systems—X-ray computed tomography (CT), ultrasound, positron emission tomography (PET), single photon emission computed

tomography (SPECT), and magnetic resonance imaging (MRI) scanners—it is now possible to capture detailed, point-by-point, three-dimensional digital models of human anatomy.[6] These models can be processed by computer to yield highly resolved, vivid, colored images of the body from whatever viewpoints are desired and with tissue sectioned or peeled away in whatever fashion is most revealing for a particular diagnostic or scientific purpose (figure 2.3).

The contemporaneous emergence of artificial-intelligence and neural-network technology has led to electronic realizations of the Cartesian connection between a visual sensor and an interpreting and directing intelligence—computer and robotic systems that analyze and act on the information contained in digital images. Increasingly sophisticated pattern-recognition and scene-analysis systems can now perform such tasks as reading printed and handwritten text, detecting flaws in manufactured products, discovering bombs in luggage, recognizing faces,[7] and enabling robots to see and navigate.[8] Architects employ such systems to convert old drawings into data manipulable at CAD workstations, and banks have even begun to use them for processing checks.[9] More threateningly, as Michel Foucault's texts on panopticism might lead us to expect, these systems have their uses in regimes of surveillance, discipline, and punishment: image-interpretation systems can be employed (with varying degrees of efficacy, according to the stages of development of the relevant artificial intelligence techniques) to monitor satellite imagery for signs of missile silo construction, to identify perpetrators by automatically matching fingerprints from the scenes of crimes to archived samples, and to track people's move-

ments by reading automobile license plates that have been recorded by surveillance cameras and then matching the numbers to license database records. The electronic homunculi inside digital imaging systems have become busier and busier; automatic interpretation of the billions of bits of visual data acquired by these systems has become routine scientific, industrial, and business practice.

And the emergence of digital imaging technology has escalated and redefined the military uses of visual information. Just as World War I military technologists combined the camera and the airplane to produce a powerful new type of reconnaissance system, so Pentagon strategists quickly saw the potential of digital imaging and pressed it into service. By the time of the 1990–91 Gulf War, the American forces depended heavily on digital imaging systems for tactical information, defense contractors had extensively incorporated them into weapons systems, and military spin doctors had realized their propaganda potential. In this war, satellite imaging systems did much of the spying and scouting. Laser-guided bombs had nose-cone video cameras; pilots and tank commanders became cyborgs inseparable from elaborate visual prostheses that enabled them to see ghostly-green, digitally enhanced images of darkened battlefields. There was no Mathew Brady to show us the bodies on the ground, no Robert Capa to confront us with the human reality of a bullet through the head. Instead, the folks back home were fed carefully selected, electronically captured, sometimes digitally processed images of distant and impersonal destruction. Slaughter became a video game: death imitated art.[10]

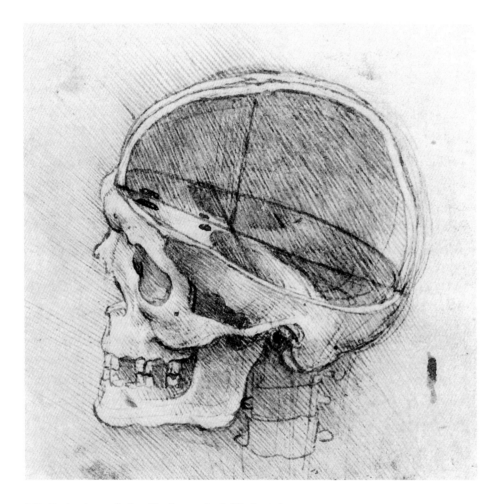

2.2 Seeing beneath the skin: Leonardo da Vinci, stud-
ies of a sectioned human skull. Windsor Castle, Royal
Library. © 1992 Her Majesty Queen Elizabeth II.

2.3 Medical imaging: an Instascan MRI image of a
brain responding to light simulation. Red and yellow
patches show activation of the visual cortex. Courtesy
John Belliveau, Massachusetts General Hospital, NMR
Center.

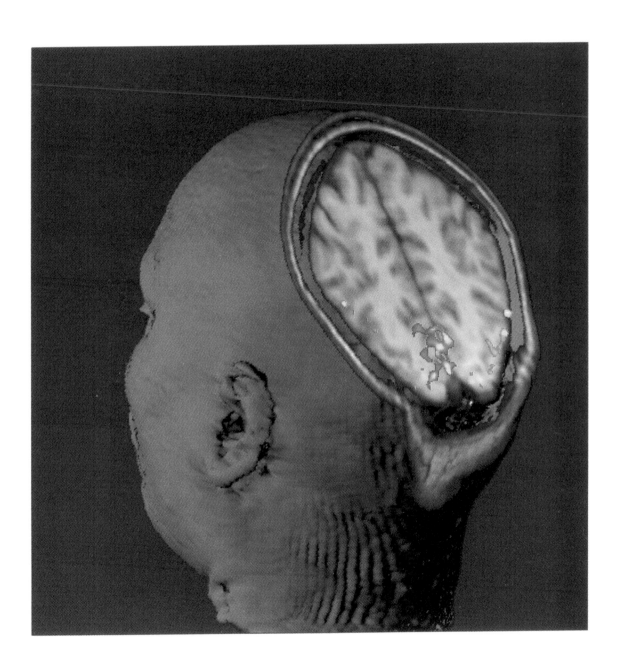

News Photography
Goes Digital

By the 1980s digital imaging technology had begun inexorably to permeate the communications industry. Television engineers were using it to achieve better picture quality, and printers were employing it for retouching, halftoning, color correcting, and color separating photographs.[11] Use of color electronic prepress systems, in particular, grew explosively in the advertising and publishing industries: in 1989—photography's sesquicentennial year—the *Wall Street Journal* estimated that ten percent of all color photographs published in the United States were being digitally retouched or altered.[12]

As use of the technology gathered momentum, the concept of image "correction" became increasingly elastic. The official photographs of Australia's new Parliament House were undetectably computer enhanced by the addition of a fluttering flag; there was no wind on the day the photographs were taken. The London *Guardian* smirkingly revealed, in an article headlined "Computers make a clean breast . . . or do they?," that the British press had discovered yet another way to exploit photographed female flesh: a cover model's indecorous nipple had been electronically replaced by "lighter flesh tones from elsewhere."[13] The editor of *Mayfair* magazine breathlessly extrapolated, "You could have a color photo of a girl playing at Wimbledon and you could quite literally take her knickers off"—an inexpensive variant on that publication's more usual practice of *paying* young women to take their knickers off. And the editors of *National Geographic* (similarly pursuing a conception of pictorial interest appropriate to *their* readership) published a cover picture in which two

of the pyramids at Giza were "retroactively repositioned" (as an editor later put it)—surreptitiously pushed a few picas closer together to make a more picturesquely exotic composition.[14] Was this any more (or less) manipulative than making sure that a passing camel train positioned itself in just the right spot *before* the exposure was made? Photojournalists and press critics debated this question.

Naive enthusiasm for the almost magical possibilities of this new electronic medium soon gave way to alarm. It was a short step, we began to realize, from innocuous enhancement or retouching to potentially misleading or even intentionally deceptive alteration of image content. And that step would put us on a slippery slope: the smug apartheid that we have maintained between the objective, scientific discourses of photography and the subjective, artistic discourses of the synthesized image seemed in danger of breaking down.

Increasingly, digital image manipulation was defined as a transgressive practice, a deviation from the established regime of photographic truth. Press photographers scented a cybernetic dystopia in the making—a world infested with subversive, uncontrollable image hackers who would appropriate photographic fragments at will and recombine them into fictions. They initiated annual conferences to explore the implications of digital imaging technology,[15] and the president of the National Press Photographer's Association gave voice to their growing alarm: "Photographers, editors and publishers need to speak out unequivocally and say 'NO!' to the abuses that can and will creep into newsrooms as the use of digital photo technology becomes widespread. . . . We cannot use this technology to create lies, no matter how tempting or easy."[16] One uneasy photojournalist, quoted by *American Photographer* maga-

zine, anticipated a new division of labor: "If we don't take hold of this technology we'll become clip-art specialists, feeding images to the art department like robots."[17] And the photography critic of *The New York Times* predicted an eventual derealization of the photographed world:

In the future, readers of newspapers and magazines will probably view news pictures more as illustrations than as reportage, since they will be well aware that they can no longer distinguish between a genuine image and one that has been manipulated. Even if news photographers and editors resist the temptations of electronic manipulation, as they are likely to do, the credibility of all reproduced images will be diminished by a climate of reduced expectations. In short, photographs will not seem as real as they once did.[18]

The species of deception that has aroused such apprehension is not that practiced by Zeuxis, who, as the legend has it, painted grapes so realistically that birds pecked at them.[19] Digital manipulation of photographs does not obliterate the distinction between depictions and their objects, but (characteristically of our age) blurs the boundary between two kinds of depictions—one of which has seemed to have special claims to veracity. We are faced not with conflation of signifier and signified, but with a new uncertainty about the status and interpretation of the visual signifier.

At the end of the 1980s there was an accelerating crisis of the image. André Bazin had once called the development of photography "clearly the most important event in the history of plastic arts" because, he argued in a well-known passage, it allowed us to "admire the painting as a thing in itself whose relation to something in nature has ceased to be the justification for its existence."[20] But, at the very moment when photography's 150th anniversary was being celebrated with elaborate exhibits and retrospective surveys and when critical commentaries were endlessly asseverating the causal rather than intentional character of the photographic process, the relation of the photograph itself to "something in nature" was becoming problematic.[21] We were forced to question whether we could still demand from the photographer, as Doctor Johnson did of playwrights, "a just picture of a real original." Could we still ask, like Lieutenant Joe Friday, for "just the facts?"

Popularization

Early technology for digitally capturing and processing images was expensive, difficult to use, and inaccessible: it provided the means for pictorial deception but not widespread opportunity for it. The end of the 1980s, though, saw a pivotal moment much like that of a century earlier, when George Eastman had popularized photography by introducing his Kodak box camera together with a photofinishing service: the burgeoning technology of digital imaging suddenly spawned a mass medium. (This did not result from some unexpected, breakthrough invention, but from the confluence of several hitherto parallel strands of technical development.) A whole new genus of gadgets evolved.

First came dramatic changes in image-capture devices. The Canon, Nikon, and Sony companies, for example, began to market compact, high-quality, still-video cameras that recorded images directly on miniature floppy

disks and so provided a practical alternative to the use of silver-based photographic film—much as video cameras and videotape had earlier substituted for home movie cameras and 8-mm or 16-mm film.[22] Initially there were costly models intended for professional and industrial use, but by the late 1980s lightweight point-and-shoot versions aimed at the consumer market—such as the Canon Xapshot—were beginning to appear.

Still-video cameras, however, record information in analog format, and it must be converted to digital format for computer processing. This conversion step is eliminated in digital camera systems, which directly record images in digital format on magnetic disk or credit-card-sized magnetic memory cards. Early models—such as the Rollei Digital ScanBack,[23] Fujix Digital Still Camera,[24] and the Kodak Professional DCS[25]—became available in the late 1980s and early 1990s. By 1991 inexpensive point-and-shoot versions such as the Logitech Fotoman, with associated image-processing software for personal computers, were coming onto the market.[26] With the appearance of digital camera systems the distinction between photography and computer graphics completely dissolved. Space-shuttle astronauts began to carry digital cameras on their missions and to use laptop computers for immediate image processing.[27]

At about the same time, a new generation ,of personal computers began to offer the processing power, memory, disk storage, and graphic-display capabilities needed for image-processing work. Recognizing a growth market, software developers and publishers produced a widening repertoire of paint and image-processing systems for personal computers. This software soon became astonishingly sophisticated—making widely available, at low cost, capabilities hitherto accessible only to scientists working with laboratory image-processing systems or graphics professionals working with advanced digital prepress systems.[28] By 1992 personal computers could handle not only storage, manipulation, and display of digital still images, but also storage, editing, and playback of digital video.[29]

Compact disc (CD) technology—introduced in 1983 as a digital sound-recording medium—emerged as an inexpensive way to store large numbers of images. In September 1990 Kodak connected the camera and the CD by announcing a system called Photo CD, which would allow photofinishers to return not only negatives and prints, but also CDs containing images that could be displayed on television sets equipped with special players.[30] (It was shown for the first time at the Consumer Electronics Show in January 1992.) Photo CD also provides storage and playback capability for images from still-video and digital cameras. In 1991 Philips introduced an interactive CD system for home use: among the first interactive CDs released for play on this device was one on photographic technique, with a camera simulator that allowed the viewer to "shoot" pictures and immediately see the effect of decisions about exposure and focus.[31] With the CD as a medium in common, distinctions between still photography, video, computer games, and music-reproduction systems began to erode.

Finally, copier technology began to switch from analog to digital format. First, laser scanners for capturing images from existing slides and photographs, which had been hugely expensive devices confined to use in large printing and publishing establishments, became popular peripherals for personal computers. These could be combined with personal computers and laser printers or imagesetters to cre-

ate systems for image capture, transformation, and output. Then in 1991 the Canon company of Japan began marketing the Pixel Epo digital color copier, which integrated all these functions and brought them into everyday work environments. In the United States, Xerox and Kodak also introduced sophisticated digital copiers.

The result was that the means to capture, process, display, and print photograph-like digital images—which had hitherto been available in only a few, specialized scientific laboratories and print shops—now fell within reach of a wide community of artists, photographers, and designers. Concern about the potential social, economic, and cultural effects of the technology reached a crescendo. As photography's 150th anniversary was celebrated, the National Press Photographers Association was calling for a code of ethics to regulate digital image manipulation,[32] the Associated Press was adopting a policy that "the content of a photograph will never be changed or manipulated in any way," and the Norwegian Press Association was proposing that an international standard warning symbol should be inserted into any manipulated photograph.[33] In Hollywood the nonprofit Artists Rights Foundation was established to protect films from electronic and other forms of tampering, and in Washington Congress considered the Film Disclosure Act of 1991, which would require producers and broadcasters to label alterations to filmed work.[34] But it was too late: opportunity to create undetectably altered digital images was no longer centralized, and (for good or ill) there was no longer any practical way of imposing institutional control on their production.

In addition to means and opportunity, there are economic motives for displacing traditional photography. Our world has developed such a voracious appetite for information in visual form,[35] and the digital image has such overwhelming technical and economic advantages as a way of meeting this demand, that it seems certain to succeed the photograph as our primary medium of visual record—much as the photograph itself succeeded the hand-drawn and painted image.[36] Unlike silver-based photographic film the digital image does not consume scarce, nonrenewable resources. It does not require a time-consuming and expensive chemical development process. It can be stored compactly, accessed by computer, manipulated freely, and transmitted to remote locations within seconds of creation. And, by virtue of its inherent manipulability, it always presents a temptation to duplicity. So the inventory of comfortably trustworthy photographs that has formed our understanding of the world for so long seems destined to be overwhelmed by a flood of digital images of much less certain status.

In his prophetic novel *1984* George Orwell imagined a sinister Records Department containing "elaborately equipped studios for the faking of photographs." What really happened in the 1980s was that elaborately equipped studios became unnecessary. It became possible for anybody with a personal computer to fake photographs.

The Displacement of Photography

Sometimes it is argued (usually by radical historians or theorists) that technical innovation results from irresistible social pressure—that, for example, "the year of Daguerre's invention, as in every important invention, meant nothing but the moment when the acquired knowledge had become so convincing and the need of realizing this invention so pressing that it could

no longer be delayed by any difficulties or obstacles."[37] On this view, it is hardly surprising that chemical photography made its appearance in the century of realism and self-confident positivism—of Dickens and Flaubert, of Courbet and Millet, of Comte and John Stuart Mill.

Symmetrically, it can be proposed (typically by commentators of more positivistic and conservative outlook) that technical innovations emerge autonomously and create new social and cultural potentials. Erwin Panofsky, for example, began his well-known essay on film with the remark, "It was not an artistic urge that gave rise to the discovery and gradual perfection of a new technique; it was a technical invention that gave rise to the discovery and gradual perfection of a new art."[38]

Either way, we can identify certain historical moments at which the sudden crystallization of a new technology (such as printing, photography, or computing) provides the nucleus for new forms of social and cultural practice and marks the beginning of a new era of artistic exploration. The end of the 1830s—the moment of Daguerre and Fox Talbot—was one of these. And the opening of the 1990s will be remembered as another—the time at which the computer-processed digital image began to supersede the image fixed on silver-based photographic emulsion.

Thus late in the century of Joyce and Borges, of cubism and surrealism, of Wittgenstein's loss of faith in logical positivism and of poststructuralism's gonzo metaphysics, the production of reproduction was again redefined. From the moment of its sesquicentennial in 1989 photography was dead—or, more precisely, radically and permanently displaced—as was painting 150 years before.

INTENTION AND ARTIFICE

■ **Claims to Credibility**

Photography's sesquicentennial year opened, fittingly enough, with an international drama turning on the credibility of photographs as evidence—on a claim that the camera does not lie. On January 4, 1989, US Navy fighters shot down two Libyan MiG-23s over the Mediterranean near the Libyan coast.[1] Libya denounced the action and called for an emergency session of the United Nations Security Council to condemn it. Ali Sunni Muntasser, Libya's UN ambassador, said that the planes were unarmed reconnaissance craft on a routine mission. A US spokesman challenged that assertion and noted, "We have the pictures to prove they were not unarmed," which means, he added, that "the Libyan ambassador to the UN is a liar." The Libyan diplomat responded in kind: "The man who said that I am a liar, he is a liar, because we are sure that our planes were not armed." Later, US Ambassador Vernon Walters exhibited blurred photographs of what he claimed was one of the MiGs visibly armed with air-to-air missiles (figure 3.1). "Do you think this is a bouquet of roses hanging under the wing?" he demanded. Libyan Ambassador Muntasser immediately suggested that the photographs were doctored. "It is completely fake," he protested, "It is untrue!" The pictures were "fabricated," they were "directed in the Hollywood manner."[2]

This cynical and loutish dialogue reveals very little about what actually took place off the Libyan coast that January day, but it does

3.1 Photographs used as evidence: US Ambassador Vernon Walters, at the United Nations Security Council on January 6, 1989, exhibits a blurred picture to support his claim that a Libyan MiG-23 shot down by US fighters had been armed. Fred R. Conrad/NYT Pictures.

demonstrate the extraordinary tenacity of the camera's claims to credibility: as Susan Sontag has put it, "A photograph passes for incontrovertible proof that a given thing happened." Ambassador Walters could urge with a straight face that "you can see for yourself whether there were or were not missiles," even though his photographs were barely decipherable as images of aircraft and showed no detail at all. Aware, like all of us, of the powerful presumption that a photograph shows something that *did* exist, Ambassador Muntasser chose not to dismiss the photographs as simply meaningless. Instead, he made the more damning suggestion that they were false evidence—fabrications produced to deceive the gullible by trading on the photograph's privileged connection to reality. This suggestion is by no means technically implausible: anybody with access to some pictures of aircraft, an image-capture device, and a personal computer with inexpensive image-processing software could produce this sort of image in a few minutes.

The play of claim and accusation over the Libyan fighter incident recalls the cogent symmetries of Aristotle's definition of truth—to say of what is that it is, or to say of what is not that it is not, is the truth; but to say of what is not that it is, or to say of what is that it is not, is falsehood—and raises some urgent questions. How is it that photographs seem to say of what is that it is? What is the foundation for their undeniably powerful implicit truth claims? When should we be wary of these? Exactly how are these claims subverted by the emergence of digital imaging? Must we now, like jesting Pilate, throw up our hands? Not surprisingly, as we shall see, the most useful answers turn out to be intimately bound up with different philosophical doctrines about the nature of meaning and truth.

Adherence of the Referent

For these questions to become meaningful we must assume, first of all, that a photograph depicts something, that it is not just an abstract pattern resulting from a chemical reaction. Whether photographs depict through resemblance (as suggested, for example, by James J. Gibson) or through the action of a denotative symbol system (as vigorously argued by Nelson Goodman) is an interesting and vexed question, but one that need not detain us here.[3] One way or another, a photograph provides evidence about a scene, about the way things were, and most of us have a strong intuitive feeling that it provides better evidence than any other kind of picture. We feel that the evidence it presents *corresponds* in some strong sense to reality, and (in accordance with the correspondence theory of truth) that it is true because it does so.[4]

A photograph is fossilized light, and its aura of superior evidential efficacy has frequently been ascribed to the special bond between fugitive reality and permanent image that is formed at the instant of exposure. It is a direct physical imprint, like a fingerprint left at the scene of a crime or lipstick traces on your collar. The correspondence with reality is thus causally established. According to Sontag, "A photograph is not only an image (as a painting is an image), an interpretation of the real; it is also a trace, something directly stencilled off the real, like a footprint or a death mask."[5] The death-mask metaphor goes back (at least) to André Bazin's 1945 essay "The Ontology of the Photographic Image," in which he compares photographs to mummies and relics—objects that exhibit a "transference of reality from the thing to its reproduction"—and mischievously

3.2 The referent adheres: René Magritte, *La Clef des champs,* 1933. Thyssen-Bornemisza Collection, Lugano, Switzerland.

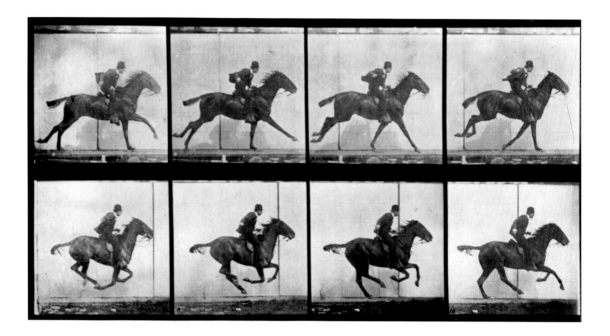

describes the Holy Shroud of Turin as a combination of relic and photograph.[6] In *Camera Lucida* Roland Barthes (perhaps recalling René Magritte; see figure 3.2) introduces another telling metaphor—that of the windowpane and the landscape—and claims that "the referent adheres."

In his brilliantly epigrammatic essay "Understanding a Photograph," the influential Marxist critic John Berger insists that the interest of a photograph depends *totally* on this tenacious adherence of the referent.[7] Photographs, as he defines them, are quite simply "records of things seen . . . no closer to works of art than cardiograms." They engage us because they result from some photographer's decision "that it is worth recording that this particular event or this particular object has been seen." Every photograph becomes "a means of testing, confirming and constructing a total view of reality."

This attitude has, no doubt, been reinforced by photography's successes in showing aspects of the physical world that would otherwise escape us, and sometimes in doing so exposing the errors of painting. Eadweard Muybridge's famous photographs of horses in motion, for example, showed that the "flying gallop" position depicted in many earlier paintings simply does not occur (figure 3.3). His sequences of instantaneous photographs, made at closely spaced intervals, provided the irrefutable evidence. As Aaron Scharf commented: "The meaning of the term 'truth to nature' lost its force: what was true could not always be seen, and what could be seen was not always true. Once again the photograph demonstrated that for many artists *truth* had really been another word for *convention*."[8]

After more than a century and a half of photographic production, we also have to contend

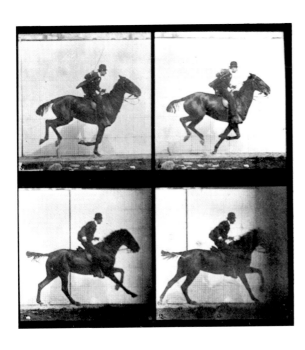

3.3 Photography exposes the errors of painting: Eadweard Muybridge, horse in motion. International Museum of Photography at George Eastman House, Rochester, New York.

with the powerful "reality effect" that the photographic image has by now constructed for itself. In his influential 1921 essay "On Realism in Art,"[9] Roman Jakobson sketched the mechanism by which certain types of images come to seem "natural" and more "faithful to reality" than others:

The methods of projecting three-dimensional space onto a flat surface are established by convention; the use of color, the abstracting, the simplification, of the object depicted, and the choice of reproducible features are all based on convention. It is necessary to learn the conventional language of painting in order to "see" a picture, just as it is impossible to understand what is said without knowing the language. This conventional, traditional aspect of painting to a great extent conditions the very act of our visual perception. As tradition accumulates, the painted image becomes an ideogram, a formula, to which the object portrayed is linked by contiguity. Recognition becomes instantaneous. We no longer see a picture.

Extending this line of argument from painting to photography yields the seemingly paradoxical proposition that, since photographs are very strongly linked by contiguity to the objects they portray, we have come to regard them not as pictures but as formulae that metonymically evoke fragments of reality. Barthes has elucidated another, complementary aspect of the reality effect by pointing out that works of realistic art often incorporate seemingly functionless detail just "because it is there," to signal that "this is indeed an unfiltered sample of the real."[10] Since photographs are rich in such details, they always connote the real.

For all these (not necessarily consistent) reasons, then, the camera has commonly been

seen as an ideal Cartesian instrument—a device for use by observing subjects to record supremely accurate traces of the objects before them. It is supereye—a perceptual prosthesis that can stop action better than the human eye, resolve finer detail, remorselessly attend to the subtlest distinctions of intensity, and not leave unregistered anything in the field of its gaze. And photographs seem to bond image to referent with superglue.

Intention and Objectivity

Even more tellingly, we can also point to the fact that there is no human intervention in the process of creating the bond between photograph and reality, this apparent Kryptonite connection to the referent: it is automatic, physically determined, and therefore presumably objective. Photographs are thus connected to the ancient Judeo-Christian tradition of *acheiropoietoi*—"true" images of Christ made "not by human hand" (figure 3.4).[11] Furthermore, this automaticity accords splendidly with poststructuralist hostility to the idea of authorial control of meaning: photography can be seen as a kind of automatic writing.[12]

André Bazin—among many to tackle this theme of physical determination—crisply formulates the crucial difference from painting as follows:

For the first time, between the originating object and its reproduction there intervenes only the instrumentality of a nonliving agent. For the first time an image of the world is formed automatically, without the creative intervention of man. The personality of the photographer enters into the proceedings only in his selection of the object to be photographed and by way of the purpose he has in mind.[13]

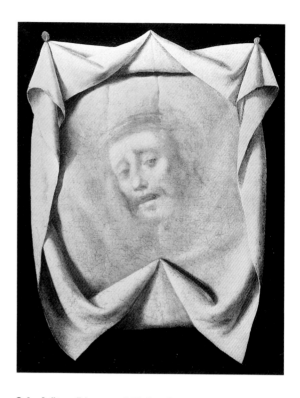

3.4 A "true" image of Christ: Francisco de Zurbarán, *The Veil of Veronica.* National Museum, Stockholm.

Such exclusion of human bias is the point of many standard scientific procedures, such as random sampling, double-blind clinical trials, and setting statistical significance levels before conducting experiments. It also motivates the "plain," ostensibly unrhetorical style of formal scientific discourse. The photographic procedure, like these scientific procedures, seems to provide a guaranteed way of overcoming subjectivity and getting at the real truth. Indeed, it has often been taken as the quintessential way, and writers who want to suggest neutral recording without the subjectivity introduced by human selection or organization often invoke

the image of the camera. Thus Christopher Isherwood memorably opens *Goodbye to Berlin*, "I am a camera with its shutter open, quite passive, recording, not thinking."[14]

This impersonal, objective neutrality has ontological implications. Isherwood's camera eye supposedly records real people in a real place, "the man shaving at the window opposite and the woman in the kimono washing her hair." The conservative philosopher Roger Scruton—wanting like the Marxist Berger to distinguish photography from fine art, but for different reasons—has usefully formulated this point by teasing out the differing intentional relations of the painter and the photographer to the objects that they depict:

If a painting represents a subject, it does not follow that the subject exists nor, if it does exist, that the painting represents the subject as it is. Moreover, if x is a painting of a man, it does not follow that there is some *particular* man of which x is the painting. Furthermore, the painting stands in this intentional relation to its subject because of a representational act, the artist's act, and in characterizing the relation between a painting and its subject we are also describing the artist's intention. The successful realization of that intention lies in the creation of an appearance, an appearance which in some way leads the spectator to recognize the subject.[15]

But he makes this analysis of photography:

A photograph is a photograph *of* something. But the relation here is causal and not intentional. In other words, if a photograph is a photograph of a subject, it follows that the subject exists, and if x is a photograph of a man, there is a particular man of whom x is the photograph. It also follows, though for different reasons, that the subject is, roughly, as it appears in the photograph. In characterizing the relation between the ideal photograph and its subject, one is characterizing not an intention but a causal process, and while there is, as a rule, an intentional act involved, this is not an essential part of the photographic relation. The ideal photograph also yields an appearance, but the appearance is not interesting as the realization of an intention but rather as a record of how an actual object looked.

In other words, the nonexistence of angels need not prevent you from painting a picture of one, but it certainly prevents you from taking a photograph of one. (We must make an exception to this general rule for convinced realists: recall Courbet's famous remark "Show me an angel and I will paint one."[16]) The existence of horses means that you can take a photograph of some particular horse, but it does not prevent a horse painting from showing no horse in particular. You cannot, however, take a photograph of no horse in particular. Thus the representational range of paintings is wider than that of photographs because a painter does not have to accept a causal relation between a depiction and the object to which it refers.

Scruton exaggerates the second part of his case by reducing the photographer's intentional acts to inessentials. Selecting a station point, framing the scene, and choosing the moment to expose are all intentional acts—the essence, for example, of Henri Cartier-Bresson's photographic art. This is demonstrated by the fact that photographers are sometimes accused of deliberate deception through tendentious framing or selection of moment to expose. (The

documentary photographer Lewis Hine remarked that, "while photographs may not lie, liars may photograph."[17]) Many serious photographers (though not amateurs who use auto-exposure, autofocus, point-and-shoot cameras) also regard manipulation of exposure and focus variables as important means of realizing their intentions. And in some views of photographic practice—as represented, for example, by Ansel Adams—the darkroom acts of development, enlarging, cropping, and printing are also taken as essential.

However, Scruton's distinction between intentional and causal components in image-production processes is helpful, particularly if we do not insist on a clearcut dividing line between paintings and photographs but think rather of a spectrum running from nonalgorithmic to algorithmic conditions—with ideal paintings at one end and ideal photographs at the other. A nonalgorithmic image, which is the product of many intentional acts, neither establishes that the object depicted exists nor (if that object does exist) provides much reliable evidence about it, but reveals a lot about what was in the artist's mind. An algorithmic image, which to a large extent is automatically constructed from some sort of data about the object and which therefore involves fewer or even no intentional acts, gives away much less about the artist but provides more trustworthy evidence of what was out there in front of the imaging system. In between, there are images that are algorithmic to a degree.

Freehand sketching, for example, is a mostly nonalgorithmic process: every freely made mark that the artist chooses to execute is the realization of an intention, and the result is usually something that has a strongly personal character. Prestige attaches to skillful and accu-rate work of this kind: not everybody can do it. But when an artist traces a form with the assistance of a stencil or physiognotrace, or a scene with the aid of a camera obscura (as Fox Talbot did on the shores of Lake Como), the process has a much more algorithmic character: there is little prestige to be had through accuracy.[18] And, when hand tracing is replaced by a highly standardized, automatic chemical process, there is almost no room left for the realization of intention.[19] So modern photography, as conceived of in the famous slogan "You press the button, we do the rest," stands near the algorithmic, depersonalized extreme of image-production processes.[20] As Sontag has said, "Photographs don't seem deeply beholden to the intentions of an artist . . . the magic box insures veracity and banishes error."

So, if you want to attack the veracity of a photograph (as did the Libyan ambassador), you can suggest that the standard procedure was *not* actually followed—for example, that some airbrushing was done or that the negative was flipped before printing.[21] (In a similar way, scientists may attack reported experimental results—such as those purporting to show cold fusion—by arguing that norms of scientific procedure were violated.) Conversely, if you want to defend its truthfulness, you can produce confirmation that the standard procedure *was* followed. You might produce the original negative to show that it had not been retouched or witnesses to attest that no deviation was introduced. Courts, passport authorities, and the users of clinical photographs often specify particularly detailed algorithms (leaving very little discretion to the photographer in choice of lens, lighting, framing, and so on) for production of photographs that will be acceptable as reliable evidence.[22] The United States Immigra-

tion and Naturalization Service, for example, requires identification photographs to be three-quarter color portraits with the right ear exposed (no earrings or hats), framed so that the head fits within an oval of strictly specified dimensions, made with a white background equal in reflectance to bond typing paper, sharply focused and correctly exposed, unretouched, printed on glossy paper at a standard size, and not stained, cracked, or mutilated. Snapshots that deviate in the slightest way from this specification are rejected, so the seedy photo studios that cluster around immigration offices set themselves up to produce the standard product and have a steady stream of clients.

Digital imaging dramatically changes the rules of this game. It creates a condition in which the image maker may choose among many different devices and procedures for mapping from intensities in a scene to intensities in a display or print, in which image fragments from different sources may quickly and seamlessly be combined, and in which arbitrary interventions in the image-construction process are easy to introduce and difficult to detect. The distinction between the causal process of the camera and the intentional process of the artist can no longer be drawn so confidently and categorically. Potentially, a digital "photograph" stands at any point along the spectrum from algorithmic to intentional. The traditional origin narrative by which automatically captured shaded perspective images are made to seem causal things of nature rather than products of human artifice—recited in support of their various projects by Bazin, Barthes and Berger, Sontag and Scruton—no longer has the power to convince us. The referent has come unstuck.

Coherence

If we cannot find grounds to conclude that a given image *is* a true record of a real scene or event, we can take the opposite tack and attempt to demonstrate that it could *not* be a true record.[23] We can try, like a suspicious jury, to see whether the visual evidence that is presented really hangs together. We can look for inconsistencies—play a sophisticated game of "What's wrong with this picture?" This, then, grounds the analysis on some kind of coherence theory rather than a correspondence theory of truth—a move that will commend itself to those who want to remain uncommitted to the existence of a unitary extrapictorial reality.

We can start by trying to show that the visual evidence cannot yield any consistent, plausible interpretation as a perspective projection of illuminated three-dimensional objects. Let us consider, for example the simple image shown in figure 3.5a. We unhesitatingly interpret it as a view from above of a cube, with the Y shape in the center seen as a convex exterior corner. (We can debate whether interpretation of the Y shape as a convex corner helps us decide that the whole thing must be a cube or whether recognition of the whole thing as a cube tells us that the Y shape must be a convex corner. Either way, interpretation of the part must be consistent with interpretation of the whole.)

With equal certainty, we interpret the next image (figure 3.5b) as a view from below of a hollow cubic box. Notice, however, that the same Y shape appears in the center, but it is now seen as a concave interior corner. The same piece of visual evidence, seen in a different context, is interpreted very differently.

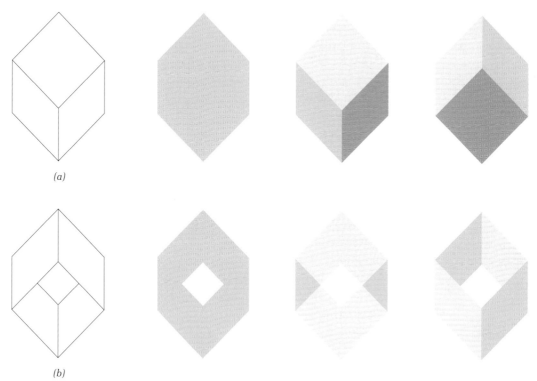

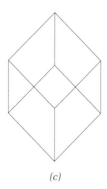

(a)

(b)

(c)

3.6 Shaded images of a cube.

3.5 Line drawings of a cube.

 a. Solid cube.

 b. Hollow box.

 c. Wireframe.

The image in figure 3.5c has two consistent interpretations. We can see it as a wireframe cube from above or as a less plausible skewed object from below. The central Y shape is a convex corner in one interpretation and a concave corner in the other, but we cannot see it as simultaneously convex and concave. The context of the whole here allows two consistent interpretations of the part, and we use an assessment of relative likelihood to choose between them. (Most Westerners immediately plump for the interpretation of this figure as a cube and probably do not even consider the other. But someone from a culture less populated with right-angled objects might see it the other way.) Or, if we like, different interpretations of the part prompt different interpretations of the whole.

Figure 3.6 shows the image translated, in various ways, from line to tone. A painter might accomplish these translations by first constructing the outlines of the faces and then filling them in. Some of the translations read as two-dimensional patterns, some are teasingly difficult to interpret, and some vividly suggest a three-dimensional cube. Those that read three-dimensionally have a common formal characteristic: the shading is consistent with the foreshortening. More precisely, if we assume a consistent direction of incident light and diffuse reflection from the faces, we can expect that the intensity of a face will vary according to its orientation to the light; so intensity provides orientation information that we can use to assist in interpretation of foreshortened shapes. Conversely, if we interpret the skewed quadrilateral shapes in the image as perspective projections of square faces at different orientations to the picture plane, we can then read the shading as the result of consistent lighting. Either way, an interpretation suggested by one kind of visual evidence is confirmed by another. Such consistency still does not necessarily constrain us to a single interpretation, however; some shaded objects can be read as either concave or convex, depending upon our assumptions about lighting direction.

Figure 3.7 contains still more visual information: in addition to surface shading there is a cast shadow. The shape of the shadow is consistent with reading the faces as foreshortened squares, and the light source suggested by the direction of the shadow is consistent with that suggested by the variation of shading. The weight of all this consistent evidence makes it very difficult (though it remains a logical possibility) for us to read the presented pattern of shaded polygons as anything but a cube on a plane surface illuminated by a single source of light. (I do not exclude the possibility that somebody with very different cultural background and expectations might find some other reading equally compelling.)

The final image in this series (figure 3.8) is more insidiously constructed. It appears, at first glance, to show some kind of three-dimensional object, and we can find reasonable interpretations of vertices, lines, and polygonal faces that begin to confirm this conjecture. But if we look closely we can always find other visual evidence that does not fit the same interpretation. We must conclude that this is an impossible object—something that, contrary to first impressions, does *not* have a consistent three-dimensional interpretation.[24] The works of Maurits Escher often depend for their paradoxical effect on this sort of ambiguity in the visual evidence (figure 3.9).

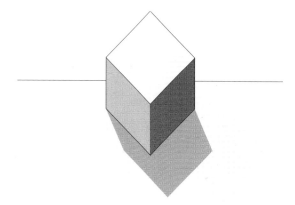

3.7 Consistent foreshortening, shading, and cast shadow.

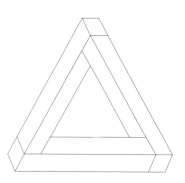

3.8 An impossible object: the Penrose triangle.

In forming interpretations of images, then, we use evidence of the parts to suggest possible interpretations of the whole, and we use the context of the whole to suggest possible interpretations of the parts. (Depending on your presuppositions, you can regard this process as high-flown Gadamerian hermeneutics or as mundane and fairly mechanical consistency checking programmable by an MIT undergraduate. It is, in fact, the basic process of many computer programs for scene interpretation.[25]) Some images turn out to have unique consistent interpretations, some like the Necker cube are ambiguous in the sense that they have multiple consistent interpretations, and some—while by no means meaningless—contain irreconcilable contradictions.

Photographs, unlike for example simple line diagrams, present rich arrays of visual evidence for us to interpret: shape and shading are registered with high precision. Furthermore (if the exposure was instantaneous) we know that they must be in essentially correct perspective projection and consistent light. So we can think of them as highly redundantly coded messages, like digital transmissions that incorporate redundancy for error-correction purposes. This redundancy gives them a ring of truth, since interpretations suggested in one way are usually confirmed in numerous other ways: no matter how we cut it, we find that the visual evidence always adds up to the same result.[26] The "layers" of visual information in a photograph are like independent witnesses that perfectly corroborate each other.

This unrelenting internal consistency also distinguishes photographs from handmade drawings and paintings, which, even when they adopt much the same conventions of perspective and shading, characteristically contain

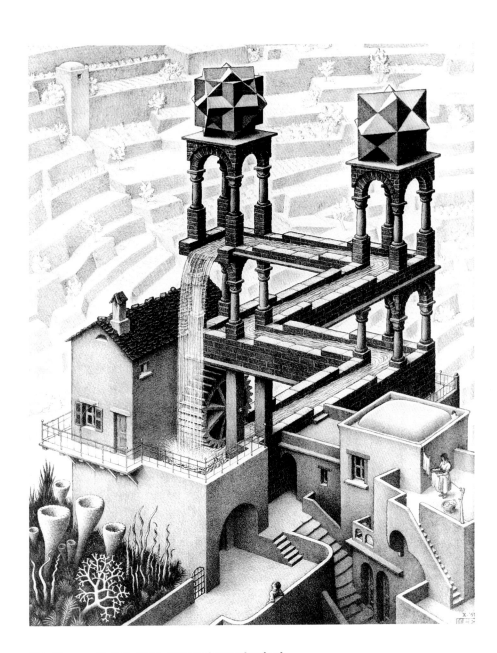

3.9 The paradoxical effect of inconsistent visual evidence: M. C. Escher, *Waterfall,* 1961—a composition derived from the Penrose triangle. © M. C. Escher/Cordon Art, Baarn, Holland.

Rashomon-like ambiguities and inconsistencies. The resulting play among the visual codes of a drawing or painting yields more complex interpretations, and may even support ludic Derridean readings of the image against itself.[27] A painting may, for example, show different objects in a scene from different vantage points—but a photograph must depict them all within a single, fully consistent perspective space. And the spatial cues given by foreshortening and shading of surfaces in a photograph must be precisely consistent with each other, while this need not be so in a painting.

It follows that we can refute claims that an image is a photographic transcription of physical reality by cross-checking the visual evidence and identifying inconsistencies.[28] This requires a suspicious frame of mind: if we do not somehow expect inconsistencies, we are likely to overlook even quite blatant ones in our effort to make sense of what we see before us. Photographic manipulators do not necessarily have to do a very good job in order to fool us, at least initially. But if we are alerted we can ask, for example, whether the foreshortening, shading, and cast shadows are consistent with each other and with reasonable assumptions about viewpoint and lighting conditions? Do indicators of time, such as clocks and shadows, seem consistent with each other? When a viewpoint suggested by the weight of visual evidence is assumed, do objects seem to be in plausible scale relationships? Do some objects seem surprisingly light or dark in relation to their surroundings? Are inserted objects betrayed by lack of expected cast shadows or by shadows cast at angles different from those cast by other objects?[29] Do unexpected discontinuities in the background suggest that objects must have been deleted from the foreground?

Are there shadows that do not seem to be cast by any object? Are shadows and specular highlights consistent with the same assumptions about locations of light sources? Do highly specular surfaces show mirror reflections consistent with our spatial interpretation of the scene?[30] Are modifications of surface and shadow intensities due to interreflection effects between surfaces consistent with our understanding of surface shapes and relationships? Are the scale and gradient of texture on a surface consistent with assumptions about the surface's size and orientation? Are geometric and aerial perspective consistent with each other? Is there a consistent gradient of sharpness from some focus plane? If there are n different types of visual evidence to consider, there will be n-squared interrelationships to cross-check for consistency, so this sort of forensic analysis can be elaborated almost endlessly. Often it will unmask as spurious an image that, at first glance, had readily passed as an authentic photograph.

The more information there is in an image, the harder it is to alter without introducing detectable inconsistencies: usually it is much quicker and easier to introduce undetectable changes into fuzzy, low-resolution, black-and-white images like that of the Libyan MiG than to do the same with sharp, high-resolution, full-color images. Furthermore, the difficulty of convincing alteration grows exponentially with the variety of types of visual evidence present. If an image shows only a silhouette, you have to give convincing shape to only the altered profile. But if there is differentiated surface shading, you also have to alter the distribution of shades to make this consistent with the new profile. If there are cast shadows, you must adjust them to maintain consistency with the ge-

ometry suggested by the new profile and shading, and so on. If you manipulate a stereo pair, you must very carefully coordinate the marks made on the left and right images; otherwise, when the images are viewed in a stereoscopic display, your marks will appear to "float" implausibly in space. A photographic manipulator, like a dissembler who weaves a tangled web of lies and eventually trips himself up, is likely to be caught by some subtle, overlooked inconsistency.

To illustrate the application of this principle of absolute coherence, let us examine the famous photograph that, the original caption claimed, was taken by the astronaut Neil Armstrong on July 20, 1969, and that shows fellow astronaut Edwin Aldrin walking on the surface of the moon (figure 3.10). The claim that man's first moon walk took place on this date, in the manner depicted, is extremely plausible, since the picture is sharp and clear—including a reflection of the photographer in Aldrin's visor—and since there are no detectable inconsistencies with the well-known facts of the first moon voyage. This picture convinced the world. Two decades later, in Fall 1989, *Time* magazine concluded a special issue on "150 Years of Photojournalism" with "a picture of something that never took place . . . produced on a computer screen." This picture, made from Armstrong's famous shot, shows seven space-suited astronauts apparently walking on the surface of the moon (figure 3.11). If we are at first persuaded to believe this evidence of our eyes, we can quickly be dissuaded by considerations of internal coherence: it is easy to miss at a casual glance, but close examination reveals an inconsistency in the reflections. Each visor shows the image of just one other astronaut, not the several that we would expect.

Relationship to Visual Discourses

If an image seems internally coherent, we can then ask whether the facts it purports to present are plausible—whether they seem consistent with other facts that, independently of the image in question, we believe to be true. (This is a procedure that has been given considerable attention, in a different context, by philosophers of history.[31]) The approach is nicely suggested by William Hogarth's famous satire on the incompetent perspectivist (figure 3.12). We can read this well enough as a depiction of a three-dimensional scene, but we laugh because doing so forces us to accept some implausible and amusing assumptions about the size and orientation of figures, architectural elements, fishing rods, and so on.

Our capacity to evaluate plausibility is not, however, conferred simply by built-in common sense. It is—as discourse theorists of various stamps will be quick to argue—constructed by our positioning within discourses (which direct our attention and set boundaries on what counts as evidence and knowledge) and constrained by limits on our stores of relevant facts. One person's vivid, compelling, important piece of visual evidence may be another's factoid, irrelevant fragment of trivia, misleadingly constructed propaganda, or aberrant result of observational error. Plausibility is relative to an ideological framework and an existing knowledge structure.

Consider, for example, the reception of spacecraft images. When we first saw pictures of the far side of the moon—something on which humankind had never set eyes before—we could cross-check them only against what we knew of the front of the moon: there was nothing else to compare them with. And when

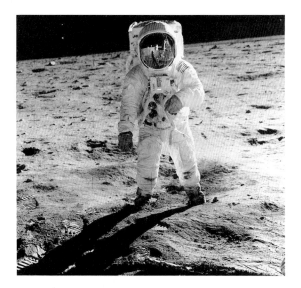

3.10 Astronaut Edwin F. Aldrin, Jr., on the moon, July 20, 1969. Courtesy NASA.

3.11 Seven astronauts on the moon. Manipulated image created by MarLo Bailey on the Quantel Graphic Paintbox at HBO Studio Productions, New York, New York, for *Time* magazine special issue "150 Years of Photojournalism." Original photography supplied by NASA.

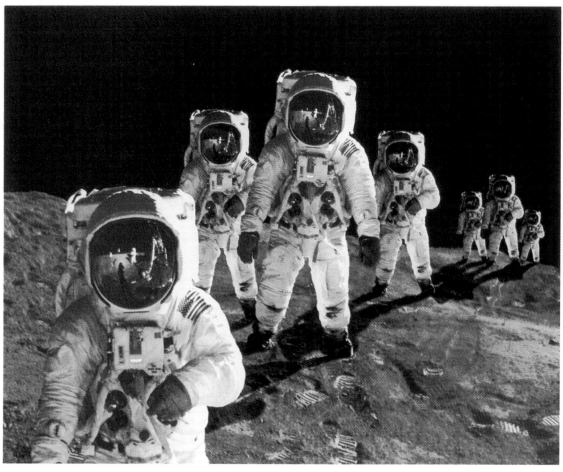

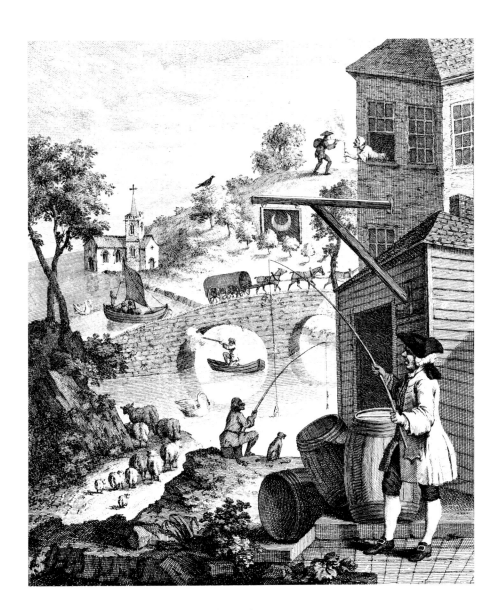

3.12 Implausible assumptions required to make sense of a picture: William Hogarth's *Perspectival Absurdities,* from Joshua Kirby's *Dr. Brook Taylor's Method of Perspective Made Easy in Both Theory and Practice,* 1754. Courtesy Yale Center for British Art, New Haven.

close-up photographs of the rocky surface of Mars were first published in 1976, we simply *had* to believe them: since none of us had ever been close to the surface of Mars, we had virtually no relevant knowledge against which to cross-check them. At best, we could make comparisons with barren, rocky deserts on Earth.

A clever deceiver can take advantage of such ignorance. For example, after the Chernobyl nuclear power plant explosion, a video clip of an Italian cement factory was passed off to American television networks (NBC and ABC) as being footage of the damaged reactor.[32] The images initially seemed plausible enough, since few people had any idea of what a Soviet nuclear reactor might look like. Similarly, when a 4,000-year-old mummy was discovered in an Alpine glacier in 1991, an Austrian newspaper published what it claimed to be a CAT scan of the mummy's brain—demonstrating, according to the accompanying article, that this prehistoric man had been epileptic.[33] This was a fairly safe ploy: expertise in the interpretation of CAT scans of mummies is not widespread. But the image was later shown to be that of the thorax of an unmummified twentieth-century man, published upside down.

An image which is proffered to support a surprising or extravagant claim, but which presents few confirmable specifics, invites suspicion. This difficulty arises with the photographs that Robert E. Peary produced to support the controversial claim that his expedition reached the North Pole on April 6, 1909. They merely show team members in a featureless landscape of ice hillocks and might have been taken anywhere in the snowy wilderness (figure 3.13). But we do know with certainty one fact about the Pole at the moment at which

Peary claimed to have exposed the film—the altitude of the sun—and we can check the cast shadows in the photographs for consistency with this. The National Geographic Society has analyzed the shadow angles and has concluded that they are indeed consistent with Peary's claim.[34] Skeptics, however, suggest that the margin of error in measurements of shadow angles is sufficiently great to make them worthless as confirming evidence.

Sometimes the visual evidence presented by an image supports alternative assertions, and we must decide which is the more plausible. Where the propaganda value of an image is at stake, the issue may become hotly contested. Consider, for instance, the famous photograph by Robert Capa shown in figure 3.14. It was published in *Vu* in 1936, then in *Life* in 1937 with the caption "Robert Capa's camera catches a Spanish soldier the instant he is dropped by a bullet through the head in front of Cordoba." The visual evidence seems consistent with belief that this the caption is truthful. But Phillip Knightley has pointed out, in *The First Casualty*, that the evidence would be equally consistent with a different and much less affecting caption, such as "A militiaman slips and falls while training for action."[35] In evaluating the truth of this photograph we need to ask not only whether the visual evidence that it presents supports the caption, but also whether the caption can more plausibly be reconciled with the facts, as we know them, of Robert Capa's career and of the Spanish Civil War than with the less dramatic alternative.

Knightley carried out an investigation of this issue. He asked first about the circumstances in which the picture was taken. When and where did Capa take it? Who is the man? Since the terrain is unspecific and the face is blurred, the

3.13 Shadow angles may indicate the time and place
of a photograph: Admiral Peary at the North Pole.
Photograph by Robert E. Peary. © National Geographic
Society.

3.14 Contested captions: "Robert Capa's camera catches a Spanish soldier the instant he is dropped by a bullet through the head in front of Cordoba" or "A militiaman slips and falls while training for action." Robert Capa, Spanish Civil War photograph, September 5, 1936. © Robert Capa/Magnum Photos, Inc.

image itself does not provide many clues. Knightley talked to Cornell Capa (the photographer's brother) and to professional associates such as Cartier-Bresson; none of them was able to provide specific details. Finally, he concluded that the photograph "turns out to be not the clear and simple statement of fact that it at first sight appears."

Other famous war photographs have been subjected to the same sort of scrutiny. Alexander Gardner's image of a dead "rebel sharpshooter" at the Battle of Gettysburg (figure 3.15) was shown to have been staged: a dead body, which had earlier been photographed elsewhere as that of a "Union sharpshooter," was dragged into the scene and arranged as in a still life.[36] Joe Rosenthal's shot of four marines planting the flag at Iwo Jima (figure 3.16) has seemed implausible to many observers because it is so rhetorically charged that it looks as if it *must* have been posed—and indeed this turns out to have been the case.[37] It is histrionics, not history. Seeking to reduce the impact of Huynh Cong Ut's picture of a terrified, naked little girl fleeing from a napalm attack in Vietnam (figure 3.17), General William Westmoreland cynically proposed that her burns were caused by "a hibachi accident."[38]

In general, if an image follows the conventions of photography and seems internally coherent, if the visual evidence that it presents supports the caption, and if we can confirm that this visual evidence is consistent with other things that we accept as knowledge within the framework of the relevant discourse, then we feel justified in the attitude that seeing is believing. But failure to satisfy any one of these requirements motivates suspicion. We dismiss supermarket tabloid photographs purporting to show the immortal King

of Rock and Roll wolfing fries at McDonald's in Kansas City, no matter how compelling the likeness, because we cannot reconcile them with abundant, sober evidence that Elvis expired long ago. (Of course, the publications we sneak glances at in the eight-items-or-less checkout lane do not expect to be taken too seriously: the outrageous implausibility of their claims—both verbal and visual—is part of the fun.) An image of a cement factory can pass for an image of a nuclear reactor just so long as we do not have any knowledge of nuclear reactors against which to cross-check it, but the more we know about reactors the less plausible it will seem. We become skeptical of Peary's purported North Pole pictures and Capa's "moment of death" image because much less dramatic captions than those proposed by the authors can be suggested and seem to fit the visual evidence equally well. But General Westmoreland's contemptible quip failed to discredit the fleeing child image in the eyes of the public because this heartbreaking picture is detailed, internally coherent, and far more plausibly described by the original caption than by the alternative he attempted to supply.

Provenance

Finally, in addition to examining an image for internal coherence and considering whether it can stand up to cross-checking against what we know of a situation, we might ask for evidence that it is an authentic record—just as we might question whether a contract or will is genuine. Was it produced at the time and place claimed, by means of a process guaranteeing fidelity, by the person identified as its originator?[39] Is the originator trustworthy and

3.15 Staging a photograph: the same body appears in two different photographs.

Below: Alexander Gardner, *Slain Rebel Sharpshooter,* **July 1863. Prints and Photographs Division, Library of Congress.**

Right: Alexander Gardner, *Fallen Sharpshooter,* **1863. International Museum of Photography at George Eastman House, Rochester, New York.**

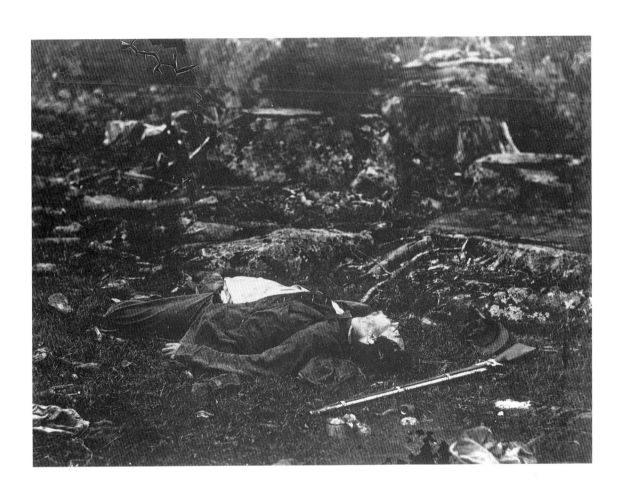

3.16 Rhetorical re-enaction: Joe Rosenthal's famous photograph of marines hoisting the stars and stripes atop Suribachi Yama, Iwo Jima, February 23, 1945. AP/Wide World Photos.

3.17 Napalm attack or "hibachi accident"? June 8, 1972. Photo by Huynh Cong "Nick" Ut. AP/Wide World Photos.

authoritative? How did the image come to be presented to us? Are there suspicious gaps in its history?

In July 1991, for example, a photograph supposedly showing three lost Vietnam War fliers stirred an emotional debate in Washington (figure 3.18).[40] The families of the men that it apparently portrayed adamantly maintained that it was authentic. Some government officials, on the other hand, suggested that it might have been a hoax perpetrated by bounty hunters. There was some argument about coherence and plausibility, and The New York Times reported:

Pentagon officials note that the three fliers look unusually well nourished for having been held in captivity for more than two decades. Some photography experts say the head of the man standing in the middle is out of proportion, suggesting that his picture was taken separately from those of the other men. Other analysts have noted that the cryptic sign held up by the men appears to have been photocopied and pasted on the picture.

But most discussion focused on the question of whether the image had a verifiable provenance that could establish its authenticity. Its history, according to The New York Times, was as follows:

The Pentagon originally received the photo by fax machine last November from a naturalized American of Cambodian descent living in Los Angeles. A Defense Intelligence Agency official provided Colonel Robinson's daughter, Shelby Robinson Quast, with the name of the man who transmitted the photograph. A friend of her family said that Mrs. Quast met with the man and that he gave her two contacts

to locate in Cambodia and a handwritten note demanding $2 million for two of the three men. Mrs. Quast flew to Phnom Penh to track down the two contacts. She found one, who maintained he took the photograph when he was a prison guard.[41]

So the claim of authenticity was based on identification of a photographer (the mysterious man in Phnom Penh), a time and place of exposure ("when he was a prison guard"), and a chain of transmission.

To find evidence for or against this claim, the US government sent a ten-member Pentagon team to Thailand to "find out the circumstances under which the photograph was supposedly carried across the Thai border into Cambodia." Soon after, a Pentagon report suggested that the provenance was suspicious and that the authenticity of the photograph was therefore doubtful: "One principal source of the photograph lies in a ring of Cambodian opportunists led by a well-known and admitted fabricator of P.O.W.-M.I.A. information," it claimed.[42] Pentagon investigators suggested that the photograph may have had the same source as some known fakes that were produced by manipulating pictures found in Soviet magazines.[43] Sufficient doubt was created for The New York Times to report, "Last summer, copies of a photograph purporting to show three captive American pilots were circulated, but U.S. authorities, after studying them, decided they were not valid." Eventually, Defense Department officials produced a convincing original—a 1923 photograph of three Soviet farmers that had been published in the December 1989 Khmer-language issue of a magazine called Soviet Union.[44] Apparently the original had been cropped, the features of the farmers had been disguised by addition of Stalinesque

3.18 Suspicious provenance: a photograph that sur-
faced in July 1991 as "evidence" of the continued
imprisonment of three lost fliers in Vietnam (Reuters/
Bettmann) and the source image from which it was ap-
parently produced—a 1923 photograph of three Soviet
farmers.

moustaches, and the banner lauding collective farming had been replaced by a cryptic placard indicating captivity. False anchorage of the purported chain of transmission had been demonstrated, so this photograph completely lost whatever initial credibility it may have had.

A really bold liar (particularly one who can exploit some mantle of authority) can simply appropriate legitimate pictures to false narratives by providing them with fake provenances—much as confidence tricksters equip themselves with fake biographies. One of Ronald Reagan's more egregious falsehoods was his claim to have been one of the Signal Corps photographers who filmed the Nazi death camps. The horrifying pictures certainly exist, and Reagan told Israeli Prime Minister Shamir that he had kept a copy of them for himself in order to be able to prove that six million Jews had been exterminated. But the provenance that Reagan supplied was a completely spurious, self-serving fabrication: in fact, he never left the States in World War II.[45]

Originals and Copies

As framed above, the question of authenticity suggests that images are unique, that they are produced by individuals, and that there is a fundamental difference between originals and copies. We might ask, for example, whether a particular sketch was an original Rembrandt or merely a copy, whether a particular Polaroid print was an authentic David Hockney, or whether a particular Signal Corps death camp photograph was really by Ronald Reagan. Where we can distinguish clearly between originals and copies we usually value the originals far more highly—both for their aura as relics of a particular human hand and for their superior status as direct rather than secondary evidence.

But the conditions for distinguishing between originals and copies do not hold in all the cases of interest to us here, and this raises some perplexities. Photographs, for example, have negatives and multiple prints. Is the negative the original? Is each print an original? Who is the author of a print made from the negative of some long-dead photographer?[46] Are Polaroid prints more truly "originals" than prints from negatives? What are we to make of photographs of photographs?[47] Sherrie Levine pointedly raised these questions when she photographed a well-known photograph by Walker Evans, then signed and exhibited the resulting print. And Brett Weston dramatized the issues by burning his negatives on his eightieth birthday—declaring that only he could print them in the way that he intended and that he did not want somebody else to make prints after his death.[48]

Digital images seem even more problematic, since they do not even have unique negatives. An image file may be copied endlessly, and the copy is distinguishable from the original only by its date since there is no loss of quality. Unlimited numbers of displays and prints may be made from each copy, and displays may be fleeting like musical performances rather than permanent like paintings. The original image file may be destroyed within a short time of its creation, but many of its descendents may live on. In some cases, digital images are not captured but synthesized by application of rendering procedures to geometric data. Is the geometric database, then, the original? What if different rendering procedures are applied to the same geometric database? Does each appli-

cation of a new rendering procedure produce a new original work of art? Is the rendering procedure really the original (as one might argue that the recipe rather than the individual dish is the original work of culinary art)?

A famous incident in the history of computer graphics has dramatized these questions. In the very early days of three-dimensional computer graphics, a beautiful digital model of a teapot was produced at the University of Utah. Copies of this model have since found their way to computer-graphics laboratories throughout the world, and dozens of very different rendering procedures have been applied to it to produce thousands of variant teapot images—smooth teapots and rough teapots, transparent ones and reflective ones, metal, stone, wooden, fleshy, and furry ones. At one SIGGRAPH computer-graphics conference there was even a teapot-rendering competition.

In his magisterial *Languages of Art* Nelson Goodman has introduced some technical distinctions that clarify the problem of differentiating appropriately between originals and copies.[49] First, he distinguishes between one-stage and two-stage arts. Production of a pencil sketch or a Polaroid print is a one-stage process. But production of music is often a two-stage process: composition followed by performance. Many images are also produced in two stages: plates are etched then printed, photographic negatives are exposed and developed then printed, and digital images are encoded then displayed. In a two-stage process, the work is often divided among different individuals: a pianist may perform a work composed by somebody long dead, a photographer may print an archived negative produced by some forgotten predecessor, and a computer hacker may generate a display from an image file of

anonymous origin that was read from some distant bulletin board.

Secondly, Goodman distinguishes between autographic and allographic arts. Painting, for example, is autographic, but scored music is allographic. The essential difference is that a musical work is specified in some definite notation system, whereas a painting is not. The musical score can be copied exactly, character by character, and any correct copy is as much a genuine instance of the work as any other. In effect, Goodman suggests, the fact that a work "is in a definite notation, consisting of certain signs or characters that are to be combined by concatenation, provides the means for distinguishing the properties constitutive of the work from all contingent properties—that is, for fixing the required features and the limits of permissible variation in each." But in painting, where the work is not specified in such a notation system, "none of the pictorial properties—none of the properties the picture has as such—is distinguished as constitutive; no such feature can be dismissed as contingent, and no deviation as insignificant."[50] A copy of a score need not, then, be the product of the composer's own hand in order to qualify as a genuine instance of a work, but a painting can be a genuine work only if it *is* actually an object made by the purported artist. If it is the work of some other hand, it is a forgery.

Autographic works such as paintings or videotapes consist of analog information: they cannot be copied exactly, and repeated copying always introduces noise and degradation. But the specification of an allographic work consists of digital information: one copy (of a musical score, of the script of a play, of an image file) is as good as another. Notice, incidentally, that two-stage works are frequently, but not

necessarily, allographic: an etching plate or photographic negative consists of analog information, cannot be copied exactly or used to make precisely identical prints, and does not specify the constitutive properties of the work in the rigorous way that a script or score does.[51]

Allographic works can be instantiated limitlessly (but the concept of instantiation does not apply to autographic works—they are unique): a musical work is instantiated in a performance that faithfully follows the score, a play is instantiated in a performance that faithfully follows the script, and a digital image is instantiated in a display or print that faithfully follows the tones or colors specified in the image file. Instances of the same work can vary (sometimes widely) in their contingent properties but must display the required features in order to count as instances. Thus musical and theatrical performers are free, to some extent, to interpret a work—and, indeed, we may place a high value on unusual and innovative interpretations that reveal hitherto unsuspected dimensions of the work. Similarly, a computer may mechanically interpret a work in different ways, using different algorithms and devices, to produce significantly differing instances.

Digital images, then, are two-stage, allographic, mechanically instantiated works. We can take a display or print to be a true record if the image-capture process was an automatic one, if the image file that was used is an exact copy of the one that was originally captured, and if a correct interpretation algorithm has been applied. When these conditions can be shown to hold, we can place at least as much confidence in the image as in an unretouched photograph—perhaps more, since copying does not produce noise and degradation and since interpretation algorithms are less beholden to

human intentions than the darkroom processes used by photographers.

But it is usually extremely difficult, in practice, to demonstrate that the conditions do hold, since electronic recording media are made to be reused, and there is simply no equivalent of the permanently archived, physically unique photographic negative. Image files are ephemeral, can be copied and transmitted virtually instantly, and cannot be examined (as photographic negatives can) for physical evidence of tampering. The only difference between an original file and a copy is in the tag recording time and date of creation—and that can easily be changed. Image files therefore leave no trail, and it is often impossible to establish with certainty the provenance of a digital image.

Mutation and Closure

Traditionally, musical scores, literary texts, and other specifications of allographic works have had final, definitive, printed versions. The act of publication is an act of closure. You can modify a printed score or text by hand, but this produces a new (if unoriginal) work, not a redefinition of the existing finished work. Where scores or texts are corrupted in some way, scholars often expend considerable effort in attempting to recover definitive versions. But there is no corresponding act of closure for an image file. In general, computer files are open to modification at any time, and mutant versions proliferate rapidly and endlessly. Scholars can often trace back through a family tree of editions or manuscripts to recover an original, definitive version, but the lineage of an image file is usually untraceable, and there may be no way to determine whether it is a

freshly captured, unmanipulated record or a mutation of a mutation that has passed through many unknown hands. So we must abandon the traditional conception of an art world populated by stable, enduring, finished works and replace it with one that recognizes continual mutation and proliferation of variants—much as with oral epic poetry.[52] Notions of individual authorial responsibility for image content, authorial determination of meaning, and authorial prestige are correspondingly diminished.

Furthermore, the traditional distinction between producers and consumers of images evaporates. A scientist interpreting a digital image may, for example, apply transformations to the digital data in order to bring out features and relationships of interest, then store the result in a new image file. The reading becomes a new work, with perhaps as much or more claim to our interest and attention as the original. We might best regard digital images, then, neither as ritual objects (as religious paintings have served) nor as objects of mass consumption (as photographs and printed images are in Walter Benjamin's celebrated analysis[53]), but as fragments of information that circulate in the high-speed networks now ringing the globe and that can be received, transformed, and recombined like DNA to produce new intellectual structures having their own dynamics and value.[54] (Text fragments manipulated by word processors and digital sound samples manipulated by computer music systems have a similar character.) If mechanical image reproduction substituted exhibition value for cult value as Benjamin claimed, digital imaging further substitutes a new kind of use value—*input* value, the capacity to be manipulated by computer—for exhibition value. The age of digital replication is superseding the age of mechanical reproduction.

The cultural production system now emphasizes processability. The digital structures that are produced and consumed do not just *refer* to each other, they are actually *made* from each other, so that they form mirror mazes of interpictoriality hooked to the external physical world (at relatively few points) by moments of image capture. Images do not just mirror the world directly, as they once seemed to do, but reflect traces (perhaps tinted or distorted) of other images. That loss of the external referent, and the growing self-referentiality of symbol systems, which has so preoccupied poststructuralist theory, are here escalated to a new level. Logical associations of images in databases and computer networks become more crucial to the construal of reality than physical relationships of objects in space. Digital imaging now constructs subjects in cyberspace.[55]

Image Ethics Redefined

As digital images have become increasingly important items of exchange in the worldwide electronic-information economy and as traditional conceptions of image truth, authenticity, and originality have consequently been challenged, ethical and legal dilemmas have emerged. Many of the traditions, standards, and laws developed in the predigital era seem inadequate when they are extended to the new situations created by the new technology.

Since the development of printing, for example, the concepts of "fixing" and "publication" of definite "works" have played key roles in copyright law. There was a basic assumption that production of copies—either as pieces of handiwork or as industrial commodities—was a difficult and expensive process and that copies were valuable material artifacts existing in

limited numbers. The US Copyright Act of 1909 was typical: it gave protection to intellectual and artistic works—such as books and photographs—that were "published with notice." The more up-to-date provisions of the Berne Convention dispense with the idea of formal publication as the starting point for copyright protection and extend it to works that are merely "fixed in some tangible medium of expression." But the speed and informality of digital image production, the practical difficulties of distinguishing between "draft" and "published" versions and between originals and copies, the existence of digital images in forms that are not eye-readable, their ease of duplication, their mutability and lack of closure, their tendency to proliferate limitless variants, and their unconventional channels of distribution conspire to make them very difficult to pin down in this way.[56] There is an erosion of traditional boundaries between artist or photographer, editor, archivist, publisher, republisher, and viewer. And digital images do not necessarily come embedded in manufactured material substrates, like texts in books and musical performances on records: often, you can just download them from a database. In multiple and sometimes subtle ways they resist treatment as privately owned material commodities.

The traditional concept of a derivative work—as exemplified by translations of books, films based on novels, paintings made from photographs, and the like—is also under challenge. As we have seen, a digital image file is *made* to be processed—to be transformed into something else—and any file is the potential progenitor of an endless sequence of descendents. It seems far from straightforward to specify the distinctions between outputs from

image-processing operations that are trivially different from the inputs, outputs that contain sufficient original content to be classified as distinct but derivative works, and outputs that are most reasonably regarded as genuinely original productions. How does this practical reality affect whatever moral and legal rights a photographer, graphic artist, or film director may have to control the production of derivative works and to prevent undesirable transformations? And when should image-processed derivatives themselves be entitled to copyright protection?

In 1986 the purchase of the MGM film library by the television entrepreneur Ted Turner raised the issues of film protection in dramatic fashion. Turner announced his intention to apply digital colorization to one hundred old feature films and commented: "The last time I checked, I owned those films. I can do anything I want with them." Many prominent directors and cinephiles protested against the colorization of black-and-white film "classics," and the Directors Guild of America called it "cultural butchery."[57] In 1991 *Star Wars* director George Lucas suggested that colorization was only, in fact, the tip of the iceberg:

The agonies filmmakers have suffered as their work is chopped, tinted and compressed are nothing compared to what technology has in store. . . . Unless the United States achieves uniformity with the rest of the world in the protection of our motion picture creations, we may live to see them recast with stars we never directed, uttering dialogue we never wrote, all in support of goals and masters we never imagined we would serve.[58]

However rights to reproduce digital images and produce derivative works from them are established and protected, the question of what these rights are worth and how they should be transferred remains. Marxist analysts are disconcerted to note that the labor theory of value is not much help here; photographers, stock agencies, and museum directors wonder what to charge for rights and how to collect their money. Photographers, for example, have traditionally retained economic control of images by keeping the negatives and selling prints, but this strategy becomes impossible when images are archived and distributed as files of digital information. Should image CDs, then, be treated like stock-photo catalogues, with users required to purchase separately the reproduction rights to any of their contents, or should such CDs become direct sources of immediately reproducible images? Should electronic reproduction rights be sold like print rights? If they are, there are some difficult pricing and contractual issues to resolve. Since electronic images are disseminated in different ways and in different quantities from print images, for example, it can be argued that rights should be priced on some different basis. And controls that museums have traditionally exerted over the quality and distribution of print reproductions become much more difficult to enforce with electronic reproductions.

If a digital image does have value to a collector, how can this be preserved? Paintings are unique and often appreciate in value, print runs are limited, and photographers can destroy their negatives to prevent the production of further prints that might devalue the ones already in existence. But, since digital image files can be replicated endlessly and prints can be made mechanically whenever desired, there is no act equivalent to burning the negative or breaking the mold: any copy of the image file will serve as well as any other as the source for further copies.

When does processing or manipulation add value to an image? It might well be argued, for example, that colorization of film adds value. What about enhancement of a poor-quality image by sharpening, or smoothing of a portrait to make it more flattering? If value is added, who is entitled to claim recompense for this?

Where does an image actually reside? The network distribution of digital images can make it difficult to determine image locations—unlike the case of, say, paintings that reside in museums. Images can exist as multiple, geographically distributed identical copies, and these copies can be moved around as in a gigantic, extremely high-speed shell game. Networks frequently cross boundaries of legal jurisdiction, potentially putting image copies beyond the statutory reach of law-enforcement and regulatory agencies.[59] This creates policing problems. Political censors will find it increasingly difficult to prevent the infiltration of their territories by seditious or otherwise unwelcome images, pornography will be harder to control, and the subjects of visual libel may not have any effective way to prevent the dissemination of offending images.

And what is fair use of a digital image? It is generally accepted that a scholar may copy short portions of a published text into his or her notes and subsequently use those excerpts in new works of criticism, comment, news reporting, teaching, and so on. Can that same scholar select part of an electronically distributed digital image and use desktop-publishing software to paste it into a page layout? If so, how much of the image can fairly be reused in

this way? Surely it is unethical, and in many cases a violation of copyright, to reuse a complete image without appropriate permission. Just as clearly, though, it would be absurd to complain about copying the value of a single pixel from an image (or a single sound from a musical performance)—it's just a number. At what intermediate point can we reasonably draw the line? What if a pattern or texture is extracted and reused in production of a computer-synthesized perspective rendering of a building? What about a dramatic sky extracted from an Edward Weston landscape photograph and reused in a new landscape composite? Where does visual plagiarism begin? Graphic artists will have to evolve norms governing fair use of digital imagery analogous to the traditions and conventions that govern the quotation, recombination, and paraphrase of fragments of text.

Finally, how should the rights of photographic subjects be defined and enforced, and are established ways of compensating subjects still adequate?[60] Does a model's signed release of an image extend to the use of that image in an electronic "clip art" collection and to its endless transformation and recombination to produce new images? How should releases be written, and how should a model be paid for this sort of use? And what limits are there to electronic transformation of photographic images to produce unflattering caricatures or scenes that show recognizable individuals in a discreditable light? The photograph's air of reality makes a difference here: a digitally manipulated photograph showing a prominent politician in a compromising or damaging situation has a very different effect from that of a drawn cartoon showing exactly the same thing. In the 1990 Massachusetts gubernatorial elec-

tion campaign, for example, the candidate John Silber was videotaped in a particularly offensive outburst against working mothers, whereupon his opponent quickly produced an effective television spot from this footage—manipulated to make Silber seem particularly menacing by showing him enlarged and slightly distorted.[61]

For photojournalists, as we have seen, the ethical issues dramatically present themselves as ones of creative control, individual and institutional responsibility for image content, and formulation of codes of conduct. Are press photographers to be reduced to little more than fleshy bipods—mobile supports for image-capture devices that send streams of pictures back to an editor's desk, where the crucial selection and framing decisions are made? Who controls the tonal and color qualities of an image—photographer, photo editor, or computer-graphics technician in the production department? When does a succession of small and apparently innocent manipulations add up to significant deception? How can this gradual degradation of evidential value be controlled? Who guarantees the integrity of a news photograph, and who checks whether an image of doubtful provenance might be a tendentious fabrication? When a digital image is the product of many hands, how should the image credit be written? And, if that image deceives or defames, who bears ultimate moral and legal responsibility?

As these signs of ethical and legal strain show, the digital image is emerging as a new kind of token—differing fundamentally from both photographs and paintings—in communicative and economic exchanges. It demands new rules for structuring those exchanges.

Devaluation

The painter, the photographer, and the digital imager have different social and cultural roles to play. A painter, firstly, is traditionally seen as an artificer, a patient maker, an urbanized craftsperson who transmutes formless raw materials into images. We naturally use the language of personal intention—reference, comment, expression, irony, conviction, truthfulness, and deception—to describe this process. There seems a comfortable fit with the Aristotelian conception of a fabricator, impelled by an anticipatory idea, who imposes form on matter.

But photography evokes predatory metaphors: a picture is "taken," the photographer operates in a ruthlessly competitive economy of image hunting and gathering. Photographs are trophies—won by skill and cunning and luck, by being in the right place at the right time, and by knowing how to aim and when to shoot.[62] Form is out there to be discovered, then impressed on matter by means of a swift, automatic process.

Long ago, Oliver Wendell Holmes fancifully described what he took to be the capitalist political economy of the photographic image (in the specialized form that particularly interested him—the stereograph).[63] He first imagined expeditions of visual conquest and plunder:

There is only one Colosseum or Pantheon; but how many millions of potential negatives have they shed—representatives of billions of pictures—since they were erected! Matter in large masses must always be fixed and dear; form is cheap and transportable. We have got the fruit of creation now, and need not trouble ourselves with the core. Every conceivable object of Nature and Art will soon scale off its surface for us. Men will hunt all curious, beautiful, grand objects, as they hunt the cattle in South America, for their *skins,* and leave the carcasses as of little worth.

Then he spoke of photographs as cognitive cold cash, the value of which was defined by reference to a kind of gold standard of nature:

Again, we must have special stereographic collections, just as we have professional and other special libraries. And, as a means of facilitating the formation of public and private stereographic collections, there must be arranged a comprehensive system of exchanges, so that there may grow up something like a universal currency of these bank-notes, or promises to pay in solid substance, which the sun has engraved for the great Bank of Nature.

Since Marx, of course (and more directly to the point, since Althusser on ideological apparatuses), many have greeted the idea of such buccaneering enterprises with far less enthusiasm. Susan Sontag, for one, has seen panoptic photographic production as a potentially sinister ally of the late-capitalist state:

A capitalist society requires a culture based on images. It needs to furnish vast amounts of entertainment in order to stimulate buying and anesthetize the injuries of class, race, and sex. And it needs to gather unlimited amounts of information, the better to exploit natural resources, increase productivity, keep order, make war, give jobs to bureaucrats. The camera's twin capacities, to subjectivize reality and to objectify it, ideally serve these needs and

strengthen them. Cameras define reality in the two ways essential to the workings of an advanced industrial society: as a spectacle (for masses) and as an object of surveillance (for rulers). The production of images also furnishes a ruling ideology. Social change is replaced by a change in images. The freedom to consume a plurality of images and goods is equated with freedom itself. The narrowing of free political choice to free economic consumption requires the unlimited production and consumption of images.[64]

Digital imaging has upped the ante in the debate defined by the formulations of Holmes and Sontag. Now there is a new, postindustrial economy of images, with superimposed processes of gathering and stockpiling raw materials, extraction, manufacture, assembly, distribution, and consumption. Perhaps the most striking illustration of this new economy is provided by the EROS Data Center near Bismarck, North Dakota. More than six million satellite and other aerial images have been stockpiled there for distribution to the public. Satellites continue to scan the earth and send images of its changing surface back, causing the stock to grow at a rate of twenty thousand per month. These ceaselessly shed skins are computer processed, for various purposes, by mineral prospectors, weather forecasters, urban planners, archaeologists, military-intelligence gatherers, and many others.[65] The entire surface of the earth has become a continuously unfolding spectacle and an object of unending, fine-grained surveillance.

In the digital image economy, form has become even cheaper and more swiftly transportable than Holmes could ever have imagined.

Furthermore, the connection of images to solid substance has become tenuous. The currency of the great bank of nature has left the gold standard: images are no longer guaranteed as visual truth—or even as signifiers with stable meaning and value—and we endlessly print more of them.

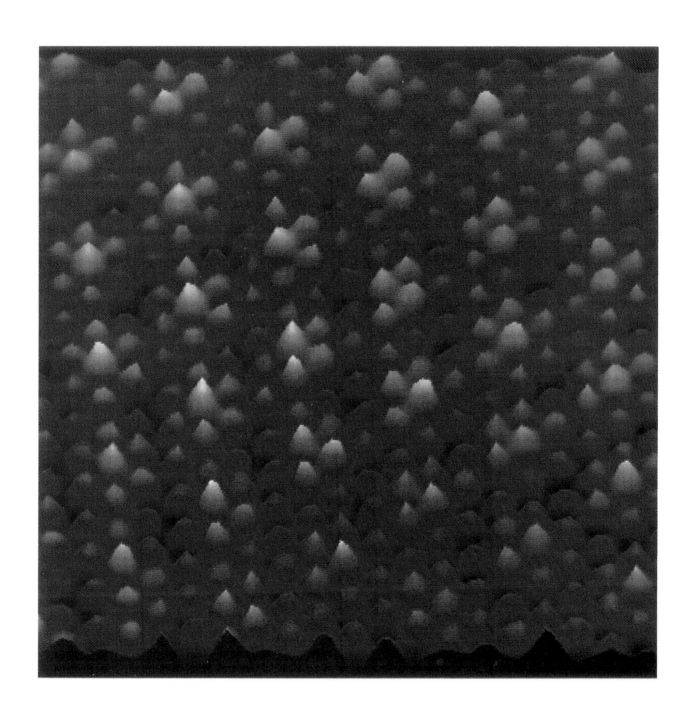

ELECTRONIC TOOLS

4.1 The invisible made visible by nonphotographic means: an atomic-resolution view of the surface of the superconductor niobium disellenide at −269 degrees C. Image recorded with a scanning tunneling microscope. Courtesy Zhe Zhang and Charles M. Lieber, Department of Chemistry, Harvard University.

■ **Tools and Purposes**

Tools are made to accomplish our purposes, and in this sense they represent desires and intentions. We make our tools and our tools make us: by taking up particular tools we accede to desires and we manifest intentions. Specifically, the tools and media of traditional photography—cameras, lenses, tripods, filters, film of various kinds, flashguns, studio lights, enlargers, darkroom chemicals, densitometers, and so on—represent the desire to register and reproduce fragments of visual reality according to strict conventions of perspectival consistency, tonal fidelity, acuity in rendition of detail, and temporal unity. They characterize a way in which we have *wanted* to see the world, and in the world since 1839 they have played a crucial role in the creation of collective memory and the formation of belief. The photographic way of seeing the world has come to seem transparent and natural to us: as Pierre Bourdieu has paradoxically put it, "in conferring upon photography a guarantee of realism, society is merely confirming itself in the tautological certainty that an image of the real which is true to its representation of objectivity is really objective."[1] While we have been using the tools, operations, and media of photography to serve our pictorial ends, these instruments and techniques have simultaneously been constructing us as perceiving subjects.

Now, after a 150 years, we are faced with a discontinuity, a sudden and decisive rupture. The technology of digital image production,

manipulation, and distribution represents a new configuration of intention. It focuses a powerful (though frequently ambivalent and resisted) desire to dismantle the rigidities of photographic seeing and to extend visual discourse beyond the depictive conventions and presumed certitudes of the photographic record (figure 4.1). Painting has always done this, of course, but it has come to occupy very different territory: the digital image challenges the photograph on its home ground.

If we want to come closely to grips with this new pattern—to comprehend its restructuring of subjectivity, to develop articulate critical positions relative to it, or to find strategies for artistic production within it—we must subject the materials, tools, and practices of digital imaging to careful, detailed analysis—much as Cennino Cennini and Giorgio Vasari minutely considered the properties and capabilities of fresco, oils, mosaic, and other traditional media and as Edward Weston later articulated the differences between painting and photography. Let us, then, begin by examining the electronic devices and systems that have come into use for capturing, storing, displaying, printing, and accessing digital images.

Image-Capture Devices

The practices of digital imaging and photography intersect at the moment of image capture, but thereafter the disjunctions become increasingly significant. Recall that automatic, instantaneous image capture is constitutive of photography: photograms, photomontages, light paintings, and other related types of images that dispense with it are only quasi-photographic. Weston—as one might expect—

claimed that this trait categorically distinguished the essential photographic act from all other acts of artistic creation. He wrote:

Among all the arts photography is unique by virtue of its instantaneous recording process. The sculptor, the architect, the composer all have the possibility of making changes in, or additions to, their original plans while their work is in the process of execution. A composer may build up a symphony over a long period of time; a painter may spend a lifetime working on one picture and still not consider it finished. But the photographer's recording process cannot be drawn out. Within its brief duration no stopping or changing or reconsidering is possible.[2]

Usually, digital images are captured through transduction of radiant energy into patterns of electric current rather than through chemical action, but in most cases the capture processes are similarly brief and automatic. Two steps are combined in any digital image-capture procedure (figure 4.2). First, intensities in the scene or source image to be captured must be sampled at grid locations. Second, each sample intensity must be converted to an integer value in some finite range—a process known as *quantization*. (Notice the analogy with sampling and quantization of sound to produce a digital recording.) This two-stage process of converting scene data near sample points into pixel values is known technically as *filtering*. An impressionist painter looking at a scene and converting it to discrete brush strokes and a digital image-capture device are both applying sampling and filtering strategies. But, whereas the impressionist painter performs sampling and filtering manually, subjectively, and probably rather inconsistently, the digital

**4.2 Sampling and quantization of an image: the aver-
age pixel value for a grid cell is calculated and approxi-
mated to an integer.**

device samples and filters mechanically, objectively, and consistently.

The continuity of digital imaging with the traditions of photography is most obvious when a still-video or digital camera is used for image capture. The earliest still-video cameras, in fact, looked exactly like ordinary 35-mm single-lens reflex cameras, but had a CCD (charge-coupled device) image sensor in place of the film plane—just as early music players took the form of pianos but substituted a mechanism for human hands. (This means, incidentally, that you do not have to wind or rewind a still-video or digital camera, motor drives become unnecessary, and frames can be shot in very rapid sequence.)

The CCD—invented at Bell Laboratories in 1969 by William S. Boyle and George E. Smith—is an array of picture-pickup elements, each of which records an intensity (in black-and-white models) or intensities for the additive primary colors red, green, and blue. When an exposure is made a still-video image is instantaneously recorded on a floppy disk mounted in the camera back.[3] (An advantage of still video over conventional video is that the CCD array is sufficiently sensitive to allow short exposures, while the video tubes used in conventional motion-video cameras are unable to capture images at shutter speeds faster than one-thirtieth of a second—usually resulting in blurred freeze frames. CCD arrays are also less subject to blooming and smearing.) The analog signal from a still-videodisc player can be used to generate a display on a video monitor, or it can be input to a computer for conversion into digital format. Digital cameras also employ CCD arrays, but record digital image files rather than analog video signals.

CCD arrays used in portable still-video and digital cameras are roughly comparable in light sensitivity to photographic film. (Those in first-generation models were approximately equivalent to 100-speed color film.) As every photographer knows, speed of the recording medium is an important issue. With silver-based film, too long an exposure will yield too dense a negative (thus too light a print, with detail burned out), while too short an exposure will yield too thin a negative (thus loss of shadow detail). If a scene has too much contrast, perfect exposure may prove to be impossible, yielding a negative in which some parts are too dense and other parts are thin.

In digital image capture this basic trade-off presents itself in a different way. Where the signal levels at detectors in a CCD array are too low (in the shadows of a scene or where exposure is too short), the result is a noisy image—one in which there are random deviations of pixel values from what they should be, with consequent degradation of picture quality (figure 4.3).[4] The more underexposed a shadow area (or an entire image), the worse the image-to-noise ratio will be. With gross underexposure, images can decay into completely random noise—fields of incoherent pixelsludge. Conversely, where the signal is too strong (in highlight areas or with overexposure), CCD detectors become saturated.

Noise, then, is the digital equivalent of the excessive grain that results from "pushing" silver-based film. Thus photographers using CCD devices should try to select exposures that avoid the extremes and keep the signal levels within the range in which the detectors respond proportionally to the amount of light reaching them. Where this is not possible, exposure should be calculated to achieve optimum distribution of noise in an image—in the same way that photographic film should be exposed for optimum distribution of density and

4.3 An image masked by increasing amounts of random noise.

detail. Some image-capture devices provide instant analyses of image noisiness, thus allowing reexposure, if necessary, to obtain a better distribution.

One of the first important applications for CCD cameras was in astronomy. The detector arrays of astronomical CCD cameras can be calibrated precisely, and in combination with amplifiers they can be used as image intensifiers. Furthermore, the digital images that they produce can immediately be filtered by image-processing systems to remove blur and distortion and reveal fine detail that would otherwise remain hidden. Thus the resolving power of optical telescopes can effectively be increased.[5] Results can be striking: when, in 1990, the expensive and controversial Hubble space telescope was found to be producing unacceptably blurred images due to excessive spherical aberration, digital filtering techniques were successfully employed to restore sharpness and contrast.

Of course there is no fundamental reason for electronic image-capture devices to imitate cameras quite so directly—simply by substituting a CCD for emulsion at the film plane—and a variety of less camera-like devices, with diverse technological pedigrees, have emerged to perform specialized image-capture functions. Images can be captured from motion video, for example, through use of a device known as a frame grabber. This is a piece of electronic circuitry, usually on a board mounted in a personal computer, that converts a video signal into a digital image of a frame. The signal might come directly from a video camera, from a television receiver, from a VCR, or from a videodisc player. In any case, the process of image capture becomes not one of pointing a camera at a scene, but one of selecting from a stream

of visual information. Newspapers have, in fact, begun to make use of pictures selected from tapes of television news broadcasts.[6] On September 26, 1991, for example, *USA Today* illustrated its story about a UN team besieged in Baghdad with a front-page picture frame-grabbed from ABC News.

The photocopier was the immediate ancestor of another popular image-capture device: the image scanner. There are three basic types: flatbed and drum scanners for prints and drawings, and slide scanners for transparencies. All work by sweeping a laser or light beam back and forth across a surface and recording variations in the intensity of reflected light. Generally they can produce images of higher resolution than still-video cameras or frame grabbers, so they are often used to capture existing photographs. Scanners eliminate the need to equip cameras with relatively expensive high-resolution CCD arrays, and they allow continued use of existing photographic equipment for initial image capture. (Still-video transfer stands can also be used—much like traditional copy stands—for capturing photographic prints and transparencies.) These devices allow appropriation at will from the inventory that began to accumulate in 1839.

The principle of sweeping a probe across a surface or through a volume underlies an extensive array of image-capture devices that employ a range of physical principles. Sonographic scanners, for example, use ultrasound, and thermographic scanners detect variations in infrared radiation. CAT (computerized axial tomography) scanners move in a circle around the body to produce a three-dimensional digital model rather than a two-dimensional perspective projection. MRI (magnetic resonance imaging) scanners create a three-dimensional digital model by placing the body in a strong magnetic field and detecting variations in frequency of atomic vibration. The Landsat multispectral scanning system uses a rotating mirror to reflect radiation from a patch of the earth's surface into a detector and builds up images in patch-by-patch fashion.[7] The Magellan spacecraft was positioned to orbit Venus and systematically radar scan most of that planet's surface over a period of months in 1991, and the topographic information that resulted from the scan was then processed to construct photograph-like digital images (figure 4.4).[8] (Most casual newspaper readers probably thought these images really were photographs.) Similarly, to produce images of Mercury's surface, Caltech astronomers beamed a radar signal from the Goldstone antenna in the Mojave Desert; received the reflected signal using twenty-seven radio telescopes near Socorro, New Mexico; and reconstructed by computer photograph-like images from the resultant data.[9] At the microscopic scale, scanning tunneling microscopes use a single atom as a probe tip for recording peaks and troughs of current as it moves over the surface of an atomic landscape—much like a finger sensing Braille dots (see figure 4.1).

Although Landsat images, MRI scans, Magellan radar scans, scanning tunneling microscope images, and the like look as if they were made with a camera, the process is entirely nonphotographic and the "exposures" are usually far from instantaneous. In fact, these sorts of pictures result from the application of scientific method in an idealized form: observations are used to construct a digital model, which is then employed in conjunction with formalized theory to produce predictions of what *would* be seen under certain viewing conditions. Reconstructed computer animations of plane crashes, produced from accurate geometric

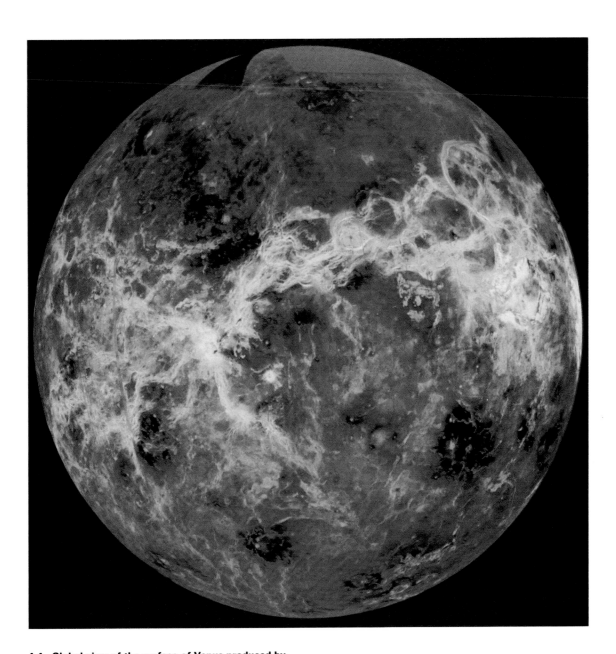

4.4 Global view of the surface of Venus produced by
mapping Magellan synthetic aperture radar mosaics
onto a sphere. Simulated hues are derived from color
images recorded by the Soviet Venera 13 and 14 space-
craft. Courtesy NASA and the Jet Propulsion
Laboratory.

models of aircraft and actual flight recorder data, extend the idea one step further. In these cases, the traditional distinction between image capture and image construction begins to break down, and perplexing questions arise. Is what we see "real" or is it a "simulation"? Where do we draw the line? Scientists do not seem very sure: when the first scanning tunneling microscope images were published by Binnig and Rohrer, they were dismissed by some (before the results were replicated) as mere computer simulations.[10]

This shift from two-dimensional image capture to three-dimensional model capture has implications for everyday life as well. For example, news and sports photographers might capture models instead of images of people, scenes, and events. The director of MIT's Media Laboratory, Nicholas Negroponte, has vividly formulated some of the consequences of this:

In the long run, model-based image transmission and encoding are better than transmission of pictures alone. Mathematical models of a scene can describe the spatial relations of the objects in it and maneuver them through space. The idea of capturing a picture with a camera is obsolete if one can instead capture a realistic model from which the receiver can generate any picture. For instance, from a realtime model of a baseball game, a fan watching at home could get the view from anywhere in the ballpark—including the perspective of the baseball.[11]

Is this hypothetical fan watching the baseball game, or is she watching a computer simulation of it—a sophisticated videogame? What if she can choose to see the game illuminated in a different way—under the lights at night, per-haps, instead of in the daytime? What if she can not only choose any viewpoint, but also move model objects out of the way to get a better view? What if she can intervene to change the positions of fielders, then run instant replays under different initial conditions? Does the computer-recreated picture tell us what "really" happened on a play? Could you look it up?

Information Content

The pixel values that constitute a digital image can be conceived of in two complementary ways: in relation to the display or print that an artist produces and in relation to the scene depicted by that display or print.[12] In relation to the display or print, a pixel value specifies a small, colored cell on the picture surface—a discrete signifying mark: the density of pixels on the picture surface determines capacity to reproduce fine detail. In relation to the recorded scene, a pixel value is a sample in time and space of light intensities projected onto the picture plane—a discrete datum: the spatial frequency and intensity resolution of samples taken from a scene determine the fidelity of the digital record. If the sampling grid is too coarse, or if intensity differences are not discriminated precisely enough, fine detail will be irretrievably lost. (Similarly, production of a digital sound recording involves sampling sound intensities at some specified temporal frequency and amplitude resolution.)

There are trade-offs to be made: high-resolution images require more storage and more processing effort than low-resolution ones. This applies to both machine-processed and hand-made images. Georges Seurat, for example, first produced quick sketches for his pointillist

paintings at coarse spatial resolution, then worked more painstakingly, at finer resolution, to construct the finished pictures.

How many pixels, and how many intensity values, are necessary to communicate a monochrome image satisfactorily? Clearly this depends to a large extent on the complexity of the image, but figure 4.5 begins to suggest orders of magnitude. A portrait was scanned at high spatial and tonal resolution, then processed to reduce both kinds of resolution. (This was a reenactment of a famous perception experiment, conducted with a photograph of Abraham Lincoln, by Leon Harmon.[13]) The highest-resolution version is at the top left of the image array. Spatial resolution halves at each row, and tonal resolution halves at each column, so that the image with the least amount of information is at the bottom right. Increased tonal resolution can compensate for poor spatial resolution and vice-versa. Even very low-resolution versions are recognizable, but higher-resolution versions tell us more, so there is usually motivation to encode images at the highest resolution possible subject to constraints on storage, transmission, and processing capacity.[14] Incidentally, reduction of resolution to the point of incomprehensibility does have its practical uses: television censors sometimes selectively reduce spatial resolution to blot out part of a picture with a pattern of very coarse pixels.

Squint your eyes at these images. You will find that the hard edges of individual pixels disappear and that the images of low spatial resolution suddenly look much more lifelike. Surprisingly, there is actually a person lurking behind the pixels. (Technically, squinting amounts to application of a low-pass filter to remove distracting fine detail and leave the broad distribution of tones intact. Painters

have long known this trick.) The same thing happens when low-resolution images are printed at a scale sufficiently small to reduce the size of an individual pixel below what can be clearly resolved by the human eye. A basic rule of thumb is that the eye's resolving power is roughly 1/60 of a degree, so that at a viewing distance of about one foot we can resolve about 600 points per inch. This means that an eight-by-ten print needs to consist of 4,800 x 6,000 = 28,800,000 pixels in order to appear completely smooth.[15]

Often it is possible to produce a recognizable image with just two intensity values—white and black—represented by one bit per pixel. If we want more subtlety we can use two bits per pixel to yield a range of white, light gray, dark gray, and black. Normally we need about 256 gray levels to represent smooth tonal gradients satisfactorily, and this degree of tonal differentiation can be specified with eight bits (one byte) of information per pixel—the same amount that is needed to store a character in a text file. (From this fact you can compute exactly how many thousands of words a given picture really is worth.) Thus the quantity of information in an uncompressed image file that stores a black-and-white image indistinguishable from a good eight-by-ten-inch print is 28,800,000 x 1 bytes—that is, 28.8 megabytes.

Notice how pixels work as signifiers. A single pixel, taken in isolation, depicts nothing in particular—merely "light thing" or "dark thing." But when a pixel is seen in context with other pixels, which narrow the range of likely interpretations, then its significance becomes more precise: it might depict the gleam of an eye or the twinkling of a star in the heavens. Where there are many pixels, they all create detailed contexts for each other, so that

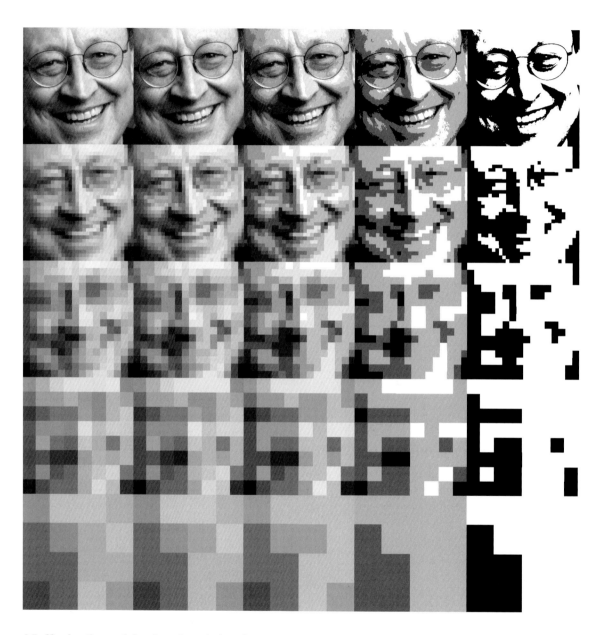

4.5 Varying the spatial and tonal resolution of an image.

each one is read as a depiction of something quite specific. If a pixel, taken in context, has a value that cannot be interpreted in this way, then it is usually seen as visual "noise" and ignored.

Usually we try to produce images that are of sufficient resolution to render the individual pixels imperceptible, but seeing pixels is not *necessarily* a bad thing. Prominent pixels call attention to the process by which a digital image is actually put together, in the same way that photographic grain or painters' brush strokes can, and this may be an important part of an image's point: the visible pixels create tensions between actual surface and illusory pictorial space, and between marking process and the object of depiction. Most of the images in this book suppress the pixels, but some result from interest in inherently low-resolution processes or illustrate technical points about image construction or emphasize surface, and in these cases the pixels unashamedly show.

Storage and Compression

Once captured, photographs and digital images exist in very different forms: photographers archive negatives or color slides—fragile rectangles of emulsion-coated plastic—in sleeves and file drawers, but digital imagers archive image files on magnetic or optical media. These files occupy a surprising amount of memory space. A typical color image might be about one thousand by one thousand pixels, with three bytes of information used to specify the color of each pixel, to yield a three-megabyte file for the complete picture. Even worse, memory requirements grow as the square of the linear resolution: a two thousand by two thousand image needs twelve megabytes. It is not unusual for a high-resolution, full-page color image in an

electronic prepress system to occupy twenty or thirty megabytes. By comparison, the text file for this entire book amounts to about half a megabyte.

This has some important practical consequences. You can store only a few images on the hard disk of a typical personal computer, and storage of high-resolution color images strains the capacity of even CD-ROM. Memory and operating-system constraints may limit the size of image files that particular computer systems can handle. Transmission of image files through modems or via computer networks, which often have severe bandwidth limitations, can become very slow. It is, however, possible to use techniques of data compression to reduce image files for storage and transmission. Some compression (usually up to about 1/2 of uncompressed size) can typically be achieved with *no* loss of image quality, substantially more compression (to between 1/10 and 1/50 of uncompressed size) can usually be achieved without *perceptible* loss of image quality, and very great compression (sometimes to 1/1000) can be accomplished when some perceptible loss of quality is acceptable. Procedures for compressing and decompressing images (particularly those that achieve high compression ratios) can be computationally demanding, so compression and decompression times can become an important practical consideration. (Analogous techniques are used for compression of digital audio data, and similar trade-offs of compression ratio versus compression and decompression time and sound quality must be considered.)

Data compression is a very active research area that involves some recondite mathematical techniques.[16] By the early 1990s, however, some important standards for digital image compression had been drafted and were gain-

ing wide acceptance. The CCITT (International Telegraph and Telephone Consultative Committee) standard for bilevel images transmitted by today's commonplace Group 3 fax machines is one of these, and its acceptance was largely responsible for the rapid growth in popularity of fax machines during the 1980s.[17] Even more significant is the JPEG (Joint Photographic Experts Group) standard for continuous-toned gray-scale and color images.[18] And the MPEG (Motion Picture Experts Group) standard specifically addresses efficient compression of motion pictures.

Traditional photography, by contrast, deals with image compression simply by reducing images onto smaller negatives—at the cost of some loss of image quality. Thus the large-format plate camera eventually gave way to the 35-mm camera in all but a few specialized applications, and microfilm carries the idea a step further in contexts where storage economy is particularly critical. Similar economies are achieved through use of 16-mm movie film in place of 35-mm, and half-inch videotape in place of three-quarter. These format reductions spread analog information over smaller areas to conserve physical storage space and achieve ease of physical transportation, whereas digital compression maps information onto fewer symbols to conserve computer memory space and make electronic data transmission easier.

Color and Color Separations

In encoding color images as integer arrays for video display, it is assumed that the color of each pixel results from additive mixture of the primaries red, green, and blue.[19] In general, to specify full-color images without losing any subtle nuances of hue, saturation, or lightness, eight bits of information per primary per pixel

are needed—a total of twenty-four bits per pixel. This provides a palette of approximately seventeen million distinct colors. (However, no image can have more different colors than it has pixels, and few images have as many as seventeen million pixels, so any *particular* digital image can usually be specified with a far smaller palette. This fact is sometimes exploited to achieve storage efficiency.)

Color CRT displays work by additive color mixture. Each colored point on the screen actually consists of a small red spot, a small green spot, and a small blue spot. The intensities of these spots are controlled by the information stored in the image file, and the eye integrates the resulting combination. If you separate out the "layers," as in figure 4.6, you can see the contributions of the three primaries to the overall color effect. Image-processing software normally provides for specification of colors in terms of red, green, and blue (RGB) values. In other words, each color has unique coordinates in the RGB color cube (figure 4.7).

Graphic artists, however, often find it more intuitive and convenient to specify colors in terms of hue, lightness, and saturation (HLS) values. This color system is illustrated in figure 4.8. Hue is specified by a number between 0 and 360 to indicate location on the color wheel, and lightness and saturation are specified by percentages. The hue, saturation, and lightness distributions for a color image can be expressed separately by gray-scale images, as shown (figure 4.9). The option of specifying colors in HLS, then automatically converting to RGB for internal storage (a simple operation), is commonly provided by image-processing software.

Printed images do not emit light but are seen in reflected light, so they are produced by cyan/magenta/yellow (CMY) color subtraction

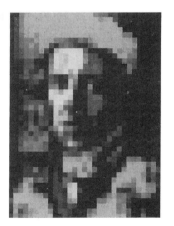

4.6 RGB and CMY color channels.

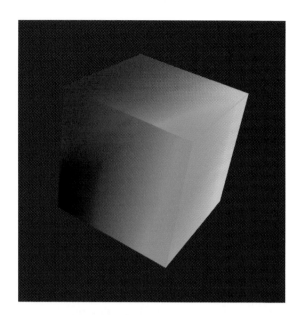

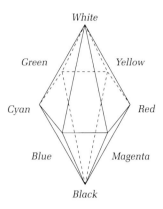

4.8 The HLS hexacone.

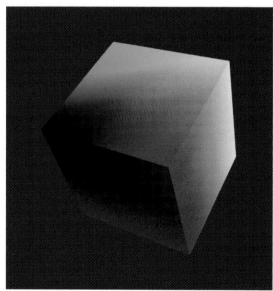

4.7 The RGB cube.

(refer back to figure 4.6) rather than by red/ green/blue color addition. (Note that cyan is the complement of red, magenta is the complement of green, and yellow is the complement of blue. For a given image, CMY layers are the "negatives" of their RGB complements.) Colored spots on the page are built up from smaller cyan, magenta, and yellow dots. In order to achieve dense tones and solid blacks in a four-color printing process, black dots are used as well: this is the CMYK color system. Separation of colored images into cyan, magenta, yellow, and black layers for printing has traditionally been accomplished by photographic means. Many image-processing systems now provide facilities for digital color separation. They transform a twenty-four-bit image into four eight-bit images specifying the cyan, magenta, yellow, and black levels for each pixel. Production of the separation layers is a very straightforward computational operation. It is, however, often difficult to judge the appearance of a finished print from a screen display. For good results, display and printing devices must be precisely calibrated, color distortions due to differences in color gamuts must be anticipated, and the process must be carefully controlled.[20]

4.9 Gray-scale expression of hue, lightness, and saturation.

Digital Halftoning

Photographs and appropriately constructed video displays produce true continuous-tone images, but most practical printing techniques (especially those used for text) are binary in nature. This means that continuous-tone pictures must normally be converted, for printing, into pictures composed of fine dot patterns that vary in size or frequency to create the effect of intermediate gray tones. The process is known as *halftoning*.

The first halftoning process was developed around 1850—hard on the heels of the invention of photography.[21] Images were photographed through a loosely woven fabric screen to convert them into arrays of varying black dots. In 1873 the New York *Daily Graphic* began to publish halftone photographs. F. E. Ives of Philadelphia perfected the technology in the 1880s, and by the 1890s ruled glass plates were being used in place of fabric screens. In the 1940s the contact screen, still used today, was introduced.

One way to prepare a digital image for printing is to record it photographically from a cathode ray tube (either by standing a camera in front of a workstation or by using a film recorder designed for the purpose), then use traditional halftoning methods. This is commonly done, but it is cumbersome and often produces disappointing results. The photographic steps can degrade original image crispness, and interaction of the pixel grid with the screen grid can generate distracting *moiré* patterns. In the case of color images it is difficult to preserve correct color balance through all the steps.

An attractive alternative, then, is to use a digital halftoning (also referred to as *dithering*) method. There are numerous algorithms for converting digital images into dot patterns

with desired visual characteristics (figure 4.10), and software that implements them is now widely available for inexpensive personal computers.[22] Many of the illustrations in this book were, in fact, both color separated and halftoned, directly from the image files output by image-processing software, on a personal computer.

A basic technical and aesthetic distinction can be drawn between clustered-dot and dispersed-dot digital-halftoning methods. Clustered-dot methods closely resemble traditional halftoning. Essentially, they replace pixels with dots of varying sizes. These dots are, in fact, made up out of clusters of smaller dots. Where resolution is low, the regularly arrayed larger dots become conspicuous—as in low-resolution newspaper halftones. Dispersed-dot methods replace pixels with dot patterns of varying density. These are usually preferred to clustered-dot methods, since they give better rendition of fine detail and constant gray regions that appear more uniform.

An additional distinction can be drawn between *ordered* and *random* dithering methods. Ordered dithering methods (both clustered-dot and dispersed-dot) tend to produce areas of perceptibly regular dot patterning and jagged renderings of smooth curves, but random dithering techniques produce irregular, mezzotint-like patterns and less jaggedness.[23] They yield a more attractive picture surface and are particularly appropriate where use of a low-resolution printer makes the halftone dots conspicuous. (Watercolorists are familiar with a similar distinction between the too-regular texture produced by washes on machine-made paper and the satisfyingly irregular texture produced when good handmade paper is used.)

You don't get something for nothing. Dithering is a strategy of sacrificing spatial resolution

(a)

(b)

4.10 Digital halftoning.

 a. Ordered dither.

 b. Random dither.

in order to gain tonal resolution. A two-by-two ordered dither pattern gives four possible gray levels, a four-by-four pattern halves the spatial resolution but gives sixteen possible gray levels, and so on. Thus dithered images printed at high spatial resolution may have a constricted tonal range, and so appear flat and muddy, while dithered images printed at low spatial resolution may have more sparkle and contrast but suffer loss of fine detail. (In the early days of desktop publishing, the combination of scanners with restricted tonal range and use of dithering on relatively low-resolution printers often resulted in disappointing reproduction of photographs.)

You do not *have* to employ standard printer dot patterns to render intensity variation. If you have the appropriate technology at your disposal, any intensity-varying set of symbols will do (figure 4.11). In the very early days of computer graphics, Leon Harmon and Kenneth Knowlton at Bell Labs produced some beautiful pictures by using printed alphabetic characters and even dominoes glued to a sheet of board. (This provocatively blurs the distinction between digital images and emblematic or figured text, such as the mouse's "long sad tale" in *Alice's Adventures in Wonderland*.[24]) Chuck Close has translated photographs into large-scale portrait paintings composed of such diverse elements as noughts and crosses, fingerprints, and small disks of colored paper. Before computer-graphics output devices were widely available, gray-scale maps and other pictures were commonly produced on line printers by overprinting characters to create appropriately varying dots.

It is even possible to make an image out of smaller versions of itself, so that a kind of visual analepsis results (figure 4.12). This vividly

illustrates that the question of a pixel's reference and significance can be more problematic than it might at first seem. Each pixel here has a double role—as an element of a smaller picture and as an element of a larger picture—and in each of these roles it refers to a different point in the original scene. And what is to prevent us from seeing each pixel in a third role, as a low-resolution image of the entire scene?[25]

The relationship between an image's microstructure and macrostructure is not a new issue, of course: it has always been an important one for graphic artists to consider. In his splendid history of printmaking William M. Ivins, Jr., examined the microstructures of various print media, explored related conventions for depicting tone, curvature, texture, and so on by means of line and dot patterns, and discussed the ways in which these have rebounded to structure our ways of seeing the world. The techniques of digital halftoning open another chapter in that long story. But there is also a significant new twist. Ivins suggested—and many would agree—that "objects can be seen as works of art only in so far as they have visible surfaces. . . . The magic of the work of art resides in the way its surface has been handled."[26] The textures of images are so important because they tell of their making: that of a handmade image speaks to us of human judgments and choices guided by and revealing the artist's intentions, while that of a digitally halftoned image is created by an algorithm that applies predefined rules to make choices automatically. The richly textured surfaces of digitally halftoned images may sometimes remind us of etchings and engravings, but the decision-making processes that generate them are of a very different kind.

4.11 A portrait constructed from square elements of unequal size.

4.12 An image made from smaller versions of itself.

Printing and Display Devices

In one of its aspects, photography can be seen as an extrapolation of the ancient tradition of printmaking: production of a photograph requires development of the latent image and printing of the negative. As all serious photographers know, these are interpretive steps: the chemical and optical processes can be manipulated to give a wide range of characters to the final permanent image. Edward Weston produced a canonical formulation of this point, too:

By varying the length of exposure, the kind of emulsion, the method of developing, the photographer can vary the registering of relative values in the negative. And the relative values as registered in the negative can be further modified by allowing more or less light to affect certain parts of the image in printing. Thus, within the limits of his medium, without resorting to any method of control that is not photographic (i.e. of an optical or chemical nature), the photographer can depart from literal recording to whatever extent he chooses.[27]

Similarly, an array of integers stored on disk or held in computer memory is a latent image that can be made visible by display on a screen or printing on paper, and display and printing processes can be controlled to yield a rich variety of results.

The basic principle underlying all display and printing techniques for digital images is nicely illustrated by the story of how the first Mariner IV images of Mars were produced. The spacecraft transmitted back arrays of integers, which were stored on magnetic tape. These numbers were then printed out, and scientists at the Jet Propulsion Laboratory colored over them, according to a specified color-coding scheme, with crayons. They would perhaps have been surprised to know that they were employing a technique developed by Paul Klee (figure 4.13).[28] Today we use computer-controlled display and printing devices to perform this interpretation task automatically and usually at very high speed.

In this respect, digital imaging can also be seen as an extension of the craft of transferring impressions to paper. The array of intensity values can be thought of as the equivalent of the engraver's plate or the photographer's negative, and computer-controlled printing devices stand in place of the press or enlarger. But the range of techniques available to the digital imager is very much wider than that available to the engraver or the photographer. Inexpensive black-and-white prints can be made on impact dot-matrix printers or medium-resolution laser printers. High-resolution laser printers can be used to achieve finer spatial and tonal resolution. Color prints can be produced by means of inkjet, thermal transfer, electrostatic, laser, and dye-sublimation processes. Film recorders can be employed to output photographic slides and negatives.

Many digital images, however, are *never* printed but appear only as transient screen displays. In other words they are replayed from digital data—using a personal computer or a specialized player such as Kodak's Photo CD—exactly as musical performances on digital compact disc are replayed. When used in this way, digital image files are more closely analogous to recordings than to negatives or printing plates. They represent the latest stage in the long evolutionary development of images as objects into images as performances—a transition away from images realized as durable, individually valuable, physically rooted artifacts

4.13 **Interpretation of the raster grid: sketches from
Paul Klee's _Notebooks_. Courtesy Paul Klee-Stiftung,
Kunstmuseum, Berne, Switzerland.**

(frescoes, mosaics, and murals), through porta-
ble easel paintings and inexpensive prints, to
completely ephemeral film projections and
video displays.

But the now-familiar display screen is still a
flat picture plane, still a tiny, glowing window
through which we can take a Cyclopean peek
at another world. In the late 1960s the com-
puter-graphics pioneer Ivan E. Sutherland real-
ized that electronic displays do not *have* to
take the etymological implication of "perspec-
tive"—viewing as "seeing through"—quite so
literally: they can dispense with the bounding
frame, break open the plane, and allow redirec-
tion of the gaze. Sutherland designed a com-
pletely new kind of display, which he
described as follows:

The fundamental idea behind the three-dimensional
display is to present the user with a perspective
image which changes as he moves. The retinal image
of the real objects which we see is, after all, two-
dimensional. Thus if we can place suitable two-
dimensional images on the observer's retinas,
we can create the illusion that he is seeing a three-
dimensional object. Although stereo presentation
is important to the three-dimensional illusion, it is
less important than the change that takes place in
the image when the observer moves his head. The
image presented by the three-dimensional display
must change in exactly the way that the image of the
real object would change for similar motions of the
user's head.[29]

Sutherland's prototype used mechanical
linkages to sense the viewer's location and di-
rection of gaze, head-mounted, miniature cath-
ode ray tube displays to place images on the
viewer's retinas, and a powerful (for the time)

computer to synthesize stereo pairs of perspective images at a sufficiently rapid rate to respond to the viewer's movements without perceptible lag. It was crude and cumbersome, but it opened up the possibility of breaking through the picture plane into a three-dimensional "virtual reality." Subsequent research has explored ultrasound and other nonmechanical position-sensing techniques and has sought to miniaturize head-mounted displays still further; by the 1990s the possibility of laser microscanners that painted images directly on the retina was receiving serious attention.[30] Vast increases in available computing power have brought the simulation of complex, detailed three-dimensional worlds within reach. The embryonic technology of virtual reality promises architects the possibility of walking through geometrically modeled proposed buildings, astronomers the possibility of flying through radar-scanned planetary landscapes, and surgeons the possibility of seeing "through the skin" by superimposing on patients' bodies three-dimensional displays generated from ultrasound or MRI scanner data.

Oliver Wendell Holmes called the Daguerreotype "a mirror with a memory"[31]: you can think of a digital-imaging or computer-graphics system as a memory with a display. By selecting from among available display and printing processes and by controlling their parameters, you can externally reflect the contents of an internally stored array of intensity values in a multitude of differently rendered and variously inflected ways. There is, then, a fundamental change in our relationship to images. You are not limited just to *looking* at digital images: you can actively *inhabit* and closely *interact* with them. By 1992 Hollywood had got the idea and translated it into the terms it knows best: the film *The Lawnmower Man* showed

the digital-image dopplegängers of its hero and heroine having simulated sex in cyberspace.

Transmission and Distribution

In the preindustrial era images were laboriously handmade, and their dissemination was limited, since they could be replicated or transported only with considerable difficulty. Then, in the industrial age, the combination of photography, the high-speed press, and rapid mechanical transport allowed the endless reproduction and distribution of images—the condition of both Walter Benjamin's "work of art in the age of mechanical reproduction" and André Malraux's "museum without walls."[32] Now, in the electronic era, an alliance of the computer, magnetic and optical storage media, and telecommunications networks is again fundamentally altering patterns of image production and consumption. Image exchange has become far less constrained by space, time, and materiality than it ever was in the past.

A traditional difficulty of photojournalism, for example, is that it is often necessary to shoot an image at a remote location, somehow develop the film, and finally get the image to the newsroom in time to meet a tight deadline. But a digital or still-video image does not have to be developed, and it can immediately be transmitted via the telephone network to a display on an editor's desk located anywhere in the world.[33] In an era of portable computers and cellular modems it is not even necessary to have a power or telephone connection to send and receive images.[34] Photojournalist and editor are now in much the same relationship as an imaging spacecraft and a NASA scientist.

Methods of image publication and sale are also changing rapidly. Associated Press, for

example, introduced analog transmission of wire-service photographs in 1935. It launched a digital news photo service in the late 1980s and by 1990 was beginning to replace first-generation digital receiving devices with Leaf Picture Desks—sophisticated computer-graphics workstations capable of receiving and archiving photographs and of performing a variety of prepress functions. Other wire services—Agence-France Presse, UPI, and Reuters—introduced their own systems. And in December 1990 the Comstock stock photography agency began providing access via modem to its huge photo library: users download images to personal computers for manipulation with image-processing and layout programs.[35] As a result, traditional work patterns in newspaper and magazine offices began to change: "No longer can the janitor drop the pictures on the sports desk," remarked one press photographer.[36]

Where ease of update and speed of distribution are less essential, videodisc and CD are increasingly popular image-publication media. (The analog format of videodisc was more practical and popular at first, but it is being supplanted by CD as the digital technology improves.) Archives of tens of thousands of agency photographs are now distributed in these formats,[37] ABC News has begun to publish parts of its vast video archive on interactive videodisc, portraits from the National Portrait Collection are available on CD, thousands of architectural images from Columbia University's Avery Library have been made available on videodisc, and undergraduate access to MIT's Rotch Visual Collection has been made possible through a combination of optical laser disc storage, a computer network, and interactive videographic workstations.[38] In 1992 the National Gallery of Art in Washington released a videodisc containing about ten thousand images of works of art from its collection.[39] And NASA distributed the data from its Magellan radar scans of Venus on a set of more than sixty optical disks.[40]

An industry concerned with repurposing photographic, film, and video archives by making them available for electronic processing is rapidly growing. William Gates of Microsoft Corporation has brought the potential of this industry dramatically to the attention of museum directors and photographers by beginning to purchase the electronic distribution rights to well-known paintings and photographs.[41] It seems increasingly clear that the days of traditional, expensively color-printed art books and catalogues are numbered. We are entering the era of the electronic virtual museum.

As video and television make the inevitable transition from analog to digital format (a development that is largely a consequence of advances in compression technology), the digital image will become even more pervasive.[42] The first applications of digital video were in video conferencing, videophone,[43] and video mail systems, and in computer-based interactive multimedia systems. More significantly, debates about future HDTV (high-definition television) technologies and standards, which gathered urgency and momentum in the early 1990s, have increasingly tilted in the direction of digital formats. Initially, it was expected that HDTV in the United States would use an analog format, and Japan began to transmit analog HDTV programming in 1991. But in June 1990 the Videocipher division of General Instrument announced that it was proposing an all-digital system for adoption as the American HDTV standard, and by December 1991 a working prototype of the Videocipher system had been demonstrated.[44] Meanwhile, all the other

groups competing to establish the HDTV standard switched from analog to digital systems.

To produce a high-quality image on a small television screen, far less information is required than that provided by a digital HDTV signal. Conversely, a low-resolution image that is adequate for a small display will break up into prominent pixels if it is displayed on a large screen. The concept of scalable digital video has been developed to resolve this dilemma. Scalable digital video displays incorporate decoders (either hardware or software) to convert appropriate amounts of information from the incoming signal into images. As more bits get decoded, either the image gets larger, or else it remains the same size but gets displayed at higher resolution. In other words, control over image size and resolution, and consequent complexity and cost of the display device, is shifted from the video originator to the recipient.

Alan C. Kay—one of the significant pioneers of the personal computer—has made a startling prediction about where these developments in digital data transmission and distribution technology will lead us. "In the near future," he suggests, "all the representations that human beings have invented will be instantly accessible anywhere in the world on intimate, notebook-size computers."[45]

Image Collections

Ever since the Renaissance, image collections have been growing larger. Before the fifteenth-century invention of printing, images were few and scarce indeed, and they typically served ritual or aesthetic purposes. The scientific gaze that was turned on the world after Bacon and Descartes generated a demand for images that objectively inventoried what was really out

there, so scientific and technical illustrations were produced in increasing quantities.[46] There was an even more rapid acceleration of image production in the nineteenth century, especially after the development of high-speed presses and photographic halftone printing processes: William Ivins has guessed that "the number of printed pictures produced between 1800 and 1901 was probably considerably greater than the total number of printed pictures that had been produced before 1801."[47] This allowed the formation of modestly-sized image archives—illustrated encyclopedias and magazines such as *The National Geographic,* stock photo archives, police archives of mug shots and fingerprints (the FBI's collection of these has now grown to twenty-five million), the X-ray collections of hospitals, the slide collections of university art history departments, and so on—that serve mostly to inform rather than in ritual or aesthetic roles. As a result, people's knowledge of the world came to derive increasingly from pictures, institutions began to wield and consolidate their power through the collection and dissemination of images, and the control of image collections became politically important.[48]

To retrieve a slide or negative from an archive we must go to a perhaps distant or inconvenient location and laboriously search through cabinets, drawers, folders, and the like. But digital images are accessed electronically from personal computers or workstations, and searches of image databases can be conducted automatically, rapidly, and at home or the office. Images are never checked out, needed negatives or slides are never missing from the file, and many users can access and download the same image for simultaneous personal use. Preservation is also easier because digital storage media are not nearly so

subject to physical decay as photographic materials: digital images do not undergo inexorable gradual degradation as color slides do, and multiple exact copies can readily be made.

Since electronic image archives are bound by fewer physical and economic constraints than traditional ones, organizations that require rapid, distributed access to large image collections are turning to centralized image databases that can be accessed via computer networks. In the late 1980s, for example, the University of California at Berkeley embarked on an ambitious program to explore the development, network distribution, and use of large-scale image databases. Prototype image databases were developed for the Lowie Museum of Anthropology, the University Art Museum, the Architecture Slide Library, the Geography Map Library, and the University Herbarium. In a very different context, the Metropolitan Toronto Police Force uses a system called RICI Mug—Repository for Integrated Computer Imaging and Identification of Mug Shots.[49] This is an indexed database of over a hundred thousand scanned mug shots. It is used to create video lineups by executing database searches for images that match descriptions of suspects.

These computerized image databases can easily become orders of magnitude larger than traditional slide libraries and photo archives. Consequently, we face new problems of sheer magnitude—of finding efficient ways to browse and navigate through these vast visual collections, of sifting out what we want from the effectively infinite number of images deluging us through electronic channels, and, most importantly, of dealing with the social, political, and cultural implications of image accumulation at an unprecedented scale. Social practices organized around image collections will change, and the roles of archivists, librarians, preserva-

tionists, and library users will be redefined. Even the family photo album will be replaced by a collection of image CDs. Who will compile and control these collections? Who will have access to them?

Indexing, Access, and Contextualization

The contexts in which images are presented, and the ways in which access to them is provided and controlled, have also been transformed over time. Painting broke free from a fixed relationship to the unfolding of architectural space when it separated from the wall and moved onto the portable canvas: this allowed the formation of private and public painting collections and the emergence of modern exhibition and curatorial practices.[50] The nineteenth-century invention of the halftone block enabled free combination of text and photographic images in the pages of widely disseminated newspapers, magazines, and illustrated books, and created roles for photo editors and art directors. Computer systems for laying out pages and stripping in photographs have now revolutionized newspaper and magazine production, and provide the capacity to put together words and images with even greater facility.[51] The twentieth-century innovations of the talkies, later television, and now digital multimedia systems have made it possible to combine images and sound on parallel, synchronized tracks—and have engendered associated practices of editing and montage.

Roland Barthes has pointed out the importance of this embedding of images in particular contexts and of the curatorial, directorial, and editorial practices that control it: a newspaper

photograph, he notes, is inextricably enmeshed in "a complex of concurrent messages of which the photograph is the center but whose environs are constituted by the text, the caption, the headline, the layout, and, more abstractly but no less 'informatively', the name of the paper itself."[52] Not only does this contextualization help to fix meanings that would otherwise be far less determinate, but it also provides indices of veracity. For example, we expect a photograph illustrating a headline on the front page of a respected newspaper to present the unvarnished truth (and we hold the editor responsible), but we would hardly be surprised to find that the image of a model on the cover of a fashion magazine had been retouched.[53]

Similarly, the meaning of an image in a slide presentation or a shot in a film or video sequence is fixed by its juxtaposition with other images or shots and its relationship to the soundtrack: this observation grounds the theory of montage and guides film editing practice. We expect the editing of theatrical film to construct fictions from photographed (if perhaps staged) realities, but we expect the editing of television news footage to show us what really happened. Sometimes such footage is contextualized in alternative ways to construct rival versions of the news. During the Gulf War, for example, American television viewers were repeatedly shown footage of moving lights and flashes in the night sky, together with commentary claiming that these sequences showed American Patriot missiles shooting down Iraqi Scuds. Later, MIT physicist Theodore Postol presented exactly the same sequences, with alternative commentary, to make a case that the Patriots had mostly *missed* the Scuds. A spokesman for Raytheon (manufacturer of the Patriots) then rather predictably responded with the accusation that

one of Postol's most telling sequences had been cut and respliced to create a misleading impression.[54]

When digital images or fragments of digital video are recorded on disk or tape (rather than reproduced in print), they may be organized into fixed replay sequences—perhaps in combination with text and sound bites—and thus rather directly assimilated to the tradition of older time-based media such as audio recording, film, and video.[55] Many of the first digital multimedia productions (appearing in the late 1980s and early 1990s) were conceived as "digital movies" to be played on personal computers, and this approach was supported by popular multimedia authoring systems such as Macromind's Director. Then in 1992 release of Apple's QuickTime operating system software stimulated the development of mass-market software for capturing, storing, sequencing, and replaying digital images and movies.[56]

But a more radical possibility emerges when digital images are indexed with appropriate content descriptors and stored on fast random-access media such as magnetic or optical disk: they can then be retrieved very rapidly by content. Thus the sequencing and contextualization of images is no longer fixed, but can vary freely from viewer to viewer. By the late 1980s this mode of storage and retrieval was making possible publications like the Apple Multimedia Lab's pioneering Visual Almanac—an encyclopedic collection of still images and video clips together with software for retrieval by content and rapid, ad hoc assembly of new sequences. In effect, a user of the Visual Almanac takes over many of the traditional functions of photo researchers and editors, and opportunities to construct meaning by selection and juxtaposition are correspondingly shifted.

Random access also makes possible the connection of images by networks of pointers, through which a viewer can navigate from image to image—a mode of image presentation that was popularized by the introduction of Apple's Hypercard system in 1987. These pointers might specify a linear sequence, like that of photographs in a printed book or shots in a movie, but they can also specify branching structures and loops so that the viewer can proceed along many different paths to find different patterns and connections.[57] Thus an image can simultaneously be embedded in many different contexts, and viewers may encounter it as an element of many different presentation sequences.

If Barthes is right in his contention that a captured image is a polysemic, free-floating signifier—something that has determinate meaning only when it is presented within the framework of a specific text (for example when it is deployed, with caption, in a newspaper article) and is thus open to appropriation by many texts—then the replacement of traditionally rigid and stable printed texts by fluid, ad hoc, recombinable electronic assemblies is particularly noteworthy. Where a news photograph might, in the past, have been published as part of a limited number of stories, its electronic counterpart may be appropriated endlessly into new information sequences. It is a condition that Marcel Duchamp surely would have relished: digital images are the ultimate readymades—manufactured objects of little intrinsic value that are given meaning through appropriation and contextualization rather than inherit meaning from the expressive craft with which they are fashioned.

As we look back on the fading photographic era, then, we can see that photography has bequeathed us a vast, unstructured, inchoate, collective visual memory. On occasion, this memory has been partially and rigidly systematized, as when an art history slide library is hierarchically organized in cabinets by fixed geographic, chronological, and stylistic categories that provide a system within which individual images can be assigned meaning of a particular kind.[58] But digital imaging combined with computer storage and retrieval expands and restructures that memory and allows it to function in new ways. It electronically accelerates the mechanisms of the visual record, enables the weaving of complex networks of interconnection between images to establish multiple and perhaps incommensurable layers of meaning, allows heterarchical association and access patterns to develop, and transforms the museum without walls into the even less spatialized virtual museum. Mnemosyne has become a digital matrix.

Vision Remade

The burgeoning ubiquity of pixel-traffic paraphernalia—of sophisticated, mass-produced devices for production, transformation, accumulation, retrieval, distribution, and consumption of arrays of intensity values—signals that digital imaging technology is being mobilized in the games of signification and implicated in the conterminous, intertwined relationships of power and division of labor that construct postindustrial subjectivity. The uses of digital imaging technology are becoming broadly institutionalized, and reciprocally, that technology is restructuring institutions, social practices, and the formation of belief. A worldwide network of digital imaging systems is swiftly, silently constituting itself as the decentered subject's reconfigured eye.

5.1 A photograph that has been scanned and then digi-
tally filtered to simplify the range and distribution of
colors.

DIGITAL BRUSH STROKES

■ **Filters**

Filters are devices for picking and choosing—
for retaining things that you want while getting
rid of things that you don't: coffee filters sepa-
rate the coffee from the grounds, gravel filters
let the small stones through and retain the
large ones, audio filters take out crackle and
hiss, Ray-Bans filter out sunlight, and rose-
tinted spectacles let you see the world in what-
ever way you like. We have seen how image-
capture devices filter the infinite amount of
information in a continuously varying scene
to produce digital images of finite spatial and
color resolution—a process that eliminates
very fine detail but retains summarized inten-
sity values. This principle of filtering a visual
field can be generalized: once a digital image
has been recorded, it can be filtered further to
bring out aspects of interest and to suppress
others (figure 5.1). Image-processing systems
typically provide extensive repertoires of digi-
tal filters for use in image enhancement, cor-
rection, and transformation. Choice of filtering
strategy is as crucial in digital imaging as se-
lection of the right combination of paper
(handmade or machine made, coarse grained or
fine grained), brushes (large or small, soft or
springy, pointed or flat), and palette of pig-
ments is to a watercolorist or decisions about
film stock, colored filters, focus, exposure, de-
velopment time, and printing paper are to a
photographer. Such choices control the granu-
larity, texture, sharpness or softness, detail,
edge and line qualities, tonality, contrast, and

color balance of the final image—its overall informativeness and graphic character.

Figures and Grounds

Digital filtering, like many more traditional graphic and photographic processes, may be applied either to entire images or to selected parts of images. In the chemical, optical, and cut-and-paste processes of photo retouching, burning and dodging, and photomontage, the areas that are to be manipulated must be picked out manually—by cutting along a contour, positioning a mask or frisket, brushing or drawing over an object, and so on. This may require considerable craft and care, and covert manipulations are often betrayed by the clumsiness with which these operations are performed. In digital image processing, however, figures of interest may be picked out automatically from their backgrounds. To see how this is done, we must briefly consider the nature of figure-ground distinctions.[1]

Notice, first of all, that there are few things that look more utterly chaotic than an array of randomly colored pixels (figure 5.2). The microstructure is one of shrieking chromatic discord, and from a distance we see only a dull mid-gray—the graphic equivalent of continuous white noise. No part of the picture plane demands our attention more than any other part. The only distinct graphic objects that you can pick out and describe are individual pixels and a few random clusters of similarly colored pixels. There is no way to select an area except by specifying an arbitrary rectangle, circle, or other closed shape.

By contrast, figure 5.3 shows a single object against a uniform background. (It was made by placing a sectioned shell on the platen of a

5.2 A random field of pixels.

5.3 A figural object that can be picked out by selection tools.

**5.4 Visual structure: figure, ground, and subfigures
of an image.**

flatbed scanner and scanning at 300 dpi.[2]) A well-defined contour—a sharp discontinuity of pixel colors—separates figure and ground. Pixel colors within the contour are distinctly different from those outside it. Thus we might pick out the figure of the shell either by tracing the contour (as in cutting it out with a knife) or by specifying a range of colors that distinguishes the pixels within the contour from those outside (figure 5.4). In similar fashion, we can pick out subfigures (the chambers of the shell) within the main figure.

Automatic-selection tools standardly provided by image-processing software can be used to pick out the shell or one of its chambers. These tools exploit the principle that figures of interest tend to have relatively distinct, closed contours and characteristic colors that distinguish them from their backgrounds. (Camouflage painting works precisely because it subverts this principle and makes objects such as aircraft difficult to pick out against their backgrounds.) The user specifies the range of pixel values that are of interest and an approximate closed contour, which then "shrinks" to fit the actual contour of the figure precisely—much as shrink-wrap packaging clings to the contours of an object. This allows quick and easy selection of a light shell out of a dark background, a dark bird out of a light sky, a red flower out of a green bush, and so on. These selected objects can then be digitally filtered, replicated, and geometrically transformed.

Tone-Scale Adjustment

The most obvious and most commonly used types of digital filters are ones that adjust the range and distribution of tones in a gray-scale image. They may be used to lighten an image or selected part of an image, to darken it, or to enhance or reduce its contrast. Thus they are the digital equivalents of dodging, burning, and printing on high-contrast or low-contrast paper—but they are considerably quicker, more convenient, and more flexible.

Folk wisdom holds that a photograph mirrors nature, that it is a *copie trompeuse* of a scene. But sophisticated commentators on photography have always insisted otherwise. The photography historian Heinrich Schwarz, for example, held that "photography does not give a lifelike reproduction, but an abstraction, a transformation."[3] (In other words, more technically, photography applies a particular, characteristic filtering strategy.) One fundamental determinant of this strategy is that the range of light intensities in a visual field will often be very much greater than the range of tones that can be captured and presented by a photograph.[4] Pigments, inks, and dyes can yield a ratio of tonal values, from darkest to lightest, of about forty to one, but the ratio from deep shadow to sparkling highlight in a sunlit scene can be thousands to one. Thus the photograph must compress the intensity range of the scene, with inevitable distortions and loss of detail.[5] Furthermore, photographic film increases in density as a logarithmic rather than linear function of the intensity of the incident light.[6] So beginning photographers swiftly learn that, when photographing a brightly sunlit scene, they cannot capture everything: they must either expose for the shadows and burn out detail in the lights, or expose for the lights and lose detail in dense shadows.

Early critics of photography were quick to notice these effects. John Ruskin, in particular, frequently deplored the loss of detail in the

lightest and darkest areas of photographs. Lady Elizabeth Eastlake similarly noted that photography's "strong shadows swallow up all timid lights within them, as her blazing lights obliterate all intrusive halftones across them; and thus strong contrasts are produced, which, so far from being true to Nature, it seems one of Nature's most beautiful provisions to prevent."[7] Modern photographic materials yield a wider tonal range, but the essential problem remains.

In the case of monochrome photographs, variations of hue and saturation in the scene, as well as variations in brightness, must be mapped onto the tonal range of the photograph. Whereas perspective projection maps from three spatial dimensions to two (with attendant loss of information and increased potential for ambiguity), this is a mapping from three color dimensions to one. Furthermore, since photographic film is not equally sensitive to all hues, this mapping is often noticeably nonlinear. Lady Eastlake pointed this out as well:

So impatient have been the blues and violets to perform their task upon the recipient plate, that the very substance of the color has been lost and dissolved in the solar presence; while so laggard have been the reds and yellows and all tints partaking of them, that they have hardly kindled into activity before the light has been withdrawn. Thus it is that the relation of one color to another is found changed and often reversed, the deepest blue being altered from a dark mass into a light one, and the most golden-yellow from a light body into a dark.[8]

She was speaking of early orthochromatic emulsions: panchromatic emulsions, which were introduced at the beginning of the twentieth century, produce less noticeable tonal distortion but still compress a scene's variations of hue, saturation, and brightness into variation over a limited tonal range.

Black-and-white photographers have always understood that the nature of this mapping from full color to a tonal range was an important variable, and they have controlled it through choice of emulsion and use of colored filters placed over the camera lens. Yellow filters are frequently used to subtly darken skies and bring out the detail of cloud forms, for example. Red filters more noticeably darken skies while lightening foliage, and thus have been favored by architectural photographers who want to dramatize building forms.

Another important issue (well known to painters) is the built-in filtering strategy of the human eye. In quantized images the difference in intensity between one level and the next is usually constant. But the eye filters in such a way that the perceived difference in intensities is related more to their ratio than to their difference: the perceived difference between intensity levels 1 and 2 is much greater than the perceived difference between levels 199 and 200. Thus, when some particular effect of smooth tonal transition, luminosity, or chiaroscuro is desired, it is often useful to redistribute intensity levels.

Sophisticated photographers have traditionally compensated for deficiencies in the tonal-rendition capabilities of photographic film and have manipulated tonal distributions and balances in photographs for aesthetic effect by manipulating the many physical variables of the photographic process. First, they can choose films with different response characteristics to produce negatives with narrower or

wider tonal ranges. Second, they can vary ex-
posure: longer exposures produce higher nega-
tive densities, which in turn yield lighter
prints. Third, they can vary development: in-
creased development expands the tonal range
of a negative, while decreased development
compacts it. Fourth, they can choose different
paper grades and vary exposure and develop-
ment of prints from a given negative. Finally,
they can resort to selective burning and dodg-
ing in printing. One step in the process can
often be used to compensate for deficiencies of
tonal rendition introduced at another, and the
variables are systematically related in the Zone
System that was popularized by Ansel Adams
and Minor White.[9] Interestingly, these tone-
scale adjustments have never been considered
deceptive unless carried to egregious excess.

The digital equivalents of such adjustments
can be characterized by tone-scale adjustment
curves, which depict the relationship of input
gray levels to output gray levels, as shown in
figure 5.5. In a tone-scale adjustment process,
the value of each pixel in the selected portion
of the image is adjusted to the output value
specified by the adjustment curve. Image-proc-
essing software typically allows the curve to be
manipulated by sketching with a mouse, by
moving a slide bar, or by typing in values.
When the curve is a straight line passing
through the origin at 45 degrees (the usual de-
fault), the process leaves the image unchanged
(figure 5.5a). But curves of all other shapes and
positions will redistribute the gray tones in
some way. Figure 5.6 arrays the effects of some
of the most useful sorts of redistributions.

a. Unchanged

b. Darkening

c. Lightening

d. Compressing to darks

e. Compressing to lights

**5.5 Tone-scale adjustment curves for lightening
and darkening images.**

5.6 Effects of lightening, darkening, and contrast enhancement.

Darkening, Lightening, and Contrast

An image can be darkened by sliding the adjustment curve down the vertical axis (figure 5.5b)—in effect adding a constant value to all pixels in the image—or lightened by sliding the curve up (figure 5.5c). Darkening is the effect produced by the Claude glass, a device that was popular in the eighteenth century for making landscape scenes appear more harmonious. Martin Kemp has described its much-admired filtering action as follows:

Its tonal effect is to reduce glare at the top end of the scale, as in a large expanse of luminous sky, and thus to allow the subtlety of the middle tones to emerge, as, for example, in a bank of clouds. The darker tones acquire unity, without totally suppressing the detail. It was these harmonizing effects that earned the Glass the name of the great landscape artist, Claude Lorraine.[10]

Ruskin characterized the pictures that resulted as "some of the notes of nature played two or three octaves below her key" and compared the dimming effect to that of the camera obscura.[11] Today we can get the same effect with Ray-Bans.

Steepening the slope of the line produces a high-key, etiolated image by compressing tonal values onto the bright end of the scale and burning out highlights (figure 5.5d). Conversely, flattening the slope of the line produces a dense image by compressing tonal values onto the dark end of the scale and blackening shadows (figure 5.5e). These operations amount to multiplying all the pixels in the image by a constant value.

a. High contrast

b. Low contrast

c. Emphasize shadows

d. Emphasize lights

5.7 Tone-scale adjustment curves for contrast enhancement.

Changing the shape of the tone-scale adjustment curve, as shown in figure 5.7, alters tonal distribution within an image in more complex ways. The overall contrast of an image can be increased by distorting the shape of the tone-scale line into an S curve, which results in redistribution of middle-grays toward the two extremes (figure 5.7a). The redistribution can be biased toward either the light or dark end of the range by manipulating the precise shape of the curve. The basic effect of this type of tonal redistribution is to clarify an image by removing middle tones that muddy it. Conversely, the overall contrast of an image can be reduced and the variations of middle tones emphasized by distorting the tone-scale line into a reverse S curve (figure 5.7b). Or tones can be spread out over a wider range at the shadow end (figure 5.7c) or at the highlight end (figure 5.7d) to bring out detail that would otherwise be lost.

Thresholding and Posterization

A thresholding filter burns out the highlights of an image (above a specified intensity threshold) to pure white and deepens the darker shades (below that intensity threshold) to pure black (figure 5.8). A variant burns out the highlights above an upper threshold, blackens the shadows below a lower threshold, and leaves the middle tones unchanged. This type of filter can often be applied strategically to create dramatic chiaroscuro effects by setting the lightest lights of an image against the darkest darks. The effect is accentuated through simultaneous contrast when small white areas are set against dark surrounds or small black areas are juxtaposed with larger light areas. Through use of these tricks, the apparent tonal range of an image can be expanded, and almost magical ef-

fects of inky shadow density, glitter, gleam, glow, and sparkle can be produced.[12]

Another way to simplify the tonal structure of an image is by posterization—mapping the tonal range onto a smaller number of levels (figure 5.9). The effect is to replace smooth tonal gradients by sequences of distinct levels separated by contours—much as a landscape architect might transform a continuously sloping hillside into a sequence of flat terraces separated by abrupt level changes. This might be done to accommodate technical constraints (such as a limitation on the number of silkscreen masks) in a reproduction process or to abstract away from distracting tonal detail to reveal the essentials of a form. A famous example of a posterized photographic image is the dramatic portrait of Che Guevara that appeared in Havana's Plaza de la Revolucion after Che's death at the hands of Bolivian forces in October 1967 and that was subsequently reproduced on many posters and buttons in the late 1960s (figure 5.10). This two-level image was produced after Guevara's death by enlarging a small, low-quality fragment of a negative onto high-contrast paper.[13] Digital posterization is accomplished by progressively stripping the least significant bits from the binary numbers that specify pixel intensities (figure 5.11). An eight-bit image has 256 levels, a seven-bit image has 128 levels, and a one-bit image has 2 levels.

All these operations of tonal redistribution can be understood in terms of pixel demographics. Any black-and-white image has a characteristic dynamic range extending from its lightest light to its darkest dark—just as a musical performance has a characteristic dynamic range of sound intensities. The distribution of intensities within this range can be

5.8 Thresholding an image at different intensity levels.

5.10 A poster made from a two-level posterized image of Che Guevara.

5.9 Posterization: mapping the tonal range of an image onto smaller numbers of levels.

5.12 A gray-scale image and its intensity histogram.

5.11 Simplifying a colored image by posterization.

represented by a histogram in which the horizontal axis represents intensity levels and the vertical axis represents numbers of pixels at each intensity level (figure 5.12). Many image-processing systems have facilities for automatically computing and displaying these histograms. Looking at a few of them soon reveals that most well-lit photographs of scenes and events have wide dynamic ranges, with topographies of hills and valleys of fairly uniform scale. High-contrast images have wide ranges and bimodal distributions, with peaks at both ends. Thin images (perhaps overexposed) have narrow ranges and a peak at the high-intensity end like a continually loud piece of music, while excessively dense images (perhaps underexposed) have narrow ranges and a peak at the low-intensity end like a continually soft piece of music. Flat, gray images, with little sparkle or density, have a peak in the middle. Posterized images have discontinuous histograms. A digital artist, like a musical performer, must adjust the dynamic range and distribution appropriately to the content and occasion.

Positives and Negatives

A special case of tone-scale transformation which has been of particular importance in photography is tone-scale reversal—that is, conversion of a negative into a positive image. It can affect the readability and effectiveness of an image dramatically: the Shroud of Turin, for example, presents a far more striking image of Christ's head when it is presented as a negative (figure 5.13). Similarly, architects sometimes perform tone-scale reversals in order to produce figure-ground reversals that yield new readings of plans.

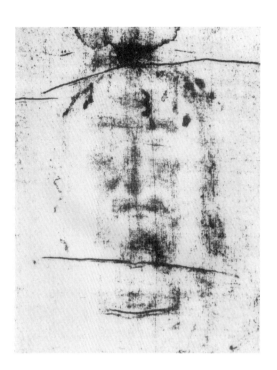

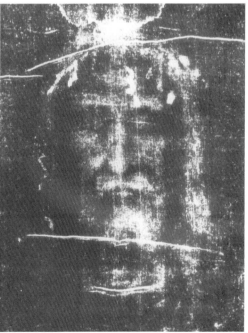

5.13 The Shroud of Turin and its tone-scale reversal.

A subtle effect of tone-scale reversal, in many contexts, is to reverse effects of relief. This is illustrated in figure 5.14. The original image reads as a convex surface rising from a light plane, while its tone-scale reversal reads as a concave surface receding from a dark plane.

In a digital image-processing system, tone-scale reversal is accomplished simply by reversing the slope of the tone-scale adjustment curve. Thus, for example, a scanned photographic negative can be digitally "printed" without recourse to any time-consuming and cumbersome chemical process. At the same time, the effects traditionally produced by varying type of paper, printing time, and chemical process can be achieved by tweaking the tone-scale adjustment curve as described earlier.

Colorization

The converse process to black-and-white photography's mapping of a colored scene onto a range of tones is colorization—supplementation of the lightness data specifying a grayscale digital image by hue and saturation data. This requires use of selection tools to specify the boundaries of approximately uniformly colored areas—flesh-colored human faces, items of clothing made out of colored cloth, shoes, carpets, painted walls, blue skies, and so on—then choice and assignment of hue and saturation values to those areas. Thus it is an updated version of the old practice of handtinting photographs and film frames—as, for example, in the famous tinted sequence of *Intolerance*.

Whereas the photographic transformation from color to gray scale is straightforward and

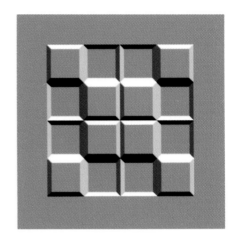

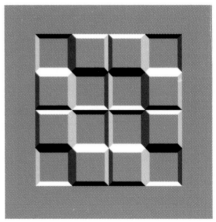

5.14 Apparent relief reversal produced by tone-scale reversal of an image.

easily automated, the colorization transformation from gray scale to color requires making decisions about how to segment a scene and about what colors to assign to segments. If you wanted to colorize an old episode of *I Love Lucy*, for example, you would have to determine the precise boundary between Lucy's forehead and her hair, and you would have to know that her hair was red. You would also have to choose colors for her dresses and for the furniture in her apartment. Segmentation and color choice can either be accomplished automatically through the application of sophisticated artificial-intelligence techniques or semiautomatically through the agency of a human graphic artist—in which case the result reflects that artist's knowledge of the world, intentions, and subjective decisions.

Although semiautomatic colorization is simple in principle, the practical problem is finding a way to achieve convincing results efficiently—particularly with large numbers of film frames. Efficient and acceptably effective commercial film-colorization processes first appeared in the 1980s and were quickly applied to produce colored videotapes from old black-and-white films such as *Topper, King Kong,* and *It's a Wonderful Life.*

Color Corrections and Transformations

No color photographic process can reproduce all the approximately seventeen million colors distinguishable by the human eye. Any particular process can display some subset, known as its color gamut, and colors outside the gamut must somehow be mapped onto colors within the gamut. This produces color shifts and distortions. (Even worse, images from earth-reconnaissance satellites cover wavebands far wider than that to which the human eye responds, so they must be mapped onto a visible range of colors to produce bizarre looking "false color" images.) Films and processes are usually "balanced" for specific purposes, such that important color ranges (for example, that of fleshtones in daylight) appear "natural" and noticeable distortions are confined to ranges judged less important. Sophisticated photographers are familiar with the color-endition capabilities of different films and processes and take care to select materials appropriate to particular subject matter.

Similarly, color scanners, CRT displays, and printing processes have their own characteristic color gamuts, so further problems of color rendition can arise when digital images are scanned and displayed or printed using devices with different gamuts. An image that looks right when displayed on a CRT, for example, may seem to have its colors seriously distorted when it is converted into a color transparency or printed on paper. And the balance of a color photograph may be distorted in scanning. The problem is exacerbated by the fact that the color-rendition characteristics of many scanning, display, and printing devices can vary over some range, so these devices need to be calibrated carefully and balanced in relation to each other. A CRT display that is balanced to show what an image will look like when reproduced on one type of color printer may provide a very misleading impression of how that image will be reproduced by another type of printer.

Another troublesome aspect of the color-rendition problem for painters and photographers is that the color mixtures needed to produce wide ranges of colors from limited ranges of

pigments inevitably result in loss of brilliance and clarity. The desaturating effect of mixing white and black with pure pigments to produce tints and tones is obvious. Less obviously, perhaps, desaturation is also a consequence of mixing pigments to produce new hues. Subtractive color mixture, as in traditional oil painting or the overlay of watercolor washes, produces desaturation combined with darkening; and additive color mixture, as in Seurat's pointillist canvases, produces desaturation combined with lightening. Colors that are produced by mixture, then, can often seem disappointingly muddy or washed out.

Thus there is a need, in digital image processing, for device-calibration, color-correction, and color-enhancement capabilities. Inexpensive personal computer systems—intended for everyday use in contexts where precise color control is not critical—typically provide only rudimentary capabilities of this sort. But the sophisticated color electronic prepress systems that are used for production of magazines and high-quality printed books have wide color gamuts, allow very precise calibration, and provide extensive repertoires of software tools for color manipulation.

Even the most basic image-processing systems provide for adjustment and correction of color balances by applying tone-scale adjustments to the red, green, and blue layers of an image. This allows correction of undesirable color distortions—such as the orange caste that results from shooting with daylight film in tungsten light, or the exceptionally objectionable green caste that results from shooting in fluorescent light—and subtle manipulation of an image's emphasis and feeling. Bringing up the red, for example, will make fleshtones seem rosier, and bringing up the green will make shadowy or washed-out foliage seem

more brilliantly colored. It has been reported that *The Orange County Register* (in southern California, where it's never supposed to rain) corrects all the skies in its outdoor color photographs to 100 percent cyan—whatever the weather conditions.[14]

Photographers often like to perform color correction and transformation in the RGB system because this allows them to draw on their intuitions about the mixture of light. Printers and graphic artists often prefer to use the CMYK system because this directly relates to the printing process. But most people find it easiest to control color using the parameters of the HLS system, since this relates to the directly perceived dimensions of color variation.

Shifting hue, by adding a constant to each hue value (or by subtracting a constant), is a transformation that can produce a particularly dramatic effect (figure 5.15). The result is an image in which all the hue relationships remain unchanged (complementary patches of color remain complementary, for example), but all the actual hues are different—as in the color photograph that illustrated the *National Enquirer* headline "Vegetarian Gives Birth to Green Baby." It is thus closely analogous to shifting the key of a musical composition. Hue ranges, like intensity ranges in gray-scale images, can also be compressed, expanded, or redistributed.

Sometimes painters manipulate hue, lightness, and saturation separately—for example, by underpainting in neutral grays to define tonality, then applying transparent washes or glazes of pigments to develop hue and saturation relationships. But this is cumbersome and leaves little opportunity for reconsideration: a painter cannot easily readjust tonal relationships after the overpainting is laid in. With HLS color-transformation software it is easy

5.15 Mutant strawberries produced by hue transformations.

5.16 Saturation and lightness transformations.

(figure 5.16). The artist can separately adjust lightness and contrast to establish desired tonal relationships and achieve an overall tonal unity, manipulate saturation to produce an appropriately brilliant or subdued effect, and shift hue values to give a satisfactory overall color cast—the warmth of incandescent light or the cool blue of sunlight. This technique allows very delicate adjustment of an image and exploration of the subtle interplay among the three dimensions of color variation.

Interesting transformations of the chromatic structure of an image can sometimes be produced by posterization combined with hue, lightness, and saturation adjustment. Painters such as Paul Gaugin and Henri Matisse, for example, learned to exploit the dramatic effect of large, flat areas of uniform, highly saturated color, and similar effects can be produced by reducing a twenty-four-bit color image to an eight-bit or four-bit image and enhancing the overall saturation level. Other possibilities are to posterize the red component while leaving green and blue at full tonal resolution, to posterize lightness or saturation while leaving hue at full resolution, and so on. Thus, for example, masses of intricately textured foliage can be unified into simpler and more continuous areas by posterizing the green component.

Color transformations can not only be used to alter the overall look of an image, but also applied to selected areas in order to alter color relationships within the image. Emphasis might be given to a foreground object, for example, by selecting and saturating that object while desaturating the background. Gray-scale images can be colorized by selecting areas and assigning hues to them. And the hues of selected objects can be shifted arbitrarily to produce blue bananas, cyan oranges, and the like.

More subtly, the brilliance of an object's color can be enhanced by giving a complementary hue to the surrounding shadows—an old painters' trick.

In general, any of the tone-scale adjustments that can be applied to a gray-scale image can be applied to the red, green, blue, hue, saturation, or lightness components of an image. They can be applied to an image as a whole to shift it to a new color register, or they can be applied differentially to selected parts to create and inflect desired tonal and chromatic relationships.

Sharpening and Smoothing

When Canaletto painted Venice he often sharpened the architectural detail by introducing fine, almost imperceptible dark outlines.[15] But when J. M. W. Turner painted the same scenes he blurred the outlines and suppressed fine detail. In digital image processing, analogous variations in treatment can be achieved by applying filtering operations known as area process transformations.

All the lightening, darkening, contrast-enhancement, and color-transformation processes I have considered so far belong to the class of *point* processes. In a point process, the value of a pixel after transformation depends only on its own value before transformation and not on the values of neighboring pixels. In *area* processes, however, the value of a pixel after transformation *does* depend on the values of neighboring pixels. Two of the most important and commonly used area processes are *smoothing* and *sharpening*.

Smoothing is accomplished in photography by putting an image slightly out of focus or by interposing some kind of diffuser between the

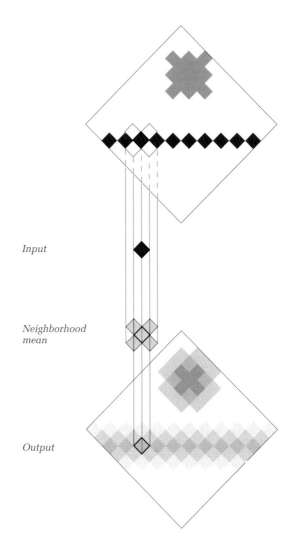

Input

Neighborhood mean

Output

5.17 A smoothing filter.

scene and the lens. It has the effect of remov-
ing fine detail—such as the wrinkles on an ag-
ing movie-star's face—while leaving the broad
distribution of tones and colors intact. Julia
Margaret Cameron, a famous early practitioner
of soft-focus portraiture, said that it healed "all
the little frets and insect-stings of life." Almost
all photographs, in fact, exhibit some smooth-
ing due to the depth-of-focus effect, and a pho-
tographer must carefully control the amount
and distribution of smoothing by manipulating
the combination of focus and f-stop.

In watercolor, smooth images are produced
by painting on a damp surface, so that brush
strokes blend into each other. In charcoal
drawing, analogous blurry effects result when
adjacent charcoal strokes are smeared together
with the fingers. As painters have always
known, we can in fact smooth any scene or im-
ages by squinting our eyes so that fine details
blend together and broad outlines remain. Digi-
tal smoothing of images is also accomplished
by a blending process. The basic idea is to re-
place the value of each pixel with some kind
of statistical summary of the values of neigh-
boring pixels. Different results can be obtained
by using different statistical summaries (mean
or median, for example) and different neigh-
borhoods. The commonest approach is to take
a five-pixel Greek cross (the pixel itself, with
the four face-adjacent pixels) as the neighbor-
hood and to calculate their *average* value (fig-
ure 5.17). This produces a slightly out-of-focus
effect (figure 5.18). Choosing a larger neighbor-
hood (for example a three-by-three square or a
five-by-five square) produces a more pro-
nounced smoothing effect. If we were to make
the whole image the neighborhood, we would
smooth it away to nothing but a uniform field.
Greater smoothing can also be achieved by re-
peating the smoothing operation.

5.18 Smoothed and sharpened versions of a photo-
graph by Fox Talbot. Smoothing followed by posteriza-
tion (top) emphasizes the broad distribution of lights
and darks. Sharpening followed by posterization (bot-
tom) emphasizes small-scale surface textures.

In the rather arcane technical terminology of digital image processing, this is called a spatial-convolution operation. More specifically, it is a low-pass filtering operation. It retains the large (low spatial frequency) components of an image while attenuating the fine detail and eliminating noise. There are very close analogies with low-pass filtering of gravel to retain the large stones and eliminate the fine particles and with low-pass filtering on an audio signal to attenuate high-frequency sound components.

Images often have clearly visible microstructures of brush strokes, hatching, or pixels, but when a low-pass filter is applied this microstructure disappears and an underlying broad formal organization emerges. Application of a low-pass filter to a realistic etching or engraving, for example, removes the microstructure of linear hatch marks and converts the image into a good approximation to a slightly fuzzy photograph. Similar strategies are useful for removing unwanted patterns of raster lines from photographed video images, dust spots from scanned photographic negatives, *craquelure* from scanned images of paintings, random noise from CCD photographs, and patterns of halftone dots from published photographs. (This is the inverse of digital halftoning, which puts a microstructure in.) And impressionist or pointillist paintings do not look like such radical departures from tradition when you squint at them (that is, apply your built-in smoothing filter): Seurat begins to look disconcertingly like Puvis de Chavannes. Pablo Picasso's 1910 cubist *Portrait of Vollard* even more dramatically exemplifies this phenomenon (figure 5.19). There is a conspicuous microstructure of dark-outlined, angular facets, but as Michael Baxandall has pointed out, "if one half-closes one's eyes the phenomenal Vollard jumps out like a photograph."[16]

Sometimes low-pass filtering is applied selectively to parts of images. This is essentially what happens in photographs where some parts are sharp and others are fuzzy due to the depth-of-focus effect. Painters often direct attention and suggest depth within images by creating gradients of sharpness: larger and larger spatial elements are smoothed out with increasing distance from the focus of attention.[17] Turner, for example, frequently allowed his landscapes to fade and blur into indefiniteness at the corners while remaining sharp at the center. And in many of Rembrandt's portraits the faces are rendered in middle fleshtones with sharp details of skin texture, but the peripheral areas are dramatically broad

brushed, dark, and desaturated. Similar effects can be created in digital images by varying the amount of smoothing according to some distance function. This may be combined with progressive darkening or burning out of the background toward the periphery.

The opposite of smoothing is sharpening—high-pass filtering to accentuate the fine detail—as, for example, in a painting by Holman Hunt that carefully picks out every blade of grass and every strand of wool on a sheep's back (refer back to figures 5.18 and 5.19).[18] The basic idea of sharpening is to identify and accentuate those pixels that are substantially different from their neighbors, so that edges and fine detail stand out. Our own visual systems,

5.19 Differently filtered versions of Picasso's *Portrait of Vollard* emphasize different aspects of its visual structure. Replacement of each pixel value by the minimum value among its neighbors accentuates the dark edges of the cubist facets (left). Replacement by the median value eliminates microstructure and allows a blurred image of Vollard's features to come through (middle). Replacement by the maximum value emphasizes the contrast of hues between the flesh-toned oval of the face and its blue/green surroundings (right).

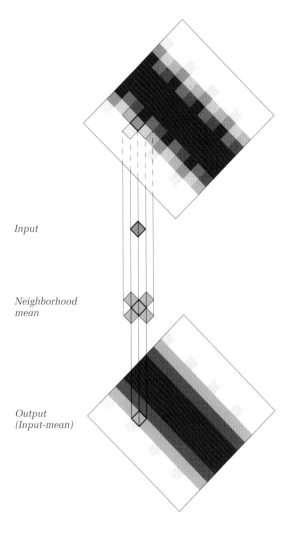

Input

*Neighborhood
mean*

*Output
(Input-mean)*

5.20 A sharpening filter.

in fact, do this to visual fields—producing on occasion an illusion known as Mach banding. If you look at a boundary between a light gray area of an image and a darker gray area, you will see a faint bright zone along the light side and a faint dark zone along the darker side. (No doubt there was some evolutionary advantage in being able to pick out the outline of the tiger lurking in the shadows.) Similarly, painters sometimes "push" edges by subtly lightening and darkening the adjacent zones on either side.

The usual way to sharpen is to multiply the value of the center pixel by the number of pixels in the neighborhood (five, for the smallest neighborhood), then to subtract the sum of the values of the other pixels (figure 5.20). If the center pixel has the same value as its neighbors, its value will remain unchanged. But if the center pixel is brighter, it will be brightened further; and if the center pixel is darker, it will be darkened further. Visually, the effect of slight sharpening is one of focus restoration. Further sharpening produces a kind of cloisonné of accented edges.

Most scanned photographs and captured video images look better with a little sharpening: edges become crisper, detail emerges from shadows and highlights, and fine patterns and textures become easier to read. But excessive sharpening tends to accentuate dust spots, photographic grain, and scanner noise and to break up continuous areas into seemingly random patterns. In the result, quite literally, we cannot see the forest for the trees.

Image quality may be inflected in subtle ways by sharpening some parts of an image and smoothing others. Painters have long been aware of this. Sir Charles Eastlake, for example, remarked that "expression of alternate sharpness and softness in the boundaries of

forms (whether forms of substance, of light, or of color) is indispensable to truth of imitation in painting." He went on to suggest that, in practice, "the brush may be considered the instrument of softness, the palette knife of crispness and sharpness. The first may represent imperceptible gradation, the other the abrupt edge and point of a crystal sharpness; the one typifies the cloud, the other the gem."[19] Smoothing and sharpening filters are the electronic equivalents of these traditional tools.

In sum, smoothing and sharpening are usually discussed as techniques for restoration of low-quality images, but from an artist's viewpoint they are better seen as ways of precisely controlling the qualities of edges, visual grain, and densities and distributions of detail in an image—of electronically painting with broad or fine brushes and with media that produce hard or soft edges.[20]

Macchiaiolation and Diffusion

Painting styles are sometimes characterized by particular brush-stroke shapes and qualities of image granularity. The nineteenth-century Italian Macchiaioli, for example, constructed their canvases using the *màcchia,* or patch of paint, as the basic element. The characteristic result was a crisp, sharply articulated image with a conspicuous microstructure of discrete colored patches. Similar results can be produced by applying digital filters that clump similar pixels together (figure 5.21). Different clumping strategies can be used to generate *màcchia* of different shapes. These shapes may form a regular pattern, such as a mosaic of squares, or they may vary according to the distribution of colors in the image. In either case the microstructural variation within the image is simplified.

An opposite strategy is to break up clumps and edges by randomly shuffling values among neighboring pixels. This produces a diffusion effect—an interpenetration of adjacent areas of color—much like that sometimes generated by watercolor wash on coarse-grained paper. Like smoothing, diffusion eliminates fine detail and softens edges, but it produces an image with a characteristically different look.

These principles can be generalized. Whenever a painter, photographer, or digital imager records scene data on a picture surface, a distribution of colors in the scene is mapped onto some characteristic geometric microstructure of brush strokes, photographic grain, or square pixels. In paintings the microstructure is often relatively coarse and quite evident to close inspection, but in photographs and digital images it is usually below the threshold of visibility—appearing only when the image is enlarged. Digital filtering can be used to map one microstructure onto another and to coarsen the microstructure so that it becomes visible. Such remapping is sometimes (rather foolishly) used to convert scanned images into "art" by giving them the visible microstructures characteristic of oil paintings, watercolors, or shaded pencil drawings.

Line Extraction

Drawing a scene is largely a matter of line work—of identifying important contours and deploying linear marks to represent them.[21] The result is an extremely economical representation, an abstraction of only the most telling information from the visual field. When we interpret line drawings, then, we must literally read between the lines.

Different artists, working in different styles, follow different rules for placement of lines:

5.21 "Broad brush" image produced by clumping
similar pixels together.

5.22 "Line sketch" produced by extracting edges from a scanned photograph.

indeed, a large part of the interest of a good line drawing is in its revelation of what the artist thought was important in a scene. But there are a couple of very basic rules—ones that are frequently taught in introductory life-drawing classes—and these can be expressed as digital filters which convert gray-scale or color images into quite convincing line draw-ings. Such filters identify and darken pixels at line locations while reducing all other pixels to white.

The first rule is to place lines at occluding contours, such as edges of walls and frames of windows or the profiles of human figures against their backgrounds. These contours nor-mally show up as sharp changes in intensity. Application of a filter sensitive to such "steps" in intensity produces the kind of result shown in figure 5.22. Filters of this sort can be tuned for sensitivity to horizontal contours, to verti-cal contours, to diagonal contours, or to con-tours running in any direction.

The second common line-extraction rule is to place lines at intensity "valleys"—small areas of relatively dark pixels surrounded by lighter pixels. In a photograph of a human face, for example, these occur along the edges of noses and cheeks, at wrinkles and folds in the skin, at eyelashes, between teeth, and so on.

A common, classical drawing strategy is to construct a silhouette so that the object appears to be sectioned by the picture plane, then to develop the volume forward—from the silhouette toward the eye—by adumbrating contours that move across and describe the surface. A good approximation to this type of drawing can be produced by digital filtering a diffusely lit photograph of a classical statue to extract the profile and the lines that bound internal surface details (figure 5.23).[22]

Once lines have been extracted they can be further processed. They can be thickened, thinned, lightened, or darkened to produce graphic effects similar to those traditionally generated through use of different types of chalks and crayons, pens, and pencils. They can also be smoothed to remove minor irregularities or roughened to introduce a kind of visual vibrato. In the past, line quality was controlled by an artist's choice of marking tool and could not easily be changed: the difference between an engraved and a drypoint line, or a freehand pencil line and a ruled ink line, is fundamental. But with the digital image, lines can at any time be extracted in many ways, and freely varied in quality, to yield line renditions with differing emphases and rhetorical inflections.

Roland Barthes thought that line drawings and photographs were very different things. Line drawings, he argued, were coded messages produced by deployment of signs (lines and structures of lines) in accordance with some arbitrary set of conventions. But photographs were messages without a code, since signifier and signified are in this case not conventionally but causally related.[23] We have now seen, however, that convention versus causality is not the issue. Line drawings can, under some circumstances, be no less causally related to their subjects than photographs. (Or, if we want to regard filtering functions as conventions, they are no more conventional.) We cannot even make the issue into one of physical versus logical causality, since it is perfectly feasible to build edge-extraction circuitry into the hardware of a digital camera or a scanner. Line drawings and photographs are simply filtered in different ways.

Arbitrary Filters

The digital filters that we have considered so far are all analogous to operations of drawing, painting, or photography. But there are, in fact, infinitely many ways to filter images for particular visual purposes, and we need not restrict ourselves to the familiar ones. In principle, pixel neighborhoods can be specified in any way we please, and any kind of numerical function can be used to convert input pixel values into an output value. Many image-processing systems provide for extending their range of built-in filters by programming or plugging in new ones. The basic idea is to specify the neighborhood that is to be considered in calculating the value of each pixel, then to express that value as some mathematical function of those of the neighborhood pixels. When the filter is applied, the original value of each pixel is replaced by the computed value of this function.

5.23 A portrait filtered to extract a line drawing.

Another way to produce custom filtering effects is to apply standard filters in sequence. A "pen-and-wash drawing" of a photographed scene might be produced, for example, by first smoothing to produce the "wash" and then overlaying extracted contours to add the "pen" (figure 5.24). Or a Turneresque high-key watercolor wash effect might be produced by reducing contrast, lightening, and smoothing.

True Colors

It is an illusion to think that we can reproduce the world in its true colors. If a visual recording medium had unlimited spatial and color range and resolution and strictly linear response, we might indeed use it to produce true-color images—ones that were point-for-point matches to the colors of a real scene. But all real recording media, including photographic film, are limited in their ranges and resolutions; have characteristic microstructures of brush strokes, tesserae, grains, and the like onto which intensity or color values must be mapped; and tend to exhibit response nonlinearities. This means that a recorded image is always filtered in some way: there is some function relating its colors to those of the real scene, but the function is not so simple as to produce a point-for-point match.[24] Filters can be incorporated in the capture device (as when a colored gel is placed over a lens), they can be introduced at some intermediate step, or they can be applied at the final output stage (as when a photograph is halftoned or dithered). But the stage of application makes no fundamental difference: in the end, the concatenation of all the filters that have been applied can be thought of as a single filter mapping from colors in a scene to colors in a display or print.

Filters are powerful rhetorical devices. They have the effect of emphasizing some things and suppressing others and of giving an overall visual character and emotional tone to an image. Artists choose different filtering strategies to produce different rhetorical effects: compare, for example, the characteristic filtering strategies of Camille Corot, Georges Seurat, Vincent Van Gogh, Henri Matisse, Charles Sheeler, and Richard Diebenkorn. It is also part of a photographer's stock-in-trade to make rhetorical use of lens filters, focus, depth of field, choice of film, exposure, development, and choice of printing paper. Thus the soft-focus portraits of Julia Margaret Cameron have a quite different rhetorical force from the sharp, precisely toned, glossy, black-and-white prints of the $f/64$ group. Photographers who have aspired to objectivity and a kind of rhetorical neutrality (such as Ansel Adams or Albert Renger-Patzsch) have worked out techniques that allow exact control and standardization of filtering: Adams's Zone System for controlling rendering of tonality through exposure and darkroom technique is perhaps the most famous example.

We must, then, abandon the naive presumption that photographs are transparent windows onto the world. They are windows with filters, like those provided by other sorts of images: the characteristic, standardized filtering strategies of photography have simply become naturalized in our culture. Our eyes have adapted to them. But the introduction of digital image processing, with its vast range of filtering possibilities, shows us that there are indefinitely many alternative windows.

5.24 "Pen and wash" produced by applying
smoothing, posterizing, and edge-finding filters to a
scanned photograph.

6.1 A computed perspective view of nine spheres
reflected in three planar mirrors.

VIRTUAL CAMERAS

■ **Algorithmic Image Construction**

There are caves in Arnhem Land, in the far north of Australia, where aboriginal people long ago placed their hands against the walls and blew ochre over them to leave stenciled impressions. Similarly, European artists have sometimes used devices like the camera obscura and the physiognotrace to record the precise outlines of actual things. The resulting images are like cameraless photographs—poignant traces of the real made not by the automatic action of light on an emulsion or a CCD array, but by manual execution of procedures for accurately locating positions in space and depositing corresponding marks on a surface.

A surveyor making a map of a city and an architect making a measured drawing of a building elevation are also following such procedures. But the surveyor and the architect introduce an additional step. First they create a set of measurements—an intermediate numerical model—and then employ projection procedures to convert this numerical model into two-dimensional images. By using different projection procedures and parameters, they can generate many different views from the same numerical model.

In his treatise *On Painting* (1436) Leon Battista Alberti set out perhaps the most famous and influential of all projection procedures of this sort—a rigorous, step-by-step algorithm for constructing, with drafting instruments, a consistent single-point perspective view of a

scene.[1] (Brunelleschi had earlier demonstrated what truly consistent perspective was by tracing pictures of the Florentine Baptistry with the aid of a peephole-and-mirror system.) Numerous later treatises on perspective elaborated the details of this procedure and developed variants of it. Perspective construction was reduced to an objective process that, if followed faithfully, was *guaranteed* to produce accurate results. Like a photographer, the perspective artist can control the image by varying the parameters of station point, direction of gaze, angle of view, and distance and inclination of the picture plane relative to the station point.

Alberti established an alliance between painting and science that lasted until the emergence of photography; with computer graphics it was born again. By the 1960s pioneering computer-graphics researchers (notably Steven A. Coons and Larry G. Roberts) had developed a version of the perspective-construction algorithm that could be executed by computer (figure 6.1)—an event as momentous, in its way, as Brunelleschi's perspective demonstration.[2] It was not only efficient, but also banished the possibility of human error or discretionary intervention in execution of the algorithm. The essential idea was to transform x,y,z coordinate triples representing end points of lines in space into x,y coordinate pairs representing end points of lines in the picture plane by performing some simple, repetitive arithmetic operations. This procedure yielded crude, wireframe images of three-dimensional objects and scenes. During the 1970s and 1980s the computer-graphics research community extended this idea in many different directions, with the result that, by the beginning of the 1990s, there were available to the artist practical algorithms, executable on inexpensive personal computers, for synthesizing shaded,

colored perspective images that are often indistinguishable from high-quality color photographs. Indeed, as we shall see in chapter 7, they can often be seamlessly combined with digitized photographs, with the result that fictional objects are convincingly inserted into real scenes.

Visual Reconstruction and Prediction

These computer-generated perspectives can stand in a wider range of intentional relations to the objects they depict than can photographs. Sometimes the underlying geometric model has a physical counterpart and sometimes it does not. If there is a physical counterpart (as in the perspectives of the topography of Venus generated from Magellan data), it may or may not be the case that the perspective station point corresponds to that of an actual observer or recording instrument. Sometimes the point of image synthesis is to get the image to match the world, sometimes it is to get the world to match the image, sometimes it is to predict what the world will be like at some moment in the future or to show what it might have been like if history had taken a different turn, and sometimes it is just to produce a convincing portrayal of a purely fictive place.[3]

Where, for example, a perspective image is generated from a surveyor's measurements of an existing building or from three-dimensional scanner data (MRI scanner data, perhaps, or the Magellan radar scan of Venus), it serves as a truthful record in much the same way as a photograph from the same viewpoint would: the image matches the world. But one crucial distinction should be kept in mind: the synthesized perspective is not a direct imprint made by light emanating from the scene, but a *recon-*

struction made by applying formalized theoretical knowledge of projection and shading to recorded observations. The verisimilitude of that reconstruction depends both on the completeness and accuracy of those observations and on the adequacy of the projection and shading techniques used.

When a perspective is constructed by taking measurements from an architect's plans and elevations for a proposed building, its usual role is to predict the visual effect that will result from execution of the design. It may also be used to specify work that a construction contractor is to execute. After construction has been completed, the prediction can be verified (and the contractor's work checked) by taking a photograph from the same viewpoint and comparing it with the perspective: if everything is correct, the world now matches the image. (A photograph, of course, cannot be used to predict in this way, since it can only depict something that already exists.)

Traditionally, handmade perspective renderings have been used for this purpose, and they have sometimes turned out to be remarkably accurate (figure 6.2). But they have never been regarded as completely trustworthy, since they are obviously subject to the effects of human error, wishful thinking, and dishonest fudging. Automated perspective-synthesis procedures, on the other hand, can be tested and validated like other techniques that apply scientific knowledge (breathalyzer tests and the like) and thereafter used to produce highly credible evidence. Thus they are used increasingly to show decision makers that proposed architectural projects will be acceptable in appearance, and as evidence in planning hearings and in courts of law.[4] For example, a computer-projected perspective was used to convince President Mitterand of France that I. M. Pei's

proposed glass pyramid in the courtyard of the Louvre would not be too obtrusive.

Similarly, since the emergence of powerful but relatively inexpensive computer-graphics workstations during the 1980s, it has become commonplace for scientists to synthesize perspective views of things that are too small to be seen or too distant or otherwise inaccessible to the direct human gaze. The procedure is to employ some appropriate scientific instrument to collect measurements and then to construct perspective views showing what *would* be seen if it were, in fact, possible to observe from certain specified viewpoints. Thus, for example, space scientists have been able to synthesize what appear to be detailed, close-up color photographs of the rings of Saturn and the mountainous topography of Venus. They are like the souvenirs of returning space travelers—but no traveler has ever witnessed these awesome scenes directly, and no camera has ever recorded them.

Modeling

The numerically encoded geometric models that are stored in computer memory and transformed into perspective views may be conceived and organized as collections of zero-dimensional points, one-dimensional lines, two-dimensional surfaces, three-dimensional solids, or combinations of these.[5] This is an extrapolation of an old idea. Leonardo da Vinci advised painters:

The first principle of the science of painting is the point; second is the line; third is the surface; fourth is the body which is enclosed by these surfaces. . . . Point is said to be that which cannot be divided into any part. Line is said to be made by moving the

6.2 Predictive perspective construction: Paul Stevenson Oles, pre-construction perspective drawing and post-construction photograph of I. M. Pei's design for the National Gallery East Wing, Washington, DC. Courtesy Paul Stevenson Oles.

point along. Therefore line will be divisible in its length, but its breadth will be completely indivisible. Surface is said to be like extending the line into breadth, so that it will be possible to divide it in length and breadth. But it has no depth. But body I affirm as arising when length and breadth acquire depth and are divisible. Body I call that which is covered by surfaces, the appearance of which becomes visible with light.[6]

Although most paintings involve, to some extent, all four of these types of geometric objects, different schools of painting have emphasized different ones. The impressionists, then even more rigorously Georges Seurat, conceived of three-dimensional scenes as collections of colored points. Perspective drafters conceive of scenes as collections of lines in space, which are to be projected onto the two-dimensional picture plane. Renaissance painters were much concerned with depicting the shapes and shadings of surfaces. Paul Cézanne advised painters to "treat nature in terms of the cylinder, the sphere, the cone, all in perspective": he (and the cubists that followed) conceived of scenes as collections of solids in space.

Sculptors and architects have worked with corresponding elements in three-dimensional space. Some have built up complex solid forms from tiny wooden blocks, bricks, or spheroidal blobs of clay—a point-by-point strategy. Others have assembled wires, rods, and sticks into frame structures—compositions of linear elements. Yet others have cut out, bent, and assembled sheets of cardboard, plywood, plexiglass, and metal to create surface structures. And sculptors in the classical tradition have characteristically proceeded by carving, casting, and assembling three-dimensional solids.

The same applies in three-dimensional computer graphics. The basic ontological assumptions that are expressed by modeling in terms of points, lines, surfaces, or solids determine, to a considerable extent, the accuracy with which various different classes of physical objects can be modeled and the accuracy with which various sorts of visual effects can be reproduced synthetically.

Point (voxel) models are often created by medical-imaging devices, such as MRI scanners. They are also particularly well suited to representation of free-form objects such as clouds, flames, and geological formations. Objects in these models are represented as collections of points, and each constituent point is described by its three spatial coordinates plus an associated density or transparency value (figure 6.3). At the lowest possible density resolution, one bit of information per voxel is used to represent the difference between solid and void, but voxel models produced by medical-imaging devices usually have high-density resolution in order to distinguish among different types of tissue. Voxel models constructed at low spatial resolution lose fine detail and often show spatial aliasing, while voxel models constructed at higher spatial resolution retain more fine detail but require substantially more storage since the number of voxels increases as the cube of the spatial resolution. Like two-dimensional digital images, voxel models can be filtered digitally to smooth them, sharpen them, and so on.

Modeling a scene in such an atomistic way usually turns out to be extremely inefficient in its use of computer resources, so there is considerable practical motivation to construct geometric models from higher-level primitives—that is, lines, surfaces, and solids. Line modeling is a particularly elegant and efficient way

6.3 A three-dimensional shape represented as a collection of voxels.

of recording geometric information, since a line model explicitly records only edges and other discontinuities that we regard as important (figure 6.4a,b). It is assumed that nothing of importance changes *between* the lines, so much can be left implicit. Thousands of points might be needed to represent a cube at acceptable resolution in a point model, for example, but it can be represented precisely in a line model by just twelve edge lines—just as it might be put together out of twelve wire rods of identical length.

The simplest kind of line model represents a scene as a collection of straight line segments. Any curves are approximated as sequences of short segments. Each segment is described by six numbers—the x,y,z coordinates of its two end points. An obvious extension of the idea is to introduce circular arcs in addition to straight lines. An arc is described by its end points plus an additional number that specifies curvature. The idea can be extended further by introducing additional types of lines, such as conics and splines, and storing values for the coefficients in the equations that describe them.

Pure line models contain the information needed for production of projected line drawings (wireframe perspectives and axonome-

trics); but they take no account of the existence of surfaces in a scene and record no information about the properties of these surfaces, so they cannot be used for synthesis of renderings that show shaded or colored surfaces. Too much of the original scene information has been filtered out, or (in the case of an imaginary scene) not enough information has been specified. For production of shaded images, it is necessary to model a scene more completely—as a collection of explicitly represented surfaces with associated data specifying surface properties.

Just as a one-dimensional line is bounded by a pair of zero-dimensional points, so a two-dimensional polygonal surface is bounded by a collection of at least three one-dimensional lines. So a line is represented by associating end points, and a surface is represented by associating boundary lines. A square facet, for example, is specified by its four straight edges. These edges, in turn, are described by their end points. Thus a cube, for example, can be modeled as a collection of six surfaces—much as it might be constructed by cutting out and fitting together four cardboard squares (figure 6.4c)

Curved surfaces are very often approximated as collections of small planar facets. These facets are often triangular, since triangular facets are guaranteed to be planar, whereas facets with four or more edges may be nonplanar. But cylindrical surfaces, spherical surfaces, conical surfaces, various kinds of warped surfaces, and so on can also be described as collections of nonplanar patches bounded by mathematically defined curves: this technique—which has its precomputer roots in Renaissance strategies for drawing curved surfaces in perspective—is useful where greater accuracy is desired (figure 6.5).

8 vertices

12 edges

6 surfaces

6.4 Boundary representations of a cube.

Surface models vary in the surface characteristics that they record. The simplest assume uniformity of surfaces throughout the scene. More elaborate models differentiate colors, degrees of transparency, specularity characteristics, textures, and so on. The greater the differentiation of surfaces, the more sophisticated the renderings that can be produced from the model.

Finally, we may note that a three-dimensional polyhedral solid is bounded by at least four two-dimensional surfaces. Thus the descriptive logic that has been emerging is extended one step further: points are associated to define lines, lines are associated to define surfaces, and surfaces are associated to define solids (figure 6.4d). Geometric models structured as collections of solids allow specification of the material properties of solid bodies. This is not always necessary for generation of realistic renderings, but it can be. If there are transparent solids, for example, information about their refractive properties is needed. The primary benefit of solid modeling, however, is that it can allow swift and convenient specification of scene geometry through a process of assembling solid "building blocks"—much as one might efficiently build a physical model out of machined blocks of wood.

Computer systems for constructing and editing geometric models of scenes are closely analogous to word-processing systems. But, instead of providing tools for arranging symbols on two-dimensional pages, they provide tools for arranging points, lines, surfaces, and solids in three-dimensional Cartesian coordinate systems. The first step in any image-synthesis process is to use these tools to construct or edit a geometric model of the scene that is to be rendered. Since this model will be the rendering system's only source of information about the

6.5 Representation of curved surfaces by surface patches.

scene, it must contain sufficient geometric detail and information about surface properties to allow computation of all the desired visual effects. The model might be rendered by procedures built in to the geometric-modeling system, or a geometry file might be transferred to a specialized rendering system.[7]

Rendering: Projecting and Shading

A three-dimensional geometric model stored in computer memory is a virtual world. We can make images of the contents of this world by introducing a virtual camera and virtual lights, then computing a synthetic photograph.[8] To the extent that the geometric model and its virtual lighting are sufficiently detailed and plausible, and the rendering techniques used to compute the synthetic photograph are sufficiently accurate, the synthetic photograph will resemble a real one. Here we shall first consider very simple rendering techniques that produce useful but abstracted images, then we shall explore successively more sophisticated

techniques—eventually ones that can produce images that are indistinguishable from good color photographs of actual scenes.

There are three basic steps in the production of a two-dimensional rendered image from a numerically encoded three-dimensional geometric model. First, points, lines, and surfaces represented in the geometric model must be projected onto the picture plane. Second, the ordering of opaque surfaces must be considered, so that the occlusion of background objects by foreground objects is correctly rendered—an operation known as hidden-line or hidden-surface removal. Finally, the intensities of visible surfaces must be computed to yield a shaded image. (We will consider the steps in this order, as a painter might, but a computer-graphics system may, for technical reasons, perform them in different sequence.) From a computational viewpoint, this amounts to conversion of one kind of numerical representation of a scene, the given geometric model, into another kind—an integer array of intensity values, a digital image.

Wireframe Projections

The simplest kind of image that can be computed from a three-dimensional geometric model is a wireframe projection. Such images were very common in the early days of computer graphics, and they still have useful roles to play in some specialized contexts—for example in the CAD task of measuring and dimensioning architectural drawings by selecting edge lines and vertices. The algorithms that generate them require information only about edge lines, so they can be produced directly from line, surface, or solid models, all of which represent such lines explicitly. (Voxel models, however, do not represent lines explicitly and must first be filtered to extract them.)

A wireframe-projection algorithm is simply a procedure for consistently converting x,y,z coordinate triples (usually the end points of lines) from the geometric model into x,y coordinate pairs in the picture plane.[9] If these projected points are then appropriately connected by lines (as in a connect-the-dots puzzle) a wireframe image results. Thus the depth of space is reduced to the planarity of the image surface. There are infinitely many ways to do this, but certain of them have particularly attractive mathematical properties, have been sanctioned by tradition, and are widely accepted as standard pictorial conventions.

The simplest possible procedure is to throw away the z coordinates in the x,y,z triples while leaving the x and y values unchanged (figure 6.6a). This results in an orthographic projection at full scale, like a shadow of an object cast onto a wall by the setting sun. (Indeed, you can produce exactly this effect by constructing a physical wireframe model and holding it up against a sunlit wall.) We may interpret it as the result of taking parallel projection lines through the xy picture plane.

This procedure is not flexible enough to be of much practical use, however. It does not provide any way to exert artistic control. One useful improvement is to provide for multiplying the x and y coordinates by some specified constant. By varying this *scale factor*, the artist can generate orthographic views of any desired size. (The aboriginal hand painters produced full-scale orthographic views by placing their palms flat against the wall to yield one-to-one correspondence between object and image, but architects usually make scaled orthographic projections—scaled-down plans, elevations, and sections.)

An even more important improvement, which complicates the mathematics only slightly, is to provide for projection onto an arbitrary picture plane (figure 6.6b). The resulting image always resembles a photograph made from a great distance with a very long telephoto lens, and it can be varied by manipulating the *view direction* parameter. (You can experiment with this by constructing a physical wireframe scale model, rotating it in sunlight, and observing the behavior of the shadow.) Choice of a view direction will usually depend on which shapes and proportions the artist wishes to leave undistorted and which can be foreshortened. Faces of the projected object that are parallel to the picture plane will always remain undistorted: that is, they will appear in true plan or elevation. If no faces are parallel to the picture plane, then the result is an axonometric projection. Depending on the viewing angle, and thus the ways that different faces are foreshortened, such axonometric projections may be classified as either transmetric, isometric, dimetric, or trimetric (figure 6.6c).

A limitation of this parallel-projection procedure is that it destroys all z-coordinate information; that is, information about depth back from the picture plane. This often results in spatial ambiguity. Artists typically vary line weight or introduce line breaks to overcome this. Projection procedures that systematically vary shape to express depth can also be used to reduce the ambiguity.

If z coordinates are multiplied by a constant *shift factor* and the results are added to the x coordinates, the result is a horizontal oblique projection—one in which shapes slide sideways with depth back from the picture plane (figure 6.6d). The amount of sliding can be controlled by varying the shift factor. Images made in this way follow the pictorial conventions characteristic of Chinese and Japanese painting rather than those of photography. Architects often make use of a variant of this idea—the vertical oblique projection—to produce drawings in which the floor planes of a building are parallel to the picture plane (so that the plan is shown undistorted), and the vertical edges of walls, columns, and so on are shown as vertical lines. These projections are easy to construct with a parallel bar and adjustable triangle, and can reveal the organization of architectural space with particular clarity. The "worm's-eye" version (popularized by Auguste Choisy) shows the development of a plan organization into three-dimensional space, while the "bird's-eye" version (a favorite of the de Stijl architects) emphasizes roof forms and exterior massing.

An alternative convention, characteristic of much Western painting, is to divide x coordinates and y coordinates by z coordinates to diminish shapes with their distance back from the picture plane. In effect, objects are scaled

down according to their distance. This produces the standard linear-perspective projection—as demonstrated by Brunelleschi, formalized by Alberti, produced automatically by a pinhole camera, and closely approximated by a lensed photographic camera. Indeed, traditional perspective-construction methods that involve horizon lines and vanishing points are just rather cumbersome, manual, analog procedures for dividing by the z coordinate (figure 6.7). In computer graphics they have been replaced by efficient, automatic, digital ones.

Standard linear-perspective projections seem "natural" to most Westerners—partly, no doubt, because they have become habituated to the convention, but also because this convention corresponds in a simple and direct way to the optical fact that the angle subtended by an object diminishes with its distance from the eye, so that distant objects are perceptually scaled down. However, many kinds of nonstandard perspective projections can also be produced by making x coordinates and y coordinates arbitrary functions of depth. For example, if coordinate values are divided by some multiple or exponent of z, then an exaggeratedly "deep" perspective results.[10] Panoramic and fisheye effects can be produced by functions that, in effect, map onto nonplanar surfaces. Painters who work on domes, vaults, and other concave curved surfaces also have to make use of these sorts of projections—a complicated matter, because straight lines in space no longer, in general, map to straight lines on the surface as they do in standard perspective.[11] Similarly, Parmigianino's poetically celebrated *Self-Portrait in a Convex Mirror* must have required very careful working out of the "reflected" image's mapping onto its hemisphere of wood. If coordinate values are multiplied rather than divided by z, then a "reverse-

(a)

(c)

(b)

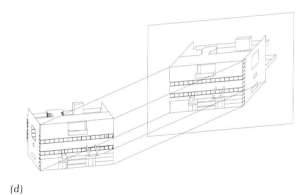

(d)

6.6 Parallel projections of a building.

 a. Plan and elevation orthographics.

 b. Axonometric orthographic.

 c. Varieties of axonometric.

 d. Oblique.

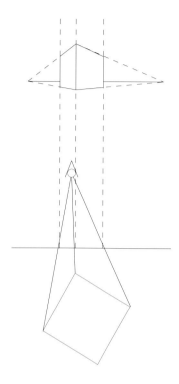

6.7 Traditional perspective construction.

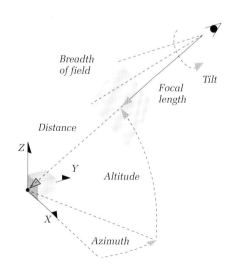

Breadth of field

Tilt

Focal length

Distance

Z

Y

X

Altitude

Azimuth

6.8 Viewing parameters for computed perspective.

perspective" image results: foreground objects are diminished and background objects grow larger (an effect that has been explored by David Hockney).

Viewing Parameters

The parameters of a standard perspective-projection algorithm correspond to those manipulated by a photographer.[12] The most important ones are *station point* and *direction of view,* which together establish the principal line of sight (alternatively known as the viewing vector) through the picture plane to the scene (figure 6.8). By varying these parameters an artist can change the number and positions of vanishing points in an image. A building, for example, can be shown in one-point, two-point, or three-point perspective (figure 6.9). Choice among one-point, two-point, and three-point perspective projections is largely a matter of convention. From the Renaissance onward, painters and architects have favored one-point and two-point perspectives because they correspond to a horizontal line of sight directed at a building with vertical walls and because they are relatively easy to construct with traditional drafting instruments. (Ceiling paintings are a variation on this: usually they are one-point perspectives with a vertical line of sight, so that architectural verticals rather than horizontals converge.) But photographers and cinematographers wield instruments that can be pointed at any angle with equal ease (exact horizontals are often, in fact, difficult to achieve) and are less concerned with the special characteristics of architectural geometry, so they have been much less inclined to work within the strict conventions of one-point and two-point perspective.

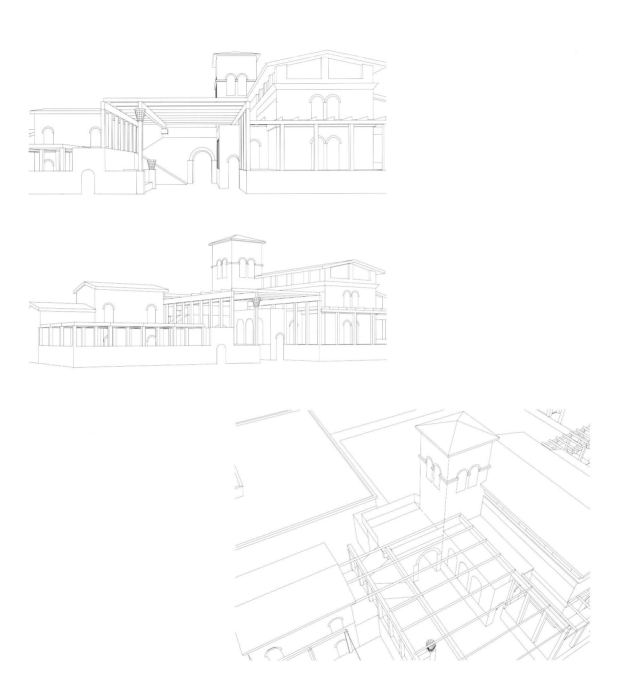

6.9 One-, two-, and three-point perspectives of an
architectural composition.

6.10 Wide-angle and telephoto views taken from the same station point.

The *angle* subtended at the apex of the viewing pyramid may also be varied to include more or less of a scene and to yield either a wide-angle or a telephoto "look" (figure 6.10). The difference between wide-angle and telephoto effects follows from the fact that projection lines near the center of a picture are approximately perpendicular to the picture plane, while projection lines near the edge are sharply angled to the picture plane. (When the viewing angle expands to 180 degrees, the outermost projection lines are parallel to the picture plane.) The result is that objects near the center of a perspective image appear in true proportion, while objects closer to the edge seem progressively more distorted. This effect is rarely noticeable in human vision, since attention is usually concentrated on the center of the field of view. But dramatic differences show up in photographs that occupy only a small part of our field of view: those taken with a long telephoto lens approximate orthographic projections, while those taken with a lens with a very wide angle seem quite distorted. When the viewing angle is about sixty degrees, a scene usually appears "normal" (so architectural perspectivists usually choose this angle for their perspective constructions).

Next, there are pitch and yaw *picture-plane rotations* like those of a view camera. (They can also be accomplished by printing a negative on a slant.) These result in elongations and compressions of the perspective image—effects exploited in anamorphic art and in "perspective-corrected" architectural photographs.[13] Anamorphic images look highly distorted—indeed may be virtually unreadable—from a conventional viewing position (figure 6.11). But when viewed from the appropriate location, the images pop into "normal" perspective.

6.11 A perspective anamorphism.

Finally, the picture plane can be placed anywhere along the principal line of sight. Moving the picture plane can dramatically change the apparent size and distance relationships between objects in a scene, and so can be extremely deceptive.[14] Specifically, if we want a perspective image to be like a true "window" onto a three-dimensional scene, we must carefully ensure that the actual distance between the viewer's eye and the image corresponds closely to the assumed distance between the station point and the picture plane. Renaissance and baroque ceiling painters often achieved breathtaking spatial effects through use of this device. They arranged the perspective station point to correspond to the viewer's actual location on the floor below and elided the frame by carefully camouflaging the transition from actual to painted architectural elements. When you stand at the right point and look up, the foreshortening snaps into place, and the solid ceiling seems suddenly to open up to the heavens.[15] (Giovanni Lanfranco's ceiling frescoes for the Villa Borghese and S. Andrea della Valle in Rome and Guercino's "Aurora" ceiling for the Casino Ludovisi come particularly to mind.)

In photography, an effect equivalent to that of moving the picture plane can be produced by operations of cropping and enlarging negatives. When photographic prints are used as evidence in courts of law, the court usually requires them to be produced in standard ways so that they are in "true perspective." Essentially, the viewing angle for the observer of the print must be the same as that of the camera pointed at the scene. Viewing angles will match, as required, when the observer's distance from the print is given by the formula $D = F \times N$, where D is the observer's distance,

F is the focal length of the lens, and *N* is the number of times the negative has been enlarged (all in the same units). Fifteen inches is usually taken as the standard viewing distance for a hand-held print. This means, for example, that a 35-mm negative made with a 50-mm lens should be enlarged to 7½ by 11¼ inches, but if it is made with a 28-mm lens it should be enlarged further to 13½ by 20 inches, and if it is made with a 100-mm lens it should be enlarged to only 4 by 6 inches. If the 28-mm image is printed too small, there will be exaggerated foreshortening of shapes near the edge of the frame; and if the 100-mm image is made too large, the depth of the scene will seem compressed. Similar effects can be produced by cropping (hence photographs used as evidence usually must be made from the entire negative.)

When selecting values for viewing parameters, the perspective artist needs to consider the appropriateness of the implied camera position to the purpose of the image. If an image is intended to present the experience of an architectural space, for example, it usually makes sense to take the view at normal eye height, from a location that would be physically accessible, and with a viewing angle that is not unusually wide or narrow. But artists sometimes choose unusual values for rhetorical effect. Andrea Mantegna, for example, painted *The Dead Christ* in extreme foreshortening with the body's feet hard up against the picture plane. As Heinrich Wölfflin noted in *Principles of Art History*, Peter Paul Rubens, Tintoretto, and other baroque painters often chose dramatically close or distant station points. More recently, photographers such as Chuck Close and film makers such as Spike Lee have effectively exploited the wide-angle,

in-your-face, extreme close-up. The converse effect of compression produced by aiming a telephoto lens at a distant scene has been used so frequently that it has become a cliché.

Computer perspectivists have far greater freedom in choosing viewing parameters than either painters or photographers. Painters and traditional architectural delineators are constrained by the technical difficulty of constructing views from certain positions and frequently opt for viewpoints and gaze directions that result in relatively straightforward one-point or two-point views. Photographers face the problems of finding physically possible places to stand, of avoiding occluding foreground objects, of finding moments when the light is right, and face the limitations of the lenses and other equipment that they happen to be carrying. Sometimes they must use cumbersome aids like tripods and camera cranes. But computer perspectivists can station themselves wherever they want in their virtual worlds and can set their virtual cameras in whatever ways they desire.

Hidden Lines and Surfaces

A wireframe view exhaustively delineates the skeletal geometry of a scene.[16] It is the abstracted view of mathematicians who, as Alberti put it in his treatise *On Painting*, "measure with their minds alone the forms of things separated from all matter." (Some Renaissance theorists also suggested—anticipating Superman's X-ray vision—that wireframes represented the view of God, who could see through everything.[17]) Speaking as a painter, Alberti went on, "Since we wish the object to be seen, we will use a more sensate wisdom." He then argued, in essence, that the painter's funda-

mental intellectual program is to study and render the appearances of surfaces in light. Central to the agenda of computer-graphics researchers has been development of algorithms to render these appearances automatically.

A first step toward realistic depiction of surfaces is to portray their opacity—the way that some surfaces in a scene occlude others (figure 6.12).[18] Algorithms to accomplish this automatically cannot operate on simple line models: they obviously require surface or solid models that specify where the opaque surfaces are located. However, they do not require any information about surface qualities or lighting conditions.

Procedures for visible-surface determination work by culling and sorting surfaces.[19] First, they discard all surfaces that are outside the viewing pyramid or facing away from the observer. Those surfaces that face toward the observer and intersect the boundaries of the viewing pyramid are "clipped" to the boundaries.[20] The remaining surfaces are sorted by depth back from the picture plane so that only those closest to the observer are displayed. If surfaces are shown by their outlines, this results in a "hidden-line" image with correctly rendered occlusion.[21] These images are uncannily reminiscent of early Renaissance drawings—by Paolo Uccello or Piero della Francesca, say—with their pedantic outlines, surface meshes, and mechanical lucidity. The effect is of a frozen moment, since any movement of the station point or motion in the scene—as in a long-exposure photograph— would disrupt the perfectly consistent relationship between foreshortening and occlusion of objects in the scene.

A hidden-line rendering algorithm applied to a three-dimensional geometric model produces

6.12 Opaque surfaces: wireframe and opaque shaded views of an object from Sebastiano Serlio's *Five Books of Architecture*, 1611.

essentially the same result as an edge-finding filter applied to a digital image of a scene. Both reduce a scene to a map of discontinuities and follow the convention of representing these discontinuities by lines. In the former case the algorithm begins with information in which projected occluding surfaces are explicitly presented, but edges are only implicit in the relationships of surface intensities. A filtering operation is applied to make the edges explicit—much as a topographic draftsman might trace edges to convert a scene projected onto the screen of a camera obscura into a line drawing. In the latter case the algorithm begins with information in which edges are already explicit, but the shapes and ordering of the projected occluding surfaces that they bound are only implicit in their relationships to each other and to a viewpoint. Projection and sorting operations are applied to make the profiles and their depth layering explicit—much as an architectural draftsman might construct a perspective from plan and elevation line drawings. In both cases the result is an organization of lines on a plane to suggest opaque surfaces in space.

Invasion of the Body Snatchers

A hidden-surface perspective view—whether photographed, hand constructed, or computed—implies an eyewitness. It suggests that there was an observer at the station point, and it puts us precisely in the shoes of that invisible observer. We are invited to see what that observer could see.

Diego Velázquez's *Las Meninas* (figure 6.13) dramatizes this displacement by actually revealing the observer—by showing us that we have been conflated with Philip IV, who stands beside his wife Maria Ana.[22] The couple return our gaze from a mirror opposite us. We cannot see ourselves, since we are inside the skin, behind the eyeballs of the king. It is like *Invasion of the Body Snatchers* from the point of view of the invading pods: we look in the mirror and see somebody else looking back. We are confronted with the paradox of disembodied viewing—a paradox that every photograph and every consistently constructed perspective contains.

Computed perspectives can displace us further. They can take us beyond the boundaries of the real world and insert our disembodied viewing presences into modeled fictional worlds—three-dimensional worlds that once were, might have been, will be, or are projected forward by designers, imagined by film directors, sought by visionaries, proffered by dissimulators. In hyper-Cartesian fashion, our perceiving faculties are pried apart from our corporeal existence and sent to places where our bodies cannot follow.

By exactly matching the projective conventions of photography, computed perspectives adjoin these constructed fictional worlds to the actual three-dimensional world that photography so assiduously and convincingly records. To the extent that computed perspectives can be shaded in photorealistic fashion, so that computed perspectives and photographs become graphically indistinguishable (an issue that we shall consider in the next chapter), the borders between the actual world and these fictional worlds will be increasingly difficult to identify and maintain. Without knowing it, we may cross those borders and step into the shoes of phantoms.

6.13. The implied eyewitness: Diego Velázquez,
Las Meninas, 1656. The Prado, Madrid.

7.1 A computer-rendered view of the interior of Le Corbusier's chapel at Ronchamp. Courtesy Eric Haines, 3D Eye.

■ **The Logic of Light**

Synthetic-shading procedures are used to develop perspective views into closer approximations to—even simulations of—photographs (figure 7.1).[1] (Thus they are closely analogous to the procedures Renaissance artists employed to convert line cartoons into tonal and colored paintings.[2]) They do so by applying mathematical formulae that convert model information about surface orientations and reflectivities into pixel values. Their parameters can be manipulated to simulate the effects of different types of light sources at different locations in a scene.

The repertoire of available shading procedures now extends from very simple ones that require only rudimentary descriptions of light sources and surfaces and that render limited ranges of effects to complex and computationally demanding ones that require extensive information about the light sources and surfaces but that render a scene with astonishing verisimilitude. In general, the simpler algorithms are based on quite rough approximations to the laws of optics and thermal radiation that govern the spatial and spectral distribution of light energy within a scene, while the more sophisticated ones take account of the precise details of these laws.

Intrinsic Color

The very simplest of all shading algorithms assumes that each surface in the scene has an intrinsic tonal value—expressed on a scale

between 0 for pure black and 1 for pure white—
and that this value is unaffected by lighting
conditions. Thus, when a hidden-surface view
is computed, the surfaces can be rendered with
their intrinsic values to produce a more highly
differentiated scene. An obvious elaboration
is to associate an intrinsic color (usually ex-
pressed in terms of red, green, and blue inten-
sity components) with each surface to produce
a view in which each surface is rendered as a
flat, colored silhouette—much as in Japanese
prints or in Paul Gauguin's Tahiti paintings
(figure 7.2). It is sometimes effective to com-
bine this simple kind of shading with edge
outlining, as in the traditional architectural
rendering technique of combining drafted ink
line work with wash infill.

Adrian Stokes wrote of the "tendency of true
colorists to discount the separateness of illumi-
nation, to identify it with the color of objects
so that these objects appear to be self-lit in vir-
tue of their color" and contrasted this with
paintings in which the "resistant otherness of
color" is suppressed and an object's intrinsic
surface qualities are "reduced by the peculiar-
ity of its illuminant."[3] Here we shall take abso-
lute intrinsic color as the base and then
consider how the peculiarities of the illumi-
nant can, if we wish, be given increasing
weight in the computed rendition of shading.

Ambient Light

The most elementary way to provide for modi-
fication of intrinsic colors by lighting condi-
tions is to assume that the scene contains
ambient light—diffuse, nondirectional light
that results from a multitude of sources and in-
terreflections in a scene. A clear, moonless,
starry night approximates a scene illuminated

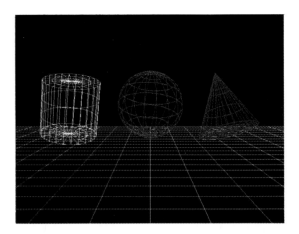

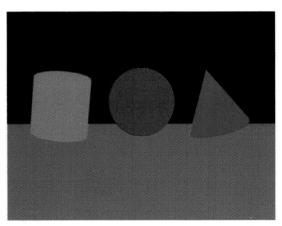

**7.2 A simple scene rendered in wireframe and as
opaque colored surfaces.**

by a low level of ambient light, while a room with dazzling white surfaces and numerous fluorescent tubes approximates a scene illuminated by a high level of ambient light.

The intensity of ambient light can be specified as a value that varies between 0 and 1. (Representation of ambient light by a single intensity value is actually a very simple first approximation to modeling the distribution of diffuse light in a scene.) Surface colors can then be computed simply by multiplying together intrinsic intensity values and the ambient light value. This is equivalent to applying a darkening filter, as discussed in chapter 5: low ambient light yields a dark image, and increasing the ambient light produces an overall lightening effect.

Lambert Shading

Ambient-light shading is too crude for most practical purposes. Painters and graphic artists usually want to shade surfaces differentially in order to indicate orientations and curvatures and to create the impression of pictorial space (figure 7.3). Leonardo da Vinci observed in his notebooks that this lay at the foundation of the art of painting:

The first intention of the painter is to make a flat surface display a body as if separated from this [picture] plane, and he who most surpasses others in this skill deserves most praise. This accomplishment, with which the science of painting is crowned, arises from light and shade, or as we may say *chiaroscuro*.[4]

Leonardo studied this problem by making numerous careful drawings of the reception of various kinds of light by various kinds of sur-

7.3 Simple differential shading of surfaces indicates orientations and curvatures of surfaces and creates the impression of pictorial space.

faces. Later scientists were to produce quantitative laws—the laws of geometric optics—that provide the basis for the surface-shading algorithms used in computer graphics.

The most basic of such laws is Lambert's cosine law, discovered by the sixteenth-century physicist and astronomer Johann Lambert and now familiar to every student of elementary physics (figure 7.4). It reduces to a precise formula the fact long known to painters, and noted by Leonardo, that the intensity of light reflected from a plane surface is related to the angle of incidence of the arriving light. If we assume perfectly uniform flow of light in one direction and perfectly diffusing surfaces, we can take it that intensity of a surface is determined entirely by diffuse reflection—uniform scattering in all directions of energy arriving at the surface from the light source. Lambert's law states that the intensity of this scattered light is proportional to the cosine of the angle of incidence. Thus intensity diminishes as a surface is tipped obliquely to the light source. Light incident perpendicular to the surface is scattered with maximum intensity, while light parallel to the surface is not reflected from that surface at all. The form of the cosine function assures that the drop in intensity is rapid in the middle ranges but that it flattens out at both extremes. Since light is scattered equally in all directions, the amount of reflected light reaching a viewer is independent of that viewer's position: apparent intensities of surfaces do not change as the viewpoint changes.

A simple but remarkably effective way to shade plane-faced objects, then, is to specify lighting direction, calculate the surface normals of faces, and use a cosine function to calculate surface intensities. Old-fashioned drawing books demonstrate how to shade according to this logic with tonal media like

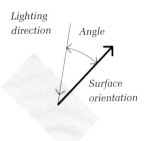

7.4 Lambert's cosine law.

charcoal or watercolor wash or by building up crosshatching. The Lambert-shading algorithms that are widely used in computer graphics accomplish exactly the same thing.[5] They produce effects much like that of a matte-surfaced architectural model photographed in diffuse light.

The simplest way to perform Lambert shading is to adopt a standard convention for the direction of light: a traditional architectural convention, for example, is to let light arrive from over the viewer's left shoulder, at angles of 45 degrees horizontally and vertically from the principal line of sight. Usually, though, Lambert-shading algorithms incorporate a parameter allowing the artist to control *lighting direction*. This can be used to shift emphasis to different surfaces in the scene and to achieve differentiation of adjacent surfaces. If, for example, the arriving light exactly bisects the angle between adjacent surfaces of the same intrinsic intensity, those surfaces will be shaded with the same value and thus not distinguished; but if the arriving light is incident on these adjacent surfaces at substantially different angles, they will be clearly distinguished.

To illustrate the effect of lighting direction under Lambert shading—much as we might explore it in the photography studio—let us consider the various ways to light a matte-surfaced monochrome cube (figure 7.5). One extreme possibility is to present a vertex symmetrically to the light: this completely grays out and flattens the cube. At the opposite extreme, we might direct the light perpendicularly at one surface and thus parallel to the others: this produces a very dramatic, high-contrast effect (one sometimes exploited by architectural renderers), but it loses detail in the blackness. A third option is to light the cube as asymmetrically as possible to produce maximum tonal differentiation of the visible surfaces from each other and from the black background.

The essential result of Lambert shading is to add to an image information about the orientations of surfaces. This clarifies angular relationships between surfaces and enhances the illusion of pictorial depth by apparently placing surfaces at various angles to the picture plane. Foreshortening and shading begin to work together to show three-dimensional shapes and relationships more clearly, "thus mutually compleating the idea of those recessions which neither of them alone could do," as William Hogarth noted in *The Analysis of Beauty*. This visual strategy was well known to Renaissance painters. The revolutionary spatial clarity of Giotto's frescoes in the Scrovegni Chapel, Padua, for example, results largely from their combination of carefully observed foreshortening with what is, in effect, meticulously consistent Lambert shading.[6] Each depends on the other: foreshortening is hard to grasp if pictorial light is inconsistent, and pictorial light cannot be consistent if the orientations of surfaces are ill defined.

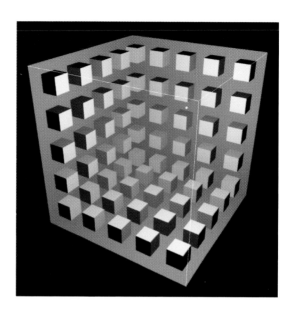

7.5 The effect on Lambert shading of varying lighting direction: a light source placed at the center of a hollow cube of blocks differentiates the surfaces of the blocks in widely varying ways.

Curved-Surface Shading

Lambert-shaded images of curved surfaces that have been approximated by small planar facets are reasonably realistic when the facets are small enough, and some painters (notably Cézanne) have valued the formal qualities that result from reduction of continuous surfaces to simpler planar organizations. But for artists with other intentions (Ingres, say), the broken-up effect of a faceted rendering is not what is sought.

Where fine nuances of surface curvature and the resulting subtle modulations of light are of primary interest, it is appropriate to use a shading procedure that smoothly distributes intensities instead of changing them abruptly at facet boundaries. Alberti formulated the task in his treatise *On Painting*, and suggested the following way to proceed:

Remember that on a flat plane the color remains uniform in every place; in the concave and spherical planes the color takes variations; because what is here light is there dark, in other places a median color. This alteration of colors deceives the stupid painters, who, as we have said, think the placing of the lights to be easy when they have well designed the outlines of the planes. They should work in this way. First they should cover the plane out to the outlines as if with the lightest dew with whatever white or black they need. Then above this another and then another and thus little by little they should proceed. Where there is more light they should use more white.

A simple computational equivalent is to calculate intensities at the centroids of planar facets, then to interpolate intensities linearly between these to produce smooth tonal variation. Linear interpolation is a numerical version of grading a watercolor wash or smearing charcoal with the finger. The procedure is known as Gouraud interpolation. The calculations involved are simple and are now often performed rapidly by special-purpose hardware, but the resulting effect can be very convincing (figure 7.6). The colored images that result from this treatment have the simplicity and clarity that characterize Early Renaissance painters such as Duccio and Uccello. Colored areas have well-defined boundaries, and subtle effects resulting from interreflection of colored light within the scene are absent. The shades grade off into black, the lights grade off to white, and chromatic effects are most pronounced in the middle ranges—an effect that painters achieve by mixing pure pigments with white and black to produce tints and tones.[7]

An alternative technique for producing smooth shading is to interpolate surface normals (which represent surface orientations) rather than intensities across a faceted approximation to a curved surface. In effect, the faceted surface is geometrically smoothed before intensities are calculated. This procedure is called Phong interpolation. It requires more computation (much less of a consideration now than in the early days of computer graphics), but produces more realistic results. It works best when the changes in orientation between adjacent facets are small. (When the changes are great, visible discontinuities may result.) Thousands of polygons may be needed to approximate a complex curved surface adequately, and in this case it may be better to work with a model that represents curved surfaces mathematically, thus allowing surface normals to be calculated accurately at any point.

7.6 Smooth shading of curved surfaces.

Whatever shading technique is used, objects with curved surfaces appear in dramatically high relief when they are shaded with a full tonal range and shown against a dark ground. Leonardo noted this in his advice to painters:

The utmost grace in the shadows and the lights is added to the faces of those who sit in the darkened doorways of their dwellings. Then the eye of the beholder observes the shaded part of the face thrown into deeper shade by the shadows from the aforesaid dwellings, and sees brightness added to the illuminated part of the face by the radiance of the atmosphere. Because of such increases in the shadows and light the face acquires great relief, and in the illuminated part the shadows are almost indistinguishable, and in the shaded part the lights are almost indistinguishable. The face depicted in this way acquires much beauty with the increase in shadows and lights.

Since we normally assume that light falls from above (the sun cannot shine from below the horizon), the effect of relief due to curved-surface shading may be reversed if light comes from an unexpected direction. Thus cameos can seem to become intaglios when lights are rotated around them, and building facades can seem strangely reversed when they are illuminated by floodlights from below rather than sunlight from above.

Specularity and Highlights

A perfectly matte surface scatters incident light equally in all directions, but a perfect mirror reflects light directionally—according to the law that the angle of reflection is equal to the angle of incidence. Most real materials exhibit

a mixture of these two behaviors: they scatter some of the incident light and they reflect some of it directionally. This directional component is responsible for the appearance of highlights (figure 7.7). Essentially, highlights are diffuse reflections of light sources. (Even the most skilled and observant artists have not always succeeded in getting this quite right: Maurice H. Pirenne has pointed out that Hogarth's engraving *A Modern Midnight Conversation* clearly shows the highlights on glassware as reflections of bright, obviously daylit windows.[8]) The position and appearance of highlights thus depend not only on the positions of the light sources, but also on the position of the viewer's eye.

Painters and photographers have long observed that the appearance of highlights is governed by three basic rules.[9] First, the color of the highlight is usually that of the light source rather than that of the surface (though there are some exceptions to this rule).[10] Second, highlights are intense and concentrated for very glossy surfaces but spread out and become less intense as glossiness diminishes. Third, highlights are brightest when the viewer's station point lies in the mirror direction.

Computer methods for rendering highlights replicate these effects. A standard approach is to describe a surface by both a diffuse-reflection coefficient and a specular-reflection coefficient, plus a third coefficient (often called roughness) that controls the size of the highlight. The Phong-shading procedure is then elaborated slightly to take account of the additional parameters.

In simple Phong-shaded images with specular reflection, objects look as if they are made of colored plastic and seen under harsh white light. This is because plastic does not shift the

7.7 Highlights on specular curved surfaces rendered by Phong shading.

7.8 Color-shifted highlights and reflections produce a metallic effect.

color of highlights. Whatever the color of the plastic, illumination by white light will produce white highlights. But some other materials do shift highlight colors. Polished gold, for example shifts highlights toward its own yellow color. More sophisticated shading algorithms provide a parameter to control how much color shifting should take place, and thus can render the appearance of metals and other materials more accurately (figure 7.8).[11] Incidentally, Renaissance painters made frequent use of color shifting—for example, a move to yellow in the lights and violet in the shadows—not only for verisimilitude, but also for effective color composition. Thus a painting by Andrea Mantegna is typically much livelier in coloring than a Phong-shaded scene. His *Madonna and Child with Saint John and Mary Magdalene* in the National Gallery, London, shows particularly spectacular color shifting in the draped garments of the figures.

Highlights in a rendered scene have several important graphic effects. They provide additional depth cues and additional information about surface curvature: Edward Weston exploited this brilliantly in his studies of peppers, shells, and nude torsos. They convey some information about material: reflections from matte painted surfaces, for example, have no specular component, while reflections from metallic surfaces have specular and ambient but no diffuse components and exhibit considerable highlight color shifting; reflections from black polished marble have only a specular component; and reflections from shiny plastic have ambient, diffuse, and specular components with no highlight color shifting. By suggesting the viewer's position, highlights can locate the viewer "in" the simulated scene and thus create greater emotional engagement with it. (Witness the powerful effect of highlights in

the eyes of portrait paintings and photographs, which is particularly dramatic when the viewer's eye is exactly at the perspective station point and the highlights are correctly worked out for viewing from that point.) When contrasted with dense shadows, highlights give a scene dramatically wide dynamic range—an effect that was much exploited by Rembrandt. And many small highlights can produce the kind of sparkle that John Constable achieved by rapidly dry brushing watercolor so that tiny flecks of white paper showed through.

Sometimes the effect of a photographic image depends upon the interaction of highlights and depth of focus. Small, intense highlights, when out of focus, produce conspicuous "circles of confusion." (Jan Vermeer noticed these—possibly through use of a camera obscura—and incorporated them in paintings such as *The Lacemaker*.) Thus, for example, the gradation from foreground circles of confusion to background pinprick highlights on glittering water can create a particularly strong sense of recession.

Surface Detail

So far we have considered shading procedures that respond to variations in the orientation of a curved surface and to globally-defined reflectivity properties of those surfaces, but not to local variations of reflectivity *within* a surface. In reality, however, such variations convey important information about the materiality of objects. The illuminated surface of a bronze sphere, for example, may exhibit subtle modulations of hue, lightness, saturation, and degree of polish, and the surface of human skin is—as painters and photographers have always known—endlessly varied and nuanced. Rendi-

tion of local modulations reveals the micro-structures, or textures, of complex surfaces.

The distinction between geometric structure and surface texture in a scene is, of course, relative rather than absolute. From a distance a brick wall is seen as a single textured surface. But from closer up the individual bricks are themselves seen as rectangular textured surfaces. A painter usually captures geometric structure by drawing and composing shapes and then renders surface texture by appropriately varying brushwork.[12] Some painters are particularly noted for their convincing treatment of certain textures in this way: Gerard Ter Borch for white satin, Rembrandt for coarse cloth, Frans Hals for lace, Adolphe Bouguereau for pearly skin, Ernest Meissonier for the churned-up snow under the feet of Napoleon's horses in *The French Campaign*, Henri Fantin-Latour for the skins of fruit and vegetables, and so on. In monotype printing the distinction between geometric structure and surface texture becomes particularly clear: fragments of wood, leaves, leather, skin, etc. are used to leave impressions of textured shapes. Similarly, in modeling a scene, a computer artist must decide what to describe geometrically in terms of surfaces (the wall as a whole or the individual bricks) and what to treat as texture *on* those surfaces. Then he or she must employ some appropriate procedure, analogous to brushwork, to render the texture of each surface.

Often the texture-rendering procedure is simply one of interpolation. Just as the Phong-shading technique uses a function to interpolate surface normals between points with specified orientations, so shading algorithms may incorporate functions to render textures by interpolating values for any of the coefficients used to describe a surface.[13] This technique can be used to give a surface a faded or airbrushed appearance, to produce rainbow gradations of hue, or to suggest differential polishing. More complex functions of position can be employed to construct regular surface patterns, such as those of wallpaper and woven cloth (figure 7.9). Through use of random numbers such functions can also construct statistically regular surface patterns.

Some surface patterns, such as wood grains and marbling, actually result from the intersection of a three-dimensional "solid" pattern with the surfaces of an object. Since different surfaces cut the three-dimensional pattern at different angles, many different two-dimensional patterns may be produced from the same solid pattern: end grain of wood is different from side grain, and so on. This effect can be simulated convincingly through use of procedures that construct appropriate solid patterns and intersect them with surfaces (figures 7.10, 7.11).

Yet other surface patterns, such as those of an orange's skin, sandpaper, mountainous terrain, and fur, are not merely two-dimensional but are in small-scale relief (figure 7.12). In other words, surface normals do not vary smoothly across the surface but are subject to local perturbations. These perturbations may be controlled by mathematical formulae or explicitly specified by means of gray-scale images in which intensities are interpreted as perturbations. This technique is known as bump mapping.[14]

The information provided by texture variation in a rendered scene can play an important role in interpretation. Adjacent surfaces may have similar intensities but differing textures, so that we read a texture boundary rather than

7.9 Regular patterns mapped onto planar and curved surfaces.

7.10 Wood-grain texture produced by intersecting solid patterns with surfaces.

7.11 Marble-textured objects.

7.12 Relief textures rendered by bump mapping.

an intensity boundary between them.[15] Furthermore, texture gradients may provide depth cues.[16] Just as some painters and photographers characteristically rely on tonal gradients and distinctions, and others (the colorists) rely more on variation of hue and saturation, yet others primarily deploy textural variation to structure their compositions. Some architects, such as H. H. Richardson, have also been preoccupied with textural composition. Similarly, a computer-generated image may work tonally, chromatically, texturally, or in some combination of these modes.

Notice, though, the important distinction between realistically filling in textural detail and recording textural detail that is actually there. A realistically shaded, texture-mapped architectural image may look almost as convincing as a color photograph (figure 7.13). But the photographed grains and patterns can be matched point-for-point with those on the actual surfaces of a real building, while the synthesized ones cannot. Computed texturing adds verisimilitude, but it does not report reality.

7.13 Realistic rendering of materiality by application of a variety of texture-mapping techniques.

Light Sources

In sum, many of the basic shading effects of classical painting—as exemplified, say, by Dominique Ingres or Joshua Reynolds—can be achieved by describing surfaces in terms of their basic reflectivity properties, specifying ambient and directional components of scene lighting, and computing surface shading from elementary laws of geometric optics as the weighted sum of ambient, diffuse, and specular reflections. The generalization from monochrome shading to full color is achieved by specifying reflectivity properties and light intensities in terms of red, green, and blue components and by repeating the shading

calculations for each of these components. If detailed rendering of surface texture is also of interest, then this can be added by incorporating patterns of variation into the shading procedures.

In real scenes, however, the geometric and color properties of light sources may be far more complex than we have allowed so far, and modeling these complexities can yield additional subtlety and realism in shading. We may go so far as to model the precise spatial and spectral distributions of light energy from different types of luminaires, then carefully "light" a modeled scene much as a studio photographer might (figure 7.14).

A first step is to allow for point light sources. Such sources distribute light evenly in all directions from a single point, but the intensity falls off with the square of the distance from the source to the reflecting surface. A flash photograph clearly shows the effect of illumination by a single point light source. Intensities of similarly colored surfaces diminish as the square of the distance that the light travels from the flash and back again to the camera: nearby surfaces are very bright, but distant surfaces fade into darkness. Surface intensities now become dependent on both orientation and distance, so overlapping parallel surfaces are usually separated by a slight tonal distinction. Furthermore, since the shading carries additional depth information, an enhanced effect of pictorial space often results. The great architectural delineator Hugh Ferriss characteristically combined radical foreshortening of forms with this shading convention to create architectural images that seemed to have immense scale. Shading procedures can easily be extended to produce similar effects by applying the inverse square law.

7.14 A scene lit by simulated spotlights.

If a source does not emit light evenly in all directions but concentrates it in a narrow cone, it becomes a spotlight. In this case, intensity of the emitted light falls off as some exponent of the angle from the center of the cone. So spotlights can be described by specifying location, direction, cone angle, and the decay of intensity with angle. A spotlight, in fact, produces an effect exactly equivalent to that of a surface receiving light from a point source and reflecting a highlight. Thus, as studio photographers know, spotlights can be used to position artificial highlights on objects.

This simple model can be generalized by adding parameters.[17] First, the angle of the cone may be varied: a point source (in which the cone expands to a sphere) can be thought of as one boundary case of the spotlight, and a linear beam (in which the cone angle contracts to zero) is the other. Secondly, the exponent controlling decay may be set to a high value to simulate a spotlight or to a low value to produce the effect of a floodlight. Finally, the cone may be clipped to simulate the effects of flaps and barn doors.

Other source geometries are possible. A fluorescent tube, for example, approximates a linear source. In this case, light is distributed in a cylindrical pattern, rather than in the spherical pattern of the point source or the conical pattern of the spotlight. Just as the point source can be contracted to the spotlight, so the linear source can be contracted to one that emits a wedge of light. Or a bank of fluorescent tubes can emit light from a rectangular area.

In reality, different types of sources not only have different shapes, but also emit light energy in characteristically different luminous intensity and spectral distributions: a candle does not produce the same spatial and spectral distribution as a halogen lamp. Comprehensive light-source models used in production of very sophisticated renderings must provide for description of these differences.[18]

Cast Shadows

Once the concept of light-source geometry has been introduced, surfaces can be treated not just as reflectors of light, but also as receptors of shadows. They become like that surface on which the Corinthian maiden traced the first drawing.

A cast shadow is the darkness thrown on a surface by an object that intercepts light. It falls on the side opposite to the light source and can become visible only when the light direction differs from the view direction. From early times painters have rendered cast shadows to enhance the verisimilitude and spatial clarity of scenes: cast shadows are conspicuous, for example, in the wall paintings of Pompeii. Of particular visual importance are *attached* cast shadows—ones that graphically "anchor" objects to the ground plane on which they rest. (They accomplish this by clarifying the orientation of the ground plane and by defining where objects come into contact with it.)

Where lighting conditions are complex, cast shadows become correspondingly so.[19] But there is one relatively simple, special case of shadow casting that is of particular interest to architects and landscape painters—that of a single, infinitely distant point light source. To a close approximation it is the case of the sun shining out of a cloudless sky. Calculation of shadow effects under these conditions is a matter of geometric projection rather than of spatial and spectral distribution of light energy. It was extensively treated in Gaspard Monge's

Géométrie descriptive (1799) and developed into the traditional architectural subject of sciagraphy.

The problem of determining the shapes and locations of cast shadows in a scene is very closely related to the problem of determining how opaque surfaces occlude each other—hidden-surface removal. To grasp this, imagine taking a perspective from the viewpoint of the sun. Those surfaces that the sun "sees" are in light, while the occluded surfaces and parts of surfaces are in shadow.[20] Practical procedures for computing cast-shadow polygons all make use of this insight in some way.[21] This also illustrates why cast shadows play such an important role in interpretation of three-dimensional scenes: they provide a "second view" of shapes, from a different vantage point. Sometimes this second view becomes the only source of information about the third dimension, as when the peaks and craters of the moon are revealed by the shadows that they cast.[22] Images that deprive us of the second view, such as flash photographs taken with the flash on the camera, seem very flat.

When only a single sunlike source is used to illuminate a scene, the result is an image with hard, opaque, black shadows (figure 7.15). However, the shadows can be lightened and made transparent through use of some ambient and diffuse light. Modeling in the shadows can be produced in the traditional ways employed by studio photographers, such as using several sources for key, fill, and back lighting.

If multiple sunlike sources are introduced into a scene, intersecting cast shadows will result. Shadow-casting procedures are usually designed to handle this. Images made with intersecting cast shadows convey the impression of a scene illuminated in artificial light, since the earth has only one natural sun.

7.15 An architectural scene with opaque cast shadows.

Transparency

Transparency effects are the inverse of shadowing. Where an opaque surface casts a patch of darkness, a transparent opening like a window casts a patch of light. And where an opaque surface occludes part of a scene, a transparent surface reveals part of a scene. Thus the projection and sorting techniques used for hidden-surface removal and shadow casting can be extended to render glass and other transparent surfaces (figure 7.16).

To render partially transparent surfaces, opacity coefficients can be associated with surfaces: a surface with zero opacity is then rendered as fully transparent (the background is seen through it), while a surface with 100 percent opacity is rendered as fully opaque (the background is fully obscured). Partially transparent surfaces are rendered by mixing the surface color with the background color in the specified proportion. Red, green, and blue components can be specified separately to describe colored glass and the like.

To produce convincing renderings of glass and similar materials, it is necessary to balance reflection and transmission effects.[23] Tinted glass absorbs a lot of light, transmits some (therefore casts tinted shadows and provides tinted views of the background), and presents prominent, condensed highlights on its highly polished surface but no shading or cast shadows (unless it is dusty). Ground or frosted glass, with its semi-opaque matte surface, *does* present shading and cast shadows, but its highlights are faint and dispersed. Polished, transparent window glass is visible *only* by virtue of the specular reflections that is presents.

When a reflective transparent surface is illuminated from both sides (as in the case of a window illuminated by daylight from outside

7.16 Semitransparent surfaces reveal themselves by shifting the colors of occluded objects.

and artificial light from inside), its appearance depends largely on the ratio of illumination intensities. By day, a window to a dark interior appears opaque and reflective from the outside but highly transparent from the inside. By night, when interior lights are on and it is dark outside, the same window appears highly transparent from outside but opaque and reflective from inside.

Global Illumination

The discussion so far has concentrated on direct illumination effects—those that depend solely on the properties of the light sources and of the surfaces that receive this light directly. The effects of light interreflection within a scene have been neglected (except insofar as they are approximated very roughly by an ambient-light component). Sometimes these effects are nonexistent or insignificant, as in the case of an isolated convex object. But in complex scenes they usually play an important role in determining the appearances of surfaces, and in architectural interiors they are particularly crucial.[24] Careful rendering of them not only adds verisimilitude, but also welds the parts of a scene into a subtly unified whole. Painters such as Jan van Eyck and Jan Vermeer realized their importance and devoted themselves to observing and recording their subtleties. In Vermeer's *The Art of Painting* the strong cross lighting of the model would produce the dramatic modeling more characteristic of Rembrandt if it were not softened by reflections back from unseen walls.

Cinematographers also know the importance of "interactive lighting"—the ways in which the illumination of one part of a scene may indirectly affect that of others. They must, for ex-

ample, consider the complex lighting dynamics that result from the movement of objects in scenes. And they must carefully simulate interactive lighting effects when close-ups are shot out of context and when special effects techniques are used to insert objects into scenes or to delete objects from scenes.

Accurate computer rendition of interactive lighting effects requires taking into account not only the spatial and spectral distributions of light energy from all light sources, and the reflective properties of surfaces visible from a particular viewpoint, but also the interreflections among *all* surfaces in the scene. An integral equation known as the rendering equation, which was published by James T. Kajiya in 1986, specifies in general how to calculate the light intensity at a surface in this way.[25] It is, however, very complex to solve for nontrivial cases. Thus research has focused on less general but more practical methods for calculating global illumination effects. Two classes of methods, which have complementary strengths and weaknesses, have become popular: ray tracing and radiosity. These both require an enormous amount of computation, and they began as supercomputer applications. But by the late 1980s implementations of them were becoming widely available on popular workstations and even on higher-powered personal computers.

Ray Tracing

Ray tracing (figure 7.17) is an elegant systematization and extrapolation of an idea that goes back at least to Brunelleschi's early perspective studies: that you can create an accurate perspective view by painting on a transparent screen interposed between the eye and the

7.17 Ray tracing yields accurate rendition of geometric optical effects—occlusion, cast shadows, mirror reflections, transparency, and refraction.

scene, matching shapes and colors on the picture plane to shapes and colors in the scene beyond. Leonardo advised:

Obtain a piece of glass as large as a half sheet of royal folio paper and fasten this securely in front of your eyes, that is, between your eye and the thing you want to portray. Next, position yourself with your eye at a distance of two-thirds of a *braccio* from the glass and fix your head with a device so that you cannot move it at all. Then close or cover one eye, and with the brush or a piece of finely ground red chalk mark on the glass what you see beyond it.[26]

Thus each ray in the viewing pyramid projects a color from a point in the scene to a point on the picture plane—as made clearly evident by Albrecht Dürer's famous illustration (figure 7.18). The culmination of this tradition was the notorious contention by psychologist James J. Gibson that the realism of a picture is a function of how closely a bundle of light rays delivered from a picture matches a bundle delivered from a scene.[27]

The basic strategy implemented by ray-tracing algorithms is to consider the picture plane as a fine grid of pixels placed between the viewer's eye and the scene and to send a ray from the eye through each pixel to the scene. By computing the red, green, and blue intensities reaching the eye along each ray, the color of each pixel can be established. Clearly this can become a very large task. If the grid has a resolution of one thousand by one thousand pixels, for example, it will be necessary to trace one million rays. (It is, of course, quicker to produce lower-resolution images with fewer and larger pixels—much as Seurat produced

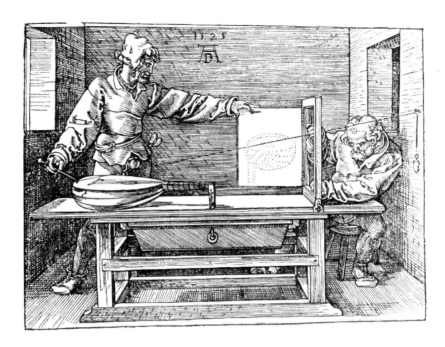

7.18 Albrecht Dürer's perspective machine anticipates the principle of ray tracing.

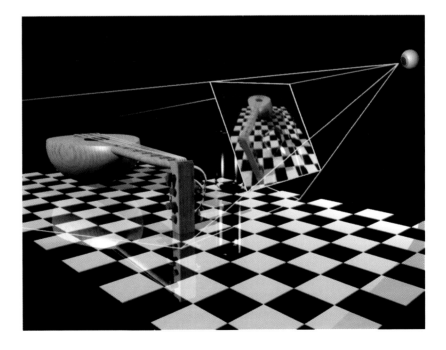

7.19 Calculating the colors of pixels in ray tracing.

relatively quick, low-resolution, preliminary sketches for his extraordinarily meticulous and time-consuming pointillist canvases.)

The recursive procedure for calculating the color of each pixel is essentially as follows, though there are many variants (figure 7.19).[28] The ray through the current pixel is traced to its first intersection with a surface in the scene. The color of that point is calculated by taking into account three effects: reflection of light reaching the point directly from light sources, reflection of light reaching the point indirectly by reflection from other surfaces, and (where the surface is partly transparent) transmission of light through the surface. To calculate the indirect and transmitted components, the ray is split into a reflected ray and a transmitted ray, and these two spawned rays are continued until they, in turn, intersect surfaces. There the calculation of direct, indirect, and transmitted components is repeated, and so on recursively (with exponential spawning of rays) until some specified limit is reached.

Ray tracing amounts to a strategy for discretizing and point sampling the scene. Discretizing is accomplished by dividing the picture plane into pixels, and sampling is accomplished by constructing the intersection trees. Like any such strategy it has characteristics that make it effective in some contexts but not in others. It works very well for highly specular scenes with point light sources, where it renders with breathtaking fidelty mirror reflections,[29] highlights, sharp cast shadows, and refraction by transparent solids. It is least effective for rendering scenes that consist mostly of matte surfaces with spot, line, and area light sources, since evaluation of integrals rather than point sampling is needed for accurate rendition of diffuse shading and interreflection effects. Effects such as soft penumbrae

and "bleeding" of colors due to diffuse interreflection between surfaces are not present in raytraced images. These limitations can be overcome, to some extent, by elaborating the basic ray-tracing procedure, but this tends to make the computations even more complex and expensive.

Radiosity

Radiosity procedures begin by dividing the surfaces in the scene, rather than the picture plane, into small discrete elements (figure 7.20).[30] Thus they are based on a different discretization strategy—one that is independent of observer position. They assume that light energy is conserved in a closed environment, and they attempt to account accurately for the way in which light emitted or reflected from each surface element is reflected from or absorbed by other surface elements. This involves calculating for each pair of patches a form factor that describes the fraction of the energy leaving one that reaches the other, then the evaluation of energy-balance equations to determine patch intensities. The form factor is dependent on the shapes and areas of the two patches, their orientations, their distance apart, and any occlusion by intervening surfaces.

For complex scenes computation of the form factors is a massive task. However, this need not be repeated when viewing parameters are changed. Thus the radiosity method is very efficient for producing multiple views or animations of static environments. If the geometry of the scene is changed in any way, though, all the form factors must be recalculated.

Radiosity procedures are particularly effective for rendering scenes composed of matte surfaces in diffuse light—such as many architectural interiors—where light spill and atten-

7.20 Subdividing the surfaces in a scene for radiosity.

uated wash effects, soft transparent shadows, and color bleeding between surfaces are important in establishing the overall effect (refer back to figure 7.1). In nondiffuse environments, however, radiosity calculations become much more complex and time-consuming to carry out—partly because the energy-balance equations become more complicated when directional reflection must be considered and partly because smaller surface patches must be used to achieve satisfactory results.

The character of some scenes derives from complex combination of diffuse and specular effects. Consider (to take a particularly famous early example) Jan van Eyck's *The Arnolfini Marriage* (figure 7.21). The faces and figures of Giovanni Arnolfini and Giovanna Cenami are gently modeled, by a flood of light from the top left, so that every nuance of surface curvature is brought out—particularly on Giovanna's swelling body as she stares into the light. There are soft shadows on the floor plane, there is a diffuse wash of window light across the plane of the wall behind them, and the interior space is unified by careful attention to the subtleties of diffuse interreflection. But there is also a sharply defined patch of luminous sky visible through the window, and the central axis dividing man and wife is occupied by specular effects: metallic highlights on the candleholder, distorted reflections in the convex mirror, the smooth glossiness of outstretched palms, and the wiry, shiny coat of the little dog.

This sort of scene can be rendered effectively (at considerable computational expense) by a two-pass process. Radiosity can be used to compute diffuse effects, ray tracing can be used to compute specular effects, and the results can be summed to produce the final image.[31] This is a digital version of the traditional

7.21 Combination of diffuse and specular effects: Jan van Eyck, *The Arnolfini Marriage,* 1434. The National Gallery, London.

painter's strategy of employing a multipass process (underpainting, scumbling, glazing, and so on) to build up a complete range of effects.

Atmospheric and Volume Effects

So far we have assumed that light is unaffected by the medium through which it travels. But Leonardo da Vinci long ago noted that light passing through the atmosphere between a surface and the eye was attenuated in intensity and changed in color.[32] This effect was accentuated by the presence of mist, dust, or smoke (figure 7.22). The greater the distance, the greater the effect—which he called aerial perspective. It later became a standard device of eighteenth-century landscape painting. The works of Claude Lorrain, in particular, exhibit a characteristic gradation from dark, brownish foreground to light, bluish background. Watercolor lends itself to rendering of aerial perspective through layering of washes. Similarly, many of the landscape photographs of Ansel Adams emphasize the delicate tonal distinctions between successively more distant landforms. (The famous 1945 print *Mount Williamson—Clearing Storm* exploits both aerial perspective and texture gradient to create an impression of enormous pictorial depth.) A simple way to approximate aerial perspective in computer-rendered images is to shift the color of surfaces in proportion to their depth back from the picture plane.

The idea of aerial perspective can be generalized to that of volume shading, where a volume is a region of space filled with material that affects the passage of light. (In general, the light will be both attenuated and refracted.) J. M. W. Turner, for example, studied volume

7.22 Attenuation of light by fog.

7.23 Diffraction of light passing through semi-transparent solids.

shading by making large, meticulously rendered watercolors of glass spheres filled with water.[33] The effects he recorded can be produced by ray-tracing procedures that take account of diffraction (figure 7.23). In his landscapes and seascapes, though, Turner tackled the much more complex task of rendering shimmering, diffuse light emanating from the sky and reflecting off water to pass through irregular volumes of mist, spray, and steam in varying densities.[34] Ruskin would no doubt be delighted to know that such scenes would tax the capacities of even the most advanced computer-modeling techniques and rendering algorithms.

Camera Artifacts

Photographs are not uniformly sharp. Since the image is cast on the film plane by a lens, rather than by a perfect pinhole, a photograph has a certain depth of field: objects within a limited range of the lens's focus plane appear accepta-

bly sharp, but objects outside that range are perceptibly blurred.[35] Narrow apertures produce wide depth of field, while wide apertures produce narrow depth of field; sophisticated photographers carefully manipulate both focus and depth of field to control density of detail and direct emphasis within an image. In effect, they apply a smoothing filter differentially with depth. Some photographers and film directors (notably Orson Welles) prefer deep-focus scenes with little of this smoothing, while others like to concentrate attention on a narrow action plane by using a wide aperture and so dramatically smoothing everything not in that plane.

Furthermore, since an exposure is not perfectly instantaneous but takes a finite time, photographs may exhibit motion blur.[36] This can result from movement of objects in the scene, movement of lights, or movement of the camera. Early photographic emulsions required long exposures, with the result that street scenes, for example, showed sharp buildings but mysteriously smeared images of moving vehicles and pedestrians—an effect that influenced some of the impressionist painters. Modern photographers use faster emulsions and shorter exposures so that motion blur is less evident, but it is still frequently present. Perfectly sharp photographs of high-speed objects, such as those of splashes and moving bullets made by Harold Edgerton, look disconcertingly strange.

The usual assumptions in computer rendering of scenes are that the virtual camera has a perfect pinhole lens and that no motion takes place in the scene as it is recorded, so that the visual artifacts characteristic of photographs are not produced. This is true to the inherent nature of the computer-graphics medium. But

when there is a need to simulate the appearance of a photograph very closely (if a synthesized image is to be blended with a captured image, for example), it is possible to modify rendering procedures so that they will produce depth-of-field and motion-blur effects.

Depth of field can be simulated by specifying focal length, focal distance, and f-stop for the virtual camera, then using these parameters to control smoothing of the image with distance from the focus plane. Motion blur can be simulated by specifying the exposure interval and the motion choreography of the scene during that interval, then computing a sequence of renderings at successive time intervals during the exposure, and finally combining these. In other words, depth of field is simulated by applying an appropriate spatial filtering strategy and motion blur by applying an appropriate temporal filtering strategy.

Photorealism

Giorgio Vasari presented his lives of Renaissance painters as parables of progress, in which successive masters found ways to render effects of light on surfaces with increasing exactitude.[37] As this transpired, expectations changed: the works of Francia and Perugino seemed, at first, to be miracles of realism; but those of Leonardo later made them seem quite naive and unconvincing. In the seventeenth century Vermeer paid even closer attention to the subtleties of surface texture and reflective qualities and to complex lighting effects such as interreflection between surfaces, washes of diffuse light across walls, and the production of intersecting shadows by multiple light sources. (All these effects are clearly visible in *The Music Lesson*, for example.) Eventually, in the era immediately preceding the birth of photography, the reputations of artists such as Meissonier and the virtuoso etcher Jacquemart were based on their extraordinary skill in convincingly rendering the minutest details of different types of surfaces under different lighting conditions.

The tale of computer image synthesis in the 1970s and 1980s, as chronicled in the proceedings of the annual SIGGRAPH conferences,[38] strikingly recapitulates the history of European painting from the miracle of Masaccio's *Trinity* to the birth of photography: the standards of verisimilitude established by Lambert shading seem to be made obsolete by those of Phong shading, and these in turn are superseded by those of ray tracing and radiosity and beyond.[39] Whereas early shading procedures were restricted to approximate rendering of monochrome, matte surfaces under highly simplified lighting conditions, more up-to-date procedures can accurately simulate complex textured surfaces under the kinds of lighting conditions that are encountered in real three-dimensional scenes. Synthesized images can now be virtually point-for-point matches to photographs of actual scenes, and there is experimental evidence that, for certain sorts of scenes, observers cannot distinguish these images from photographs.[40] They can successfully borrow the photograph's mantle of veracity and pass as true records of actual scenes and events.

8.1 Collage can destroy the photograph's strict Aristo-
telian unities of place and time: Louis Armstrong
(filmed in *High Society*) meets Elton John in a 1991
Diet Coke commercial. © 1992 Turner Entertainment
Co. All rights reserved. © 1991 The Coca-Cola
Company.

COMPUTER COLLAGE

■ **Mise en Image**

Collage—the transformation and combination of image fragments to yield new images—has traditionally been regarded as a subversion of the photograph because it destroys the normal photograph's strict, Aristotelian unities of place and time (figure 8.1). A photograph shows what can be seen from a single, fixed viewpoint, but a collage can combine multiple viewpoints or aspects of quite different scenes in a single image. Furthermore, a photograph shows things as they were at the precise moment of exposure, but a collage can combine things that took place at different moments into a single event. Whereas a straightforward photograph, like a drama by Corneille, stringently preserves the unities, a collage plays fast and loose with them, like Shakespeare. It undermines our mental geography and chronology—our conceptions of where things are and when they happened.

The history of such photographs of doubtful repute goes back to the 1850s, when early photographers sought ways to overcome the limitations of their still-primitive medium through use of a technique known as combination printing. This was described by Henry Peach Robinson, one of its best-known practitioners, as

a method which enables the photographer to represent objects in different planes in proper forms, to keep the true atmospheric and linear relation of varying distances, and by which a picture can be

divided into separate portions for execution, the parts to be afterwards printed together on one paper, thus enabling the operator to devote all his attention to a single figure or sub-group at a time, so that if any part be imperfect from any cause, it can be substituted by another without the loss of the whole picture, as would be the case if taken at one operation.[1]

To make a combination print, a photographer first produced multiple negatives of objects photographed against black grounds or of scenes with portions masked out by hand. Then the negatives were successively printed on the same piece of paper, with careful attention being paid to softening or vignetting of edges, where necessary, to obtain a natural effect. Some astonishingly complex and seamlessly executed combination prints were made within a few decades of the birth of photography, in particular Robinson's *Fading Away* (1853), and Oscar G. Reijlander's *The Two Ways of Life* (1857), which was made with thirty negatives (figure 8.2). Such prints have frequently been reviled by modernist photographers as the misbegotten offspring of photography and painting, and modernist historians have been loath to recognize them as a legitimate part of photography's lineage, but the technique of combination printing has succeeded in finding a few notable recent exponents, particularly Jerry Uelsmann.

A related technique is *photomontage*—cut-and-paste combination of image fragments to produce new compositions. This creole of photography and graphic design was popular among European artists of the 1920s and 1930s: Max Ernst and others enlisted it in service of the surrealist program, László Moholy-Nagy produced frozen choreographies of cutout photographed figures in spaces evoked by

sparse drawn lines, and John Heartfield meticulously constructed biting political satires from contemporary news photographs. More recently, David Hockney has assembled large images in approximate fisheye or cylindrical panoramic perspective from many small, overlapping photographs that record roughly adjacent scene fragments.[2] Some collage artists, like Moholy-Nagy and Hockney, have presented assemblages of disparate pieces that, with ironic or deprecatory intent, frankly reveal seams, sutures, and discontinuities—the traces of their construction. Others, particularly Heartfield, have sought an illusion of unity similar to that achieved in Victorian combination prints.

But physical collage of photographic fragments—by cutting and pasting, masking, airbrushing, rephotographing, multiple exposure, printing from multiple negatives, and the like—is usually technically difficult, time-consuming, and fairly easily detectable. So, although it has had successful exponents, it has until now remained marginal to the practice of photography. This situation has changed dramatically with the emergence of the digital image: the tools for electronic collage of digital image fragments have become widely available, they are quick and easy to use, and their application can be almost impossible to detect. Furthermore, electronic collage allows ready combination of synthesized images with captured ones—to place synthesized objects in real scenes, or real objects in synthesized scenes. Just as execution of a brush stroke is a fundamental painting operation and exposure is a fundamental photographic operation, so selection, transformation, and assemblage of captured, synthesized, and drawn fragments to reconstitute the *mise en image* are fundamental operations on the digital image.

8.2 Traditional combination printing: Oscar G. Reijlan-
der, *The Two Ways of Life*. International Museum of
Photography at George Eastman House, Rochester,
New York.

Cutting and Pasting

Cutting and pasting of a digital image fragment displayed on a computer screen is accomplished by picking out a set of contiguous pixels (using any of the selection techniques discussed in chapter 4) and copying their values at some new location in the raster grid (figure 8.3). This new location can be specified by placing a cursor somewhere in the selected area and clicking to establish a reference point and then by moving the cursor across the surface of the image and clicking again to specify the destination point. The interface is usually arranged so that the first click appears to "pick up" the selected fragment, movement of the cursor appears to "slide" the fragment across the image, and the second click appears to "paste" the fragment permanently in place. This metaphor was popularized by early versions of the Macintosh personal computer and associated graphics programs such as Macpaint.

If the pixel values at the original location of the cut-and-pasted fragment are left unchanged, then an effect of duplication is produced. Alternatively, these pixels may be reset to a uniform background color to yield the effect of a "hole"—just as in physically cutting and pasting a fragment of a photographic print.

Fragments may be cut and pasted not only within an image, but also between images. (The ease with which this can actually be done depends primarily on the capabilities of the operating system of the particular type of computer being used.) Thus the digital collager, like the traditional photographic collager, can begin with a stock of source images and can, piece-by-piece, assemble fragments of these into an entirely new image.

8.3 A scanned image of a leaf (left) is rescaled and re-
colored, and an image of a shell is cut-and-pasted into
the resulting image to produce a computer collage:
Shell and Leaf, scanned images and collage, by Elaine
Fisher.

8.4 Removing the statue of John Harvard from Harvard Yard by copying the background texture over the foreground object.

Cutting and pasting can obviously be used to move objects around (that is, when they exist in perspective space, to translate them parallel to the picture plane) and to insert objects into scenes. Less obviously, it can be used to remove foreground objects from scenes by copying background textures over them (figure 8.4). And sometimes it is employed for "reverse cropping" images—extending them at edges to fit desired formats. An area of sky might be replicated at the top to transform a horizontal picture into a vertical one, or a wall might be extended at one side to make a picture more horizontal.

Rotating and Reflecting

These elementary techniques of cutting and pasting can readily be extended to provide not only for translation of selected fragments to new locations, but also for additional geometric transformations that alter the orientation, handedness, size, and shape of those fragments. (Figure 8.5 illustrates a general taxonomy of these transformations.) For our purposes here, they should be understood not simply as operations on arbitrary two-dimensional shapes, but as manipulations of shaded objects that exist in perspective space.

The most basic are the additional isometric transformations of rotations by multiples of ninety degrees and reflections across horizontal and vertical axes (figure 8.6). (Traditionally, photographers have accomplished these transformations by rotating the print rectangle relative to the negative and by flipping over the negative—practices that are sometimes regarded as unethically deceptive.) Rotations by arbitrary increments are less straightforward to produce, however, and the results can be less

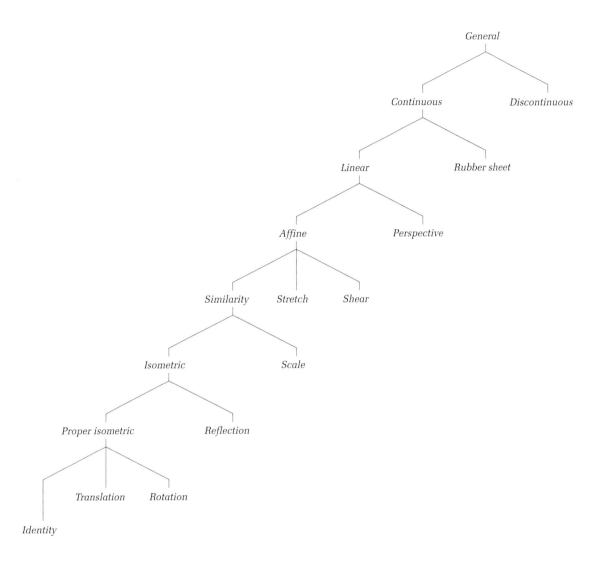

8.5 A taxonomy of geometric transformations.

8.6 A symmetrical pattern produced by isometric transformation and replication of an image fragment.

satisfactory, since rotated pixels will not, in general, correspond exactly to pixels in the original grid. Thus arbitrarily rotated shapes must be reapproximated to the pixel grid, and perceptible distortion of profiles and patterns often results. However, if the resolution of the image is fine enough, arbitrary rotation can be used to perform operations like straightening the Leaning Tower of Pisa—or making it lean at an even more alarming angle.

Notice, however, that rotations and reflections often produce readily detectable inconsistencies in shading. If a side-lit object is rotated or reflected, for example, it will end up with its lights and shadows in the wrong places. (This does not happen with translation of sunlit objects, since translation does not change an object's orientation to the sun. It may, however, happen with translation of artificially lit objects.) The inconsistency is less apparent in very evenly lit scenes or in scenes with flat, frontal lighting, as with a camera-mounted flash.

Scaling

To match one of the basic operations of photography, the repertoire of geometric transformations provided by image-processing software may be extended a step further to encompass enlargement and reduction (figure 8.7). (Photographers, of course, accomplish these transformations through use of appropriately chosen camera and enlarger lenses.) Because of the inherent ambiguities of perspective projection, scaling an object in a scene up or down may have either one of two effects: the object may appear to remain in the same location but change its size, or it may appear to move forward or backward in space but with its size

staying constant. Sometimes the effect is ambiguous. One of the wittiest early explorations of enlargement effects and their ambiguities is in Georges Méliès's 1902 film *The Man with the Rubber Head,* in which a character apparently inflates a severed head with a pair of bellows: the effect of inflation is actually produced by dollying in the camera.

Foreshortened repetitive objects, such as facades of buildings, can be extended by copying, scaling, and translating. Figure 8.8 illustrates use of this technique to "complete" a famous unfinished project by Andrea Palladio. The result is compelling, since this operation preserves the consistency of shading and cast shadows.

Convincing use of scaling requires careful consideration of the interrelationships among object size, object distance, and image resolution. Recall that when a three-dimensional scene is perspectively mapped onto pixels in this way, a nearby colored shape will cover many pixels and its outline will be recorded relatively accurately. The same shape, further away, will cover fewer pixels and its outline will be approximated more roughly. If it is moved even further away, the shape will eventually fit within a single pixel. At this stage, all geometric information about the outline of the shape is lost, though the presence of the shape does have an effect on the color of the pixel. Thus the perspective mapping from the three-dimensional scene to a two-dimensional pixel grid not only diminishes objects with distance, but also drops out detail with distance.[3] So, when distant objects are enlarged by too great a factor, prominent pixels and jagged edges will result, and the effect will be crude and unconvincing. (Visible pixels and jagged edges resulting from excessive scaling can be re-

8.7 A photographic fractal produced by reduction and replication of an image of a hand.

8.8 Completing a Palladian palazzo by enlargement, translation, and replication of photographed elements.

moved by interpolating intermediate pixel values or by applying smoothing filters, but this results in blurring, which may be equally undesirable.) In this respect digital images behave very differently from photographs, which can be enlarged indefinitely (until the grain begins to appear) to bring new levels of detail to light. One way to detect doctoring of a digital image is to look for discontinuities in the density of detail resulting from scaling operations.

Stretching and Shearing

In his *Four Books of Human Proportion* Albrecht Dürer systematically explored the use of stretch and shear transformations to produce variations on the theme of the human face and figure (figure 8.9). Similar effects can be produced by applying these transformations to selected fragments of digital images (figure 8.10). This technique can even be used to "correct" El Greco. If the distortion is too great, however, fine details and textures will be smeared and clotted.

Silhouetted objects can often be stretched and sheared convincingly to take on new proportions, but the presence of internal detail can create difficulties. If a brick wall is stretched, for example, bricks with unusual dimensions will result, and this may give the game away. Sometimes replacement of internal detail is required: if a door is stretched into a taller shape, and the doorknob is thus transformed from a circle into an implausible ellipse, the original knob might be pasted back over the transformed one. Similarly, when a face is sheared or stretched, a more convincing result may be produced if untransformed eyes are pasted back in.

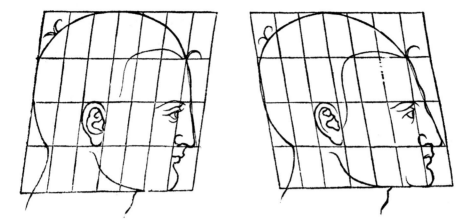

8.9 Illustrations in Dürer's *Four Books of Human Proportion* demonstrate the effects of stretch and shear transformations.

8.10 "I am not a crook": use of a stretch transformation to produce a caricature.

False Foreshortening

When a slide projector is angled at the screen, the normally rectangular image is distorted into a trapezoidal one in which the sides converge. The same result can be produced by using an enlarger to print a negative on a slant, or by photographing an obliquely positioned photograph—as in the famous scene in *Citizen Kane* where Kane addresses a crowd before a huge photograph of himself. In all these cases, the image undergoes a transformation known as two-dimensional perspective distortion. Image-processing systems usually provide for specification of this sort of transformation by selecting a rectangular (or more generally, trapezoidal) area and then shifting corners to reshape it (figure 8.11).

This transformation can be employed to correct converging vertical parallels that result from tilting a camera upward—the same effect as that of a perspective-correcting lens. Conversely, it can be used to introduce the effect of perspective recession by making parallels converge. Or it can be applied to vary the rate of convergence and hence the apparent orientation of an object to the picture plane. Another common application is in mapping rectangular images to the foreshortened rectangles that appear in photographs. This trick can be used to put pictures into frames, views into windows, or reflections into mirrors (figure 8.12).

These tricks exploit the effects of depth perception that were demonstrated in a famous series of experiments by the painter and psychologist Adelbert Ames.[4] He constructed a "distorted" room out of trapezoidal wall, floor, and ceiling planes such that, when viewed from a specified, fixed station point, it appears to be a "normal" rectangular room: we interpret it as such because, out of the infinitely

8.11 Mapping a rectangular image onto a trapezoidal area produces a foreshortening effect and creates the impression of pictorial space.

8.12 A paradoxical picture gallery produced by repeatedly mapping an image into foreshortened rectangles.

many three-dimensional shapes that could yield the particular perspective projection that we see, that of the rectangular room seems most likely. When people and other objects of known size are placed in the room, however, inconsistencies start to show up: either they appear to have very unusual sizes, or the illusion of the room's rectangularity is destroyed—depending upon how we choose to interpret the evidence of our eyes. Ames also constructed a flat, trapezoidal, rotating "window" with "shadows" painted on it: this very ambiguous object creates startling illusions of size variation, rotation reversal, and movement of the light source. By distorting rectangular areas into trapezoids, and trapezoids into rectangular areas, an image manipulator can rig the visual evidence in much the same way that Ames did.

The two-dimensional perspective mapping can also be used to create or rectify anamorphic images. A perspective anamorphism results when a square or rectangular image is transformed into an elongated, converging trapezoid; when this trapezoid is viewed obliquely from the narrow end, the resulting foreshortening counteracts the distortion and a recognizable image reappears. Conversely, the distortions of an existing anamorphic image can be corrected by applying an inverse transformation to return the image to its original shape and proportions.

Displacement Mapping

We are not limited to linear transformations of images. More complex distortions can be produced by software that simulates the effect of reflecting a scene in a distorting mirror or of projecting an image onto a curved surface. Figure 8.13 illustrates a variety of possibilities.

Distortion can usefully be understood as spatial-displacement filtering—the effect of taking a photograph through a sheet of corrugated or relief-patterned glass. It can be controlled by means of horizontal and vertical displacement maps—gray-scale images in which intensities stand for spatial displacements. When the filter is applied, the value of each pixel in the original image is replaced by the value of some other pixel at a location specified by the displacement maps. If, for example, the horizontal displacement map has a value of 2 at a pixel location and the vertical displacement map has a value of −3, the pixel's value will be replaced by that of the pixel two spaces right and three spaces down. Thus a uniform displacement map simply translates the entire image, but a smoothly varying displacement map creates continuous distortions, and a displacement map that varies in discrete steps will fragment the image.

Spatial-displacement filtering can be used to vary, exaggerate, and caricature human features with a technique similar to that first demonstrated by Dürer in his *Four Books of Human Proportion* (figure 8.14). We simply replace Dürer's compressed and expanded bands by displacement maps with correspondingly varying intensities. By editing and applying these maps, we can rapidly produce variations on a face or figure.

Blends, Mattes, and Masks

In straightforward cutting and pasting, transformed image fragments are overlaid opaquely to produce new images. An alternative possibility is to blend foreground and background images so that forms seem transparently overlaid. Photographers have long used techniques

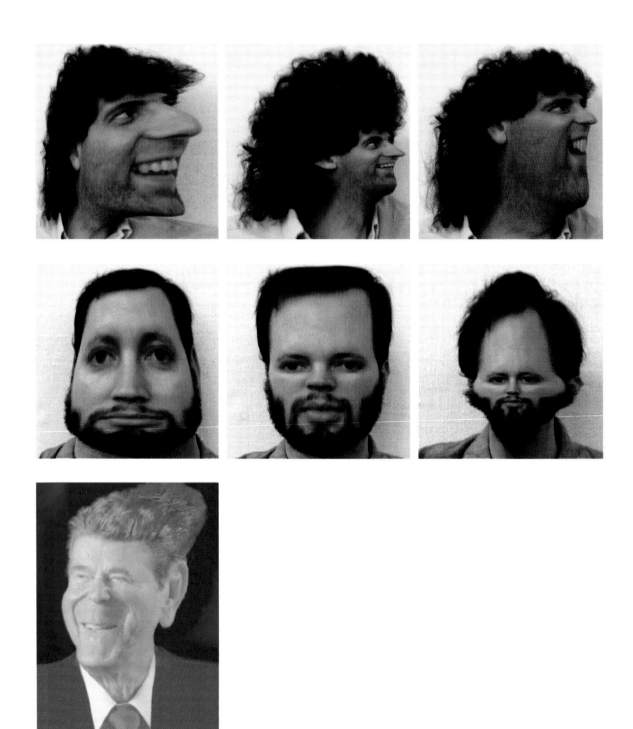

8.13 Caricatures produced by displacement mapping.

8.14 Illustrations in Dürer's *Four Books of Human Proportion* anticipate the principle of displacement mapping.

of double exposing negatives and making prints from multiple negatives to achieve this effect. These techniques can be generalized to the overlay of many images to yield a complex blend. In the nineteenth century, for example, the statistician Francis Galton developed a technique for producing composite portraits (to illustrate various human "types") by successively exposing carefully registered portrait prints in front of a copy camera. The exposure time for each individual portrait was determined by dividing the total exposure by the number of portraits in the sample, so that a kind of visual generalization resulted. He wrote of this technique:

Composite pictures are . . . much more than averages; they are rather the equivalents of those large statistical tables whose totals, divided by the number of cases and entered on the bottom line, are the averages. They are real generalizations, because they include the whole of the material under consideration. The blur of their outlines, which is never great in truly generic composites, except in unimportant details, measures the tendency of individuals to deviate from the central type.[5]

More recently, the artist Nancy Burson has used image-processing techniques to similar effect. A 1990 show at the Jayne H. Baum Gallery in New York included image-processed portraits of a composite spiritual leader (formed from images of Christ, Buddha, and Mohammed) and a composite alcoholic; and in December 1991 *The New York Times* used her digital composite of Lenin and Gorbachev to illustrate an article on the collapse of the USSR.[6] Her "Warhead" series blended faces of world leaders in proportion to the numbers of

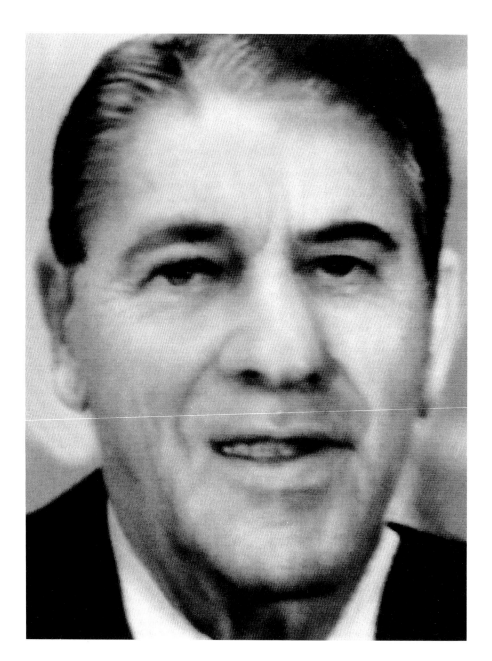

8.15 A digital composite: Nancy Burson, *Warhead IV,*
1985. Composite of 52% Reagan and 48% Gorbachev.
Courtesy Jayne H. Baum Gallery, New York.

nuclear weapons that they controlled (figure 8.15). For the Whitney Museum's "Image World" exhibition she made the process interactive by installing a "portrait machine" that allowed visitors to combine their faces with those of celebrities.

Digital image-processing software produces this effect by averaging foreground and background pixel values rather than (as in cutting and pasting) simply replacing background values by foreground values. More generally, any function of pixel values may be used to combine any number of images. Graduated blending can be accomplished through use of a matte or (to use alternative terminology) an alpha buffer.[7] This is a gray-scale image that you can think of as being registered "between" the background and foreground images. The value of the matte at each point controls the relative contributions of the background and foreground images to the final result. Thus smoothly graduated mattes yield smoothly graduated transitions between images (figure 8.16).

A one-bit matte, in which pixels are either black or white, is commonly known as a mask. This performs much the same function as a masks used by Robinson and Reijlander to produce their combination prints: where it is black the foreground image has no effect, and where it is white the foreground image shows through (figure 8.17). Masks that fit snugly to the outlines of objects can often be created by posterizing images.

If the edge of a mask is blurred, for example by applying a smoothing filter to it, foreground and background images will be smoothly blended together at the edges. Thus the perceptible discontinuities that result from simple cutting and pasting can often be eliminated:

8.16 Graduated blending of an image with its negative.

8.17 Use of a lace pattern as a mask to control the combination of foreground and background images.

8.18 A new head blended onto a torso.

new heads can be blended convincingly onto torsos, and so on (figure 8.18).

In film and video production, digital matting and masking techniques are now commonly used in place of traditional blue screen and chromakey methods for special effects work.[8] Digital compositing is more flexible and less time consuming than optical compositing, it provides for electronic correction of common problems such as blue-spill onto objects in a scene, it enables repeated combination of mattes without the generation loss that is inevitable with analog media, and it allows a director to experiment interactively with mattes at a graphics workstation.

Retouching and Painting

Traditional photo-retouching and photomontage techniques often involve making marks by hand, and thus they erode the usually clear distinction between photography and painting. Soon after the invention of photography, photographers realized that negatives could be retouched by hand. Nineteenth-century photographers learned to scratch and paint negatives in order to remove blemishes, add highlights to eyes in portraits, drop out backgrounds, strengthen outlines and accentuate contours, and bring up detail. The pioneering portrait photographer Nadar employed in his business "six retouchers of negatives; and three artists for retouching the positive prints."[9] Engravers went a step further and developed the idea of the *cliché-verre,* a glass plate that could be scratched or painted, then used as a contact negative for producing photographic prints. Camille Corot, Jean-François Millet, and Eugène Delacroix were among the artists to employ this technique.

Another traditional approach is to mark and rephotograph prints. Initially, first-generation prints are cut and pasted to produce the configuration of objects that is sought. This image is then photographed to produce a second-generation print with a flat surface that can be conveniently drawn upon. Retouching tools such as pencils and airbrushes are used on this print to blend edges and clean up details. Finally, the marked second-generation print is photographed to produce a third-generation negative in which (if the work has been done with sufficient skill) the image appears seamless and the manipulations are undetectable. The slight image degradation that inevitably results from successive rephotographing has a smoothing effect that usually helps to conceal any minor discontinuities.

Analogous "paint" tools for retouching digital images and for producing the digital equivalent of the *cliché-verre* are available on image-processing software. Such tools are created by programming a mouse-controlled or stylus-controlled cursor to behave like a "brush," "pencil," "pen," or "eraser" and to deposit a color or pattern as it is dragged across the displayed image. Different tools deposit different patterns: a "pen," for example, might have a square, linear, or round tip, which produce different relationships of line thickness to direction and different types of line endings. Tones, colors, or patterns to be applied by a tool can be selected from displayed palettes or by pointing at areas in the image itself. Application of tools can be controlled through use of mattes and masks. In sophisticated systems tools may be programmed not just to apply opaque color, but also to perform many of the filtering and combination processes that were discussed earlier. (The tool really just provides

8.19 Foliage removed by application of a copy brush.

an alternative way of selecting an area to which a process is to be applied.) Using these capabilities, color can be applied transparently as in watercolor, and areas can be colorized, lightened, darkened, saturated, desaturated, blended, smoothed, sharpened, and so on.

These tools can be used—very much like traditional retouching tools—for such mundane tasks as eliminating dust spots and scratches, taking overhead electrical wiring and television antennae out of architectural views, deleting skin blemishes, and intensifying the unremarkable eyes of a model to a particularly glamorous shade of blue. Such deletions and replacements can sometimes be accomplished by simple "airbrushing," but this works well only if the object to be removed is isolated against a fairly uniform background, such as the sky. A much more versatile technique is employment of a copy brush to overpaint a background texture taken from elsewhere in the scene (figure 8.19).

Digital erasure techniques were used in a 1989 picture in the *St. Louis Post-Dispatch*, which showed the photographer Ron Olshwanger holding up a Pulitzer-Prize-winning image of a firefighter rescuing a child. Later it emerged, ironically, that the image of Mr. Olshwanger—with its implied subtext celebrating the photograph's capacity for accurate reportage of news events—had been electronically doctored to erase a prominent and unsightly Coke can from the foreground. Similar cosmetic surgery was performed on the dramatic, widely reproduced 1984 photograph of the fallen Olympic runner Mary Decker, which has become such a classic that it was among the images reproduced on the cover of *Time* magazine's 1989 special issue "150 Years of Photojournalism." In the original photograph,

the antenna of an official's walkie-talkie seems to jut incongruously from Ms. Decker's pouting lower lip.[10] And digital removal of suspension cables has become a standard special-effects technique in film. In the Peter Pan sequel *Hook*, for example, Robin Williams appears to zip through the air with daring élan. In reality, on the set, he was supported by a heavy cable guide wire; this was digitally painted out to produce a very convincing illusion of free flight.

Combining Synthetic and Captured Images

The images used in electronic collages can come from any source: photographs may be combined with photographs, synthesized images with synthesized images, or photographs with synthesized images. In August 1984, for example, *Science* magazine published a photographically realistic cover image of a hand, billiard cue, and moving billiard balls (with motion blur); the hand and cue were photographed, the image of the balls was synthesized, a composite was made, and the headline read "This picture is a fake." An increasingly popular architectural technique is to photograph a site, synthesize a shaded perspective image of a proposed building from the same viewpoint and under the same lighting conditions, and then carefully blend the two together to show the proposal in its context. This technique is also useful for reconstruction of unbuilt, destroyed, or altered projects (figures 8.20, 8.21).

There are many subtleties to consider when applying this technique. First, the perspective parameters of the synthesized image must be matched exactly to the camera position and

settings. This is usually accomplished by carefully recording the camera position and settings when the photograph is taken, then using this information to determine the values of perspective parameters. If such information is not available, then reverse-perspective calculations must be performed on the photograph to obtain it. Even when great care is taken, there are usually small perspective discrepancies between the photograph and the synthesized image. These can be corrected by performing two-dimensional geometric transformations on the images.

Second, if there are complex surface and lighting conditions to consider, a sophisticated rendering algorithm must be employed and the lighting parameters must be set to match the lighting conditions of the photograph.[11] It is particularly hard to account for the interreflections that would occur between photographed and synthesized objects and for shadows that would be cast from one sort of object onto another.

As with traditional collage, great care must be taken with extracting and masking fragments for combination. Synthesized images produced for combination with photographs usually depict isolated objects against monochrome backgrounds, so that the objects can be extracted cleanly. Combination is relatively straightforward when synthesized objects mask a photographed background, but can become much more difficult when complex photographed foreground elements (such as screens of foliage) must partially mask synthesized objects in the background.

Finally, the filtering of the different image fragments must be made consistent in order to avoid perceptible discontinuities. The synthesized objects should not, for example, be

8.20 Image synthesis and computer collage in architectural reconstruction: Palladio's Villa Pisani as it exists today (top) and as it would have appeared if built to Palladio's earlier scheme (bottom). Courtesy Anne Scheou, Harvard University Graduate School of Design.

8.21 Palladio's Villa Rotonda before and after computer reconstruction of the dome.

sharper than the photographed objects that sur-
round them. Some tone-scale and color adjust-
ment of the parts is invariably required to
achieve seamless blending.

Another way to combine synthetic and cap-
tured images is to wrap digitized photographs
like decals onto the surfaces of a scene that is
to be rendered.[12] This is an extension of the
method, discussed in chapter 7, for rendering
patterns and textures on surfaces: instead of
using some function to calculate the color at a
location on a surface, a function is used to
look up the color at the corresponding location
in the scanned photograph. The technique is
known as surface mapping. It can be used to
add drawn or photographed textures to both
flat and curved surfaces, to map figures onto
vases, to hang paintings and photographs on
walls, and so on (figure 8.22).

Surface mapping provides a relatively eco-
nomical way to render reflections in glass,
water, and metal.[13] A flat mirror produces the
impression that the surface is transparent and
the viewpoint is reversed. Thus, for rendering
from the original viewpoint, an image known
as a reflection map can be computed from the
viewpoint behind the surface and then mapped
onto the surface. Under some circumstances it
is more practical to photograph and scan a re-
flection map than to calculate it. Consider, for
example, a site on which a reflective glass
building is proposed. The site can be photo-
graphed from a viewpoint on one side of the
proposed reflective wall and also from the re-
verse viewpoint on the opposite side. Then,
when an image of the proposed building is
synthesized and matted into the site photo-
graph, reflection mapping can be employed to
render reflections of the surroundings in the
glass. The reflections might even include the
photographer's own image.

**8.22 Image mapped onto the surfaces of a three-
dimensional scene.**

Extension of these techniques to film—for insertion of live actors into synthesized virtual sets or of computer-generated characters into live-action scenes—requires meticulous coordination of live action with synthesized action, synchronization of the actual camera paths used in filming the live action with the virtual camera paths used in producing the computer animations, and careful editing to create illusions of continuity. This was spectacularly accomplished in two science fiction films of the early 1990s: in *Terminator II* a terrifying synthesized cyborg (with beautifully surface-mapped reflections on its smooth metallic skin) convincingly interacts with characters in live-action scenes; and in *The Lawnmower Man* we are shown flesh-and-blood actors being transported into wholly artificial, *Tron*-like cyberspace. Traditional conceptions of inhabitation—a matter of integral human bodies in actual, physical places—are rudely jarred.

The Missing Witness

Canaletto's exquisitely detailed and lucid paintings of Venice have a secure place at the pinnacle of the renderer's art. Their perspective seems convincing, and their shading appears to be miraculously accurate. They convince us that they must, like photographs, have been made from a particular viewpoint at a particular moment. They seem to be true records. (Indeed there has been considerable speculation that Canaletto actually employed a camera obscura.) But the painter is craftier than he appears: scholars have shown that many of his views have no consistent coordinates in space and time and depict a Venice that never was. They are not, in fact, eyewitness accounts of actual scenes. Viola Pemberton-Pigott observes:

From Canaletto's earliest paintings of Venice, he manipulated the topography by combining two or more viewpoints so that it is rarely possible to stand in the presumed position of the painter and see each building at the angle at which it appears in the painting. To provide the framework for his compositions he changed the heights of buildings and falsified the line of the horizon.[14]

So it is with computer collage. Its spatial and temporal dislocations—its explosions and reassemblies of the decisive moment—undermine photographic integrity in a particularly insidious way. The standard photograph's instantaneous character makes it essentially a record of an *event*—something with definite spatial and temporal coordinates.[15] (Photo albums often record these coordinates, and some popular cameras even automatically stamp the date on each image.[16]) We say that a photographed event took *place* at the particular *moment* of exposure. Seeing the photograph, we can go back to those coordinates—as the sight of a photograph took Marcel Proust's narrator (in *The Guermantes Way*) back to his grandmother's room at a precise point in the past and made him stand in the shoes of the photographer, made him become for a moment "the witness, the observer with a hat and traveling coat, the stranger." Photographs like those of Cartier-Bresson make us catch our breath in amazement that the photographer was *there*, that he actually *saw* it, that he somehow seized the instant and framed the action. The traditional photographer's essential message is always, as John Berger trenchantly reminded us, "I have decided that seeing this is worth recording."[17]

If you are uncertain about whether the evidence of a photograph demonstrates that an

event actually took place or if you do not see why the event was thought to be significant, you can try to locate the photographer who was there—the missing witness—as Philip Marlowe tracked down the blackmailing, soon-to-be-dead photographer Orrin P. Quest in Raymond Chandler's *The Little Sister.* And you can attempt to figure out the exact place and time of exposure; Marlowe deduced the name of the restaurant in which Quest's picture of a couple was taken from the emblematic upholstery pattern of the booth and discovered the time and date by peering through his magnifying glass at the headline of a newspaper lying on the table. The value of this photograph as evidence depended on establishing its connection to a place, a time, and a witness, as a lawyer later pointed out to Marlowe:

"Well, let's assume a proceeding," Farrell said. "One in which that photo is part of your evidence. . . . You'd have to connect it up with a witness who could swear as to when, how and where it was taken. Otherwise I'd object—if I happened to be on the other side. I could even introduce experts to swear the photo was faked."

"I'm sure you could," Endicott said drily. "The only man who could connect it up for you is the man who took it," Farrell went on without haste or heat. "I understand he's dead."[18]

But an electronically assembled event has unascertainable coordinates, and there is no flesh-and-blood photographer—alive or dead—to find. Nobody can claim to have stood behind the camera and made the decision to record: there are no shoes into which we can step. It creates an ontological aneurism—a blowout in the barrier separating visual fact and fancy.

**9.1 A counterfactual conditional "photograph": If
Groucho and Rambo had been at Yalta. Paul Higdon/
NYT Pictures.**

■ **Functions of Pictures**

The central metaphor of André Gide's *Les Faux-Monnayeurs* suggests that, just as economies are destabilized by counterfeit coinage, so the practices of textual production and exchange through which subjects construct their understandings of the world are subverted by the surreptitious interjection of signifying tokens of uncertain value. Gide's character Strouvilhou remarks of "those promissory notes which go by the name of *words*":

I must own that of all nauseating human emanations, literature is one of those which disgust me most. . . . We live upon nothing but feelings which have been taken for granted once for all and which the reader imagines he experiences, because he believes everything he sees in print. . . . And as everyone knows that "bad money drives out good," a man who should offer the public real coins would seem to be defrauding us. In a world in which everyone cheats, it's the honest man who passes for a charlatan.[1]

Similarly, the photographic falsifier holds up not a mirror to the world but a looking glass through which the observing subject is slyly invited to step, like Alice, into a place where things are different—where facts seem indistinguishable from falsehoods and fictions and where immanent paradox continually threatens to undermine established certainties (figure 9.1). To grasp precisely how this can be so, we

must consider not only how photographs and pseudo-photographs are *made,* but also how they are *used*—how their potential uses are established, how they are appropriated and exchanged, how they are combined with words and other pictures and made to play roles in narratives, and how they may have the effect of creating beliefs and desires.

This strategy finds some precedent among the high modernists in Clement Greenberg's well-known insistence that photographs must be considered essentially in terms of their narrative uses. In 1964 Greenberg argued:

The art in photography is literary art before it is anything else; its triumphs and monuments are historical, anecdotal, reportorial, observational before they are purely pictorial. The photograph has to tell a story if it is to work as art. And it is in choosing and accosting his story, or subject, that the artist-photographer makes the decisions crucial to his art.[2]

It also draws from the legacy of structuralism—on Roland Barthes's influential suggestion that the press photograph should not be regarded as "an isolated structure." It is always, Barthes noted, "in communication with at least one other structure, namely the text—title, caption or article—accompanying every press photograph."[3] This is essentially an expansion and reworking of some earlier remarks by Walter Benjamin, who had suggested that, without captions "all photographic construction must remain bound in coincidences" and who had gone on to ask, "Will not captions become the essential component of pictures?"[4]

Philosophers of a more analytical disposition have sometimes made the similar point that pictures, when combined with labels, can be used like declarative sentences to make assertions which are either true or false. (Ludwig Wittgenstein no doubt encouraged this by insisting, in *Tractatus Logico-Philosophicus,* that "A picture is a fact."[5]) John G. Bennett, for example, has written:

Consider a picture postcard. It has on one side a picture of a sunny beach with a large modern hotel in the background. On the face of the postcard there is the written phrase, 'Diddle Beach.' I get the impression that Diddle Beach is a sunny place with a fancy modern hotel and a pleasant beach. Later, when I go out of my way to visit it, I find nothing of the sort; Diddle Beach consists entirely of sharp rocks, the largest building within twenty miles is a rundown gas station, and the sun hasn't shown there in the memory of anyone living. I have been misled. . . .

The picture by itself would not have misled me. . . . The label 'Diddle Beach' was necessary. On the other hand, the label without the picture could not have given me the false belief. . . . It was the combination of the label and the picture which led me to have false beliefs.[6]

This example leads Bennett to conclude that the label is analogous to a name, that the picture is analogous to a predicate, and that combining the label and the predicate gives something which can be true or false, like a sentence. According to this account, it seems, you can perjure yourself by proffering a picture with a false label (the place pictured is not really called Diddle Beach) or a label with a false picture (the actual Diddle Beach does not really have the attributes shown in the picture). Photographs with false labels are nothing

new: they have been used to mislead since the earliest days of photography—as, for example, when Hippolyte Bayard photographically portrayed himself as a drowned man in 1839 (figure 9.2). But labels with pseudo-photographic false pictures have become much easier to produce in the era of digital imaging.

The most useful place to start, however, is with the traditional distinction between facts and evidence.[7] A piece of evidence is a fact with significance in some context, a fact that has been pressed into service, used to support some claim or argument. It serves to tell us about something that happened in the past or is happening somewhere else or will happen in the future or is just too small to see or otherwise takes place in a setting to which we have no direct access. Photographs, then, *present* facts but are frequently *used* as evidence. Any photograph *might* be used as evidence of many things, but it only *becomes* evidence when somebody finds a way to put it to work. In *The High Window* Raymond Chandler shows us Philip Marlowe as a not-too-bright would-be exegete performing this task—picking out a relationship as significant, finding a way to use it as evidence, then embedding it in a reconstructed chain of events:

There I was holding the photograph and looking at it. And so far as I could see it didn't mean a thing. I knew it had to. I just didn't know why. But I kept on looking at it. And in a little while something was wrong. It was a very small thing, but it was vital. The position of the man's hands, lined against the corner of the wall where it was cut out to make the window frame. The hands were not holding anything, they were not touching anything. It was the inside of the wrists that lined against the angle of the bricks. The hands were in air.

The man was not leaning. He was falling.

This narrative turned the mute facts of the photograph into the telling evidence that Marlowe needed to crack the case.

In much the same fashion, a famous snapshot of Lee Harvey Oswald holding the rifle used at Dealey Plaza has often been seized upon as evidence demonstrating that Oswald was, indeed, John Kennedy's assassin. But Oliver Stone's film *JFK* shows this photograph being doctored—suggesting that production of this picture was part of a conspiracy. Here, one aspect of what the picture shows—Oswald's possession of the rifle—is picked out and tellingly embedded in alternative narratives.

Let us begin, then, by considering how photographs and pseudo-photographs may be pressed into service as evidence—how they may be employed within larger signifying structures to report the significant facts (or "facts") about states of affairs that are claimed to have existed and events that are claimed to have taken place, and how such reports are used to convince, to create belief, and to command assent. Let us note, in particular, how the potential uses and misuses of images are modified by various types of interventions in image-production processes. This by no means exhausts the possibilities: the issue might usefully be examined from any of the alternative perspectives opened up by the recent fecundity of literary theory—from before Bakhtin to beyond Barthes. But it's a start.

9.2 False labeling: Hippolyte Bayard, self-portrait as a drowned man. Collection of the Société Française de Photographie, Paris.

Denotation and Existence

The photographer is more of a pointer than a painter. Just as the pointing finger indicates something real out there, so does the pointing camera. Above all else, a photograph *denotes* objects, persons, or scenes about which something may then be said. (To "denote"—literally from the Latin root—is to "mark out.") But we should not be misled into assuming, therefore, that a photograph works just like the referring expression of a sentence: we can easily write, "The present king of France is bald," but it is beyond the powers of the most intrepid *paparazzi* to frame such an individual in their viewfinders. As we have seen, a photograph can denote *only* something that exists at definite spatial and temporal coordinates in the physical world, so a photograph *always* tells us—as the footprint on the beach told Robinson Crusoe—that something was actually out there. Vicki Goldberg has noted that "bearing witness is what photographs do best; the fact that what is represented on paper undeniably existed, if only for a moment, is the ultimate source of the medium's extraordinary powers of persuasion."[8] Conversely, if a photograph of a bald individual is captioned "The present king of France," the label of a nonexistent thing is being falsely applied to a real person.

This presumptive anchorage of the photograph to the real provides an opportunity for photographic fakers to take advantage of us. They can subvert ontology by assembling available image fragments into pseudo-photographs that convincingly match accepted conceptions of what some nonexistent thing *would* be like—much as sixteenth-century entrepreneurs manufactured specimens of mermen and mermaids, furry fish, sea bishops, unicorn horns, and griffin claws and their nineteenth-century counterparts produced grotesque "medieval" torture devices and sinister-looking chastity belts to satisfy expectations aroused by gothic tales.[9] (Conversely, when a specimen of the unlikely looking platypus was first carried back to Europe, it was widely suspected of being an assembled fake. Nobody thought that *anything* would look like *that!*) The assemblage—depicting, say, a UFO, a Loch Ness monster, or a street in Atlantis—is proffered as evidence that the thing denoted by the label was witnessed by the photographer. If we can be fooled into thinking that the assemblage is a photograph, then the presumption that photographs can show only things that exist will do the rest. These sorts of images function as pseudo-*acheiropoietoi*—ersatz relics used to create belief that something existed on earth.[10]

A variant of this game is use of photographic evidence—claimed to be of recent date—to create the belief that something *still* exists. In the long and bitter aftermath of America's defeat in the Vietnam War, for example, fake photographs were used by those with a propaganda or blackmail interest in the situation to perpetuate the pathetic myth of the continued existence of American prisoners in the jungles of Southeast Asia—prisoners waiting to be rescued and returned to their loved ones by the likes of Rambo.[11] There was a sadly symmetrical trade in doubtful relics: photographs with fake provenances were produced to demonstrate that prisoners still remained, and bones—sometimes of animals if sufficient human ones were not available—were proffered by the Vietnamese to show that there were indeed no prisoners left.

It matters little whether the image fragments are deceptively assembled before or after the moment of exposure. A particularly famous example of assembly before exposure was used to

hoodwink Sir Arthur Conan Doyle—the creator of Sherlock Holmes, masterly interpreter of physical evidence—in 1917.[12] Conan Doyle was a convinced spiritualist, had faith in the existence of fairies, and thought he knew what they would be like. Two girls, Elsie Wright and Frances Griffiths, produced a doctored photograph showing a group of fairies buzzing like big blowflies around the head of a child (figure 9.3). Even though the fake was quite crude, Conan Doyle welcomed it as confirming evidence. He wanted to believe, and the Wright girls had the right stuff to convince him. In fact, the girls used cutout fairy figures from a children's book, held in place by hatpins.

There is, then, a symmetry of uses. Straightforward photographs can be used legitimately and effectively to show that things exist. But mislabeled or manipulated photographs can be used to create illusions of existence.

Insertions

Walt Whitman, it seems, perpetrated a deception similar to that of the Wright girls.[13] A studio portrait of 1883, which was later used as a frontispiece to *Leaves of Grass*, shows a butterfly dramatically perched on his index finger (figure 9.4). He was not, of course, attempting to demonstrate that butterflies exist, but making a self-serving point about his own nature. "I've always had the knack of attracting birds and butterflies and other wild critters," Whitman told the historian William Roscoe Thayer. Skeptically, Thayer later commented: "How it happened that a butterfly should have been waiting in the studio on the chance that Walt might drop in to be photographed, or why Walt should be clad in a thick cardigan jacket on any day when butterflies would have been disporting themselves in the fields, I have

never been able to explain." A later biographer, Esther Shephard, reported that Whitman's memorabilia contained "a small cardboard butterfly with a loop of fine wire attached, by means of which it could be fastened to a finger." This famous photograph is certainly not worthless as evidence: it told the truth—at least about some things—but it did not restrict itself to nothing but the truth.

The spirit photographers who flourished in the early decades of the twentieth century employed a different insertion technique.[14] Their strategy was to preexpose parts of a negative plate with images of a client's deceased loved ones, then to use that same plate in a portrait sitting. When the plate was developed, the picture showed ghostly spirit images (figure 9.5). The spirits had been invisibly there, it seemed, but the eye of the camera had revealed them.

Digital dissemblers, of course, need have no recourse to cardboard fairies or butterflies or to double exposures: they can scan the images that they want to insert and fix these apocrypha in place without the use of hatpins or wire loops. On October 27, 1989, for example, *Newsday*'s cover photo showed eighteen Grumman F-14 fighter jets taking off in formation; but it never occurred: the photograph was manufactured by copying one of a single jet landing, rotating it to point the nose upward, and repeatedly pasting it into the scene (figure 9.6).[15] A similar technique can be applied to "complete" unfinished or ruined buildings—to produce electronic Potemkin villages by cutting and pasting repetitive facade elements.

Accompanying text can put these sorts of images to use in several different ways. It can falsely assert, or encourage the natural assumption, that the depicted event took place or that the depicted state of affairs *did* exist. It can enframe the content as that construction dear to

9.3 A false existence proof: Cottingley fairy photo-
graph, *Alice and the Fairies*. Brotherton Collection,
Leeds University Library.

9.4 A staged incident: Walt Whitman and the cardboard butterfly, 1883. Feinberg Collection, Library of Congress.

9.5 A spirit photograph produced by double exposure:
Reverend Tweedle and Spirits. Photography Collection,
Harry Ransom Humanities Research Center, The University of Texas at Austin.

9.6 Digital replication: *Newsday* cover showing numerous F-14 aircraft climbing in formation, produced by copying and transforming a photograph of a single F-14 landing. © 1989 Newsday.

philosophers, a counterfactual conditional, such as "If a butterfly had landed on my finger, then this is how I *would* have looked."[16] Or it can make a prediction, such as "When the building is completed it *will* look like this." In other words, it can present a possible world rather than the actual one. Photographs can present only the actual world, but constructed pseudo-photographs can—like naturalistic novels or carefully staged film scenes—present possible worlds *as if* they were actual.

Effacements and Elisions

The converse way to fake the photographic evidence is to efface something. The result is an image that tells the truth up to a point, but not the whole truth. For example, one of the most notorious photographs of the twentieth century exists in two versions (figure 9.7). The first, taken on May 5, 1920, shows a dramatically posed Lenin addressing a meeting with the conspicuous figure of Trotsky at his side. In the second, Trotsky is absent—deleted from the image as he was in general from Stalinist history.[17] Those who want to rewrite political narratives know such strategies well—hence also the removal of Alexander Dubcek from a 1968 photograph of Czech leaders outside Saint Vitus Church in Prague, and the removal of the Gang of Four from a photograph of Chinese leaders at Mao's funeral in Tiananmen Square in 1976.[18] (Similar effects can be achieved by selectively excising portions of audio tapes, as in the notorious Nixon Watergate tapes.) The photograph's metonymic power—its capacity to stand for a larger world outside the frame and to suggest a larger narrative that embraces the moment of exposure—is being exploited here. Modifying what the photograph

9.7 Selective removal of the politically inconvenient:
Trotsky erased from a photograph of Lenin addressing a
crowd on May 5, 1920.

explicitly shows has the more important effect of changing what it implicitly constructs.

On another famous occasion, the wife of a British newspaper proprietor was offended by a photograph of a prize bull and caused its testicles to be erased prior to publication. The owner of the bull, furious at this misrepresentation of his animal's capacities, sued. (Presumably, if the photograph had been labeled with the name of some other bull, he would not have found reason to complain.) For not dissimilar reasons (and perhaps to similar indignation), *Rolling Stone* magazine electronically deleted a shoulder holster and pistol from the portrait of a macho television actor for its March 28, 1985, cover. The holster could just as easily been removed *before* the moment of exposure to produce an image with exactly the same content, so the difference between directorial and electronic manipulation seems theoretically insignificant in this case. (Of course it is significant to the bull.)

Aesthetically inconvenient elements have frequently been excised from architectural photographs. Some of the most influential plates in Le Corbusier's 1923 modernist tract *Vers une architecture*, for example, portrayed the dramatically pure, unadorned, geometric forms of North American grain elevators: they compellingly illustrated Corbusier's definition of architecture as "the masterly, correct and magnificent play of volumes brought together in light."[19] But earlier versions of these photographs, published by Walter Gropius in the *Jahrbuch des Deutschen Werkbundes* of 1913, had shown something quite different. Corbusier removed prominent classical pediments from atop some Canadian silos to leave simple cylinders and in another instance dropped out a splendid classical dome so that what remained was a pure composition of rectangular boxes and square pyramids (figure 9.8). "So much the worse," he insouciantly wrote, "for those who lack imagination!"

Traditionally, photographers have tendentiously effaced and elided, when they wished to do so, through carefully selective framing and cropping and through use of camera angles in which foreground objects occlude unwanted background objects. (For example, *Time* magazine was accused of digitally altering its striking December 16, 1988, cover image of Reagan, Gorbachev, and Bush to remove the surrounding crowd.[20] In fact, the photographer had succeeded in getting an unusual angle that excluded the crowd.) This is a game of layering and sightlines, much like that played by stage designers. Digital image processing simply extends the game by allowing easy insertion of new foreground layers *after* exposure to obscure objects that do not fit the narrative purposes to which the image is being put and that were not or could not be obscured by more conventional means.

Logically, any photograph can be used to show the absence of indefinitely many things—that Elvis Presley did not accompany Lenin in May 1920, that there was no UFO fly-by at Mao's funeral, and that the posturing actor did not sport a sequined handbag. Absence only becomes interesting as evidence when it conflicts with our presuppositions—that Trotsky was an important Bolshevik who would naturally have accompanied Lenin, that buildings would normally have classical details, or that a stud bull would typically have testicles. When such absences can be made to seem sufficiently plausible, they can change our beliefs.

9.8 Selective removal of the aesthetically inconven-
ient: classical details are removed from pictures of
grain elevators in Montreal (top) and Buenos Aires (bot-
tom) in Le Corbusier's *Vers une architecture*, 1923. The
unmanipulated originals were published by Walter
Gropius in the *Jahrbuch des Deutschen Werkbundes*,
1913.

Substitutions

Just as a declarative sentence has a referring expression and a predicate, so many photographs that we regard as informative have components which uniquely identify individuals and other components that assign certain attributes to those individuals. Conversely, as in traditional pictures of saints, certain attributes—uniforms, tools of trade, characteristic haircuts, and so on—may be displayed so that we can identify an individual who might otherwise be anybody. (The problem with saints is that we usually have no idea of what their faces were actually like, so we have to rely on stereotyped attributes for visual identification.) In either of these cases, a photographic manipulator can change the meaning and potential uses of an image as evidence by adding, deleting, or interchanging identifying elements. Thus, for example, a nineteenth-century scandal was created by a photograph manipulated to show the pope improbably wearing the insignia of a freemason.[21]

Since people are most readily identified by their facial features, such shifts can effectively be accomplished by substituting well-known heads onto whatever available bodies have the appropriate attributes—a practice which reduces those bodies to signifying commodities. (It is not too much different from inserting a portrait photograph into a false passport.) There is a well-known precedent for this from Roman antiquity: the emperor Hadrian removed the head of Nero from an imperially garbed statue and replaced it with another more to his liking. Similarly, Pierre Lombart's famous *Headless Horseman* prints of an equestrian figure exist in three states—one with no head (which we may read as a kind of visual aposiopesis), one with the head of Oliver Cromwell, and one with the head of Charles I (figure 9.9).[22] Political power is a passing thing, but statues and printing plates endure.

In the prewar and Civil War era in the United States, which coincided with the first decades of photography, images of various politicians were recycled with the highly recognizable head of Abraham Lincoln. At different times, Lincoln's likeness assumed the engraved bodies of Alexander Hamilton, Martin Van Buren, and the Southern politician John C. Calhoun (figure 9.10).[23] Henry S. Sadd's elaborate 1852 mezzotint engraving *Union* showed Calhoun in a prominent central position, but a later version (ca. 1861), replaced his face with that of an unbearded Lincoln and introduced the portraits of half a dozen lesser pro-Union figures as well (figure 9.11)—a shrewd marketing move under the circumstances.[24] After Lincoln was assassinated, new pictures of the dead president were created by pasting his head, from a famous Mathew Brady photograph (the one engraved on the five-dollar bill), onto an appropriately statesmanlike full-length portrait of Calhoun (figure 9.12). (A new text is also substituted on the papers under the figure's hand: "Strict Constitution" becomes "Constitution," "Free Trade" becomes "Union," and "The Sovereignty of the States" becomes "Proclamation of Freedom.") Lincoln's head had to be mirrored in order to make it fit; the deception was discovered when somebody noticed that the late president's highly recognizable mole was on the wrong side.

In our own era, interchangeable heads have mostly been used pornographically rather than politically—to present women as desirable boy toys rather than to incorporate men in the emblematic raiments of political power. The integral female subject is reconstructed as

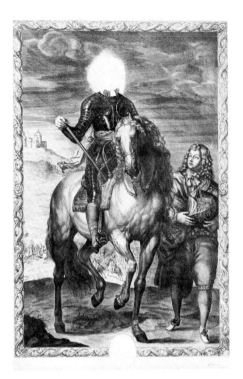

9.9 A formally costumed male body used to signify political power: three versions of Pierre Lombart's *Headless Horseman*. Courtesy of the Trustees of the British Museum, London.

9.10 The same head on different bodies: Abraham Lincoln's head substituted on bodies originally intended to represent (clockwise) Alexander Hamilton, Martin Van Buren (in two versions), and the Southern politician John C. Calhoun. The Lincoln National Life Museum, Fort Wayne, Indiana, a part of Lincoln National Corporation.

9.11 The scene stays the same but the actors change:
Henry S. Sadd's mezzotint engraving *Union* in two ver-
sions—in 1852 (top) with Calhoun and in ca. 1861
(bottom) with Lincoln and pro-Union figures. Prints
and Photographs Division, Library of Congress.

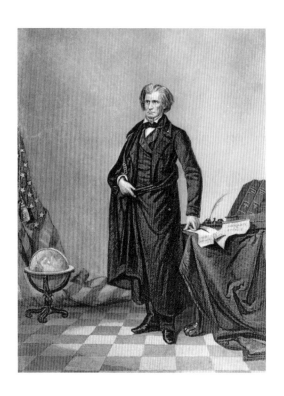

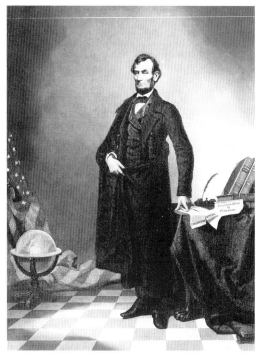

9.12 The same body with different heads: John C. Calhoun (top left), Mathew Brady's portrait of Lincoln (top right), and composite (bottom). Prints and Photographs Division, Library of Congress.

stereotyped sexual object. The magazine *TV Guide*, for example, was caught embodying the not-so-svelte talk show host Oprah Winfrey as the more lithe actress Ann-Margret to produce a cover picture (figure 9.13). Use of a body double in this way is quicker than a diet and cheaper than a health club membership, but a smitten fan would certainly be disappointed if he sought out this alluring composite. (This deception was discovered when Ann-Margret's husband noticed a familiar ring on one of the reallocated fingers.) The distributors of the film *Pretty Woman* put together a similarly rebuilt fantasy figure for a publicity poster by supplanting the body of the film's star, Julia Roberts, with that of an anonymous, seductively clad and posed model. This game can, of course, be recast as one of ambiguity, androgyny, and scrambled sexual difference; in 1991, in response to a *Vanity Fair* cover photograph of the unmistakably pregnant actress Demi Moore, *Spy* magazine sniggeringly substituted the face of the father, actor Bruce Willis. The composite became a rhetorical figure—an oxymoron.

There is an old but still-robust tradition of maliciously recapitating photographed bodies to show public personages compromised, naked, in bad company, or just having too good a time. In 1861 an attempt was made to discredit the exiled Queen of Naples by producing a composite showing her cavorting naked with the pope and cardinals.[25] More recently, the head of the photogenic Princess Di has been grafted onto nude bodies to produce the pictures that tabloid magazines wanted to get but couldn't. At the time of the Third French Republic, a photographer named Eugène Appert fanned anti-Communard feeling by posing

9.13 A seductively costumed female body deployed to construct a fantasy sexual object: Ann-Margret's body combined with the face of Oprah Winfrey on a *TV Guide* cover, 1989. AP/Wide World Photos.

models in dramatic tableaux and then substituting heads of Communards and their victims.[26]

A more subtle and increasingly common form of transfiguration by attribute substitution is alteration of eye, hair, or skin color. The color of a model's eyes can be changed by fitting tinted contact lenses before a shot is taken or by color correction afterward. Similarly, hair color and style can be changed by a prephotographic visit to the hairdresser or by postexposure manipulation of the digital image: in 1991 the Japanese weekly *Shukan Bunshun* published manipulated photographs of the unmarried Crown Prince Naruhito with ten alternative hairstyles, together with an article entitled "Hairstyle Remodeling Plan," in which a hundred young women were asked which style they preferred (figure 9.14).[27] (It is reported that the Imperial Household Agency was not amused.) And a pale-faced model can get a tan on the beach or in the digital darkroom. When images substitute for bodily presence, digital makeovers may serve just as well as visits to hairdressers and makeup artists.

Props and scenery can also be recolored for cosmetic effect: the *Orange County Register* once color corrected an implausibly colored swimming pool to a more normal shade of blue: unfortunately, the accompanying story was about how vandals had dyed the pool red. Rather less trivially, in a 1970 budget request to Congress, NASA presented a colorized version of black-and-white film footage from the Apollo moon mission: it showed not the recorded colors of the scene of this historic event, but somebody's reconstruction of those colors.[28]

Sometimes digital disguises are put on to feign the fit of a photograph to a story. In 1989 the Washington producers of ABC News photographed a staged scene of one man passing a briefcase to another, then electronically manipulated the image so that one of the anonymous protagonists appeared to be Felix Bloch, a diplomat who had been accused of espionage.[29] An ABC News spokesperson—embarrassed by the revelation of this deception—later said that the image had been intended as a "simulation" and that failure to identify it as such had been an oversight.

The converse process, of disguising recognizable facial features for the sake of anonymity—like a movie star putting on dark glasses—has also surfaced from time to time. A former photographer for Hearst's *New York Journal*, for example, has described how file photographs were adapted to serve new narrative purposes in this way. Photographers would "dig up a real photograph of, say, John L. Sullivan, remove his ferocious moustache, paint a General Grant beard across his massive chin, and send it to the engravers as a legitimate picture of an unidentified body in a foul murder."[30] The result is an image that passes for a photograph of somebody—but not anybody that we know.

Anachronistic Assemblages

Another informative type of photograph (one that we might regard as newsworthy) shows an event—a meeting, a tryst, or a murder perhaps—taking place. Such a photograph locates certain individuals at a specific location at some particular moment. We presume that photographed events—unlike drawn or painted ones—must *really* have happened, and we value photographs showing significant events as part of the historical record. Alfred Hitchcock's *Rear Window* is grounded on this

9.14 Cosmetic manipulation: alternative hairstyles for Prince Naruhito proposed by the Japanese weekly *Shukan Bunshun,* 1991. AP/Wide World Photos.

premise: Jimmy Stewart, the immobilized photographer, takes pictures that add up to evidence of a murder and is stalked by the sinister Raymond Burr—the killer who realizes that the testimony of photographs can put him away. And Antonioni's photographer in *Blow-Up* is convinced by the evidence of his enlargements that somebody was killed—until both the photographs and the body disappear.

News photographs showing us young women perched illicitly on middle-aged presidential candidates' knees and amateur snapshots of family gatherings and posing vacationers have the same power to demonstrate that significant events indeed transpired. Photofinish pictures provide evidence acceptable to punters and bookmakers of the order in which horses crossed the line. Videotapes of politicians taking bribes in motel rooms have been used to put these malefactors in jail. Terrorists and kidnappers provide photographs of hostages to demonstrate that they really do have them. And the effectiveness of blackmail photographs depends entirely on the victim's concession that they are undeniable. (Blackmail drawings, however, are easily deniable and would not work.)

This effect of displaced witnessing—of being confronted with real events in the lives of real people—can make photographs disturbing in a way that the most horrific drawings can never be. Eddie Adams's famous 1968 photograph of General Loan shooting a Viet Cong suspect through the head created such outrage because we knew that we were not seeing allegory or agitprop but the actual slaughter of a helpless human being. Weegee's flashlit pictures of murder victims at the scenes of the crimes are numbing in their matter-of-fact inscriptions of squalid death. Brassai's photographs of

prostitutes turn us into voyeurs. Execution photographs and snuff films (the privatized equivalent of this traditional state product) have the uniquely malevolent power to transform their viewers into complicitous witnesses. A 1991 videotape of white Los Angeles police officers brutally beating black motorist Rodney King provided such irrefutable evidence of what really happened that, when a jury with no blacks failed to convict the officers on criminal charges, Los Angeles exploded into days of violent rioting; most people believed their eyes, not what the legal system tried to tell them.[31]

But events that *never* occurred can also be shown—sometimes to similarly telling effect—by bringing together, within a frame, photographic images taken at different times in different places. The early pictorialist photographers—notably Oscar G. Reijlander and Henry Peach Robinson—exploited this possibility to produce wannabe-paintings in the traditional modes of allegory, sentimental narratives, and history pieces. Reijlander's *The Two Ways of Life* convoked posed figures from thirty different negatives to produce an action-packed Victorian crowd scene that today makes a life of gambling, liquor, and lust seem a good more interesting than the proffered alternative of religion, charity, and industry. And in 1890 a photograph of painter Henri de Toulouse-Lautrec—somehow anticipating poststructuralist fetishization of reproducibility and reflexivity—pictured Toulouse-Lautrec portraying Toulouse-Lautrec (figure 9.15).

Visual misrepresentations of what happened have obvious political uses. During the McCarthy era a crude cut-and-paste fake photograph showing US Senator Millard Tydings in a meeting with the communist leader Earl

9.15 An impossible event: Toulouse-Lautrec painting Toulouse-Lautrec. Musée Toulouse-Lautrec, Albi.

Browder (the one with the Joe Stalin moustache) probably cost the senator his seat (figure 9.16).[32] (Stalin's propagandists found it useful to take a widely known communist *out* of a picture, and McCarthy's found that it served their purposes to put one *in*.) Since the collapse of the Soviet Union, of course, caricature communists have become much less effective as emblems of unreliability; male politicians are now more easily discredited through juxtaposition with stereotypical bimbo figures.

One of John Heartfield's most compelling political collages—*Like Brother, Like Murderer* (1933)—simply conjoins a portrait of brownshirt leader Julius Streicher with a picture of a bloodied murder victim from the Stuttgart police archives and an Italian officer holding a dagger (figure 9.17). An alternative version, without the Italian officer, was published under the title *A Pan-German*. Within this directorial mode, it is actually of only minor technical interest whether genuine image fragments are recombined or impersonators are posed for a real photograph. And it makes little difference whether a backdrop is painted on canvas in the photographer's studio before the exposure is made or electronically matted in afterward.

Convincing assemblages of this sort are easy to produce by digital image manipulation. For a 1989 article on the film *Rain Man*, for example, the picture editors of *Newsweek* separately photographed actors Dustin Hoffman and Tom Cruise—one in New York and the other in Hawaii—then produced a composite showing them beaming together, as if sharing a joke.[33] Similarly, in 1990 *The New York Times* demonstrated this principle by showing a composite in which Rambo and Groucho Marx appear at the Yalta Conference (refer back to figure 9.1).[34] And in 1991 the *Times* illustrated the steps involved in combining a photograph of Iraqi President Saddam Hussein taken in Baghdad on July 8 with a photograph of US Secretary of State James Baker taken in Kuala Lumpur on July 23 to produce the appearance of a cordial meeting.[35] More prosaically, formal group pictures of boards of directors for annual reports, groups of political candidates for magazine covers, and the like are now fairly routinely put together with image-processing systems from photographs taken on different occasions. (In much the same fashion, record producers tape musicians on separate tracks and assemble musical performances that never took place. The practice is so prevalent that recordings of actual performances have to be labeled "live" or "in concert." Recorded sounds can also be combined with recorded images, as when videos of performers—such as the pop group Milli Vanilli—who look better than they sing are lip-synched with audio tracks from others who sing better than they look. Rap music goes even further, with its practice of "sampling"—freely appropriating and recombining fragments of existing recordings.[36])

Similar techniques can be used to produce anachronistic assemblages of filmed characters. In the 1983 Woody Allen film *Zelig*, for example, Allen's character convincingly interacts with historical figures from 1920s black-and-white newsreels. And in 1991 a Diet Coke television commercial seamlessly combined colorized old film footage of Humphrey Bogart, James Cagney, and Louis Armstrong with modern footage to yield a spectacular nightclub scene in which these long-dead characters mingle and converse with the living (figure 8.1).[37]

Of course it does not suffice merely to surround characters by the same frame: their actions or attitudes must be connected visually

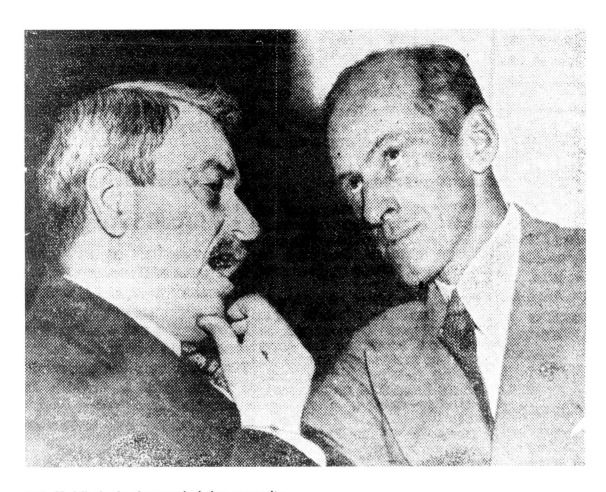

9.16 Mudslinging by photo manipulation: composite
picture of Millard Tydings (right) and Earl Browder
(left), 1951. AP/Wide World Photos.

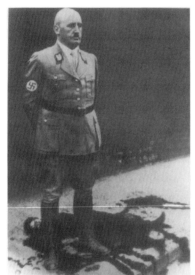

9.17 A fictional assemblage: John Heartfield's *Like Brother, Like Murderer* makes its political point by assembling separate pictures of a body from the Stuttgart police archives, Julius Streicher, and an Italian officer holding a knife. Courtesy Kent Gallery, New York.

in a way that serves some narrative purpose. The picture must have a point. Thus, for example, Heartfield's *Like Brother, Like Murderer* achieves its barbed clarity by fitting the three characters into an easily understood stereotypical pattern of standing victors and fallen, bloodied victim—one that is found both in Greek vase paintings and in boxing pictures on the sports pages of newspapers. Just as Vladimir Propp[38] analyzed folk tales as embeddings of characters in stereotyped action sequences—contracts, seductions, betrayals, and so on—we might analyze successful news pictures in terms of the stereotypical (and therefore recognizable) frozen-action patterns that they instantiate. They are iterated enactments of basic narrative functions, and we might well develop a systematic and quite exhaustive narratology of them.

An interpretation may be suggested or contested by proposing that an image shows enactment of some familiar action sequence. Many people who saw the notorious videotape of Rodney King being beaten by Los Angeles police officers immediately and confidently assimilated it to the ancient narrative of the helpless victim—the powerless member of an underclass being ill-used by his oppressors. But the defense in the criminal trial of those officers successfully constructed it in the minds of the jury as the well-worn racist narrative (long familiar from such instantiations as *Birth of a Nation* and *King Kong*) of the big, threatening, irrational black male who had to be brought under control by the forces of law and order.

Digital cut-and-paste rearrangements of the elements of a photograph can transform one action pattern into another, and in so doing dramatically alter the image's meaning—our

understanding of what the protagonists are doing. Figure 9.18 illustrates this. In the original photograph Margaret Thatcher and George Bush have their heads inclined toward each other as they engage in what clearly appears to be an amicable chat. But, in the manipulated version, Thatcher's figure has been mirrored, so that the two now turn away from each other and seem to be quarrelling. Conversely, simply moving them closer together makes their conversation seem more intimate.

Sometimes a narrative connection can be established without even placing the protagonists within the same pictorial frame. Textual enframing of separate images may work almost as well. Consider the supermarket tabloid story "5-Ton Rhino Rams Train—and Knocks It OFF the Tracks."[39] To illustrate this story, it suffices to juxtapose a stock photo of an angry rhinoceros captioned "Tourist captured this head-on shot of charging rhino on film" with another one of a train wreck presented as "Rhinoceros 1, train 0! Shocking aftermath of passenger train derailment."

Thus images suitable for appropriation by narratives can be produced in several different ways. The procedure of a traditional photojournalist is to watch for the emergence of significant patterns out of the flux of continuous action and to expose precisely at the decisive moment. That of the directorial photographer—such as Edward Curtis in producing some of his ennobled scenes of Native American life—is to marshall characters, props, and scenery into the desired relationships.[40] And that of the electronic collagist is to assemble such patterns from available image fragments: disparate found objects may encounter each other on the digital dissecting table.

**9.18 A chat, a quarrel, and an intimate whisper.
Rearranging the figures of George Bush and Margaret
Thatcher within the frame of a photograph changes
our interpretation of the action. Original photo
AP/Wide World Photos.**

Falsehoods and Fictions

In all these cases of image manipulation we
feel that somebody is not quite playing by the
rules, that we are somehow being cheated, that
invalid reports are being given.[41] But precisely
how? Speech-act theorists have thrown some
light on the matter by pointing out that the
transaction of valid reporting, stating, or assert-
ing (like other speech acts and analogous
nonverbal or partially verbal acts of communi-
cation) is defined by constitutive rules.[42] Most
obviously, the maker of the report must be
committed to the truth of the expressed propo-
sition and cannot simultaneously hold some
contradictory proposition to be true. Then
there is the preparatory rule: the maker of the
report must be authorized by an ability to pro-
vide evidence or arguments for the truth of the
expressed proposition. (Thus responsible histo-
rians and newspaper reporters check sources
and do not just guess at what happened or
make things up.) Next, there is the informative-
ness rule: the expressed proposition must not,
in the relevant context, be obviously true to
both the speaker and the hearer. And finally,
there is the sincerity rule: the maker of the re-
port must believe in the truth of the expressed
proposition or else be open to charges of lying,
prevarication, or perjury.

A successful act of reporting conveys infor-
mation that the reporter appropriately believes
to be true and the addressee accepts as credi-
ble. But there are various cases of failure due
to violation of the constitutive rules: makers of
reports may not sincerely believe what they
say or be committed to its truth, their beliefs
may not be firmly grounded in evidence, or
they may not be conveying anything that is not
already obvious to the addressee. Invalid re-
porting conveys inaccuracies or untruths or

does not make coherent sense. It may not be believed or it may create false beliefs or it may have no effect whatsoever on the addressee's beliefs.

Under normal circumstances, presentation of an unmanipulated photograph to show that something was there, that some state of affairs existed, or that some event took place is playing by the rules of valid reporting. But presentation of photorealistic synthesized images or pseudo-photographic assemblages (photographs with additions, deletions, substitutions, or rearrangements) as straightforward photographs usually is not, and the resulting transaction then becomes something other than valid reporting—either falsehood or fiction. (There are some exceptions: a combination print carefully made from two negatives to retain details of a cloudy sky might reasonably be regarded as truer to nature than a conventional print made from a single negative in which the sky is completely bleached out by overexposure.)

In the simplest case, photographic forgers and manipulators violate the sincerity rule by using their productions in the context of enframing narratives to convey knowingly false information—lies: the propagandists who removed Trotsky from Lenin's podium or who juxtaposed Senator Tydings and Earl Browder surely did not believe that what they were showing really happened, but they wanted us to. Successful use of pseudo-photographs in this way has the effect of producing or confirming false beliefs—as when the Wright girls convinced Conan Doyle of the existence of fairies.

Heartfield's *AIZ* cover image *Like Brother, Like Murderer*, though, is subtly and importantly different. Julius Streicher may or may not actually have stood over a bloodied corpse in a Stuttgart street, but (we may reasonably presume) Heartfield was not committed to the belief that Streicher did, and he was not prepared to produce any evidence that such an event took place. However, we cannot accuse Heartfield of insincerity: he was not reporting anything at all, he was not (unlike the *National Geographic* editors who shifted the pyramids for their cover) being cavalier with the truth, and he was certainly not trying to take anybody in. This powerful picture is fiction: Heartfield *pretends* to show us something that took place, and we recognize that it is a pretense.[43] We understand that the artist is projecting a possible world, not reporting on the actual one. Like Sir Philip Sydney's poet, "he nothing affirms, and therefore never lieth." We take his work as a realization of the imaginary rather than an image of the real. It succeeds in its purpose not by creating false belief about a particular event in a Stuttgart street, but by engaging us and by compellingly suggesting a general way of understanding Streicher's character and political role.

To take a work as fiction in this way, we must somehow understand that what we are seeing is *just* a picture, that it is not being used to report on an actual scene or event—even though it may look as if it could be. We must, in other words, appreciate that the constitutive rules governing valid reporting are suspended. If this suspension of the rules is not signaled with sufficient clarity, or if it is deliberately fudged, then we may justifiably feel deceived—that fiction has slipped into falsehood. Oliver Stone's 1991 film on the Kennedy assassination, *JFK*, for example, was vigorously attacked by many press critics because it combined actual newsreel footage with simulated footage and therefore, they claimed, did not play fair. A typically apoplectic response was that of

Richard Christiansen, who complained in the *Chicago Tribune* that the film tries to "persuade its audience that because certain incidents are shot in grainy black-and-white newsreel style, these incidents did, in fact, happen." He concluded that *JFK* "tries to make its viewers believe that speculation is truth and that fiction is verity."[44] The basic point is that if we do not know when the rules of reporting are in effect, we cannot know what to believe.

There are many ways to intimate that the rules of reporting are *not* in effect. A framing narrative may simply tell us that this is the case by specifying that an image is a "simulation" or "reenactment." Or the context may signal it: according to widely accepted ethical conventions, we can expect to see visual fictions when we go to the movies and to find them on the covers of magazines or in art galleries, but not to encounter them in the pages of respectable newspapers. (Oliver Stone could reasonably claim that *JFK*—made with actors and shown in movie theaters—was using realistic fiction to make a valid political point in much the same fashion as Heartfield.) Even the image itself may signal that it is not actually a straightforward photographic report, for example by incorporating obviously hand-drawn lines or by displaying conspicuous inconsistencies of perspective or shading.

Sometimes just the same image can be used, in different contexts, to make valid reports, to deceive, and to project fictions. Consider the photograph of Walt Whitman and the butterfly. Historians can legitimately use this picture to report on Whitman's appearance at a particular date—to show the length of his beard and the style of his attire. Whitman himself apparently used it, on at least some occasions, to create the false belief that a live butterfly had spontaneously settled on his finger. But Whitman's readers might most reasonably take it as a posed fiction; it is, after all, the frontispiece of a book in which the poet repeatedly constructs and contemplates images of his own psyche's transmutation and resurrection. Why should not the photograph be read as a visual allegory on the same theme? Whatever the photographer's (or Whitman's) original intentions, the image can be appropriated and used for a variety of purposes.

Even completely straightforward photographs can sometimes be used to dissimulate or project fictions. Imagine a photograph of a bloody dictator smilingly dandling an infant on his knee—a work in a propaganda genre that has been popular from Stalin to Saddam Hussein. The photograph may well be unposed and unmanipulated; there is no reason to doubt that dictators are capable of sentimentality about grandchildren. But if the photograph is used as evidence of the dictator's generally benevolent nature, then it is used to create a false belief.

Thus we can begin to see that the truth, falsehood, or fictionality of an image is not simply a congenital property—one conferred at birth by a particular capture or construction process. It is, at best, only partially determined by the maker of the image. It is a matter, as well, of how that image is being *used*—perhaps by somebody other than the maker—in some particular context.

How Pictures Do Things with Us

So far, though, we have taken a rather narrow view of the uses of pictures. They can actually be used to do many more things than report on

events and states of affairs, tell lies, and project fictions. In a sushi restaurant with a pictorial menu, for example, you can use pictures to order. (Point, and say "Bring me one of these." You do not need to know the word for it.) Architects use pictures to specify work that is to be done, then to create contracts for execution of that work. Gruesome pictures can be used to warn or threaten, and pornographic pictures can be used to elicit sexual response. Photographs in mail-order catalogues are used to promise goods in return for money. Passport photographs are used to identify, and photographs of birds in the *Audubon Society Field Guide* are used to classify. In the terminology of speech-act theorists, the use of a picture in a particular act of communication gives that picture a certain illocutionary force, and the illocutionary force given to a particular picture may vary from context to context.[45]

But there are constraints: pictures—like other types of physical artifacts—must be fit for the particular uses to which they are put. They must have properties that assure their functional adequacy. In this they differ from spoken sounds: language, as Saussurean semiotics long ago taught us, puts available speech sounds to arbitrary and conventionally maintained rather than causally constrained uses.

Firstly, image-production processes make certain representational commitments: they record certain kinds of things and not others, and they record some kinds of things more completely and accurately than others. These representational commitments determine in a very obvious way the limits of a resulting image's potential uses in acts of communication. A color photograph or drawing can be used, for example, to report on the hue of an object,

to specify that an object should have a certain hue, or to promise that an object will have a certain hue; but a black-and-white drawing or photograph clearly cannot. Photographs and mathematically constructed perspectives are committed to absolute spatial consistency and can be used to report the existence of, specify, or promise precise spatial relationships; but hand sketches are not committed in this way and so cannot be used to show anything more than approximate relationships—except, perhaps, when they are appropriately annotated with dimensions and comments.[46] Instantaneous photographs are committed to temporal unity, but collages are not. A photofinish picture can be used to report that horses crossed the line in a certain order and at a certain spacing, but not (since it is the trace produced by the horses crossing in front of a slit aperture rather than an instantaneous snapshot) to report that that a particular configuration of horses existed at a specific moment. One-point perspective drawings or photographs of buildings are committed to representing certain elevation planes without foreshortening, but two-point and three-point views are not. Different medical-imaging techniques—CT, ultrasound, PET, MRI, and so on—are committed to acquiring different types of data about bony and soft tissue diseases and physiological activities, and so are used for different diagnostic purposes.

Secondly, a picture used in an act of communication must have the correct type of intentional relationship to its subject matter. (In other words, it must be *about* the right sort of thing.) A photographic or identikit portrait of Abu Nidal can be used by an immigration officer to identify that individual but not to classify somebody else as a terrorist, and a

drawing of a fictional character such as Sherlock Holmes is of no use to an immigration officer at all. Conversely, an ornithologist's generic drawing of a grackle in a field guide can be used by a birdwatcher to classify a particular specimen as a member of that species, but not to identify that bird as the individual Tweety. A sushi-menu photograph is used appropriately to order fresh pieces of the depicted sushi types—certainly not the particular sushi instances that were actually photographed some time ago! A news photograph can be used effectively by a journalist or a historian to make a precise report about an event or a state of affairs at some definite moment in the past, but a handmade drawing works less well in this role. And a synthesized perspective view can be used by an architect to project a possible future world, but a photograph can only show an anterior state of the actual material world.

In general, then, an attempted pictorial act of communication—making a report, carrying out an identification, giving an order, or whatever—will fail if the image used does not have the requisite sort of graphic content or if its intentional positioning is not appropriate. This is misuse of a physical artifact—like attempting to drive nails with a marshmallow. The act will misfire or it will succeed only in some hollow or fraudulent way: your report may be greeted with disbelief, you may wrongly identify somebody (who happens to resemble a fictional illustration) as Sherlock Holmes, or your sushi order may produce an unappetizing surprise.[47] Just as you must understand the different uses afforded by marshmallows and hammers if you want to perform physical tasks successfully, so you must distinguish between the varying functional capabilities of paintings and drawings, photographs, and digital images produced under various different circumstances in order to use these different types of images felicitously.

Now, the process of photographic image construction is highly standardized, its representational commitments are well known, and the intentional relationships of standard photographs to their subject matter are relatively straightforward and unambiguous. Furthermore, if one accepts the Foucaultian thesis that modern science reversed the scholastic view of an assertion's authority as something derived from its author and substituted the notion that matters of fact are impersonal things, then it becomes obvious that the impersonal process of photography answered to a dominant conception of what the coinage of communication should be. Thus the rules that societies have evolved for acceptable and effective usage of photographs in acts of communication are both clear (if not always explicit) and widely understood. These rules valorize photographs as uniquely reliable and transparent conveyors of visual information and concomitantly structure familiar practices of graphic production and exchange—among them the practices of photojournalism, feature illustration, advertising photography, photo-illustrated fiction, the legal use of photographic evidence, the family snapshot, photographic portraiture, photo identification, medical imaging, and art photography. Photography has established a powerful orthodoxy of graphic communication.

But digital images—as we have seen—have much less standardized production processes than photographs. These processes are less subject to institutional policing of uniformity, offer more opportunities for human intervention, and are far more complex and varied in

their range of possible representational commitments. Furthermore, digital images can stand in a wider variety of intentional relationships to the objects that they depict. And, because they are so easily distributed, copied, transformed, and recombined, they can readily be appropriated (or misappropriated) and put to uses for which they were not originally intended. Thus they can be used to yield new forms of understanding, but they can also disturb and disorient by blurring comfortable boundaries and by encouraging transgression of rules on which we have come to rely. Digital imaging technology can provide openings for principled resistance to established social and cultural practices, and at the same time it can create possibilities for cynical subversion of those practices.

The growing circulation of the new graphic currency that digital imaging technology mints is relentlessly destabilizing the old photographic orthodoxy, denaturing the established rules of graphic communication, and disrupting the familiar practices of image production and exchange. This condition demands, with increasing urgency, a fundamental critical reappraisal of the uses to which we put graphic artifacts, the values we therefore assign to them, and the ethical principles that guide our transactions with them.

10.1 The reconfigured eye.

THE SHADOWS ON THE WALL

■ For a century and a half photographic evidence
seemed unassailably probative. Chemical pho-
tography's temporary standardization and sta-
bilization of the process of image making
served the purposes of an era dominated by
science, exploration, and industrialization.
Photographs appeared to be reliably manufac-
tured commodities, readily distinguishable
from other types of images. They were comfort-
ably regarded as causally generated truthful re-
ports about things in the real world, unlike
more traditionally crafted images, which
seemed notoriously ambiguous and uncertain
human constructions—realizations of ineffable
representational intentions. The visual dis-
courses of recorded fact and imaginative con-
struction were conveniently segregated. But the
emergence of digital imaging has irrevocably
subverted these certainties, forcing us to adopt
a far more wary and more vigilant interpretive
stance—much as recent philosophy and liter-
ary theory have shaken our faith in the ulti-
mate grounding of written texts on external
reference, alerted us to the endless self-referen-
tiality of symbolic constructions, and con-
fronted us with the inherent instabilities and
indeterminacies of verbal meaning.

An interlude of false innocence has passed.
Today, as we enter the post-photographic era,
we must face once again the ineradicable fra-
gility of our ontological distinctions between
the imaginary and the real, and the tragic elu-
siveness of the Cartesian dream. We have in-
deed learned to fix shadows, but not to secure
their meanings or to stabilize their truth val-
ues; they still flicker on the walls of Plato's
cave.

NOTES

■ 1 Beginnings

1

Pliny the Elder, *Natural History* xxxv, 15, first com-
ments: "The origin of painting is uncertain. . . .
Some Greeks claim it was discovered in Sicyon, oth-
ers in Corinth; but there is universal agreement that
it began by the outlining of a man's shadow." Later
(xxxv, 151) he recounts the tale of Butades, the
daughter of a potter from Sicyon: "She was in love
with a young man, and when he was going abroad
she drew a silhouette on the wall round the shadow
of his face cast by the lamp. Her father pressed clay
on this to make a relief and fired it with the rest of
his pottery."

Athenagoras (*Embassy*, 17) has a variation: "Linear
drawing was discovered by Saurias, who traced the
outline of the shadow cast by a horse in the sun,
and painting by Kraton, who painted on a whitened
tablet the shadows of a man and woman. The
maiden invented the art of modeling figures in relief.
She was in love with a youth, and while he lay
asleep she sketched the outline of his shadow on the
wall. Delighted with the perfection of the likeness,
her father, who was a potter, cut out the shape and
filled in the outline with clay; the figure is still pre-
served at Corinth."

2

In the late eighteenth century, a few decades before
the birth of photography, this process eventually was
mechanized. A contraption called the physiogno-
trace was invented for the purpose of accurately cap-
turing portrait silhouettes.

3

Fox Talbot's reminiscences are recorded in "A Brief
Historical Sketch of the Invention of the Art," conve-
niently reprinted in Alan Trachtenberg (ed.), *Classic
Essays on Photography* (New Haven: Leete's Island
Books, 1980), 27–36.

4

This, at least, is the standard story. If it is not quite true, it should be.

5

R. A. Kirsch, L. Cahn, C. Ray, and G. H. Urban, "Experiments in Processing Pictorial Information with a Digital Computer," in *Proceedings of the Eastern Joint Computer Conference* (New York: Institute of Radio Engineers, 1958), 221–29.

6

Reprinted in Trachtenberg, *Classic Essays on Photography,* 37–38.

7

Edward Weston, "Seeing Photographically," *Encyclopedia of Photography* 18 (New York: Greystone Press, 1965). Reprinted in Trachtenberg, *Classic Essays on Photography,* 169–78.

8

It is important to distinguish carefully between analog and digital electronic images. Video images are analog, not digital. Although video images are subdivided into a finite number of horizontal scan lines, the variations in intensity along scan lines are represented by a continuously varying signal.

9

This is not to say that a photograph has unlimited resolving power. Grain appears and the image begins to break up at high levels of enlargement: fine-grained film records more information than coarse-grained film. Any photographic image also has limited acutance—edge sharpness. Resolving power of film is tested by photographing a target of closely spaced black-and-white lines. The point is that photographic images degrade *gradually* with enlargement, and although resolution can be measured approximately, it cannot be specified exactly.

10

The replicability of digital information has important implications in other areas. The introduction of digital audio tape into the United States was long delayed because of fears that its capacity to make perfect copies would lead to extensive and uncontrollable piracy of recordings. And biologists have suggested that, because replicability is so important, the DNA code *must* be digital.

11

Weston, "Seeing Photographically," in Trachtenberg, *Classic Essays on Photography,* 169–78.

12

Paul Strand, "Photography," *Seven Arts* (August 1917): 524–26. Reprinted in Trachtenberg, *Classic Essays on Photography,* 141–44. Similarly, Lewis Mumford articulated a standard modernist view when he wrote: "As for the various kinds of *montage* photography, they are in reality not photography at all but a kind of painting, in which the photograph is used—as patches of textiles are used in crazy-quilts—to form a mosaic. Whatever value the montage may have derives from the painting rather than the camera" (*Technics and Civilization* [New York: Harcourt Brace Jovanovich, 1934], 339).

13

For comparisons of modernist and postmodernist stances, see Terry Eagleton, "Awakening from Modernity," *Times Literary Supplement,* February 20, 1987; and David Harvey, *The Condition of Postmodernity* (Oxford: Basil Blackwell, 1989).

2 The Nascent Medium

1

In particular, they performed digital filtering operations to remove camera and transmission imperfections and to bring out fine detail with maximum clarity. This type of filtering is discussed in chapter 5.

2

John Noble Wilford, "On the Trail from the Sky: Roads Point to a Lost City," *The New York Times,* Wednesday, February 5, 1992, A1, A14.

3

John Noble Wilford, "Lofty Instruments Discern Traces of Ancient Peoples," *The New York Times,* Tuesday, March 10, 1992, C1, C6.

4

Gerd Binnig and Heinrich Rohrer, "The Scanning Tunnelling Microscope," *Scientific American* (August 1985): 50–56.

5

H. Kumar Wickramsinghe, "Scanning Probe Microscopes," *Scientific American* (October 1989): 98–105.

6

For a popular account of the recent development of medical-imaging systems, see Stephen S. Hall, "Vesalius Revisited," in *Mapping the Next Millennium: The Discovery of New Geographies* (New York: Random House, 1992), 141–54. A comprehensive survey of technologies for acquiring and processing body-image data is provided by Martin R. Stytz, Gideon Frieder, and Ophir Frieder, "Three-Dimensional Medical Imaging: Algorithms and Computer Systems," *ACM Computing Surveys* 23:4 (December 1991): 421–500.

7

Mathew Turk and Alex Pentland, "Eigenfaces for Recognition," *Journal of Cognitive Neuroscience* 3:1 (1991): 71–86.

8

For general introductions to this technology, see Dana Ballard and Christopher Brown, *Computer Vision* (Englewood Cliffs, NJ: Prentice Hall, 1982); and Martin D. Levine, *Vision in Man and Machine* (New York: McGraw-Hill, 1985). Important research papers are collected in Martin Fischler and Oscar Firschein (eds.), *Readings in Computer Vision* (Los Altos, CA: Morgan Kaufmann, 1987). A concise, popular account of some of the central issues is provided by Thomas O. Binford, "The Machine Sees," in Marvin Minsky (ed.), *Robotics* (New York: Anchor Press/Doubleday, 1985), 98–121.

9

Glenn Rifkin, "The Giants Focus on the Image of a Check," *The New York Times*, Sunday, March 11, 1990, F9.

10

For an analysis of the videogame effect of Gulf War reporting, see Timothy J. McNulty, "In Gulf War, TV Was Both Friend, Foe," *Chicago Tribune*, Monday, December 23, 1991, 1–12. This was a war in which, as W. J. T. Mitchell has pointed out, "a major objective . . . was the erasure of the human body from the picture" ("Culture Wars," *London Review of Books* 14:8, April 23, 1992, 7). US General H. Norman Schwarzkopf quickly made it clear that there would be no announcements of body counts, as there had been in Vietnam, and no images of body bags. Later, as the effects of this style of reporting took hold, that same general felt compelled to complain, "This is not a Nintendo game."

11

Color scanners came into widespread use in the publishing industry in the 1970s, replacing earlier photographic techniques for producing color separations. Sophisticated color electronic prepress systems (CEPS), capable of retouching, editing, correcting, and combining digital color images, emerged with the introduction of the Scitex system at the Print '80 show in 1980. This system was powerful but expensive (up to about one million dollars for a full installation). It soon achieved considerable success: the newspaper *USA Today*, for example, quickly came to rely on it. Competing systems were introduced by Hell and by Crosfield. For a discussion of color prepress technology, see Peter Johnston, "From Computer to Page," *Computer Graphics World* 13:1 (January 1990): 28–34.

12

Clare Ansberry, "Alterations of Photos Raise Host of Legal, Ethical Issues," *The Wall Street Journal*, January 26, 1989, B1.

13

Mike Gerrard, "Computers Make a Clean Breast . . . Or Do They?" *Guardian Weekly*, July 9, 1989.

14

This picture appeared on the cover of the February 1982 issue (vol. 162, no. 2). The story of the incident is recounted in Fred Ritchin, *In Our Own Image* (New York: Aperture, 1990), 14–15. Many journalists and photographers saw this unacknowledged (but

later admitted) manipulation as a paradigmatic case of ethically questionable use of the new technology, and there was considerable criticism. Ten years later, the editors of *National Geographic* (less insouciant than the editor of *Mayfair*) were still so chagrined about being caught at it that they adamantly refused repeated requests to allow reproduction of the offending image in this book. The Director of Illustrations rather disingenuously replied: "I regret that our answer still is: 'No.' We feel that this early instance of digital manipulation, when the means first became available to do such things, is not representative of how *National Geographic* uses electronic imaging technology in the preparation and correction of its color separations for printing."

15

The Fifth Annual Digital Photography Conference was held by the National Press Photographers Association in Washington, DC, on February 8–10, 1990. For a critical discussion see Timothy Druckrey, "News Photography and the Digital Highway," *Afterimage* 17:10 (May 1990): 3.

16

John Long, "Truth, Trust Meet New Technology," in *The Electronic Times*, a publication produced at a National Press Photographers Association workshop on electronic photojournalism at Martha's Vineyard, Massachusetts, October 6, 1989.

17

For a discussion of threats posed to the traditional role of the photojournalist, see Gary Hoeing, "Assignment: Survival," *Region One News* (National Press Photographers Association) (Spring 1990): 18–19.

18

Andy Grundberg, "Ask It No Questions: The Camera Can Lie," *The New York Times*, Sunday, August 12, 1990, Section 2, 1, 29.

19

Recounted by Pliny, *Natural History*, xxxv, 64–66. Not to be outdone even by this, Zeuxis's rival Parrhasius painted a curtain that fooled Zeuxis into requesting that it be drawn back. "When he realized his mistake, with an unaffected modesty, he conceded the prize, saying that whereas he had deceived birds, Parrhasius had deceived him, an artist."

20

André Bazin, "The Ontology of the Photographic Image," in *What is Cinema?* (Berkeley: University of California Press, 1967), 16.

21

This point is illustrated not only by electronic manipulation, but also by photographers who have used staged and appropriated images to insist on photography's fictional possibilities. See for example Cindy Sherman's "Untitled Film Stills."

22

Sony demonstrated its Mavica prototype in 1981.

23

The ScanBack fits on a standard Rolleiflex camera. Exposure times are long—seconds or minutes—and the system is intended for high-precision studio work. In essence, it converts a Rolleiflex into a three-dimensional scanner.

24

John Durniak, "New from Japan: Photographs You Can View on a Television Screen or Personal Computer," *The New York Times*, September 22, 1991, 61. Fuji first developed a digital camera in 1988 and marketed it in Japan in 1989. The Fujix is a $5,000 portable system that records twenty-one color images on a credit-card-sized memory card. It is the approximate functional equivalent of a 35-mm SLR.

25

"Kodak Introduces Electronic Camera," *The New York Times*, May 29, 1991, D4. The Kodak Professional DCS is a $20,000 system intended primarily for use by photojournalists and in surveillance tasks. It consists of a Nikon F3 body with a digital camera back. Images are captured by a 1024 by 1280 CCD array. The camera back is connected by cable to a rather bulky shoulder-pack digital storage unit (DSU). The digital storage unit contains a 200-megabyte Winchester disk for image storage and a LCD display monitor. Up to six hundred images can be stored on the disk in compressed format. The DSU provides immediate image-analysis and manipulation capabilities.

26

The Fotoman was one of the first of these to appear in the United States. It is packaged with image-processing software for the IBM PC. The Dycam Model 1 is a similar product. See Peter H. Lewis, "New Ways to 'Paste' a Photo Into Your Documents," *The New York Times*, Sunday, January 19, 1992, F9.

27

"Shuttle Missions Turn to Hands-On Imaging and Image Processing," *Advanced Imaging* 6:11 (November 1991): 8.

28

Among the first sophisticated systems to achieve widespread use were Digital Darkroom, Adobe Photoshop, and Letraset Color Studio.

29

A key development was the introduction by Apple Computer of an operating system extension called Quicktime. This provided a "movie" file format for digital video, together with utilities for handling such files. Microsoft introduced similar extensions to their Windows system. See John Markoff, "Mouse! Movie! Sound! Action!" *The New York Times*, Sunday, October 27, 1991, F11.

30

John Holusha, "New Kodak System for Showing Photos on TV," *The New York Times*, Tuesday, September 18, 1990, D6; and John Durniak, "Coming Soon to Your TV Screen: Family Snapshots, Brought to You by CD Technology," *The New York Times*, Sunday, January 19, 1992, Y19. On the history of CD technology, see the special issue of *IEEE Spectrum* 25:11 (1988): 102–8.

31

This sort of simulation can be accomplished either through storage of multiple versions of images or by means of the digital filtering techniques that are discussed in chapter 5.

32

See "Call for a Code at NPPA," in *The Electronic Times*, a publication produced at a National Press Photographers Association workshop on electronic photojournalism held at Martha's Vineyard, Massachusetts, October 6, 1989. Some of the published comments by attending photographers were: "This is ours. We need to retain control of the images." "This stuff is seductive and needs control by experts." "NPPA should be willing to take the high road in setting a moral and ethical standard for the industry." Partly in response to concerns about digital manipulation, the NPPA has distinguished between photojournalism and so-called editorial illustration, and has eliminated the editorial illustration category from its Pictures of the Year awards.

33

On Associated Press and the Norwegian Press Association, see the report by Phil LoPiccolo, "What's Wrong with This Picture?," *Computer Graphics World* (June 1991): 6–9.

34

Deborah Starr Seibel, "Splitting Image: Film Technology's Ability to Mix and Match Past and Present Divides Entertainment Industry," *Chicago Tribune*, Monday, December 30, 1991, Section 5, 1–3.

35

There has, for example, been a growing tendency among American newspapers to supplement traditional news photographs with contrived, set-up, or manipulated editorial illustrations in order to produce a more graphically appealing product.

36

Early digital images—especially those produced by first-generation still-video and digital cameras—were considerably inferior to the best silver-based photographs, and this limited their application. But the level of quality obtainable in digital images is primarily a function of available digital storage capacity and processing speed, and these constantly improve, so the digital image will seem increasingly attractive as time goes by.

37

Heinrich Schwarz, *Art and Photography: Forerunners and Influences* (Chicago: University of Chicago Press, 1987). On the optical side, the direct ancestor of the photographic camera was the camera obscura, which had become particularly popular in the eighteenth century as an aid to artists. On the chemical

side, it had long been known that sunlight could darken human skin and fade dyes, and the darkening effect of sunlight on silver nitrate, in particular, had been known since the early eighteenth century. Daguerre in France and Fox Talbot in England found ways of combining the two in service of nineteenth-century ideals of realistic depiction. For further arguments along these lines, see Chris Titterington, "Construction and Appropriation," in Mike Weaver (ed.), *The Art of Photography 1839–1989* (New Haven: Yale University Press, 1989); and Geoffrey Batchen, "Burning With Desire: The Birth and Death of Photography," *Afterimage* 17:3 (January 1990): 8–11. For resistance to the standard story of the birth of photography, see Jonathan Crary, *Techniques of the Observer: On Vision and Modernity in the Nineteenth Century* (Cambridge, MA: The MIT Press, 1990).

38

Erwin Panofsky, "Style and Medium in the Moving Pictures," in Daniel Talbot (ed.), *Film* (New York: Simon and Schuster, 1959).

3 Intention and Artifice

1

See Robert Pear, "U.S. Downs 2 Libyan Fighters, Citing Their 'Hostile Intent'; Chemical Plant Link Denied," *The New York Times*, Thursday, January 5, 1989, A1; and Richard Halloran, "U.S. Says Tape Shows Missiles on a Libyan Jet," *The New York Times*, Friday, January 6, 1989, A1, A10. Halloran commented, "The quality of the tape was poor and what is said to be missiles appears as a darkened blur." An Agence-France Presse photograph showing Ambassador Walters exhibiting a very indistinct, but carefully labeled still at the United Nations was widely published on Saturday, January 7. The wrangle about this photographic evidence is reported in William G. Blair, "U.N. Hears Defense in Downing of Jets," *The New York Times*, Saturday, January 7, 1989, 4; and "Soviets Say U.S. Lacks Proof of Libyan Arms Plant," *Chicago Tribune*, Saturday, January 7, 1989, 3.

2

This sort of political drama had been enacted before. During the Cuban missile crisis the US ambassador to the UN, Adlai E. Stevenson, produced aerial photographs to document the claim that the Russians had installed offensive missile bases in Cuba, and the Soviet ambassador Valerian A. Zorin declared that they were faked.

3

For perspectives on this issue, see Nelson Goodman, *Languages of Art* (Indianapolis: Hackett, 1976); Margaret A. Hagen, *Varieties of Realism* (Cambridge: Cambridge University Press, 1986); David Novitz, *Pictures and Their Use in Communication* (The Hague: Martinus Nijhoff, 1977); Flint Schier, *Deeper into Pictures* (Cambridge: Cambridge University Press, 1986).

4

For a brief, clear introduction to correspondence and coherence theories of truth, see W. V. Quine, "Truth," in *Quiddities* (Cambridge, MA: The Belknap Press of Harvard University Press, 1987), 212–16. Those committed to the correspondence theory will claim that "grass is green" is true if and only if grass is green, and may want to extend this line of argument to photographs of green grass.

5

Susan Sontag, *On Photography* (New York: Farrar, Straus & Giroux, 1977). For criticism of this view, see Joel Snyder, "Picturing Vision," *Critical Inquiry* 6 (Spring 1980): 499–526.

6

Significantly for the theme of this book, the authenticity of the Holy Shroud has been hotly disputed. Perhaps it is the world's first fake photograph.

7

John Berger, "Understanding a Photograph," in Alan Trachtenberg (ed.), *Classic Essays on Photography* (New Haven: Leete's Island Books, 1980), 291–94.

8

Aaron Scharf, "The Representation of Movement in Photography and Art," in *Art and Photography* (New York: Penguin, 1986).

9

This is conveniently reprinted in Roman Jakobson, *Language in Literature* (Cambridge, MA: The Belknap Press of Harvard University Press, 1987), 19–27.

10

Roland Barthes, "The Reality Effect," in Tzvetan Todorov (ed.), *French Literary Theory Today* (Cambridge: Cambridge University Press, 1982), 11–17.

11

See Ewa Kuryluk, *Veronica and Her Cloth: History, Symbolism, and Structure of a "True" Image* (Cambridge, MA: Basil Blackwell, 1991).

12

Thus Rosalind E. Krauss rehearses the standard cliché that a photograph is "an imprint or transfer off the real" and dutifully mentions fingerprints and the Shroud of Turin, but provides a less expected twist by connecting photography and writing via André Breton's remark that "automatic writing, which appeared at the end of the 19th century, is a true photography of thought" ("The Photographic Conditions of Surrealism," in *The Originality of the Avant-Garde and Other Modernist Myths* [Cambridge, MA: The MIT Press, 1986], 87–118).

13

André Bazin, "The Ontology of the Photographic Image," in *What is Cinema?* (Berkeley: University of California Press, 1967). Others have produced similar formulations. Lewis Mumford, for example, wrote in *Technics and Civilization* (New York: Harcourt Brace Jovanovich, 1934) that "photography differs from the other graphic arts in that the process is determined at every state by the external conditions that present themselves." Stanley Cavell has observed in *The World Viewed* (New York, 1971): "So far as photography satisfied a wish, it satisfied a wish not confined to painters, but the human wish, intensifying since the Reformation, to escape subjectivity and metaphysical isolation. . . . Photography overcame subjectivity in a way undreamed of by painting, one which does not so much defeat the act of painting as escape it altogether: by *automatism*, by removing the human agent from the act of reproduction." Rudolf Arnheim has spoken of "the funda-mental peculiarity of the photographic medium: the physical objects themselves print their image by means of the optical and chemical action of light" and suggested that, as a result of this peculiarity, "we are on vacation from artifice" when we look at photographs ("On the Nature of Photography," *Critical Inquiry* 1 [1974]: 149–61). There are not too many more ways to say it! For an argument that the "automatic" character of photography has been exaggerated, see Joel Snyder and Neil Walsh Allen, "Photography, Vision, and Representation," *Critical Inquiry* (Autumn 1975).

14

Christopher Isherwood, "A Berlin Diary," in *The Berlin Stories* (New York: New Directions, 1963).

15

Roger Scruton, "The Eye of the Camera," in *The Aesthetic Understanding* (London: Methuen, 1983). On intentionality and representation, see also Richard Wollheim, "On Drawing an Object," in *On Art and the Mind* (Cambridge, MA: Harvard University Press, 1974), 3–30; and "What the Spectator Sees," in Norman Bryson, Michael Ann Holly, and Keith Moxey (eds.), *Visual Theory: Painting and Interpretation* (New York: HarperCollins, 1991), 101–50.

16

John Canaday, *Mainstreams of Modern Art* (New York: Simon and Schuster, 1959), 103. The supermarket tabloid *Weekly World News* has no such scruples. It has published (March 24, 1992), with an accompanying photograph, an article entitled "Baby Born with Angel Wings: He Really IS a Gift from Heaven Says Joyful Mom."

17

Lewis Hine, "Social Photography," in Trachtenberg, *Classic Essays on Photography*, 111.

18

For a discussion of the role of the camera obscura in drawing and painting, see Svetlana Alpers, *The Art of Describing: Dutch Art in the Seventeenth Century* (Chicago: University of Chicago Press, 1983). Alpers comments, on critical attitudes to use of the camera obscura, "Art is assumed to be that which is not due to an instrument but to the free choices of a human maker." See also Jonathan Crary, "The Camera

Obscura and its Subject," in *Techniques of the Observer: On Vision and Modernity in the Nineteenth Century* (Cambridge, MA: The MIT Press, 1990), 24–66.

19

A similar analysis can be made of constructed perspective renderings. Before the Renaissance there were drawings and paintings in roughly correct perspective, but there were no complete, well-defined perspective-construction algorithms, so the results of attempts to depict architectural space were unpredictable. The Renaissance perspective theorists succeeded in establishing such algorithms. If a perspective construction algorithm is rigorously applied by a draftsperson to geometric data (measurements from a survey of a building, say), the results are highly predictable. However, architectural drafters have often taken liberties in order to "improve" the appearance of a perspective drawing, and these may be difficult to detect. Computer generation of a perspective image from geometric data is an entirely algorithmic process, and we can trust the objectivity of the results.

20

Perhaps the most algorithmic form of photograph is one produced by a mechanism that has nobody looking through the viewfinder when the button is pushed; for example, an unmanned spacecraft that takes pictures at preprogrammed moments. It is certainly within the current capability of artificial-intelligence technology to go a step further and produce a photographer-robot that could independently decide, according to programmed criteria, to make an exposure whenever something "interesting" appeared within the viewfinder frame. At this point, photography is only very indirectly related to human intention.

21

Another line of attack is to concede that the standard algorithm was followed but to claim that the event itself was staged—that the photographer acted in a "directorial" rather than "straight" mode. I shall be only peripherally concerned with the dispute that has raged between proponents of these two modes. For an introductory discussion, see A. D. Coleman,

"The Directorial Mode: Notes toward a Definition," *Art Forum* (September 1976).

22

See Eastman Kodak Company, *Clinical Photography* and *Basic Police Photography* (Rochester, NY, 1974).

23

This task is analogous to that of a literary scholar who undertakes to demonstrate that a text cannot be genuine. See Anthony Grafton, *Forgers and Critics* (Princeton: Princeton University Press, 1990), on the interplay between textual forgery and the development of techniques of textual authentication.

24

For discussions of impossible objects, see L. S. Penrose and R. Penrose, "Impossible Objects: A Special Type of Illusion," *British Journal of Psychology* 49:31 (1958); D. A. Huffman, "Impossible Objects as Nonsense Sentences," *Machine Intelligence* 6 (1971): 295–23; and Marianne L. Teuber, "Sources of Ambiguity in the Prints of Maurits C. Escher," *Scientific American* 231:1 (1974).

25

For a detailed discussion of the standard approach to computer interpretation of line drawings as three-dimensional scenes, see D. Waltz, "Understanding Line Drawings of Scenes with Shadows," in P. H. Winston (ed.), *The Psychology of Computer Vision* (New York: McGraw-Hill, 1975), 19–91. On the use of intensity information in scene-interpretation procedures, see Berthold K. P. Horn, "Understanding Image Intensities," in Martin A. Fischler and Oscar Firschein (eds.), *Readings in Computer Vision: Issues, Problems, Principles, and Paradigms* (Los Altos, CA: Morgan Kaufmann, 1987), 45–60.

26

This point might be connected to Michael Riffaterre's thesis, developed in *Fictional Truth* (Baltimore: Johns Hopkins University Press, 1990), that the ring of truth in successful fiction depends on richly tautological representation within the text rather than on exterior referentiality.

27

See for example Norman Bryson's analysis of the difference between Vermeer's *The Artist in His Studio* and a photographic transcription in *Vision and*

Painting (New Haven: Yale University Press, 1983), 111–17.

28

In similar fashion, we can cross-check narratives. There is a well-known inconsistency to be discovered in *Robinson Crusoe,* for example. Defoe has Crusoe swim naked to the wreck, then fill his pockets with things found there.

29

The importance of cast shadows in establishing credibility was demonstrated by the film *Who Framed Roger Rabbit?*. Drawn cartoon characters were inserted into photographed scenes with no attempt to produce an illusion of continuity. Indeed, the difference between cartoon and live characters was part of the point and was graphically emphasized. But live and cartoon characters were made to seem as if they occupied the same pictorial space by casting convincing shadows from the drawn characters onto photographed surfaces.

30

Edouard Manet's *Bar at the Folies Bergère* is a well-known example of a picture in which a prominent reflection is clearly *not* consistent with our spatial interpretation of the scene. The reflection of the woman's back in the mirror behind the bar cannot be consistent with the viewer's location directly in front of her. This produces a discomfiting effect of spatial ambiguity. Conversely, in the film *Terminator 2: Judgment Day,* a computer-synthesized metallic cyborg inserted into photographed scenes was made to seem convincingly solid and real by the reflection of surrounding scenery in its shiny body. See Peter Sorensen, "Terminator 2: A Film Effects Revolution," *Computer Graphics World* 14:10 (October 1991): 56–62.

31

A basic discussion is provided in G. A. Collingwood, *The Idea of History* (Oxford: Clarendon Press, 1967 [1946]). For a more recent view see Carlo Ginzburg, "Checking the Evidence: The Judge and the Historian," *Critical Inquiry* 18 (Autumn 1991): 79–92. Ginzburg attacks the view that a historical document is like a naively understood photograph—"a

transparent medium . . . an open window that gives us direct access to reality."

32

A more extreme case of this sort of deception is that of the fifteenth-century *Nuremberg Chronicle,* which was illustrated with a large number of woodcuts of personages and places. Images from the same block are used in different places with different captions: one view is used to illustrate eleven different towns. See William M. Ivins, Jr., *Prints and Visual Communication* (Cambridge, MA: The MIT Press, 1969), 38.

33

William D. Montalbano, "From the Ice Comes a Mystery," *Los Angeles Times,* Monday, October 21, 1991, A1, A12.

34

Paul Wallich, "Polar Heat: The Argument Continues over an Explorer's Good Name," *Scientific American* 262:3 (March 1990): 22–24.

35

Phillip Knightley, *The First Casualty* (New York: Harcourt Brace Jovanovich, 1975), 209–12. See also Richard Whelan, *Robert Capa* (New York: Knopf, 1985), 95–100.

36

Frederic Ray, "The Case of the Rearranged Corpse," *Civil War Times* (October 1961).

37

See Karal Ann Marling and John Wetenhall, *Iwo Jima: Monuments, Memories and the American Hero* (Cambridge, MA: Harvard University Press, 1991). There was, indeed, a dramatic flag-raising on the summit of Suribachi a few hours after the Marines invaded Iwo Jima. But Rosenthal's photograph is of a staged event, with a different flag, which took place hours later.

38

"Viet War Photo Is Challenged," *Washington Post,* January 19, 1986.

39

Similar questions are sometimes raised about literary works, and the charge of fraud may be made if claims about authorship and date do not seem to correspond to the facts. A celebrated recent instance was the 1981 publication in *Harper's Magazine* of a

piece that the historian Peter Gay presented as a translation of a newly discovered contemporary review of Freud's *The Interpretation of Dreams*. Gay later said that it was a spoof, but Freudians who had been taken in angrily denounced it as a fraud. The argument between Gay and his detractors turned on the questions of what claims about provenance had explicitly and implicitly been made, whether these had been made with lighthearted or deceptive intent, and whether those deceived had been insufficiently alert to the cues that normally allow us to distinguish fiction from evidence.

40
For a fuller account of this episode, see Clifford Krauss, "A Photo Said to Show 3 Lost Fliers Jogs Congress on Vietnam Missing," *The New York Times*, Wednesday, July 24, 1991, International Section, A6.

41
Andrew Rosenthal, "Pentagon Casts Doubt on Photo," *The New York Times*, Friday, July 26, 1991.

42
Ibid.

43
"MIAs Photo Was From Magazine, US Says," *Boston Globe*, August 9, 1991, 70.

44
Barbara Crossette, "New Interest in Missing Servicemen May Imperil Move Toward Hanoi Ties," *The New York Times*, Monday, January 6, 1992, A3; Barbara Crossette, "U.S. Cites New Data on Picture," *The New York Times*, Sunday, July 19, 1992, A12.

45
Benjamin C. Bradlee, "Lies, Damned Lies, and Presidential Statements," *Guardian Weekly*, December 1, 1991, 21.

46
The print that I have on the wall before me as I write is a dramatic example. It depicts the Elephant Stables at Vijayanagara, India. The large-format glass-plate negative was exposed by the British photographer Alex Greenlaw in 1856. The print was made, using modern techniques that were not available to Greenlaw, by the Australian photographer John Gollings in 1982. Similar issues are raised by casts made after the death of a sculptor. See Rosalind E. Krauss, "The Originality of the Avant-Garde," in *The Originality of the Avant-Garde and Other Modernist Myths*, 151–70.

47
This is connected to the question of what we are to make of hearsay—verbal reports of reports. You can look at hearsay as an indirect (and therefore probably untrustworthy) report of the original incident, or you can look at it as a direct report of what a witness said—a report of a speech act. Similarly, you can look at a photograph of a photograph as an indirect image of the original three-dimensional scene or as a direct image of a two-dimensional graphic artifact. This becomes particularly clear when the photographed photograph contains halftone dots or other graphic elements that were not in the original scene.

48
Charles Hagen, "The Debate Over Photo Negatives Fires Up Again," *The New York Times*, Tuesday, March 3, 1992, C13, C16.

49
Nelson Goodman, *Languages of Art* (Indianapolis: Hackett, 1976). For an alternative view, see Nicholas Wolterstorff, "Works," in *Works and Worlds of Art* (Oxford: Clarendon Press, 1980), 33–105.

50
Consider, for example, William Blake's watercolored relief etching *The Ancient of Days* in the British Museum and his *The Ancient of Days* in the Fitzwilliam Museum, Cambridge. Although the two are very similar, and have the same title, they differ in numerous subtle ways. They are different works with elements in common, not different instances of the same work.

51
Some modernist photographers, however, have emphasized standardized, precisely controlled printing processes, so that results are highly predictable and one print is *almost* indistinguishable from another. Ansel Adams, in particular, explicitly compared negatives to musical scores and prints to performances of them.

52
Closure eventually occurs when a tradition dies. The Homeric epics must have evolved through many versions as they were retold, but we now regard them as closed, finished works.

53
Walter Benjamin, "The Work of Art in the Age of Mechanical Reproduction," in *Illuminations*, ed. Hannah Arendt, trans. Harry Zohn (New York: Harcourt Brace & World, 1955). For a more recent treatment of the theme, see David Harvey, "The Work of Art in an Age of Electronic Reproduction and Image Banks," in *The Condition of Postmodernity* (Oxford: Basil Blackwell, 1989).

54
Not only does DNA carry hereditary information, it apparently does so in digital form—allowing replication without degradation.

55
Many theorists of the postmodern would, no doubt, assimilate this point to a general argument that subjects are constructed by symbol systems and that photographic, print, film, video, and digital images now do much of the work of construction. See for example Jean-François Lyotard, *The Postmodern Condition: A Report on Knowledge* (Minneapolis: University of Minnesota Press, 1984); and Jean Baudrillard, "Simulacra and Simulations," in *Jean Baudrillard: Selected Writings*, ed. Mark Poster (Stanford: Stanford University Press, 1988). The role of digital information is explicitly addressed in Mark Poster, *The Mode of Information: Poststructuralism and Social Context* (Chicago: University of Chicago Press, 1990). On the idea of cyberspace—electronic "virtual reality," see William Gibson, *Neuromancer* (New York: Ace Books, 1984); and Michael Benedikt (ed.), *Cyberspace: First Steps* (Cambridge, MA: The MIT Press, 1991).

56
For general discussion of copyright protection for works in electronic form, see US Congress, Office of Technology Assessment, *Intellectual Property Rights in an Age of Electronics and Information* (Washington, DC, 1986).

57
On the issues raised by colorization, see "Moral Right Protections in the Colorization of Black and White Motion Pictures: A Black and White Issue," *Hofstra Law Review* 16 (1988): 503; "Motion Picture Colorization, Authenticity, and the Exclusive Moral Right," *New York University Law Review* 64 (1989): 628; and Stuart Klawans, "Colorization: Rose-Tinted Spectacles," in Mark Crispin Miller (ed.), *Seeing Through Movies* (New York: Pantheon, 1990).

58
Quoted by Deborah Starr Seibel in "Splitting Image," *Chicago Tribune*, Monday, December 30, 1991, Section 5, 1–3.

59
See Richard Jay Solomon, "Vanishing Intellectual Boundaries: Virtual Networking and the Loss of Sovereignty and Control," *Annals of the American Academy of Political and Social Science* 495 (January 1988): 40.

60
Rights of photographic subjects are discussed extensively in Larry Gross, John Stuart Katz, and Jack Ruby (eds.), *Image Ethics: The Moral Rights of Subjects in Photographs, Film, and Television* (Oxford: Oxford University Press, 1988).

61
Anne W. Branscomb, "Common Law for the Electronic Frontier," *Scientific American* 265:3 (September 1991): 154–58.

62
John Szarkowski provided the canonical formulation of this point in *The Photographer's Eye* (1966): "The invention of photography provided a radically new picture-making process—a process based not on synthesis but on selection. The difference was a basic one. Paintings were made . . . but photographs, as the man on the street put it, were taken."

63
Oliver Wendell Holmes, "The Stereoscope and the Stereograph," *Atlantic Monthly* 3 (June 1859). Reprinted in Trachtenberg, *Classic Essays in Photography*. For commentary see Alan Trachtenberg,

Reading American Photographs (New York: Hill and Wang, 1989). The metaphor of photographic images as wealth is also used, with an ironic twist, in Jean-Luc Godard's *Les Carabiniers:* two peasants, induced to join an army by the prospect of looting, end up with a suitcase full of picture postcards.

64
Susan Sontag, *On Photography* (New York: Farrar, Straus & Giroux, 1977).

65
See *The New York Times*, March 2, 1988, A12. The idea of this sort of comprehensive photographic documentation is an old one. In 1899 *The British Journal of Photography* called for formation of an archive "containing a record as complete as it can be made . . . of the present state of the world" (vol. 36, p. 688).

4 Electronic Tools

1
Pierre Bourdieu, *Photography: A Middle-brow Art* (Stanford: Stanford University Press, 1990), 77.

2
Edward Weston, "Seeing Photographically," *Encyclopedia of Photography* 18 (New York: Greystone Press, 1965). Reprinted in Alan Trachtenberg (ed.), *Classic Essays on Photography* (New Haven: Leete's Island Books, 1980), 169–78.

3
NTSC video format is used. Each 2-by-2-inch (approximately the size of a 35-mm slide) still-video floppy disk has fifty concentric tracks and can store twenty-five "frame" images or fifty "field" images. A frame image has full NTSC video resolution, but a field image stores only every other raster line.

4
On exposure control with electronic cameras and other digital image-capture devices, see Don Lake, "Electronic Cameras, Sensors, and Electronic Exposure Control," *Advanced Imaging* 6:11 (November 1991): 24–30. On the effect of noise in images, see L. Harmon and B. Julesz, "Masking in Visual Recognition: Effects of Two-Dimensional Filtered Noise," *Science* 180 (1973): 1194–97.

5
See Nigel Henbest and Michael Marten, *The New Astronomy* (Cambridge: Cambridge University Press, 1983), for discussion and examples of the use of astronomical CCD cameras. Details of the construction of these cameras are given in Christian Buil, *CCD Astronomy: Construction and Use of an Astronomical CCD Camera* (Richmond, VA: Willmann-Bell, 1991).

6
George Garneau, "Turning TV Footage into Newspaper Photos," *Editor and Publisher*, November 23, 1985.

7
For an introductory discussion of satellite scanning systems, see Arthur Cracknell and Ladson Hayes, *Introduction to Remote Sensing* (London: Taylor and Francis, 1991).

8
John Noble Wilford, "Spacecraft's Maps Show Evidence of Active Volcanoes on Venus," *The New York Times,* Wednesday, October 30, 1991, A21; Corey S. Powell, "Venus Revealed," *Scientific American* 226:1 (January 1992): 16–17; and Stuart J. Goldman, "Venus Unveiled," *Sky and Telescope* 83:3 (March 1992): 258–62.

9
John Noble Wilford, "Photos by Radar Hint at Ice Poles of Mercury," *The New York Times*, Thursday, November 7, 1991, A22.

10
See Gerd Binnig and Heinrich Rohrer, "Scanning Tunnelling Microscopy—From Birth to Adolescence," *Reviews of Modern Physics* 59:3 (July 1987): 615–25.

11
Nicholas P. Negroponte, "Products and Services for Computer Networks," *Scientific American* 265:3 (September 1991): 106–15. On the technology for capturing three-dimensional models, see Alex Pentland and Stan Sclaroff, "Closed-Form Solutions for Physically Based Shape Modeling and Recognition," *IEEE Transactions on Pattern Analysis and Machine Intelligence* 13:7 (July 1991): 715–29; and Alex

Pentland and Bradley Horowitz, "Recovery of Non-rigid Motion and Structure," *IEEE Transactions on Pattern Analysis and Machine Intelligence* 13:7 (July 1991): 730–42.

12

The distinction between these two ways of regarding pixels is clearly developed in Steve Upstill, *The RenderMan Companion* (Reading, MA: Addison-Wesley, 1990).

13

See Leon D. Harmon, "The Recognition of Faces," *Scientific American* 229 (1973): 70–82. For an empirical study of spatial and color resolution requirements and the human ability to discriminate among variations in quality, see Michael Ester, "Image Quality and Viewer Perception," *Leonardo*, Digital Image—Digital Cinema Supplemental Issue (1990): 51–63.

14

Pressure to increase resolution in order to convey more information is no new thing. William M. Ivins, Jr., has noted that, in early-sixteenth-century woodcuts, "the cramming of more and more lines and detailed information into the given areas became notable." This caused technical difficulties, a resolution limit was soon reached, and eventually woodcuts were replaced by engraved and etched copper plates that could provide much finer resolution. See *Prints and Visual Communication* (Cambridge, MA: The MIT Press, 1969), 47–50.

15

The relationship between image size, capacity to resolve detail, and the effect of an image is more subtle than it might at first seem, as the gigantic photographic portraits and nudes produced by Chuck Close have demonstrated. Our vision is sharp in the central, foveal part of the visual field and becomes progressively less acute toward the edges. An eight-by-ten print at normal viewing distance is sufficiently small to appear uniformly sharp. But Close's wall-sized images extend toward the edges of the visual field, sharply focus our attention on skin pores and other minute details, and so achieve an insistent carnality.

16

For discussions of image-compression issues and technologies, see H. K. Ramapriyan (ed.), *Proceedings of the Scientific Data Compression Workshop* (NASA, 1989). More accessible brief overviews are given in Edward A. Fox, "Compression Techniques," *Communications of the ACM* 34:4 (April 1991): 28; Wayne E. Carlson, "A Survey of Computer Graphics Image Encoding and Storage Formats," *Computer Graphics* 25:2 (April 1991): 67–75; John Larish, "Compression and Electronic Photography: The Basic Picture," *Advanced Imaging* 6:9 (September 1991): 82–84; and Rachel Powell, "Digitizing TV Into Obsolescence," *The New York Times,* Sunday, October 20, 1991, Section 3, 11.

17

"Standardization of Group 3 Facsimile Apparatus for Document Transmission," CCITT Recommendations, Fasicle VII.2, Recommendation T.4, 1980.

18

Gregory K. Wallace, "The JPEG Still Picture Compression Standard," *Communications of the ACM* 34: 4 (April 1991): 30–44.

19

This assumption is based on the tristimulus theory of color perception, which derives ultimately from the theories of Young and Helmholtz. This theory has certain limitations (which are addressed, for example, by Land's more recent theory), but it is universally employed as the basis for computer-graphics and image-processing technology. The basics of color vision are introduced in Richard L. Gregory, "Seeing Color," in *Eye and Brain: The Psychology of Seeing,* fourth ed. (Princeton: Princeton University Press, 1990). For a useful discussion of theories of color perception from a philosophical perspective, see C. L. Hardin, *Color for Philosophers* (Indianapolis: Hackett, 1988). Color models commonly used in computer graphics and image processing are surveyed in Alan Watt, "Color Science and Computer Graphics," in *Fundamentals of Three-Dimensional Computer Graphics* (Reading, MA: Addison-Wesley, 1989), 309–55.

20
The sophisticated color prepress systems used by
newspaper, magazine, and book publishers usually
provide significantly better calibration and control
than inexpensive desktop publishing systems.

21
Before halftone screening came into widespread use,
photographs were reproduced in print through the
work of reproductive engravers. Daguerreotypes
were also etched directly to produce aquatint-like
photomechanical reproductions—the ancestors of
modern photogravures.

22
For details see J. Jarvis, C. Judice, and W. Ninke, "A
Survey of Techniques for the Display of Continuous
Tone Pictures on Bilevel Displays," *Computer
Graphics and Image Processing* 5 (1976): 13–40;
Donald Knuth, "Digital Halftones by Dot Diffusion,"
ACM Transactions on Graphics 6:4 (October 1987):
245–73; Robert Ulichney, *Digital Halftoning* (Cam-
bridge, MA: The MIT Press, 1987); and Luiz Velho
and Jonas de Miranda Gomes, "Digital Halftoning
with Space Filling Curves," *Computer Graphics* 25:4
(July 1991): 81–90.

23
Mezzotint is a precisely controllable halftoning proc-
ess developed in Holland in the seventeenth cen-
tury—an era in which Rembrandt and other Dutch
painters were exploring subtleties of tonal rendi-
tion—by Ludwig von Siegen and perfected by Prince
Rupert of the Palatinate. It involves roughening a
metal plate with a serrated edge to produce ran-
domly prickled areas that print dark tones, then
scraping off the prickles in places to yield high-
lights. The related process of aquatint was also a
Dutch seventeenth-century invention. This is a proc-
ess of dusting a metal plate with grains of protective
coating, then eroding the plate with acid to produce
a pitted surface.

24
The philosopher Charles S. Peirce—subtle expositor
of signifiers and their modes of action—was inter-
ested in figured text and produced a copy of Poe's
The Raven written with a technique that he called

"art Chirography." See Martin Gardner (ed.), *The
Annotated Alice* (New York: Meridian, 1960), 50–51.

25
In *Languages of Art* (Indianapolis: Hackett, 1976)
Nelson Goodman discusses the question of whether
a photograph showing a tiny gray dot in the distance
can truthfully be presented as a picture of "a certain
black horse."

26
Ivins, *Prints and Visual Communication*. See also
Estelle Jussim, "The Syntax of Reality: Photogra-
phy's Transformation of Nineteenth-Century Wood
Engraving into an Art of Illusion," in *The Eternal
Moment: Essays on the Photographic Image* (New
York: Aperture, 1989).

27
Weston, "Seeing Photographically," in Trachtenberg,
Classic Essays on Photography, 169–78.

28
Fresco painters have traditionally produced small,
gridded cartoons, which are then replicated by assis-
tants, at larger scale, on the wall. A square cell
might contain a simple, easily copied fragment of
the image or even just a specification of intensity,
which allows execution by completely unskilled as-
sistants. A recent example of this technique is pro-
vided by the huge image of Hercules by Jean-Marie
Pierret on the face of the Tignes Dam of the Isère
River in France. This 250-by-180-meter image is
composed of approximately 260,000 gray pixels,
each 20 centimeters square. It was produced in sixty
days by a team of eight assistants. See Bruce Weber,
"That Dammed Hercules," *The New York Times
Magazine*, November 5, 1989, 130.

29
Ivan E. Sutherland, "A Head-Mounted Three-Dimen-
sional Display," *Proceedings of the Fall Joint Com-
puter Conference* (1968), 757–64.

30
See Andrew Pollack, "What is Artificial Reality?
Wear a Computer and See," *The New York Times*,
April 10, 1989, 1; and Howard Rheingold, *Virtual
Reality* (New York: Summit Books, 1991).

31

Oliver Wendell Holmes, "The Stereoscope and the Stereograph," *Atlantic Monthly* 3 (June 1859). Reprinted in Trachtenberg, *Classic Essays in Photography,* 74.

32

Fox Talbot produced photographs of works of art in the 1830s, and by the 1860s the Alinari brothers were already making photographic records of drawings in Italian collections. The development of photogravure and halftone printing processes soon allowed reproduction in large quantities.

33

An important milestone in image-transmission technology was the introduction by Associated Press, in 1988, of the Leafax portable negative transmitter.

34

In February 1992 Mitsubishi and Microcom began to market a cellular telephone with internal error-correcting modem.

35

Douglas E. Howe, "Three Million Slides Go Digital—and On-Line," *Advanced Imaging* 6:1 (January 1991): 39–40.

36

Scott Henry at the *Marin Independent*, quoted in *News Photographer* (March 1990): 10.

37

See Rebecca Hansen, "Computers and Photography," *Computer Graphics World* (January 1989): 53–60.

38

Patrick Purcell and Dan Applebaum, "Light Table: An Interface to Visual Information Systems," in Malcolm McCullough, William J. Mitchell, and Patrick Purcell (eds.), *The Electronic Design Studio* (Cambridge, MA: The MIT Press, 1990).

39

Vicki Goldberg, "On a Pizza-Size Disk, the History of American Art," *The New York Times,* Sunday, March 1, 1992, Arts and Leisure, 35–36.

40

Corey S. Powell, "Venus Revealed," *Scientific American* 266:1 (January 1992): 16–17.

41

G. Pascal Zachary, "Gates Quietly Bids for Electronic Rights to Works of Art," *The Wall Street Journal,* Wednesday, December 19, 1990, B1.

42

For discussions of digital video and television, see Andrew B. Lippman, "HDTV in the 1990s: Open Architecture and Computational Video" (Cambridge, MA: MIT Media Laboratory, June 1990); Andrew B. Lippman, "HDTV Sparks a Digital Revolution" (Cambridge, MA: MIT Media Laboratory, December 1990); "Digital Multimedia Systems," special issue of *Communications of the ACM* 34:4 (April 1991); and Negroponte, "Products and Services for Computer Networks."

43

By early 1992 videophone technology had advanced to the point where AT&T could announce the introduction of a relatively inexpensive consumer-level videophone that could be plugged into a standard telephone jack. See Anthony Ramirez, "Consumer Videophone by A.T.&T," *The New York Times,* Tuesday, January 7, 1992, D1–4.

44

Andrew Pollack, "A Milestone in High-Definition TV," *The New York Times,* Tuesday, December 3, 1991, D1, D6.

45

Alan C. Kay, "Computers, Networks and Education," *Scientific American* 265:3 (September 1991): 138–48.

46

Illustrated factual travel accounts demonstrate this development with particular clarity: see Barbara Maria Stafford, *Voyage into Substance: Art, Science, Nature, and the Illustrated Travel Account, 1760–1840* (Cambridge, MA: The MIT Press, 1984).

47

Ivins, *Prints and Visual Communication*. See also Gerald Needham, "The Desire to Record the World, 1830–1850," in *19th Century Realist Art* (New York: Harper and Row, 1988), 35–86.

48

See John Tagg, *The Burden of Representation: Essays on Photographies and Histories* (Amherst: University of Massachusetts Press, 1988); and Vicki Goldberg, "Someone Is Watching," in *The Power of Photography* (New York: Abbeville, 1991), 59–73, for discussions of the relationships between institutional power and photographic practice.

49

"Rounding Up the Usual Suspects, on a Screen," *The New York Times,* Wednesday, November 20, 1991, D9.

50

See Frank Stella, *Working Space* (Cambridge, MA: Harvard University Press, 1986), for a discussion of this point. The development of the art museum is chronicled by André Bazin in *The Museum Age* (New York, 1967).

51

For discussions of this technology and its impacts, see Michael L. Morse (ed.), *The Electronic Revolution in News Photography* (Durham, NC: National Press Photographers Association, 1987).

52

Roland Barthes, "The Photographic Message," in *Image—Music—Text* (Glasgow: Fontana, 1977), 15.

53

This variation of expectation about veracity and fictionality does seem to be leading to correspondingly varying treatment of printed digital images. A 1989 survey of thirteen American magazine editors elicited the unanimous response that substantive electronic alteration of news photographs was unacceptable. (The editors would, however, agree with some uneasiness to color correction, removal of "indistinguishable blobs," and alteration of backgrounds to make photographs fit layouts.) There was disagreement about feature photographs: some editors would approve removal of unsightly telephone wires from a scenic photograph, for instance, but some would not. The covers of certain specialty magazines, however, are routinely manipulated without qualm: it was reported that forty-five of the forty-eight *Better Homes & Gardens* covers between 1984 and 1988 were digitally manipulated. As one specialty magazine editor remarked, "News magazines are dealing in reality and we're dealing in dreams—wish books." See Sheila Reeves, paper presented to the Magazine Division, Association for Education in Journalism and Mass Communications, Washington, DC, August 1989. Extracted as "Ethics: Report Airs Editors' Debate on Principles of Pixels," in *The Electronic Times,* a publication produced at a National Press Photographers Association workshop on electronic photojournalism, Martha's Vineyard, Massachusetts, October 6, 1989.

54

Boston WCVB-TV News Center 5, April 6, 1992. Postol, unimpressed by the Raytheon claims, replied, "I was expecting a more sophisticated approach to trying to discredit me." See also Daniel Golden, "Missile-blower: How MIT professor Theodore Postol punctured the Patriot myth," *The Boston Globe Magazine,* Sunday, July 19, 1992, 10–11, 16–26.

55

This requires images to participate simultaneously in multiple artistic structures and raises the same sorts of problems as those resulting from the addition of dialogue to film in the early talkies. See Rudolf Arnheim's 1938 essay, "A New Laocoön: Artistic Composites and the Talking Film," in *Film as Art* (Berkeley: University of California Press, 1957), for a classic discussion of these.

56

Among the first to be marketed were Adobe's Premiere and DiVA's VideoShop.

57

See William J. Mitchell and Malcolm McCullough, "Hypermedia," Chapter 14 of *Digital Design Media* (New York: Van Nostrand Reinhold, 1991), 313–26.

58

On arrangement and meaning in image archives, see Donald Preziosi, *Rethinking Art History* (New Haven: Yale University Press, 1989), 75–79, and "The Question of Art History," *Critical Inquiry* 18:2 (Winter 1992): 368–69.

5 Digital Brush Strokes

1

The scientific study of figure-ground distinctions was pioneered by E. Rubin in his *Synsoplevede figurer* (Copenhagen: Gyldendalske, 1915). It was paid much attention by the Gestalt psychologists.

2

Since the scanning laser passes perpendicularly through the platen, the effect is of intense, uniform, diffuse light from the view direction—the kind much favored by Edouard Manet. There are no cast shadows. Surfaces are lightest when close to parallel to the picture plane and darken as they come close to perpendicular, so that clear, crisp contours result.

3

Heinrich Schwarz, *Art and Photography: Forerunners and Influences* (Chicago: University of Chicago Press, 1985), 91.

4

On human perception of light intensity, see Richard L. Gregory, "Seeing Brightness," in *Eye and Brain: The Psychology of Seeing*, fourth ed. (Princeton: Princeton University Press, 1990).

5

The same applies to paintings. Hermann von Helmholtz pioneered the scientific study of this issue; see *Popular Scientific Lectures*, trans. E. Atkinson (New York: Appleton, 1881), 73–138. E. H. Gombrich has noted, in connection with his well-known analysis of John Constable's *Dedham Vale*, that an artist "cannot transcribe what he sees; he can only transcribe it into the terms of his medium. He, too, is strictly tied to the range of tones which his medium will yield" (*Art and Illusion* [Princeton: Princeton University Press, 1961], 36). See also John Ruskin's chapter "Of Truth of Tone" in *Modern Painters*. Ruskin remarks, "Not only does nature surpass us in power of obtaining light as much as the sun surpasses white paper, but she also infinitely surpasses us in her power of shade." Those paintings of J. M. W. Turner that look directly into the face of the sun itself, such as *The Angel Standing in the Sun*, are extreme examples of tone-scale compression.

6

Responses of different types of photographic film are described technically by characteristic curves, which plot density agaions brightness.

7

Lady Elizabeth Eastlake, "Photography," *London Quarterly Review* (1857): 442–68. Reprinted in Alan Trachtenberg (ed.), *Classic Essays on Photography* (New Haven: Leete's Island Books, 1980).

8

Ibid.

9

There are many books on the Zone System. A clear, concise introduction is provided in John J. Dowell, III, and Richard D. Zakia, *Zone Systemizer for Creative Photographic Control* (Dobbs Ferry, NY: Morgan and Morgan, 1973).

10

Martin Kemp, *The Science of Art* (New Haven: Yale University Press, 1990), 199.

11

John Ruskin, *Modern Painters*, second ed. (London: Smith, Elder and Co., 1873), 1: 139. Christian Huygens had much earlier noted that the dimming effect of the camera obscura produced a "beautiful brown picture." See Arthur K. Wheelock, Jr., "Perspective and Its Role in the Evolution of Dutch Realism," in Calvin F. Nodine and Dennis F. Fisher (ed.), *Perception and Pictorial Representation* (New York: Praeger, 1979), 110–17.

12

These effects and painters' uses of them are discussed in detail in Julian Hochberg, "Some of the Things That Paintings Are," in Calvin F. Nodine and Dennis F. Fisher (eds.). *Perception and Pictorial Representation* (New York: Praeger, 1979), 17–41. For examples see Caravaggio's characteristic deployment of illuminated profiles against dark grounds; Rembrandt's embedding of tiny, brilliant highlights from metal and jewelry in broad, deep shadows; and the painting that gave impressionism its name— Claude Monet's *Impression—Sunrise*, in which small, dense silhouettes of boats are set against wide, apparently glowing sweeps of sea and sky.

13

The original negative was exposed by the Cuban photographer Alberto Korda on March 5, 1960, during a speech by Fidel Castro.

14

Daniel Cohen, "Photography Gets Digitized," *Photo District News* (August 1985).

15

The simplest way to achieve this sharpening effect is to use uniformly black outlines. But skilled delineators often employ a more subtle strategy of varying outline intensity and hue according to the surrounding conditions. For a discussion see Paul Stevenson Oles, *Drawing the Future* (New York: Van Nostrand Reinhold, 1979).

16

Michael Baxandall, *Patterns of Intention* (New Haven: Yale University Press, 1985), 65.

17

This parallels the way in which the center of the human retina, the fovea, resolves fine details and subtle color distinctions, but acuity rapidly diminishes with distance from the fovea.

18

See, for example, William Holman Hunt, *Strayed Sheep*, in the Tate Gallery, London.

19

Sir Charles Lock Eastlake, *Methods and Materials of Painting of the Great Schools and Masters* (New York: Dover, 1960 [1847]), 2: 375.

20

It is reported in Charles Holroyd's biography of Michaelangelo, *Michael Angelo Buonarroti* (London: Duckworth, 1903), that the master described Flemish painting as concerned with "stuffs, bricks, and mortar, the grass of the fields, the shadows of trees, and bridges and rivers, which they call landscapes, and little figures here and there . . . without care in selecting or rejecting." In other words, he did not like the way that the Flemish painters filtered their scenes. Ruskin was even more vividly critical. In *Modern Painters* he suggested that the admirers of Flemish painting might be "left in peace to count the spicula of haystacks and the hairs of donkeys."

21

For a detailed analysis of the various graphic functions of lines in drawings, see Philip Rawson, "Technical Methods," in *Drawing*, second ed. (Philadelphia: University of Pennsylvania Press, 1987), 76–193.

22

See for example Don Pearson, E. Hanna, and K. Martinez, "Computer-generated Cartoons," in Horace Barlow, Colin Blakemore, and Miranda Weston-Smith (eds.), *Images and Understanding* (Cambridge: Cambridge University Press, 1990).

23

Roland Barthes, "Rhetoric of the Image," in *Image—Music—Text* (Glasgow: Fontana, 1977).

24

On this point, Richard Wollheim has commented, "Indeed it has been argued that a good representation, or a representation that is 'revealing', requires an alien or resistant medium through which it has been 'filtered'" (*On Art and the Mind* [Cambridge, MA: Harvard University Press, 1974], 22). See also Stuart Hampshire, *Feeling and Expression* (London, 1961), 14–15.

6 Virtual Cameras

1

Leon Battista Alberti, *On Painting*, trans. John R. Spencer (New Haven: Yale University Press, 1956). A useful concise summary of Alberti's construction is provided by Martin Kemp, *The Science of Art* (New Haven: Yale University Press, 1990), 21–24.

2

Important early documents were L. G. Roberts, *Machine Perception of Three-Dimensional Solids* (Cambridge, MA: MIT Lincoln Laboratory TR 315, May 1963); L. G. Roberts, *Homogeneous Matrix Representations and Manipulation of N-Dimensional Constructs* (Cambridge, MA: MIT Lincoln Laboratory MS 1405, 1965); and D. V. Ahuja and S. A. Coons, "Geometry for Construction and Display," *IBM Systems Journal* 7:3/4 (1968): 88. The first comprehensive textbook on computer graphics, William M. Newman

and Robert F. Sproull, *Principles of Interactive Computer Graphics* (New York: McGraw-Hill, 1973), provided a detailed introduction to three-dimensional transformations and perspective.

3

This parallels a distinction commonly drawn by theorists of speech acts and the intentions that lie behind them. See G. E. M. Anscombe, *Intentions* (Oxford: Blackwell, 1957); and John R. Searle, "A Taxonomy of Illocutionary Acts," in *Expression and Meaning* (Cambridge: Cambridge University Press, 1979), 1–29.

4

See Jelena Petric, "Computer Aided Visual Impact Analysis of Transmission Lines: Report of a Study for SSEB/CEGB," ABACUS, University of Strathclyde, December 1987, for a discussion of validation strategies and uses of validated perspective-generation procedures in visual-impact prediction.

5

For a more detailed introduction to geometric-modeling techniques, see William J. Mitchell and Malcolm McCullough, *Digital Design Media* (New York: Van Nostrand Reinhold, 1991).

6

Martin Kemp (ed.), *Leonardo on Painting* (New Haven: Yale University Press, 1989), 15.

7

Three-dimensional geometric-modeling systems developed rapidly in the 1960s, 1970s, and 1980s. By the early 1990s the technology had begun to stabilize, and geometric-model transfer standards such as IGES and DXF were increasingly widely supported. Then development of the RenderMan standard for three-dimensional rendering systems (see Steve Upstill, *The RenderMan Companion* [Reading, MA: Addison-Wesley, 1990]) encouraged the emergence of stand-alone rendering systems that could be "fed" by a variety of geometric modelers.

8

The metaphors of virtual world, virtual lights, and virtual camera are explicitly employed in the RenderMan standard for three-dimensional rendering software and are developed in detail by Upstill, *The RenderMan Companion*.

9

A comprehensive survey of such algorithms is given by I. Carlblom and J. Paciorek, "Planar Geometric Projections and Viewing Transformations," *Computing Surveys* 10:4 (December 1978): 465–502.

10

This device can be used to rhetorical effect, as for example in Giovanni Battista Tiepolo's *Banquet of Cleopatra* in the National Gallery of Victoria, where the square tiles converge at twice the normal rate to a point just below that where Cleopatra dramatically holds aloft the pearl.

11

Omnimax film, which is projected onto a dome, makes use of such a projection. For a discussion of how to compute this type of perspective, see Nelson Max, "SIGGRAPH 84 Call for Omnimax Films," *Computer Graphics* 16:4 (December 1982): 208–14.

12

For a discussion, from a Gibsonian viewpoint, of how to set these parameters to achieve a maximally realistic effect, see Margaret A. Hagen, "How to Make a Visually Realistic 3D Display," *Computer Graphics* 25:2 (April 1991): 76–81.

13

See Jurgis Baltrusaitis, *Anamorphoses*, third ed. (Paris: Flammarion, 1984); Eugenio Battisti, Andrea Carnemolla, Raymond J. Masters, and Filiberto Menna, *Anamorphosis: Evasion and Return* (Rome: Officina Edizioni, 1981); and Fred Leeman, Joost Elffers, and Michael Schuyt, *Anamorphoses: Games of Perception and Illusion in Art* (New York: Harry N. Abrams, 1976).

14

For a detailed treatment of this issue, see Maurice H. Pirenne, "The Perception of Ordinary Pictures," in *Optics, Painting and Photography* (Cambridge: Cambridge University Press, 1970), 95–115.

15

So-called virtual reality computer-graphics systems make even more striking use of this effect. The viewer wears a head-mounted display, which directs a stereo pair of images to the eyes. The frame is elided by carrying the display out to the edges of

peripheral vision, and the station point is set so that the sensation of being "in" a virtual space is produced. As the viewer moves around, locations are sensed and the perspective parameters are correspondingly readjusted to maintain a continuous illusion.

16

Some painting styles emphasize this aspect of the physical world. The "X-ray" paintings of the Australian aboriginal people, for example, show the bones and internal organs of fish and animals.

17

See Michael Baxandall, *Painting and Experience in Fifteenth Century Italy* (Oxford: Oxford University Press, 1982), 104–5. He quotes Bartholomew Rimbertinus: "An intervening object does not impede the vision of the blessed. . . . If Christ, even though himself in heaven after his Ascension, saw his dear Mother still on earth and at prayer in her chamber, clearly distance and interposition of a wall does not hinder their vision."

18

For a discussion of the relations between the ideas of diminution, occlusion, and perspective construction, see John Hyman, "Art and Occlusion," in *The Imitation of Nature* (Oxford: Basil Blackwell, 1989), 65–83.

19

The ideas of precedence, occlusion, and sorting are closely interrelated. Visual occlusion has its analogues in the other senses, and these might also be analyzed by sorting according to appropriate criteria: white noise masks conversation, scents drown stinks, and chili dominates the taste of Chardonnay. The classic paper on hidden-line and hidden-surface removal by application of sorting procedures is Ivan E. Sutherland, R. F. Sproull, and R. A. Schumacker, "A Characterization of Ten Hidden-Surface Algorithms," *ACM Computing Surveys* 6:1 (March 1974): 1–55. The trick, as this paper demonstrates, is to exploit knowledge of scene geometry in order to perform the sorting with high efficiency. Some very clever procedures have been developed.

20

Traditionally, painters have begun with the given surface—a vaulted ceiling perhaps, or a lunette or a rectangular piece of canvas—and have composed their scenes within its boundaries. Photography reversed this relationship by taking preexisting scenes of indefinite extent and imposing frame boundaries upon them. Thus early snapshots seemed surprising in their fortuitous compositions, in the way that the frame could insouciantly clip figures, and in their allusions to space outside the frame—effects that were soon replicated in impressionist paintings. Computer-generated perspective images follow the conventions of photography in this respect and so produce similar compositional effects.

21

The problem of depth sorting turns out to be a surprisingly subtle one. Simple sorting algorithms are defeated by such special conditions as cyclic overlap—surface A obscures part of B, B obscures part of C, and C obscures part of A—and so can produce erroneous results. The spatial ambiguities of imperfectly depth-sorted scenes recall paintings such as Duccio's *Flagellation of Christ*, in which the figure of Pontius Pilate seems to be behind a column while his arm is impossibly in front of it.

22

The painting is thus a self-referential conundrum, which has fascinated many commentators. See Michel Foucault, "Las Meninas," in *The Order of Things: An Archaeology of the Human Sciences* (New York: Random House, 1970); John R. Searle, "*Las Meninas* and the Paradoxes of Pictorial Representation," *Critical Inquiry* 6 (Spring 1980): 477–88; and Martin Kemp, *The Science of Art*, 105–8. Among the other famous examples in painting of the eyewitness revealed are Jan van Eyck's *The Arnolfini Marriage*, Gustave Courbet's *Studio of the Painter: A Real Allegory of a Seven-Year Phase in My Life as an Artist*, and Norman Rockwell's 1960 *Saturday Evening Post* cover *Triple Self-Portrait*. In *The Arnolfini Marriage* (see figure 7.21 below) the painter appears in the mirror behind the couple and attests in an inscription that he was there. Courbet,

the determined realist, avoids such tricks with mirrors: he shows us the front of the picture plane and the painter's eye and hand. Rockwell, who could construct a self-referential paradox as cunningly as any postmodernist, shows us his reflection in the mirror and the corresponding image on the canvas—and invites us to see what a good likeness he has captured.

7 Synthetic Shading

1

Technical details on all the shading procedures discussed in this chapter are given in James D. Foley, Andries van Dam, Steven K. Feiner, and John F. Hughes, "Illumination and Shading," in *Computer Graphics: Principles and Practice*, second ed. (Reading, MA: Addison-Wesley, 1990), 721–814.

2

Giorgio Vasari, for example, explicitly defined painting as the filling up, by means of a specified procedure, of accurately constructed outlines: "A painting, then, is a plane colored with patches of color . . . which, by virtue of a good design of encompassing lines, surround the figure. If the painter treat his flat surface with right judgement, keeping the center light and the edges and the background dark and medium color between the light and the dark in the intermediate spaces, the result of the combination of these three fields of color will be that everything between the one outline and the other stands out and appears round and in relief" (*Vasari on Technique*, trans. Louisa S. Maclehose [New York: Dover, 1960], 208–9).

3

Adrian Stokes, "Color and 'Otherness'," in *The Image in Form* (Harmondsworth: Penguin, 1972), 50–52.

4

Martin Kemp (ed.), *Leonardo on Painting* (New Haven: Yale University Press, 1989), 15.

5

For computational details see Foley, van Dam, Feiner, and Hughes, "Lambertian Reflection," in *Computer Graphics: Principles and Practice*, 723–25. The computation is basically one of repeatedly computing normals and evaluating the cosine function.

6

For discussion see Paul Hills, *The Light of Early Italian Painting* (New Haven: Yale University Press, 1987). The interaction of foreshortening and shading is considered more generally by E. H. Gombrich, *Art and Illusion*, second ed. (Princeton: Princeton University Press, 1961), 265–67. Hogarth's comments are found in *The Analysis of Beauty*, ed. Joseph Burke (Oxford: Oxford University Press, 1955), 110–11.

7

Cennino Cennini described this technique in detail. See *The Craftsman's Handbook* (New York: Dover, 1960), chapters 1–3.

8

Maurice H. Pirenne, *Optics, Painting and Photography* (New Haven: Yale University Press, 1970), 169 (the engraving is reproduced). On the other hand, Jan van Eyck got a similar window highlight triumphantly right in the convex mirror of *The Arnolfini Marriage* (see figure 7.21).

9

E. H. Gombrich, "Light and Highlights," in *The Heritage of Apelles* (Oxford: Phaidon, 1976), 1–35.

10

Sir Charles Eastlake noted, "The shine (suppose of ordinary daylight) on red morocco, appears to be the color of the light only—the cool, whitish, silver lights form an exquisite contrast to the toned, red lake depths, and would be agreeable in separate objects placed next each other (the same perhaps is true of all *shines* as contrasted with the local color on which they appear)" (*Methods and Materials of Painting of the Great Schools and Masters* [New York: Dover, 1960], 2: 354).

11

For a clear explanation of the technical details, see Alan Watt, "A More Advanced Reflection Model," in *Fundamentals of Three-Dimensional Computer Graphics* (Reading, MA: Addison-Wesley, 1989), 65–82.

12

The role of texture in handmade images is analyzed in Philip Rawson, "Texture and Touch," in *Drawing*, second ed. (Philadelphia: University of Pennsylvania Press, 1987), 187–93. See Hills, "Pattern, Plain and Splendour of Gold in Sienese Painting," in *The Light of Early Italian Painting*, 95–114, for a detailed analysis of how Duccio, Simone Martini, and Pietro Lorenzetti deployed brushwork to render the patterns and textures of folded and draped fabrics.

13

For technical details and examples, see Watt, "Texture," in *Fundamentals of Three-Dimensional Computer Graphics*, 227–47.

14

See James F. Blinn, "Simulation of Wrinkled Surfaces," *Computer Graphics* 12:3 (1978): 286–92. For fractalization techniques see Michael Barnsley, *Fractals Everywhere*,

15

For a discussion of texture boundary discrimination, see B. Julesz, "Textons, The Elements of Texture Discrimination and Their Interactions," *Nature* 290 (1981): 91–97.

16

Texture gradients and their effects were extensively studied by J. J. Gibson; see *The Senses Considered as Perceptual Systems* (Boston, 1966).

17

D. R. Warn, "Lighting Controls for Synthetic Images," *Computer Graphics* 17:3 (1983): 13–21.

18

See for example C. P. Verbeck and D. P. Greenberg, "A Comprehensive Light Source Description for Computer Graphics," *IEEE Computer Graphics and Applications* 4:7 (1984): 66–75.

19

Factors affecting the appearance of cast shadows are explored in detail, with many beautiful photographed examples, in M. Luckiesh, "The Cast Shadow," in *Light and Shade and Their Applications* (New York: D. Van Nostrand Company, 1916), 33–55.

20

Goethe once remarked that the sun "never saw the shadow."

21

See Watt, "Shadows," in *Fundamentals of Three-Dimensional Computer Graphics*, 219–27.

22

Furthermore, by measurement of the lengths of these shadows, the heights of lunar features can be computed.

23

This becomes a particularly important issue in architectural delineation. See Paul Stevenson Oles, *Architectural Illustration* (New York: Van Nostrand Reinhold, 1979), and *Drawing the Future* (New York: Van Nostrand Reinhold, 1988).

24

This was explicitly noted as long ago as the thirteenth century, in the optics treatises of Roger Bacon and John Pecham. See Hills, *The Light of Early Italian Painting*, 65.

25

James T. Kajiya, "The Rendering Equation," *ACM Computer Graphics (SIGGRAPH 86)* 20:4 (1986): 143–50. See also Watt, "The Rendering Equation," in *Fundamentals of Three-Dimensional Computer Graphics*, 403–4.

26

"How to Portray a Place Accurately," in Kemp, *Leonardo on Painting*, 216. The even more distant ancestor of modern pixel grids was Leon Battista Alberti's *reticolato*—a transparent grid that could be placed in front of a scene as an aid to drawing in perspective. This was later elaborated into the *machine à dessiner*, various forms of which were popular before the emergence of photography. James Ackerman has pointed out how literally the window analogy was taken by Italian Renaissance painters by noting that Italian picture frames were once designed to resemble window surrounds (James Ackerman, "Alberti's Light," in Irving Lavin and John Plummer (eds.), *Studies in Late Medieval Painting in Honor of Millard Meiss* [New York: New York University Press, 1977], 19). In *The Theory of Vision Vindicated*

(1732) Bishop Berkeley invited the reader to consider "a diaphanous plane erected near the eye, perpendicular to the horizon, and divided into small equal squares." Paradoxically, of course, painters usually work on opaque picture planes which they have to look around rather than through. When they are looking at the scene, their eyes can *never* actually be at the station point.

27

Gibson's theories are set out in *The Perception of the Visual World* (Boston: Houghton Mifflin, 1950); "A Theory of Pictorial Perception," *Audio-Visual Communication Review* 1 (1954): 3–23; "Pictures, Perspective and Perception," *Daedalus* 89 (1960): 216–27; *The Senses Considered as Perceptual Systems* (Boston: Houghton Mifflin, 1966); and "The Information Available in Pictures," *Leonardo* 4 (1971): 27–35. They follow in the tradition of Alhazen, Kepler, and Descartes, who all traced light rays to explain how an image was formed on the back of the eye.

28

There is an extensive technical literature on ray tracing. Many of the key ideas are introduced in Arthur Appel, "Some Techniques for Shading Machine-Renderings of Solids," in *Proceedings of the Spring Joint Computer Conference 1968* (Washington, DC: Thompson Books, 1968). An important pioneering paper, which motivated much subsequent work, is Turner Whitted, "An Improved Illumination Model for Shaded Display," *Communications of the ACM* 23:6 (June 1980). Comprehensive treatments are provided by Andrew S. Glassner (ed.), *An Introduction to Ray Tracing* (London: Academic Press, 1989), and by Watt in *Fundamentals of Three-Dimensional Computer Graphics.*

29

To render mirror images manually, artists have always had to elaborate perspective-projection techniques into a form of ray tracing. For extraordinary displays of virtuosity in this, see Jan van Eyck's *The Arnolfini Marriage* (figure 7.21), Diego Velázquez's *Las Meninas* (figure 6.13), and Hendrik Goltzius's *An Artist and His Model.*

30

Radiosity techniques were originally developed for engineering analysis of radiative heat transfer between parts of complex objects such as furnaces and spacecraft. Later they were adapted, by Donald Greenberg and his coworkers at Cornell University, to the analysis for purposes of rendering of light transfer within a scene. A detailed technical introduction to radiosity procedures and their physical basis is provided by Roy Hall, *Illumination and Color in Computer Generated Imagery* (New York: Springer-Verlag, 1989). See also Watt, "Diffuse Illumination and the Development of the Radiosity Method," in *Fundamentals of Three-Dimensional Computer Graphics,* 201–17.

31

J. R. Wallace, M. F. Cohen, and D. P. Greenberg, "A Two-Pass Solution to the Rendering Equation: A Synthesis of Ray Tracing and Radiosity Methods," *Computer Graphics* 21:4 (1987): 311–20.

32

See the extracts from his writings under "Distances, Atmosphere and Smoke," in Kemp, *Leonardo on Painting,* 165–68. For more modern discussions see S. Q. Duntley, "The Visibility of Distant Objects," *Journal of the Optical Society of America* 38 (1948): 237–49; and W. E. K. Middleton, *Vision Through the Atmosphere* (Toronto: University of Toronto Press, 1986).

33

Martin Kemp, *The Science of Art* (New Haven: Yale University Press, 1990), 159. Earlier, Descartes had used similar spheres in his famous investigation of the rainbow—in effect, anticipating the basic strategy of ray tracing.

34

A simpler case of the effect of mist which varies in density is often observable in the Chicago Loop. The fog that drifts in from Lake Michigan becomes gradually denser with height above the ground, so that the tall buildings fade into it.

35

For an analysis of this issue, see Pirenne, "The Pinhole Camera" and "The Photographic Camera and the Eye," in *Optics, Painting and Photography.*

36

For discussions of the role and uses of motion blur in photography, and numerous examples, see Adam D. Weinberg (ed.), *Vanishing Presence* (New York: Rizzoli, 1989). Note that depiction of motion blur preceded photography. Velázquez showed a blurred spinning wheel in the *Hilanderas,* for example.

37

For commentary on Vasari's idea of artistic progress, see E. H. Gombrich, *Art and Illusion,* second ed. (Princeton: Princeton University Press, 1961), 11. The very idea of such "progress" has frequently been derided as naive by more recent commentators on the visual arts. See for example Hugh Honour and Fleming, *A World History of Art* (London, 1982), 8; and Norman Bryson, *Vision and Painting* (New Haven: Yale University Press, 1983). Nonetheless, a typical attitude in the computer-graphics community is that "the representation of a realistic image of both actual and imagined scenes has been the goal of artists and scholars for centuries" (M. F. Cohen and D. P. Greenberg, "The Hemi-cube: A Radiosity Solution for Complex Environments," *Computer Graphics* 19:3 [July 1985]: 31–40).

38

SIGGRAPH is the Association for Computing Machinery's Special Interest Group on Computer Graphics. The annual conference proceedings are published as issues of the ACM journal *Computer Graphics.*

39

See Michael I. Mills, "Image Synthesis: Optical Identity or Pictorial Communication?," in Nadia Magnenat-Thalmann and Daniel Thalmann (eds.), *Computer-Generated Images: The State of the Art* (New York: Springer-Verlag, 1985), 3–10.

40

Gary W. Meyer, Holly E. Rushmeier, Michael F. Cohen, and Donald P. Greenberg, "An Experimental Evaluation of Computer Graphics Imagery," *ACM Transactions on Graphics* 5:1 (1986): 30–50.

8 Computer Collage

1

Henry Peach Robinson, *Pictorial Effect in Photography,* 1869; reprinted Pawlet, VT: Helios, 1971. The relevant excerpt is also found in Vicki Goldberg (ed.), *Photography in Print* (Albuquerque: University of New Mexico Press, 1988), 156.

2

Hockney has condemned seamless collages as "Stalinist photography." See David Hockney, *Hockney on Photography* (New York: Harmony Books, 1988).

3

The operation of scaling a rectangle of pixels down to a smaller size also results in loss of visual information, since the pixels in the original rectangle must be mapped onto a smaller number of pixels in the scaled-down rectangle. This information cannot be regained by scaling the rectangle back up to its original size.

4

W. H. Ittelson, *The Ames Demonstrations in Perception* (Oxford: Oxford University Press, 1952).

5

Francis Galton, "On Generic Images," *Proceedings of the Royal Institution* 9 (1879): 166.

6

The New York Times, Sunday, December 29, 1991, Op-Ed.

7

For technical details see T. Porter and T. Duff, "Compositing Digital Images," *Computer Graphics* 18:3 (1984): 253–59. An illustrated, nontechnical introduction is provided by Andrew S. Glassner, "Mattes and Composition," in *3D Computer Graphics: A User's Guide for Artists and Designers* (New York: Design Press, 1989), 200–9.

8

Bob Fisher, "The Dawning of the Digital Age," *American Cinematographer* 73:4 (April 1992): 70–86.

9

Beaumont Newhall, *The History of Photography* (New York: Museum of Modern Art, 1982), 69. See

also *Le cliché-verre: Corot et la gravure diaphane*, catalogue of an exhibition at the Cabinet des estampes du Musée d'art et d'histoire, Geneva, 1982 (Geneva: Editions du Tricorne).

10

The incident is discussed (with a reproduction of the unretouched version of the photo) by Bennett Daviss, "Picture Perfect," *Discover* 11:7 (July 1990): 58.

11

For ways of accomplishing this see E. Nakamae, K. Harada, T. Ishizaki, and T. Nishita, "A Montage Method: The Overlaying of Computer Generated Images onto a Background Photograph," *Computer Graphics* 20:4 (1986): 207–14.

12

P. S. Heckbert, "Survey of Texture Mapping," *IEEE Computer Graphics and Applications* 6:11 (1986): 56–67.

13

Alan Watt, "Environment Mapping," in *Fundamentals of Three-Dimensional Computer Graphics* (Reading, MA: Addison-Wesley, 1989), 247–50.

14

Viola Pemberton-Pigott, "The Development of Canaletto's Painting Technique," in Katharine Baetjer and J. G. Links (eds.), *Canaletto* (New York: Metropolitan Museum of Art, 1989). See also Martin Kemp, *The Science of Art* (New Haven: Yale University Press, 1990), 144–46.

15

In some types of photographs the relationship of spatial and temporal coordinates is not as straightforward as it may seem, since exposure is not actually instantaneous and since the camera may not remain fixed. A photofinish picture, for example, is made by pulling film past a thin vertical slit aligned with the finish line. The resulting image appears to be a wide-angle snapshot taken at the exact moment when the leading horse reaches the finish line. In fact, it shows (appropriately for its purpose) the changing state of the narrow field of view over the time that it takes for several horses to pass through it, and thus reveals the order of finishing. If the film

is moved at the correct speed the horses will appear in correct proportion. But, if it is moved too rapidly or too slowly, the horses will appear correspondingly elongated or compressed.

16

In the future, perhaps, signals from global positioning satellites will allow spatial coordinates to be stamped as well. Town, country, and historical context in which the picture was made might then be inferred automatically by a computer system equipped with geographic and historical knowledge.

17

John Berger, "Understanding a Photograph," in Alan Trachtenberg (ed.), *Classic Essays in Photography* (New Haven: Leete's Island Books, 1980), 292.

18

Raymond Chandler, *The Little Sister* (New York: Ballantine, 1971 [1943]), 251.

9 How to Do Things with Pictures

1

André Gide, *The Counterfeiters* (New York: Vintage, 1973), 331–32.

2

Clement Greenberg, "Four Photographers," *New York Review of Books*, January 23, 1964.

3

Roland Barthes, "The Photographic Message," in *Image—Music—Text* (Glasgow: Fontana, 1977), 16.

4

Walter Benjamin, "A Short History of Photography," in Alan Trachtenberg (ed.), *Classic Essays on Photography* (New Haven: Leete's Island Books, 1980), 215.

5

Ludwig Wittgenstein, *Tractatus* 2.141.

6

John G. Bennett, "Depiction and Convention," *The Monist* 58:2 (April 1974): 259–69. For a critical discussion see Nicholas Wolterstorff, "The Bennett Theory," in *Works and Worlds of Art* (Oxford: Clarendon Press, 1980), 270–79.

7

In this I draw on the cogent summary offered by Lorraine Daston, "Marvelous Facts and Miraculous Evidence in Early Modern Europe," *Critical Inquiry* 18 (Autumn 1991): 93–124.

8

Vicki Goldberg, *The Power of Photography* (New York: Abbeville, 1991), 19. Jocelyn Moorehouse's film *Proof* pushes this point to an ironic extreme: a blind man takes photographs, which must be described to him by somebody else, to prove that the external world exists just as he imagines it.

9

The 1990 British Museum exhibition *Fake? The Art of Deception* contained an impressive array of such productions. See the catalogue, edited by Mark Jones.

10

On *acheiropoietoi* in the Christian tradition, see Ewa Kuryluk, *Veronica and Her Cloth: History, Symbolism, and Structure of a "True" Image* (Cambridge, MA: Basil Blackwell, 1991). Kuryluk observes: "In order to establish Christ, masses of potential converts had to be convinced of the existence of a unique Man-God. Material proofs of his presence on earth were highly desirable; photographs would have been extremely helpful. Thus were acheiropoietoi invented—traces, relics, and likenesses of the one and only 'true' God."

11

On construction and perpetuation of the POW/MIA myth, see H. Bruce Franklin, "The POW/MIA Myth," *The Atlantic* 268:6 (December 1991): 45–81.

12

"The Cottingley Fairy Photographs," in Jones, *Fake? The Art of Deception*, 87–90.

13

The story is recounted in Justin Kaplan, *Walt Whitman: A Life* (New York: Touchstone, 1986), 250; in Esther Shephard, *Walt Whitman's Pose* (New York: Harcourt, Brace and Company, 1938), 250–52; and in Gay Wilson Allen, "The Iconography of Walt Whitman," in Edwin Haviland Miller (ed.), *The Aesthetic Legacy of Walt Whitman: A Tribute to Gay Wilson Allen* (New York: New York University Press, 1970), 134. See also the "Whitman Photographs" issue of *Walt Whitman Quarterly Review* 4:2/3 (Fall/Winter 1986–87). The entry on this photograph (p. 54) quotes Whitman: "Yes—that was an actual moth: the picture is substantially literal: we were good friends: I had quite the in-and-out of taming, or fraternizing with, some of the insects, animals." If you inspect a good print of the original negative through a magnifying glass, however, you can clearly see the wire loop fixing the cardboard wings to his forefinger.

14

J. Black, "The Spirit-Photograph Fraud," *Scientific American* (October 1922): 224–25.

15

Phil LoPiccolo, "What's Wrong with This Picture," *Computer Graphics World* (June 1991): 6–9.

16

There is an extensive literature on counterfactual conditionals. See R. M. Chisolm, "The Contrary-to-Fact Conditional," *Mind* 55 (1946): 289–307; and Nelson Goodman, "The Problem of Counterfactual Conditionals," in *Fact, Fiction, and Forecast* (London, 1954).

17

Numerous additional examples of politically motivated erasures from photographs are provided by Alain Jaubert in *Making People Disappear: An Amazing Chronicle of Photographic Deception* (McLean, VA: Pergamon-Brassey's International Defense Publishers, 1989).

18

The original and manipulated versions of these images are reproduced by Jaubert, *Making People Disappear*.

19

Le Corbusier, *Towards a New Architecture* (London: The Architectural Press, 1927), 27–33. For the story of these photographs see Stanislaus von Moos, *Le Corbusier: Elements of a Synthesis* (Cambridge, MA: The MIT Press, 1979), 46–47.

20

See "Ethics: Report Airs Editors' Debate on Principles of Pixels," in *The Electronic Times*, a publica-

tion produced at a National Press Photographers Association workshop on electronic photojournalism held at Martha's Vineyard, Massachusetts, October 6, 1989.

21

Vicki Goldberg, *The Power of Photography*, 89.

22

G. S. Layard, *The Headless Horseman* (London, 1922).

23

Charles Hamilton and Lloyd Ostendorf, *Lincoln in Photographs: An Album of Every Known Pose* (Norman: University of Oklahoma Press, 1963), 272.

24

Harold Holzer, Gabor S. Boritt, and Mark E. Neely, Jr., *The Lincoln Image: Abraham Lincoln and the Popular Print* (New York: Charles Scribner's Sons, 1984), 68–69.

25

Kathleen Collins, "Photography and Politics in Rome: The Edict of 1861 and the Scandalous Montages of 1861–62," *History of Photography* 9 (October–December 1985): 297.

26

Donald E. English, *Political Uses of Photography in the Third French Republic, 1871–1914* (Ann Arbor, MI: UMI Research Press, 1984), 33–34.

27

"Criticism of Prince's Hairstyle Creates a Royal Row in Japan," *The Boston Globe*, Tuesday, June 18, 1991, 16.

28

Stuart Klawans, "Colorization: Rose-Tinted Spectacles," in Mark Crispin Miller (ed.), *Seeing Through Movies* (New York: Pantheon, 1990), 152.

29

David Wise, "The Felix Bloch Affair," *The New York Times Magazine*, May 13, 1990, 42.

30

Harry J. Coleman, *Give Us a Little Smile, Baby* (New York: E. P. Dutton, 1943).

31

Los Angeles Mayor Tom Bradley spoke for many when he said, "Our eyes did not deceive us. We saw what we saw and what we saw was a crime."

32

For details of this story see Vicki Goldberg, *The Power of Photography*, 90–95.

33

"Who's on First," *Newsweek*, January 16, 1989, 52–53. The incident is discussed by the photographer, Douglas Kirkland, in *Light Years: Three Decades Photographing among the Stars* (New York: Thames and Hudson, 1989), and in Fred Ritchin, *In Our Own Image* (New York: Aperture, 1990), 8.

34

Andy Grundberg, "Ask It No Questions: The Camera Can Lie," *The New York Times*, Sunday, August 12, 1990, Section 2, 1, 29.

35

"Playing With Photographs," *The New York Times*, Wednesday, July 24, 1991, International Section, A6.

36

See Ronald Sullivan, "Judge Rules Against Rapper in 'Sampling' Case," *The New York Times*, Tuesday, December 17, 1991, B3; and Sheila Rule, "Record Companies Are Challenging 'Sampling' in Rap," *The New York Times*, Tuesday, April 21, 1992, C13.

37

Deborah Starr Seibel, "Splitting Image: Film Technology's Ability To Mix and Match Past and Present Divides Entertainment Industry," *Chicago Tribune*, Monday, December 30, 1991, Section 5, 1–3.

38

Vladimir Propp, *Morphology of the Folktale* (Austin: University of Texas Press, 1968 [1928]). Propp, in fact, claimed that there were just thirty-one such "functions"—"the interdiction is violated," "the villain is defeated," and so on—in the Russian folktales that he studied.

39

Weekly World News, March 24, 1992, 39.

40

On Curtis's directorial interventions, see Vicki Goldberg, "Fiddling With History in a Cause That Seemed Just," *The New York Times*, Sunday, November 17, 1991, Arts & Leisure, 35, 42.

41

On the relationship between rules and meaning in general, see Mary Douglas (ed.), *Rules and Meanings: The Anthropology of Everyday Knowledge* (Harmondsworth: Penguin, 1973).

42

The basic sources on speech acts are J. L. Austin, *How To Do Things with Words* (Cambridge, MA: Harvard University Press, 1962); John Searle, *Speech Acts* (Cambridge: Cambridge University Press, 1969); and John Searle, *Expression and Meaning: Studies in the Theory of Speech Acts* (Cambridge: Cambridge University Press, 1979). For related work in literary theory, see Terry Eagleton, *Literary Theory: An Introduction* (Minneapolis: University of Minneapolis Press, 1983), 118–19; and Stanley Fish, "How To Do Things with Austin and Searle: Speech Act Theory and Literary Criticism," in *Is There a Text in This Class* (Cambridge, MA: Harvard University Press, 1980). In Austin's pioneering exposition, a distinction is initially drawn between constatives that report events or states of affairs and performatives (such as questions and promises) that are used to do rather than to say something. But Austin then undermines the distinction and argues that reporting is a kind of doing.

43

See Searle, "The Logical Status of Fictional Discourse," in *Expression and Meaning*, 58–75.

44

Richard Christiansen, "In 'JFK,' Stone Turns a Film into Flimflam," *Chicago Tribune*, Friday, December 20, 1991, Section 5, 1. Other critics made similar points, expressed in various modulations of outrage. Tom Wicker wrote in *The New York Times* that the film treats "matters that are wholly speculative as fact and truth, in effect rewriting history." Hugh Aynesworth of the *Dallas Morning News* worried that "People will think this movie is real." *Newsweek* shrilled on its cover, "The Twisted Truth of 'JFK'—Why Oliver Stone's New Movie Can't Be Trusted." Some of these critics developed a parallel line of attack, claiming that, while Stone might sincerely believe the account of the Kennedy assassinations that he was presenting, it was unwarranted speculation. They suggested, in effect, that Stone did not have the evidence—that he was violating the preparatory rule of valid reporting. *Daily Variety* reported one uncontested fact: the grosses were good.

45

See Searle, "A Taxonomy of Illocutionary Acts," in *Expression and Meaning*, 1–29.

46

See, in this connection, Austin's discussion of the assertion "France is hexagonal" in *How To Do Things with Words*, 143. Austin says that this report is "good enough for a top-ranking general, perhaps, but not for a geographer."

47

Speech acts can also misfire, and speech-act theorists have given considerable attention to this. See Austin on "infelicities" in *How To Do Things with Words*, 14–45.

SELECTED READINGS

■ **Pictorial Representation**

Black, Max. "How Do Pictures Represent?" In E. H. Gombrich, Julian Hochberg, and Max Black, eds., *Art, Perception and Reality*. Baltimore: Johns Hopkins University Press, 1972.

Barlow, Horace, Colin Blakemore, and Miranda Weston-Smith, eds., *Images and Understanding*. Cambridge: Cambridge University Press, 1990.

Bennett, John G. "Depiction and Convention." *The Monist* 58:2 (1974): 259–69.

Bryson, Norman. *Vision and Painting: The Logic of the Gaze*. New Haven: Yale University Press, 1983.

Danto, Arthur C. "Works of Art and Mere Representations." In *The Transfiguration of the Commonplace*. Cambridge, MA: Harvard University Press, 1981.

Elgin, Catherine Z. "Representation, Comprehension, and Competence." In V. A. Howard, ed., *Varieties of Thinking*. New York: Routledge, 1990.

Falk, B. "Portraits and Persons." *Proceedings of the Aristotelian Society* 71 (1974–75): 181–200.

Gibson, James J. "The Ecological Approach to the Visual Perception of Pictures." *Leonardo* 11 (1978): 227–35.

Gibson, James J. "The Information Available in Pictures." *Leonardo* 4 (1971): 27–35.

Gibson, James J. "Pictures, Perspective and Perception" *Daedalus* 89 (1960): 216–27.

Gombrich, Ernst H. *Art and Illusion*. Princeton: Princeton University Press, 1960.

Gombrich, Ernst H. *The Image and the Eye*. Ithaca: Cornell University Press, 1972.

Gombrich, Ernst H. "Mirror and Map: Theories of Pictorial Representation." *Philosophical Transactions of the Royal Society of London* 270 (1975): 119–49.

Gombrich, Ernst H. "Standards of Truth: The Arrested Image and the Moving Eye." In W. J. T. Mitchell, ed., *The Language of Images*. Chicago: University of Chicago Press, 1980.

Gombrich, Ernst H. "The 'What' and the 'How': Perspective Representation and the Phenomenal World." In Richard Rudner and Israel Scheffler, eds., *Logic and Art*. Indianapolis: Bobbs-Merrill, 1972.

Gombrich, Ernst H., Julian Hochberg, and Max Black, eds. *Art, Perception and Reality*. Baltimore: Johns Hopkins University Press, 1972.

Goodman, Nelson. *Languages of Art*. Indianapolis: Hackett, 1976.

Gregory, Richard L., and Ernst H. Gombrich, eds. *Illusion in Nature and Art*. New York: Scribners, 1973.

Hagen, Margaret A., ed. *The Perception of Pictures*. New York: Academic Press, 1980.

Hagen, Margaret A. *Varieties of Realism: Geometries of Representational Art*. Cambridge: Cambridge University Press, 1986.

Hermeren, Goran. *Representation and Meaning in the Visual Arts*. Lund: Scandinavian University Books, 1969.

Howell, Robert. "The Logical Structure of Pictorial Representation." *Theoria* 40:2 (1974): 76–109.

Hyman, John. *The Imitation of Nature*. Oxford: Basil Blackwell, 1989.

Ihde, Don. *Experimental Phenomenology*. New York: Paragon Books, 1979.

Kennedy, J. *A Psychology of Picture Perception*. San Francisco: Jossey-Bass, 1974.

Kubovy, Michael. *The Psychology of Perspective and Renaissance Art*. Cambridge: Cambridge University Press, 1986.

Manns, J. W. "Representation, Relativism and Resemblance." *British Journal of Aesthetics* 11 (1971): 281–87.

Margolis, Joseph. "Puzzles of Pictorial Representation." In Joseph Margolis, ed., *Philosophy Looks at the Arts*. Third ed. Philadelphia: Temple University Press, 1987.

Maynard, Patrick. "Depiction, Vision, and Convention." *American Philosophical Quarterly* 9 (1972): 243–50.

Novitz, David. *Pictures and Their Use in Communication: A Philosophical Essay*. The Hague: M. Nijhoff, 1977.

Nodine, Calvin F., and Dennis F. Fisher, eds. *Perception and Pictorial Representation*. New York: Praeger, 1979.

Panofsky, Erwin. *Perspective as Symbolic Form*. [1927]. New York: Zone Books, 1991.

Pirenne, Maurice Henri. *Optics, Painting and Photography*. Cambridge: Cambridge University Press, 1970.

Pitkanen, Risto. "On the Analysis of Pictorial Representation." *Acta Philosophica Fennica* 31:4 (1980).

Rogers, L. R. "Representation and Schemata." *British Journal of Aesthetics* 5 (1965): 159–78.

Rudner, Richard. "On Seeing What We Shall See." In Richard Rudner and Israel Scheffler, eds., *Logic and Art*. Indianapolis: Bobbs-Merrill, 1972.

Schier, Flint. *Deeper into Pictures: An Essay in Pictorial Representation*. Cambridge: Cambridge University Press, 1986.

Scruton, Roger. "Photography and Representation." *Critical Inquiry* 7 (1981): 577–603.

Searle, John R. "*Las Meninas* and the Paradoxes of Pictorial Representation." *Critical Inquiry* 6 (Spring 1980): 477–88.

Snyder, Joel. "Picturing Vision." *Critical Inquiry* 6 (Spring 1980): 499–526.

Squires, Roger. "Depicting." *Philosophy* 44 (1969): 193–204.

Walton, Kendall L. *Mimesis as Make-Believe: On the Foundations of the Representational Arts.* Cambridge, MA: Harvard University Press, 1990.

Walton, Kendall L. "Transparent Pictures." *Critical Inquiry* 11 (December 1984): 246–77.

Wartofsky, Marx W. "Pictures, Representation and Understanding." In Richard Rudner and Israel Scheffler, eds., *Logic and Art.* Indianapolis: Bobbs-Merrill, 1972.

Wartofsky, Marx W. 1979. "Picturing and Representing." In Calvin F. Nodine and Dennis F. Fisher, eds., *Perception and Pictorial Representation.* New York: Praeger, 1979.

Wheelock, Arthur K. *Perspective, Optics, and the Delft Artists around 1650.* New York: Garland, 1977.

White, John. *The Birth and Rebirth of Pictorial Space.* Third ed. Cambridge, MA: The Belknap Press of Harvard University Press, 1987.

Wolterstorff, Nicholas. *Works and Worlds of Art.* Oxford: Clarendon Press, 1980.

Relevant Aspects of Drawing, Painting, and Printmaking

Ackerman, James S. "Alberti's Light." [1978]. In *Distance Points: Essays in Theory and Renaissance Art and Architecture.* Cambridge, MA: The MIT Press, 1991.

Ackerman, James S. "On Early Renaissance Color Theory and Practice." [1980]. In *Distance Points: Essays in Theory and Renaissance Art and Architecture.* Cambridge, MA: The MIT Press, 1991.

Eastlake, Charles L. *Methods and Materials of Painting of the Great Schools and Masters.* [2 vols., 1847, 1868]. New York: Dover, 1960.

Hochberg, Julian. "Some of the Things That Paintings Are." In Calvin F. Nodine and Dennis F. Fisher, eds., *Perception and Pictorial Representation.* New York: Praeger, 1979.

Hoffman, Howard S. *Vision and the Art of Drawing.* Englewood Cliffs, NJ: Prentice-Hall, 1989.

Ivins, William M., Jr. *Prints and Visual Communication.* Cambridge, MA: The MIT Press, 1969.

Kemp, Martin, ed. *Leonardo on Painting.* New Haven: Yale University Press, 1989.

Kemp, Martin. *The Science of Art.* New Haven: Yale University Press, 1990.

Mayor, A. Hyatt. *Prints and People.* Princeton: Princeton University Press, 1980.

Oles, Paul Stevenson. *Architectural Illustration.* New York: Van Nostrand Reinhold, 1979.

Oles, Paul Stevenson. *Drawing the Future.* New York: Van Nostrand Reinhold, 1988.

Rawson, Philip. *Drawing.* Second ed. Philadelphia: University of Pennsylvania Press, 1987.

Ruskin, John. *The Elements of Drawing.* [1857]. New York: Dover, 1971.

Ruskin, John. *Modern Painters.* Second ed. London: Smith, Elder and Co., 1873.

Spencer, John R. *Leon Battista Alberti On Painting.* New Haven: Yale University Press, 1966.

Wollheim, Richard. "On Drawing an Object." In *On Art and the Mind*. Cambridge, MA: Harvard University Press, 1974.

Wollheim, Richard. *Painting as an Art*. London: Thames and Hudson, 1987.

Photography

Arnheim, Rudolf. *Film as Art*. Berkeley: University of California Press, 1957.

Arnheim, Rudolf. "On the Nature of Photography." *Critical Inquiry* 1 (1974): 149–61.

Barrow, Thomas F., Shelley Armitage, and William E. Tydeman, eds. *Reading into Photography: Selected Essays, 1959–1980*. Albuquerque: University of New Mexico Press, 1982.

Barthes, Roland. *Camera Lucida: Reflections on Photography*. New York: Noonday Press, 1981.

Barthes, Roland. "Image." In *The Responsibility of Forms*. New York: Hill and Wang, 1985.

Barthes, Roland. "The Photographic Message." [1961]. In *Image—Music—Text*. Glasgow: Fontana, 1977.

Barthes, Roland. "Rhetoric of the Image." [1964]. In *Image—Music—Text*. Glasgow: Fontana, 1977.

Bayer, Jonathan, ed. *Reading Photographs: Understanding the Aesthetics of Photography*. New York: Pantheon, 1977.

Bazin, André. "The Ontology of the Photographic Image." [1945]. In *What is Cinema?* Berkeley: University of California Press, 1967.

Berger, John. "Understanding a Photograph." In *The Look of Things*. New York: Viking, 1974.

Berger, John. "Uses of Photography." In *About Looking*. New York: Pantheon, 1980.

Bolton, Richard, ed. *The Contest of Meaning: Critical Histories of Photography*. Cambridge, MA: The MIT Press, 1989.

Bourdieu, Pierre. *Photography: A Middle-brow Art*. Stanford: Stanford University Press, 1990.

Braive, Michel F. *The Era of the Photograph: A Social History*. London, 1966.

Burgin, Victor. *The End of Art Theory: Criticism and Postmodernity*. Atlantic Highlands, NJ: Humanities Press, 1986.

Burgin, Victor, ed. *Thinking Photography*. London: Macmillan, 1982.

Cavell, Stanley. "Sights and Sounds." In *The World Viewed*. Enlarged ed. Cambridge, MA: Harvard University Press, 1979.

Collier, John. *Visual Anthropology: Photography as a Research Method*. New York: Holt, Rinehart and Winston, 1967.

Gernsheim, Helmut. *A Concise History of Photography*. Third ed. New York: Dover, 1986.

Gernsheim, Helmut. *The History of Photography*. London: Thames and Hudson, 1988.

Gernsheim, Helmut. *The Origins of Photography*. New York: Thames and Hudson, 1982.

Goldberg, Vicki. *Photography in Print*. Albuquerque: University of New Mexico Press, 1981.

Goldberg, Vicki. *The Power of Photography: How Photographs Changed Our Lives*. New York: Abbeville, 1991.

Greenough, Sarah, Joel Snyder, David Travis, and Colin Westerbeck. *On the Art of Fixing a Shadow: One Hundred and Fifty Years of Photography*. Boston: Bulfinch Press, 1989.

Grundberg, Andy, and Kathleen McCarthy Gauss. *Photography and Art: Interactions Since 1946*. New York: Abbeville, 1987.

Jeffrey, Ian. *Photography: A Concise History.* London: Thames and Hudson, 1981.

Jones, Bill. "Legal Fictions." *Arts Magazine* (November 1991): 47–51.

Joyce, Paul. *Hockney on Photography.* New York: Harmony Books, 1988.

Jussim, Estelle. *The Eternal Moment: Essays on the Photographic Image.* New York: Aperture, 1989.

Krauss, Rosalind E. "The Photographic Conditions of Surrealism." In *The Originality of the Avant-Garde and Other Modernist Myths.* Cambridge, MA: The MIT Press, 1986.

Krauss, Rosalind E. "Photography's Discursive Spaces." In *The Originality of the Avant-Garde and Other Modernist Myths.* Cambridge, MA: The MIT Press, 1986.

Lester, Paul. *Photojournalism: An Ethical Approach.* Hillsdale, NJ: Lawrence Erlbaum Associates, 1991.

Messmer, Michael W. "Apostle to the Techno/Peasants: Word and Image in the Work of John Berger." In David B. Downing and Susan Bazargan, eds., *Image and Ideology in Modern/Postmodern Discourse.* Albany: State University of New York Press, 1991.

Moholy-Nagy, László. *Painting, Photography, Film.* [1925]. Cambridge, MA: The MIT Press, 1969.

Newhall, Beaumont. *The History of Photography.* New York: Museum of Modern Art, 1982.

Phillips, Christopher. *Photography in the Modern Era: European Documents and Critical Writings, 1913–1940.* New York: Metropolitan Museum of Art/ Aperture, 1989.

Rothstein, Arthur. *Documentary Photography.* Boston: Focal Press, 1986.

Scharf, Aaron. *Art and Photography.* New York: Penguin, 1986.

Schultz, John, and Barbara Schultz. *Picture Research: A Practical Guide.* New York: Van Nostrand Reinhold, 1991.

Schwarz, Heinrich. *Art and Photography: Forerunners and Influences.* Chicago: University of Chicago Press, 1987.

Scruton, Roger. "The Eye of the Camera." In *The Aesthetic Understanding.* London: Methuen, 1983.

Sekula, Allan. "The Invention of Photographic Meaning." *Artforum* (January 1975): 27–45.

Snyder, Joel, and Neil Walsh Allen. "Photography, Vision, and Representation." *Critical Inquiry* 2 (1975).

Sontag, Susan. *On Photography.* New York: Farrar, Straus & Giroux, 1977.

Stroebel, Leslie, John Compton, Ira Current, and Richard Zakia. *Photographic Materials and Processes.* Boston: Focal Press, 1986.

Szarkowski, John. *Looking at Photographs.* New York: The Museum of Modern Art, 1973.

Szarkowski, John. *The Photographer's Eye.* New York: The Museum of Modern Art, 1980.

Szarkowski, John. *Photography Until Now.* 1990.

Tagg, John. *The Burden of Representation: Essays on Photographies and Histories.* Amherst: University of Massachusetts Press, 1988.

Time. "150 Years of Photojournalism." Special edition. Fall 1989.

Trachtenberg, Alan, ed. *Classic Essays on Photography.* New Haven: Leete's Island Books, 1980.

Trachtenberg, Alan. *Reading American Photographs: Images as History, Mathew Brady to Walker Evans.* New York: Hill and Wang, 1989.

Vitz, Paul C., and Arnold B. Glimcher. "Light, Depth, and Photography." In *Modern Art and Modern Science.* New York: Praeger, 1984.

Weaver, Mike, ed. *The Art of Photography 1839–1989*. New Haven: Yale University Press, 1989.

Younger, Daniel P., ed. *Multiple Views: Logan Grant Essays on Photography 1983–89*. Albuquerque: University of New Mexico Press, 1991.

Traditional Photomontage

Ades, Dawn. *Photomontage*. London: Thames and Hudson, 1976.

Berger, John. "The Political Uses of Photomontage." In *The Look of Things*. New York: Viking, 1974.

Burson, Nancy, Richard Carling, and David Kramlich. *Composites*. New York: Beech Tree Books, 1986.

Evans, David, and Sylvia Gohl. *Photomontage: A Political Weapon*. London: Gordon Fraser, 1986.

Feinstein, Roni. *Photographic Fictions*. New York: Whitney Museum of American Art, 1986.

Gettings, Fred. *Ghosts in Photographs: The Extraordinary Story of Spirit Photography*. New York: Harmony Books, 1978.

Hockney, David. *Hockney on Photography*. New York: Harmony Books, 1988.

Hoy, Anne H. *Fabrications: Staged, Altered, and Appropriated Photographs*. New York: Abbeville, 1987.

Jaubert, Alain. *Making People Disappear: An Amazing Chronicle of Photographic Deception*. McLean, VA: Pergamon-Brassey's International Defense Publishers, 1989.

Kennard, Peter. *Images for the End of the Century*. London: Journeyman Press, 1990.

Metz, Christian. *"Trucage and the Film." Critical Inquiry* 3 (Summer 1977): 657–75.

Orvell, Miles. "Almost Nature: The Typology of Late Nineteenth-Century American Photography." In Daniel P. Younger, ed., *Multiple Views: Logan Grant Es-*

says on Photography 1983–89. Albuquerque: University of New Mexico Press, 1991.

Phillips, Christopher, et al. *Montage and Modern Life: 1919–1942*. Boston: Institute of Contemporary Art, 1992.

Robinson, Henry Peach. *Pictorial Effect in Photography*. [1869]. Pawlett, VT: Helios, 1971.

Root, Marcus A. *The Camera and the Pencil*. [1864]. Pawlett, VT: Helios, 1971.

Smith, Joshua P. *The Photography of Invention*. Cambridge, MA: The MIT Press, 1989.

Sobieszek, Robert A. 1978. "Composite Imagery and the Origins of Photomontage." *Artforum* 17:1 (1978): 58–65, and 17: 2 (1978): 40–45.

Teitelbaum, Matthew, ed. *Montage and Modern Life: 1919–1942*. Boston: Institute of Contemporary Art, 1992.

Uelsmann, Jerry N. "Some Humanistic Considerations of Photography." [1971]. In Vicki Goldberg, ed., *Photography in Print: Writings from 1816 to the Present*. Albuquerque: University of New Mexico Press, 1981.

Uelsmann, Jerry N. *Uelsmann: Process and Perception*. Gainesville: University of Florida Press, 1985.

Vertrees, Alan. "The Picture Making of Henry Peach Robinson." In Dave Oliphant and Thomas Zigel, *Perspectives on Photography*. Austin: University of Texas Press, 1982.

Computer Manipulation of Photographs

Ansberry, Clare. "Alterations of Photos Raise Host of Legal, Ethical Issues." *The Wall Street Journal*, January 26, 1989, B1.

Armbrust, Roger. "Computer Manipulation of the News." *Computer Pictures* (January–February 1985): 6–14.

Bossen, H. "Zone V: Photojournalism, Ethics, and the Electronic Age." *Studies in Visual Communication* 30 (Summer 1985).

Brand, Stewart, Kevin Kelly, and Jay Kinney. "Digital Retouching: The End of Photography as Evidence of Anything." *Whole Earth Review* (July 1985): 42–49.

Browne, Malcolm W. "Computer as Accessory to Photo Fakery." *The New York Times*, July 24, 1991, A6.

Chapnick, H. "We All Know Pictures Can Lie." *Popular Photography* (August 1982): 40–41.

Couture, Andrea M. "Electronic Imaging's Revolution." *ASMP Bulletin* (March 1989): 8–13.

Daviss, Bennett. "Picture Perfect." *Discover* 11:7 (July 1990): 54–58.

Digital Photography. San Francisco: SF Camerawork, 1988.

Druckrey, Timothy. "From Representation to Technology: Photography for the Video Generation." *Afterimage* 17:4 (1989): 12–21.

Druckrey, Timothy. "News Photography and the Digital Highway." *Afterimage* 17:10 (1990): 3.

Durniak, John. "Some People Take Pictures with Cameras, and Some Now Make Them on Computers." *The New York Times*, Sunday, January 19, 1992, Y19.

Fisher, Bob. "The Dawning of the Digital Age." *American Cinematographer* 73:4 (April 1992): 70–86.

Gerrard, Mike. "Computers Make a Clean Breast . . . Or Do They?" *Guardian Weekly*, July 9, 1989.

Grundberg, Andy. "Ask It No Questions: The Camera Can Lie." *The New York Times*, August 12, 1990, Arts and Leisure Section, 1, 29.

Grundberg, Andy. "Photography in the Age of Electronic Simulation." In *Crisis of the Real: Writings on Photography 1974–1989.* New York: Aperture, 1990.

Heimsohm, W. "The Enhancement Effect." *American Photographer* (October 1982): 94–107.

Hulick, Diana Emery. "The Transcendental Machine? A Comparison of Digital Photography and Nineteenth-Century Modes of Photographic Representation." *Leonardo* 23:4 (1990): 419–25.

Krauss, Clifford. "A Photo Said to Show 3 Lost Fliers Jogs Congress on Vietnam Missing." *The New York Times*, July 24, 1991, A6.

Lasica, J. D. "Photographs that Lie." *Washington Journalism Review* (June 1989): 24.

Lasica, J. D. "Pictures Don't Always Tell Truth." *The Boston Globe*, Monday, January 2, 1989, 29–30.

Lee, E. "Rob Lowe Cover: Spoof or Dangerous Deception?" *SixShooters* (September–October 1989): 8–9.

Lester, Paul Martin, ed. *The Ethics of Photojournalism.* Durham, NC: National Press Photographers Association, 1990.

LoPiccolo, Phil. "What's Wrong with This Picture?" *Computer Graphics World* 1 (June 1991): 6–9.

Manganis, Julie. "Just for a Change of Face." *The Boston Herald*, Thursday, February 9, 1989, 30–31.

Morse, Michael L., ed. *The Electronic Revolution in News Photography.* Durham, NC: National Press Photographers Association, 1987.

New York Times. "New Picture Technologies Push Seeing Still Further From Believing." July 3, 1989, 42.

O'Connor, M. "Fix It with Scitex." *How* (January 1986): 44–49.

O'Connor, Michael. "The Serious Implications of Digital Image Processing." *Print* 40 (1986): 51–59, 127–28.

Parker, Douglas. "Ethical Implications of Electronic Still Cameras and Computer Digital Imaging in the Print Media." *Journal of Mass Media Ethics* 3 (1988): 2.

Pollack, Andrew. "Computer Images Stake Out New Territory." *The New York Times,* July 24, 1991, C11–12.

Reaves, Sheila. "Digital Retouching," *News Photographer* (January 1987): 27.

Ritchin, Fred. *In Our Own Image: The Coming Revolution in Photography.* New York: Aperture, 1990.

Ritchin, Fred. "Photography's New Bag of Tricks." *New York Times Magazine,* November 4, 1984, 42–56.

Ritchin, Fred. "Photojournalism in the Age of Computers." In Carol Squiers, ed., *The Critical Image: Essays on Contemporary Photography.* Seattle: Bay Press, 1990.

Rogers, Elizabeth. "Now You See It, Now You Don't." *News Photographer* 44 (August 1989): 16–18.

Rosenberg, J. "Visual Enhancement of Photos." *Editor and Publisher,* March 25, 1989, 47.

Rosler, Martha. "Image Simulations, Computer Manipulations: Some Considerations." *Afterimage* 17:4 (1989): 7–11.

Seibel, Deborah Starr. "Splitting Image: Film Technology's Ability To Mix and Match Past and Present Divides Entertainment Industry." *Chicago Tribune,* Monday, December 30, 1991, Section 5, 1–3.

Sheridan, Daniel. "The Trouble with Harry." *Columbia Journalism Review* 28 (January–February 1990): 4–6.

Sutherland, Don. "Journalism's Image Manipulation Debate: Whose Ethics Will Matter." *Advanced Imaging* 6:11 (November 1991): 59–61.

Terry, Danal, and Dominic Lasorsa. "Ethical Implications of the Easy Manipulation of News Photos with Digital Imaging Technology." Presented at the Association for Education in Journalism and Mass Communication Annual Conference, Washington, DC, August 1989.

Tomlinson, Don E. "Coalesce or Collide? Ethics, Technology, and TV Journalism 1991." *Journal of Mass Media Ethics* 2:2 (Spring/Summer 1987).

Digital Image-Processing Technology

Asmus, John F. "Computer Enhancements of the Mona Lisa." *Perspectives in Computing* 7 (1987): 11–22.

Asmus, John F. "Digital Image Processing in Art Conservation." *Byte* 12:3 (1987): 151–65.

Baxes, Gregory A. *Digital Image Processing: A Practical Primer.* Englewood Cliffs, NJ: Prentice-Hall, 1984.

Benton, John F. "Digital Image Processing Applied to the Photography of Manuscripts." *Scriptorium* 33 (1979): 40–55.

Breslow, Norman. *Basic Digital Photography.* Boston: Focal Press, 1991.

Castleman, Kenneth R. *Digital Image Processing.* Englewood Cliffs, NJ: Prentice-Hall, 1979.

Cannon, T. M., and B. R. Hunt. "Image Processing by Computer." *Scientific American* 245:4 (1981): 214–25.

Gonzalez, Rafael C., and Paul Wintz. *Digital Image Processing.* Reading, MA: Addison-Wesley, 1987.

Green, William B. *Digital Image Processing: A Systems Approach.* New York: Van Nostrand Reinhold, 1989.

Hall, Ernest L. *Computer Image Processing and Recognition.* New York: Academic Press, 1979.

Holtzmann, Gerard J. *Beyond Photography: The Digital Darkroom.* Englewood Cliffs, NJ: Prentice Hall, 1988.

Lindley, Craig A. *Practical Image Processing in C.* New York: John Wiley, 1991.

Linehan, Thomas E. "Digital Image-Digital Cinema." *Communications of the ACM* 33:7 (July 1990): 29–37.

Niblack, Wayne. *An Introduction to Digital Image Processing.* Englewood Cliffs, NJ: Prentice-Hall, 1986.

Pavlidis, Theo. *Algorithms for Graphics and Image Processing.* Rockville, MD: Computer Science Press, 1982.

Pickover, Clifford A. "Image Processing of the Shroud of Turin." In *Computers, Pattern, Chaos and Beauty.* Stroud, Gloucestershire: Alan Sutton, 1990.

Pratt, William K. *Digital Image Processing.* New York: John Wiley, 1978.

Sandbank, C. P., ed. *Digital Television.* New York: John Wiley, 1990.

Schreiber, William F. *Fundamentals of Electronic Imaging Systems: Some Aspects of Image Processing.* New York: Springer-Verlag, 1991.

Stone, Maureen C., William B. Cowan, and John C. Beatty. "Color Gamut Mapping and the Printing of Digital Color Images." *ACM Transactions on Graphics* 7:4 (1988): 249–92.

Tazelaar, Jane Morrill, ed. "In Depth: Sound and Image Processing." *Byte* 14:13 (1989): 240–321.

Ulichney, Robert. *Digital Halftoning.* Cambridge, MA: The MIT Press, 1987.

Computer Image Synthesis

Beatty, John C., and Kellogg S. Booth, eds. *Tutorial: Computer Graphics.* Second ed. New York: IEEE, 1982.

Deken, Joseph. *Computer Images: State of the Art.* New York: Stewart, Tabori and Chang, 1983.

Farin, Gerald. *Curves and Surfaces for Computer Aided Geometric Design.* San Diego: Academic Press, 1988.

Fiume, Eugene L. *The Mathematical Structure of Raster Graphics.* New York: Academic Press, 1989.

Foley, James, Andries van Dam, Steven Feiner, and John Hughes. *Computer Graphics: Principles and Practice.* Reading, MA: Addison-Wesley, 1990.

Franke, Herbert W. *Computer Graphics—Computer Art.* Berlin: Springer-Verlag, 1985.

Freeman, Herbert. *Tutorial and Selected Readings in Interactive Computer Graphics.* New York: IEEE, 1980.

Friedhoff, Richard Mark, and William Benzon. *Visualization: The Second Computer Revolution.* New York: Harry N. Abrams, 1989.

Glassner, Andrew S., ed. *An Introduction to Ray Tracing.* New York: Academic Press, 1989.

Glassner, Andrew S. *3D Computer Graphics: A User's Guide for Artists and Designers.* Second ed. New York: Design Press, 1989.

Goodman, Cynthia. *Digital Visions.* New York: Harry N. Abrams, 1987.

Greenberg, Donald P., et al. *The Computer Image: Applications of Computer Graphics.* Reading, MA: Addison-Wesley, 1982.

Greenberg, Donald P. "Computer Graphics and Visualization." In Alan Pipes, ed., *Computer-Aided Architectural Design Futures.* London: Butterworths, 1986.

Greenberg, Donald P. "Light Reflection Models for Computer Graphics. *Science* 244 (1989): 166–73.

Hall, Roy. *Illumination and Color in Computer Generated Imagery.* New York: Springer-Verlag, 1989.

Hill, Fransis S. *Computer Graphics*. New York: Macmillan, 1990.

Jankl, Annabel, and Rocky Morton. *Creative Computer Graphics*. Cambridge: Cambridge University Press, 1984.

Joy, Kenneth I., et al. *Computer Graphics: Image Synthesis*. Washington: IEEE, 1988.

Kajiya, James T. "The Rendering Equation." *ACM Computer Graphics (SIGGRAPH 86)* 20:4 (1986): 143–50.

Kalay, Yehuda E. *Modeling Objects and Environments*. New York: John Wiley, 1989.

Kerlow, Isaac, and Judson Rosebush. *Computer Graphics for Artists and Designers*. New York: Van Nostrand Reinhold, 1986.

Lewell, John. *Computer Graphics: A Survey of Current Techniques and Applications*. New York: Van Nostrand Reinhold, 1985.

Magnenat-Thalmann, Nadia, and Daniel Thalmann. *Image Synthesis: Theory and Practice*. Tokyo: Springer-Verlag, 1987.

Mantyla, Martti. *An Introduction to Solid Modeling*. Rockville, MD: Computer Science Press, 1988.

Mitchell, William J., Robin S. Liggett, and Thomas Kvan. *The Art of Computer Graphics Programming*. New York: Van Nostrand Reinhold, 1987.

Mortensen, Michael E. *Computer Graphics: An Introduction to the Mathematics and Geometry*. New York: Industrial Press, 1989.

Mortensen, Michael E. *Geometric Modeling*. New York: John Wiley, 1985.

Mullineux, Glen. *CAD: Computational Concepts and Methods*. New York: Macmillan, 1986.

Newman, William M., and Robert F. Sproull. *Principles of Interactive Computer Graphics*. New York: McGraw-Hill, 1979.

Penna, Michael A., and Richard R. Patterson. *Projective Geometry and Its Application to Computer Graphics*. Englewood Cliffs, NJ: Prentice-Hall, 1986.

Prusinkiewicz, Przmyslaw, and Aristid Lindenmayer. *The Algorithmic Beauty of Plants*. New York: Springer-Verlag, 1990.

Reghbati, Hassan K., and Anson Y. C. Yee. *Tutorial: Computer Graphics Hardware*. Washington, DC: Computer Society Press, 1988.

Rivlin, Robert. *The Algorithmic Image*. Redmond, WA: Microsoft Press, 1986.

Rogers, David F. *Procedural Elements for Computer Graphics*. New York: McGraw-Hill, 1985.

Rogers, David F., and J. Alan Adams. *Mathematical Elements for Computer Graphics*. New York: McGraw-Hill, 1976.

Salmon, Rod, and Mel Slater. *Computer Graphics: Systems and Concepts*. Reading, MA: Addison-Wesley, 1987.

Upstill, Steve. *The RenderMan Companion*. Reading, MA: Addison-Wesley, 1990.

Ward, Fred. 1989. "Images for the Computer Age." *National Geographic* 175:6 (1989): 718–51.

Watt, Alan. *Fundamentals of Three-Dimensional Computer Graphics*. Reading, MA: Addison-Wesley, 1989.

Medical and Scientific Imaging

Binnig, Gerd, and Heinrich Rohrer. "The Scanning Tunnelling Microscope." *Scientific American* (August 1985): 50–56.

Carlblom, Ingrid, Indranil Chakravarty, and William M. Hsu. "Integrating Computer Graphics, Computer Vision, and Image Processing in Scientific Applications." *Computer Graphics* 26:1 (January 1992): 8–17.

Golden, Frederic. "Diagnostic Wizardry." *Los Angeles Times Magazine*, October 8, 1989, 19.

Hall, Stephen S. *Mapping the Next Millennium: The Discovery of New Geographies*. New York: Random House, 1992.

Henig, Robin Marantz. "The Inner Landscape." *New York Times Magazine*, April 17, 1988, 59–60.

Lillesand, Thomas M., and Ralph W. Kiefer. *Remote Sensing and Image Interpretation*. Second ed. New York: John Wiley, 1987.

Mack, Pamela E. *Viewing the Earth: The Social Construction of the Landsat System*. Cambridge, MA: The MIT Press, 1990.

Sider, Lee, ed. *Introduction to Diagnostic Imaging*. New York: Churchill Livingstone, 1986.

Simonett, David S. "The Development and Principles of Remote Sensing." In Robert N. Colwell, ed., *Manual of Remote Sensing*. Second ed. Falls Church, VA: American Society of Photogrammetry, 1983, 1–35.

Sochurek, Howard. "Medicine's New Vision." *National Geographic* (January 1987): 2–41.

Stytz, Martin R., Gideon Frieder, and Ophir Frieder. "Three-Dimensional Medical Imaging: Algorithms and Computer Systems." *ACM Computing Surveys* 23:4 (December 1991): 421–99.

Trefil, James. "Seeing Atoms." *Discover* (June 1990): 54–60.

Visual Cognition and Image Interpretation

Ballard, Dana, and Christopher Brown. *Computer Vision*. Englewood Cliffs, NJ: Prentice Hall, 1982.

Bennett, Bruce M., Donald D. Hoffman, and Chetan Prakash. *Observer Mechanics*. Cambridge, MA: The MIT Press.

Fischler, Martin A., and Oscar Firschein, eds. *Readings in Computer Vision: Issues, Problems, Principles, and Paradigms*. Los Altos, CA: Morgan Kaufmann, 1987.

Gregory, Richard L. *Eye and Brain: The Psychology of Seeing*. Fourth ed. Princeton: Princeton University Press, 1990.

Gregory, Richard L. "Perceptions as Hypotheses." *Philosophical Transcripts of the Royal Society* B290 (1980): 181–97.

Harmon, Leon D. "The Recognition of Faces." *Scientific American* 229 (1973): 70–82.

Horn, Berthold K. P. *Robot Vision*. Cambridge, MA: The MIT Press, 1986.

Horn, Berthold K. P., and Michael J. Brooks, eds. *Shape from Shading*. Cambridge, MA: The MIT Press, 1989.

Kasturi, Rangachar, and Ramesh Jain. *Computer Vision: Advances and Applications*. Washington, DC: IEEE Computer Society, 1991.

Kasturi, Rangachar, and Ramesh Jain. *Computer Vision: Principles*. Washington, DC: IEEE Computer Society, 1991.

Levine, Martin D. *Vision in Man and Machine*. New York: McGraw-Hill, 1985.

Livingstone, M. S. "Art, Illusion and the Visual System." *Scientific American* 258:1 (1988): 78–85.

Marr, David. *Vision: A Computational Investigation into the Human Representation and Processing of Visual Information*. San Francisco: W. H. Freeman, 1982.

Pinker, Steven. *Visual Cognition*. Cambridge, MA: The MIT Press, 1985.

Richards, Whitman. *Natural Computation*. Cambridge, MA: The MIT Press, 1988.

Shepherd, Roger N. *Mind Sights*. New York: W. H. Freeman, 1990.

Suetens, Paul, Pascal Fua, and Andrew J. Hanson. "Computational Strategies for Object Recognition." *ACM Computing Surveys* 24:1 (March 1992): 5–61.

Truth, Verisimilitude, Deceit, and Fiction

Adams, Robert. "Truth and Landscape." In *Beauty in Photography: Essays in Defense of Traditional Values*. New York: Aperture, 1989.

Bacon, Francis. "Of Truth." [1639]. In *Essays Civil and Moral*. London: Ward, Lock and Co., 1910.

Bailey, F. G. *The Prevalence of Deceit*. Ithaca: Cornell University Press, 1991.

Barthes, Roland. "The Reality Effect." In Tzvetan Todorov, ed., *French Literary Theory Today*. Cambridge: Cambridge University Press, 1982.

Baudrillard, Jean. *Simulations*. New York: Semiotext(e), 1983.

Bok, Sissela. *Lying: Moral Choice in Public and Private Life*. New York: Pantheon, 1978.

Booth, Wayne C. *The Rhetoric of Fiction*. Chicago: University of Chicago Press, 1961.

Burgin, Victor. "Art, Common-Sense and Photography," *Camerawork* 3 (1976): 86–91.

Chisolm, Roderick, and Thomas D. Feehan. "The Intent to Deceive." *The Journal of Philosophy* 74 (1977): 143–59.

Crary, Jonathan. *Techniques of the Observer: On Vision and Modernity in the Nineteenth Century*. Cambridge, MA: The MIT Press, 1990.

Dretske, Fred. "Seeing, Believing, and Knowing." In Daniel N. Osherson, Stephen M. Kosslyn, and John M. Hollerbach, eds., *Visual Cognition and Action*. Cambridge, MA: The MIT Press, 1990.

Durand, Jacques. "Rhétorique et Image Publicitaire." *Communications* 15 (1970): 70–95.

Freedberg, David. *The Power of Images: Studies in the History and Theory of Response*. Chicago: University of Chicago Press, 1989.

Goodman, Nelson. "On Rightness of Rendering." In *Ways of Worldmaking*. Indianapolis: Hackett, 1978.

Goodman, Nelson. "Reference." In *Of Mind and Other Matters*. Cambridge, MA: Harvard University Press, 1984.

Jakobson, Roman. "On Realism in Art." [1921]. In *Language in Literature*. Cambridge, MA: The Belknap Press of Harvard University Press, 1987, 19–27.

Juhl, P. D. "Life, Literature, and the Implied Author: Can (Fictional) Literary Works Make Truth-Claims?" In *Interpretation: An Essay in the Philosophy of Literary Criticism*. Princeton: Princeton University Press, 1980.

Kenner, Hugh. *The Counterfeiters: An Historical Comedy*. [1968]. Baltimore: The Johns Hopkins University Press, 1985.

Kerr, Philip, ed. *The Penguin Book of Lies*. London: Viking Penguin, 1990.

Knightley, Phillip. *The First Casualty*. New York: Harcourt Brace Jovanovich, 1975.

Lyotard, Jean-François. *The Postmodern Condition: A Report on Knowledge*. Minneapolis: University of Minnesota Press, 1984.

Martin, Edwin. "Against Photographic Deception." *Journal of Mass Media Ethics* 2 (1987): 2.

Nichols, Bill. *Ideology and the Image: Social Representation in the Cinema and Other Media*. Bloomington: Indiana University Press, 1981.

Riffaterre, Michael. *Fictional Truth*. Baltimore: The Johns Hopkins University Press, 1990.

Roskill, Mark, and David Carrier. *Truth and Falsehood in Visual Images*. Amherst: University of Massachusetts Press, 1983.

Searle, John R. "The Logical Status of Fictional Discourse." In *Expression and Meaning: Studies in the Theory of Speech Acts*. Cambridge: Cambridge University Press, 1979.

Reproductions and Forgeries

Arnau, Frank. *Three Thousand Years of Deception in Art and Antiques*. London: Jonathan Cape, 1961.

Benjamin, Walter. "The Work of Art in the Age of Mechanical Reproduction." In *Illuminations*, ed. Hannah Arendt, trans. Harry Zohn. New York: Harcourt Brace & World, 1955.

Dorner, Alexander. "Original and Facsimile." [1930]. In Christopher Phillips, ed., *Photography in the Modern Era: European Documents and Critical Writings, 1913–1940*. New York: Metropolitan Museum of Art/Aperture, 1989.

Dutton, Denis. *The Forger's Art*. Berkeley: University of California Press, 1983.

Eberlein, Kurt Karl. "On the Question: Original or Facsimile Reproduction?" [1929]. In Christopher Phillips, ed., *Photography in the Modern Era: European Documents and Critical Writings, 1913–1940*. New York: Metropolitan Museum of Art/Aperture, 1989.

Eco, Umberto. "Fakes and Forgeries." In *The Limits of Interpretation*. Bloomington: Indiana University Press, 1990.

Fleming, Stuart James. *Authenticity in Art: The Scientific Detection of Forgery*. Oxford: Institute of Physics, 1975.

Gilson, Etienne. "Individuality" and "Duration." In *Painting and Reality*. New York: Pantheon, 1957.

Goodman, Nelson. "Art and Authenticity." In *Languages of Art*. Second ed. Indianapolis: Hackett, 1976.

Grafton, Anthony. *Forgers and Critics: Creativity and Duplicity in Western Scholarship*. Princeton: Princeton University Press, 1990.

Haywood, Ian. *Faking It: Art and the Politics of Forgery*. Brighton: Harvester Press.

Jones, Mark, ed. *Fake?: The Art of Deception*. London: British Museum Publications, 1990.

Lovejoy, Margot. "The Copier: Authorship and Originality." In *Postmodern Currents: Art and Artists in the Age of Electronic Media*. Ann Arbor: UMI Research Press, 1989.

Mendax, Fritz. *Art Fakes and Forgeries*. London: Werner Laurie, 1955.

Reith, Adolf. *Archaeological Fakes*. London: Barrie and Jenkins, 1970.

Savage, George. *Forgeries, Fakes and Reproductions*. London: White Lion Publishing, 1976.

Wright, Christopher. *The Art of the Forger*. London: Gordon Fraser, 1984.

Intellectual Property

Branscomb, Anne W. "Common Law for the Electronic Frontier." *Scientific American* 265:3 (1991): 154–58.

Cavallo, Robert M., and Stuart Kahan. *Photography: What's the Law?* New York: Crown, 1976.

Crawford, Tad. *Legal Guide for the Visual Artist: The Professional's Handbook*. New York: Madison Square Press, 1987.

Feldman, Franklin, Stephen E. Weil, and Susan Duke Biederman. *Art Law, Rights and Liabilities of Creators and Collectors*. Boston: Little Brown, 1986.

Gilbert, Steven W., Peter Lyman, and D. Linda Garcia. "Intellectual Property in the Information Age." *Change* 21:3 (1989): 22.

Gross, Larry, John Stuart Katz, and Jack Ruby, eds. *Image Ethics: The Moral Rights of Subjects in Photographs, Film, and Television.* Oxford: Oxford University Press, 1988.

Oakley, Robert L. *Copyright and Preservation: A Serious Problem in Need of a Thoughtful Solution.* Washington, DC: The Commission on Preservation and Access, 1990.

Patry, William F. *Latman's The Copyright Law.* Washington, DC: Bureau of National Affairs, 1986.

Plowman, Edward, and Clark L. Hamilton. *Copyright: Intellectual Property in the Information Age.* London: Routledge and Kegan Paul, 1980.

Rule, Sheila. "Record Companies Are Challenging 'Sampling' in Rap." *The New York Times,* Tuesday, April 21, 1992, C13.

Samuelson, Pamela. "Copyright Law and Electronic Compilations of Data." *Communications of the ACM* 35:2 (February 1992): 27–32.

Samuelson, Pamela. "Is Information Property?" *Communications of the ACM* 34:3 (March 1991): 15.

Solomon, Richard Jay. "Vanishing Intellectual Boundaries: Virtual Networking and the Loss of Sovereignty and Control." *Annals of the American Academy of Political and Social Science* 495 (January 1988): 40.

■ INDEX